C A L I F O R N I A S T U D I E S

I N T H E H I S T O R Y

O F A R T

WALTER HORN, *General Editor*

JAMES MARROW, *Associate Editor*

The publisher gratefully acknowledges the generous contribution provided by the Director's Circle of the Associates of the University of California Press, whose members are

Virginia and Richard Adloff
Edmund Corvelli, Jr.
Diane and Charles L. Frankel
Florence and Leo Helzel
Sandra and Charles Hobson
Valerie and Joel Katz
Penny and Robert Marshall
Lucia and Paul Matzger

Ruth and David Mellinkoff
Elvira and Byron Nishkian
Helene H. Oppenheimer
Ava Jean Pischel
Lydia and Martin Titcomb
Adelle and Erwin Tomash
Mrs. Paul Wattis
Marcia Weisman

The publisher also gratefully acknowledges the assistance of the Spanish Ministry of Culture and the Program for Cultural Cooperation between Spain's Ministry of Culture and United States Universities for their generous support.

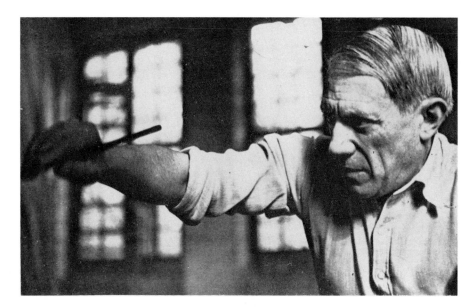

Picasso painting *Guernica*. Photograph by Dora Maar.

PICASSO'S

G U E R N I C A

History, Transformations, Meanings

HERSCHEL B. CHIPP

with a chapter by Javier Tusell

UNIVERSITY OF CALIFORNIA PRESS

Berkeley · Los Angeles · London

University of California Press
Berkeley and Los Angeles, California

Library of Congress Cataloging in Publication
Data

Chipp, Herschel Browning.
Picasso's Guernica: history, transformations,
meanings / Herschel B. Chipp; with a chapter by
Javier Tusell.
p. cm.—(California studies in the history of art;
26)
Bibliography: p.
Includes index.
ISBN 0-520-06043-1
1. Picasso, Pablo,
1881–1973. Guernica. 2. Picasso, Pablo,
1881–1973—Criticism and
interpretation. 3. Painting, French.
4. Painting, Modern—20th century—
France. 5. Spain—History—Civil
War, 1936–1939—Art and the war. I. Tusell,
Javier, 1945–
II. Title. III. Series.
ND553.P5A66 1988b
759.4—dc19 87-30893

Printed in the United States of America

1 2 3 4 5 6 7 8 9

CONTENTS

PREFACE

I have always believed, and still believe, that art-
ists who live and work with spiritual values can-
not and should not remain indifferent to a
conflict in which the highest values of humanity
and civilization are at stake.

—*Picasso*

This book is a search for the meanings underlying one of Picasso's great-
est paintings, *Guernica*. The work comes from the time when the artist
was fifty-five years of age, at the height of his artistic powers, and keeping
company with two beautiful women, both of whom obsessed his imagi-
nation and were reflected ambivalently in his art. Picasso was living and
working in the close company of the surrealist poets—at the time they
were the leading edge of the avant-garde—and for a time he had given up
painting and was writing poetry with vivid imagery and disjointed syntax
that were in many ways related to his art. A number of the images in his
art and poetry coincide in date and reflect critical moments in his per-
sonal life: the birth of his daughter to Marie-Thérèse Walter and the
furious departure of his wife Olga, with their fourteen-year-old son, from
the family apartment. Evoked in part by the intense emotions racking the
artist's personal life, images from the bullfight emerged from his lifelong
devotion to the Spanish *fiesta nacional* to provide some of the poetic ana-
logues for the themes of suffering in *Guernica*.

But the shock that with overpowering urgency was to call into being
the painting, with its cry of outrage and horror, came from another,
wholly unexpected, source—the brutal terror bombing of the peaceful
Basque town of Guernica. In Paris, the news of the atrocity, at first de-
layed and then censored, eventually became so contradictory that it in-
flamed even further the aroused emotions of the Spanish Republicans and
eventually outraged the world. The reverberations of the news engendered
such bitter controversy that as the historian Pierre Vilar has written, the
case of Guernica "is not one of an event becoming a problem but of
the problem itself taking the place of the event."[1] Moreover, although the
bombing was in effect only a minor military episode, it corroborated for a
world already terrified by Nazi and Fascist aggressions the fearful fact of
massive foreign military intervention in the Spanish Civil War. The inter-
vention of German, Italian, and Russian armed forces and even of inter-
national volunteer battalions in the Spanish conflict demonstrated the
bitter schism growing throughout Europe and the Western world be-
tween totalitarian and democratic regimes.

In view of the extraordinary conditions out of which *Guernica* arose, one needs to ask: Are there still other dimensions of meaning to the painting that may not yet have been uncovered, meanings that would remain out of reach of even the most judicious traditional study if it were limited to the visual evidence of the work itself? In attempting to answer, this book surveys the historical and political context that gave rise to *Guernica* and then evaluates Picasso's attitudes toward its various elements— that is, defines his politics. It also considers the degree to which these environmental elements may have provided the motivation for the painting and may even appear in its images.

We may consider *Guernica* in a certain sense as a history painting, although it is not a traditional battle scene representing the heroics of a victor and the suffering of the vanquished. Picasso's modernity lies in his rejection of these and other devices of nineteenth-century and earlier art and in his creation, instead, of an image of a particular tragic event based on sometimes seemingly unrelated motifs drawn from his own art and private life. The final image he conceived does not reflect the point of view of the main combatants in the civil war, to which he had already alluded in *Dream and Lie of Franco*. Rather, we sense in the sketches and then in the painting the brutality of an unseen but monstrous war machine crushing bodies and spirits. Further, Picasso presents the event in perspective as if it were a tableau on a theater stage with no victors but only victims in the principal roles.

Picasso's contemporary definition of history painting, avoiding the traditional glorification of conflict, features those who suffer. Through Picasso's eyes we sense the devastation of the town and the plight of the victims, and thus we become aware of the bitter cruelties of the Spanish Civil War. In this special sense *Guernica* is sometimes seen as an antiwar protest. The work proved to be prophetic of similar terrors that were soon to engulf our age. By transcending the actual event, it evokes the evils of foreign intervention in Spain and implicitly condemns the other aggressions that shortly cast the world into horrors far beyond those of the painting. The broad historical and political implications of the tragedy in Spain propelled *Guernica* into world consciousness and made the painting a symbol of the plight of victims everywhere. Through its symbolic power it exerted its own subtle influence on the course of later practical political affairs. Its odyssey to Britain, Scandinavia, and the United States to appeal for aid on behalf of the Spanish victims and refugees was only the first step. Since that odyssey it has been enlisted many times in the cause of peace, justice, and freedom. Finally, as Picasso had always wished, *Guernica* went to Spain, where it became a symbol of the new post-Franco nation developing toward democracy and public liberties.

These are the justifications for beginning this book with a lengthy summary of the emotional ideological conflicts of 1 May 1937 when, even as the largest May Day demonstrations ever seen thronged the boulevards of Paris, Picasso took up pencil and paper and in a single day conceived his vision of *Guernica*. And given that the painting has accrued new significance with each passing decade and has influenced the course of history, it would be impossible not to discuss either its long exile in America or its ultimate journey to its destined home, Spain.

Photographs in this volume have been provided in most cases by the owners, custodians, or publishers of the works or have been used with their permission, as indicated in the list below. It was impossible, however, to locate all the owners, especially of photographs and documentary materials of the Spanish Civil War years but also of works by Picasso that have recently changed hands. I regret any inadvertent omissions or errors.

The copyright for certain works reproduced herein is controlled by S.P.A.D.E.M. Paris / A.R.S. New York, and to such works the following notice applies: © S.P.A.D.E.M. Paris / A.R.S. New York.

We acknowledge the gracious cooperation of Madame Dora Maar and her permission to reproduce the photographs of *Guernica* she took while it was in progress. We thank the director of *Cahiers d'Art*, M. Yves Fontebrune, who, in the great tradition established in 1932 by Christian Zervos, has allowed me to use the invaluable documentary material assembled and published by that journal. Director General de Bellas Artes Sr. Don Miguel Satrústegui has provided documents and photographs of the stages of Picasso's work on *Guernica*, only recently made available from the Sección "Guerra Civil" of the Archivo Histórico Nacional. The director of the Museo del Prado, Madrid, Sr. Don Alfonso Pérez Sánchez, has kindly lent the photographs and color transparencies of *Guernica*, which were produced by Jesús González. The sketches for *Guernica* as well as the painting itself are in the Casón del Buen Retiro, Museo del Prado, Madrid.

We wish to acknowledge the following sources for specific illustrations:

ABC (Madrid): 11.1

Archivo Histórico Nacional, Sección Guerra Civil; Sección Político-Social, Serie Madrid, Expediente Pabellón Español en París (1937) (legajo 2.760), Madrid and Salamanca: Frontispiece, 7.1, 7.19, 8.19, 8.25

Basque government: 3.11, 3.12, 3.13, 3.14, 4.2

Bastlund, K. *José Luis Sert:* 1.1

Beumelberg, Werner, *Kampf um Spanien:* 1.8

Blanco y Negro (Madrid): 10.1

Boston Herald: 9.7

Brissaud, André, *Canaris: La guerra española:* 2.1

Cahiers d'Art: 1.17, 5.2, 5.3, 5.8, 5.9, 5.14, 5.15, 5.22, 5.23, 5.30, 5.31, 5.33, 6.2, 6.10, 6.13, 6.18, 6.19, 6.20, 6.21, 6.22, 6.38, 6.42, 6.51, 6.68, 6.71, 7.13, 7.20, 7.21, 7.23, 7.25, 7.30, 7.33, 7.37, 8.14, 8.16, 8.18, 8.21, 8.23, 8.26, 8.27

Calder, Alexander, *An Autobiography with Pictures:* 8.17

Castillo, Alberto del, *José María Sert:* 8.15

Documentation photographique de la Réunion des musées nationaux: 5.24, 5.26, 5.34, 5.35, 5.36, 5.37, 5.38, 6.57

El País (Madrid): 11.3, 11.5

Emiliani, Angelo, Faenza, Italy: 3.4.

Europa Press: 10.3, 11.4, 11.6, 11.7, 11.8, 11.9, 11.10

Le Figaro (Paris): 2.4

Galería Juana Mordo, Madrid: 10.2.

Galerie Impressions, 1900–1950, Paris: 8.2

Galerie Jan Krugier, Geneva: 7.10.

Hemingway, Ernest, *Death in the Afternoon:* 5.11, 6.59

Hills, George, *Franco: El hombre y su nación:* 1.10

Hoyos, Max, *Pedros y Pablos:* 3.7, 3.8, 3.9, 3.18

Huelva, Editorial Everest, Leon: 1.14

L'Humanité (Paris): 4.1, 4.3, 6.27, 6.44

L'Illustration: 8.4, 8.9

Life: 6.76

London, Arthur G., *Espagne:* 6.45

Moderna Museet, Stockholm: 6.64.

Mouseion (Paris): 1.5, 1.6

Musée National d'Art Moderne, Centre Pompidou, Paris: 8.13

Museu Picasso, Barcelona: 1.2, 1.3, 1.4, 5.6, 7.24

The Museum of Modern Art, New York: 9.8, 11.2

1937: Exposition internationale (Centre Pompidou): 8.4, 8.5, 8.6, 8.7, 8.10

O'Connor, Francis, *Jackson Pollack:* 12.2

Pabellón Español 1937: 8.20, 8.28

Paris Match: 5.32, 6.62

Penrose, Roland, *Portrait of Picasso:* 1.18, 5.1, 6.8, 9.3, and *Scrapbook, 1900–1981:* 9.1

Renau, Josep, *Arte en peligro:* 1.7

Ries, Karl, and Hans Ring, *Legion Condor, 1936–1939:* 3.10

Rosenblum, Robert, *Cubism and Twentieth Century Art:* 7.40

S.E.R.P., Paris: Map 1.

Talón, Vicente, *Arde Guernica!:* 2.3, 3.3, 3.5, 3.15, 3.16

Thomas, Gordon, and Max Morgan Witts, *Guernica: The Crucible of World War II:* Map 4

Times (London): Map 3

UPI: 10.4

I am indebted, as are all authors writing on artists, first to the artist himself. Although Picasso did not explain the meaning of his monumental painting *Guernica* to me—nor did he ever to anyone—still, by conversations with him and by observation I began to achieve insights into what seemed natural for him, what was possible, and what was not. Most important, I saw confirmed what many of his friends described as his characteristic tendency to transform meanings: his delight in playful and witty double entendres and in high-spirited quasi-dadaist assaults on anything resembling a cliché. Most touching to me personally was his genuine interest in showing me—a graduate student at the time—his collection of his own work. I still remember the intense gaze he fixed on me while I was looking at his paintings. I met with him in 1952 in his studio on the rue des Grands-Augustins (and later in his house in Vallauris and on the beach at Juan-les-Pins) at a time when many of the political issues of 1937 were still alive and his memory of them still fresh.

I am indebted secondly to my teacher and friend Meyer Schapiro, whose lecture on *Guernica,* alas, I was never able to hear but whose example of perceptive scholarship has deeply inspired his students and followers for half a century. Sensitive to both art and social history, he was a participant in, as well as an interpreter of, the artistic and intellectual ferment of the 1930s in the United States and Europe.

Some of Picasso's friends helped me gain a sense of both the art and the spirit of Paris in 1937, especially Daniel-Henry Kahnweiler, Jaime Sabartés, Marie-Thérèse Walter, Josep Lluis Sert, Brassaï, André Malraux, Roland Penrose, Lee Miller, Douglas Cooper, André Breton, Arthur Koestler, Alexander Calder, Georges Braque, James Whitney.

I was able to understand better the passionate devotion of Spanish artists and writers to the cause of the Republic during the ordeal of the war through conversations, in particular with Josep Renau, Jaume Miravitlles, and Dolores Ibarruri (La Pasionaria), all of them refugees for most of their lives. The friendship of the veterans of the Abraham Lincoln Brigade was valuable and most appreciated. Several members of the Republican government in exile in France remain anonymous because at the time of our conversations they were still carrying on clandestine operations against the Franco regime.

More recently, I have received valued stimulus and aid from José Mario Armero, Rafael Fernández Quintanilla, Rafael Alberti, Roland Dumas (now foreign minister of France), Vicente Talón, Javier Tusell, Josep Palau i Fabre, Carlos Rojas, Rosa María Subirana, María Teresa Ocaña, Catherine Coleman, Joaquín de la Puente, Basilio Martín Patino, Luis Romero, José Melicula, Antonio González Quintana, Tom Entwhistle, Patrick Laureau, Thomas Sarbaugh, and Paul Whelan.

Among those Americans who secured *Guernica* for a tour of this country, I am indebted for firsthand information especially to Sidney Janis, Blanche Mahler Weisberg, Evelyn Ahrend Kirkpatrick, Margaret Scolari Barr, Earl Stendahl, Grace McCann Morley, Charles Lindstrom, and John Humphrey.

Since this work examines *Guernica* from a new point of view, I list for special mention here only those that were especially stimulating, provocative, or relevant to my research or methodology, recommending that the reader refer to my bibliography for a comprehensive listing of references.

Most of the best writings from the time of *Guernica* were published by *Cahiers d'Art*. A double issue (Vol. 12, nos. 4–5 [1937]) devoted to *Guernica* included Dora Maar's invaluable photographs of the work in progress as well as some dozen essays by leading poets and critics.

Books by a number of authors have made substantial contributions to my study of *Guernica*. I am indebted for quite different reasons to those by Juan Larrea, Jan Runnqvist, and, most especially, Rudolf Arnheim, whose book established a much-needed discipline in the study of a painting of extraordinary complexity.

Jerome Seckler's interview with Picasso in 1944 was the first published in English and introduced a political intent to the painting, a point of view that was continued in writings by many others, not all of which have survived the test of time. Among those I have found particularly useful are works by Georges Sadoul, Ramón Gómez de la Serna, Christian Zervos, Michel Leiris, Herbert Read, Elizabeth McCausland, Robert Goldwater, and James Thrall Soby.

Among recent articles and books, those of special interest are by José López-Rey, Reinhold Hohl, Sidra Stich, Patricia Failing, Gloria K. Fiero, Josefina Alix Trueba, Mary Matthews Gedo, Phyllis Tuchman, Beryl Barr-Sharrar, José Barrio-Garay, Ruth Kaufmann, Kirsten Hoving Keen, Catherine B. Freedberg, Sebastian and Herma C. Goeppert, Hilton Kramer, and John Richardson.

I regret that space does not permit me to mention by name the many public officials, librarians, museum directors and staffs, authors, and graduate students in my seminars who have lent me their expertise. They have all contributed to this book and I most gratefully remember their assistance.

I must, however, express my appreciation for patient guidance to James Clark, director of the University of California Press, and William J. McClung, my sponsoring editor, and for devoted and intelligent concentration on the editorial preparation of the manuscript to Stephanie Fay of the Press and to Lisa Bornstein, Joan Bossart (who has also contributed to the text), and Lorna Price. Translations of Spanish and Catalan texts were handled by Radiça Ostojíc.

G. Geiser, Bernhard G. *Picasso, peintre-graveur,* Vol. 2 (nos. 258–572): *Catalogue raisonné de l'oeuvre gravé et des monotypes, 1932–1934.* Bern: Kornfeld and Klipstein, 1968.

S. Spies, Werner. *Picasso: Das plastische Werk.* Stuttgart: Gerd Hatje, 1971.

Z Zervos, Christian. *Pablo Picasso.* Catalogue raisonné, vols. 1–33. Paris: Cahiers d'Art, 1932–.

LP *Guernica—Legado Picasso.* Madrid: Ministerio de Cultura, 1981.

MOMA The Museum of Modern Art, New York

MPB Museu Picasso, Barcelona

MPM Museo del Prado, Madrid

MPP Musée Picasso, Paris

PART ONE

PREHISTORY OF

THE PAINTING

In the nightmare of the dark
All the dogs of Europe bark,
And the living nations wait,
Each sequestered in its hate.

—*W. H. Auden*

Early in January 1937 Picasso received an urgent call from his friend the young Catalan architect Josep Lluis Sert, asking to see him. Shortly afterward, Sert arrived, accompanied by several other Spaniards. The delegation included Max Aub, cultural counselor of the Spanish embassy; Juan Larrea, poet and director of public information for the embassy; and Luis Lacasa, another architect. They climbed the stairway to Picasso's studio on the top floor of the fashionable apartment building at 23, rue la Boétie, on the right bank in Paris, with considerable emotion, for they were coming to ask Picasso to participate in a project of great symbolic significance for the Spanish Republic.

The Spanish ambassador in Paris, Luis Araquistáin, had observed the elaborate preparations under way for the 1937 Paris World's Fair—officially, Exposition internationale des arts et techniques dans la vie moderne—the most magnificent ever conceived, and he hoped fervently to have his own Spanish Republican government represented on the banks of the Seine among the other countries of the world.[1] Although his was the legitimately elected government of Spain (called Loyalist by its supporters), in January 1937 it was staggering beneath the heavy blows of a military uprising that with strong support from Nazi Germany and Fascist Italy had in six months overrun more than half the country (Map 1). At that moment Madrid was under siege by air, Cádiz had been taken by the rebels and had become the port of disembarkation for the Italian forces, and Málaga—Picasso's birthplace, where many members of his family still remained—was already surrounded by the Italians. On 6 January, Hitler's ultimatum to the Basques in the north ordering them to cease all resistance or face destruction appeared in the Paris press; Franco reinforced this threat by declaring a blockade of all Spanish ports.[2]

Araquistáin desired to demonstrate emphatically, first, that the Spanish Republic still existed and, second, that it, and not Franco's military regime, legally represented the country and its economic and cultural resources. The pavilion he proposed to build would thus be enthusiastically devoted to extolling the merits of the largely civilian army then defending

Map 1. By 1937, the Basques were isolated in the north (see blackened area, top center) from the rest of Spain.

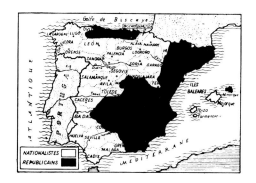

1.1 Proposed design for the Spanish pavilion, Paris, January 1937; Josep Lluis Sert, architect. Compare with the completed structure (8.12).

the Republic and to praising the Republic's social programs, particularly those in agriculture and public education (1.1).

It was late to start planning a pavilion. The official opening of the exposition was scheduled for May Day, less than four months away. Construction of some of the other buildings had begun, and the German pavilion—on the right bank of the Seine immediately adjacent to the plot assigned to Spain—already held promise of becoming the tallest and most grandiose of all. Sert, who had been commissioned to design the Spanish pavilion, had not even drawn up his plans. Although the project had not yet been approved by the Republican government—at that moment still establishing itself in Valencia after having fled Madrid in haste—Sert had already aroused the interest of the artists Joan Miró, Alberto Sánchez, and Julio González, the film director Luis Buñuel, the late Federico García Lorca's La Barraca dramatic troupe, and the poster artist Josep Renau (who was also director general of fine arts for the Republic).[3]

In the hope that he would join them, Sert and his colleagues visited Picasso. But even when Sert asked him to contribute a large mural painting on a subject of his own choice, which would be hung in a prominent location in the entrance hall, Picasso's response was typically noncommittal. He hesitated to join his countrymen and fellow artists for several reasons. The project was obviously intended as political propaganda for the Republic and was to be part of a world's fair, normally a place for popular entertainment and edification. Moreover, Picasso was indifferent to officialdom: he had repeatedly ignored overtures from the Spanish embassy as well as invitations to social functions. He still resented a slight of several years earlier by the director general of fine arts in Madrid who, in discussing a proposed exhibition, had not only questioned Picasso's Spanish citizenship but, even worse, had compared him to such traditional Spanish artists as Zuloaga and Anglada. During a visit to San Sebastián in 1934, Picasso had had other distressing experiences with officials over plans for an exhibition. The organizer of that exhibition, according to the accounts of the historian Javier Tusell, had not planned to insure the paintings, believing that to engage the Guardia Civil as an escort during the trip by railway would offer sufficient protection. Horrified at the thought of his paintings being exhibited without protection, Picasso was not placated by the promise of a military escort: the Guardia Civil had come to symbolize for Picasso's coterie—made up in large part of artists of anarchistic thought—the persecution of freethinkers and Gypsies.[4] Unlikely as it might seem, Picasso had once complained to José Antonio Primo de Rivera, future founder of the Falange Española, that the only Spanish government official who had ever shown any regard for him as an artist and a countryman was Primo de Rivera's own father, General Miguel Primo de Rivera, when he was prime minister and dictator during the reign of King Alfonso XIII.

Picasso is generally thought to have had little concern with politics. This is true only insofar as he had rarely, if ever, allowed politics to intrude into his art. As a youth in Barcelona he made several sheets of drawings relating to wars. For example, at the time of the rebellion in Cuba in 1895, he made a posterlike patriotic scene with waving Spanish flags and beating drums entitled *Divine Allegory* (1.2); and in 1900, during the Boer War in South Africa, he made cartoonlike sketches of soldiers labeled "Boers" (1.3). The gouache *End of the Road*, of 1898, is thought to

depict a scene from a contemporary play about the return to Spain of defeated soldiers and colonists during the Spanish-American War. Before 1900, while a student at the School of Fine Arts in Barcelona copying the Spanish masters in the museums, he made several drawings, probably copied from paintings, which are thought to celebrate great battles in Spanish history (1.4). Apparently none of these was otherwise politically motivated. Almost nothing in Picasso's statements or his work prior to the Spanish Civil War indicates a particular concern over the dramatic political struggles in his native land. A notable exception, *Dream and Lie of Franco,* is discussed below.

In 1923 a coup d'état established Miguel Primo de Rivera as virtual dictator of a new Spanish government patterned after Mussolini's blueprint for Italy. His rule lasted until 1930, when the rising Republican opposition forced the abdication and exile of King Alfonso XIII. The provisional Republican government, taking the Weimar constitution as a model for resolving factional conflicts, maintained itself for two or three years. But Hitler's rise to power and Mussolini's growing influence gave sufficient encouragement to the conservative opposition in Spain—army leaders, church officials, industrialists, and aristocrats—to split the Cortes (Spanish parliament) irreconcilably between the two factions. In the elections of February 1936 the Popular Front, following the example of the Popular Front in France, which was also soon to succeed at the polls, united the Socialists, Communists, and Anarchists to win the elections and establish its own Republican government. This victory was followed by acts of violence on both sides and by an intense Republican euphoria that led to vandalism against the church and to the assassinations of priests and government officials. Five months later, on 18 July 1936, the

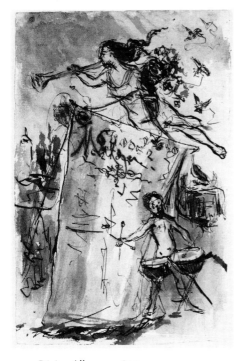

1.2 *Divine Allegory,* 1895–1896. Watercolor, pen, and pencil. $9\frac{7}{8}'' \times 6''$ (25.2 × 15.5 cm). MPB.

1.3 Caricature of Boer and English soldiers, c. 1900. Ink. $9\frac{1}{2}'' \times 8\frac{5}{8}''$ (24.3 × 22 cm). MPB.

1.4 Battle scene, 1895–1896. Pen, watercolor, and Conté crayon. $12\frac{1}{8}'' \times 18\frac{1}{2}''$ (31 × 47.5 cm). MPB.

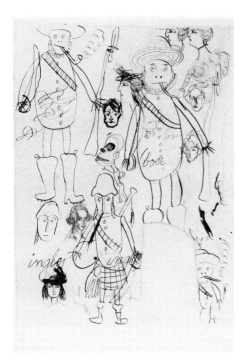

simultaneous rebellion of army units in the larger cities and the invasion of the peninsula by the regular Spanish army and the foreign legion from Morocco threw the country into civil war.

Picasso was certainly aware of these momentous events—the Paris newspapers were filled with sensational reports and his mother had written him of her terror at the fighting and the bombings in the very streets of Barcelona, where he had grown up.[5] But he never publicly took a partisan political position, even though his closest friends during these years, Paul Eluard, Louis Aragon, and André Breton—indeed, all the surrealist poets—and his Spanish friends living in Paris, Sert, Larrea, Ramón Gómez de la Serna, Luis Quintanilla, and many more, were fervent supporters of the Republican cause to which they also devoted their art.

Picasso had recently returned to Spain twice, in the summers of 1933 and 1934, during which time he had visited old friends in Barcelona, Madrid, and San Sebastián; had attended bullfights; had seen the new museum of medieval Catalan art in Barcelona; and, in general, had renewed his "Spanishness,"[6] in which he took great satisfaction. According to Gertrude Stein's much quoted remark, Picasso was less concerned with the events themselves than with their having happened in Spain. Despite all these close connections with his native land, he took no public stand on the events leading to the civil war. Even during the agony of the first confused days of the fighting when so many innocents were being murdered, he went ahead with his plans for a summer vacation and left Paris in August 1936, in accordance with the French custom. Although he had been there just a few weeks earlier, he returned to the Côte d'Azur. During this vacation, Dora Maar, his new companion, dominated his art much as Marie-Thérèse Walter had dominated it in recent years. No trace of the violence and hatreds that racked his country, now geographically very close to him, entered into his art.

The memoirs of his friends provide conflicting views of the extent of Picasso's concern. D.-H. Kahnweiler, his oldest friend and longtime dealer, often stated that Picasso was the most apolitical man he had ever known. Jaime Sabartés, a lifelong friend since their youth in Barcelona as well as Picasso's secretary and constant companion in 1936, recorded only that they had heard of "certain events" in Spain from Spanish friends who had visited them.[7] According to Christian Zervos, Picasso was undecided for a long time whether to become involved in the events in Spain. Roland Penrose, who was with Picasso on the Côte d'Azur in August 1936, wrote, however, that Picasso was very anxious about the news.[8]

Ultimately, the matter seems less one of Picasso's politics than of his way of expressing himself. When he once answered a question about his politics by stating that he was a Royalist because Spain was a monarchy and that he would be a Republican if Spain were a republic, his reply should not be taken strictly at face value.[9] Questions stated in a point-blank form and out of any meaningful context did not interest him. Many of the statements thought to be evasive or maliciously misleading were simply his impudent replies to probing or unanswerable questions. Anyone who had discussions with him quickly observed his mental agility and his refusal to be cornered or maneuvered into agreeing with ideas not his own.[10] In his book Sabartés gleefully describes a running game in which he and Picasso concealed their real meanings in their correspondence by semipoetic or jesting obfuscations of commonplace ideas as well as by the invention of new meanings for old words.[11]

Despite these ambiguities, there can be no doubt that Picasso's sentiments, even if they did not follow doctrinaire channels, were wholly with the Republic. By late 1935 he had already agreed to participate in an exhibition of his art that had been arranged by the privately organized Amigos de las Artes Nuevas (ADLAN)—of which Sert was a director—and that subsequently enjoyed great success in Barcelona, Madrid, and Bilbao. Later in the war, his two nephews—sons of his sister Lola—provided an even more intimate tie by taking up arms against Franco as members of a Barcelona militia battalion.

In September 1936 the civil war touched him personally when he received an invitation from Manuel Azaña, president of the Spanish Republic, to become honorary director of the Museo del Prado.[12] This surely was an irresistible appointment for an artist who as a student had spent so many hours in its galleries painting after the great masters, especially Velázquez, El Greco, and Goya. In his response Picasso expressed pleasure in the appointment (even though his name had been garbled) since it made him once again, in his own words, "feel so Spanish." He often proudly referred to himself as "director," although the title was honorary and his appointment required none of the usual administrative functions.

The nature of this new appointment underwent a dramatic change when in November the Prado was struck by artillery shells fired by Nationalist troops attempting to enter Madrid through the Casa de Campo after they had partially encircled the museum. Although the stubborn resistance of the Loyalist troops halted the assault, both sides entrenched themselves and hammered away at each other's defenses. Despite the great damage already inflicted on the city, Franco called upon the commander of the German Condor Legion to support his drive with bombing attacks. The several squadrons of converted Lufthansa Junkers 52 transports at Seville had completed the airlift of regular army troops from Tetuán in Spanish Morocco, and their crews, with new Heinkel 111 B bombers, were eager for more action. During the bombing attacks on Madrid, the Prado was severely damaged on the roof and upper floors; this led to a demand that the great paintings be moved to a safe place outside the city (1.5). Since the government had hastily evacuated the capital on 6 November and was establishing itself in Valencia, it was decided that the treasures of the Prado should follow at once and be stored in the Museo Provincial de Pinturas and in the reinforced Las Torres de Serranos (1.6). A heavily guarded caravan of enclosed trucks made its precarious way by night from Madrid to the relative safety of the shores of the Mediterranean over the only access road still controlled by the Republic.[13]

Picasso's close friend the poet José Bergamín was designated conservator and was asked to examine the condition of the treasures after their perilous journey and to provide suitable protective measures against air attacks on Valencia. Picasso responded enthusiastically to his friend's report, and it was probably at that time that he had the idea of moving the Prado masterpieces to even safer havens. To avoid the risk of a sea voyage and the threat of an attack by the Italian submarines operating off the Catalonian coast, it was planned to transport the paintings overland to Geneva and thence to Paris. They were not actually sent outside Spain until 1939, however, and then only after the Nationalists were already pressing into Catalonia and their planes were beginning to bomb and

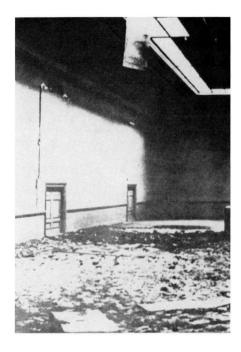

1.5　Gallery of the Prado after bombing, 1936.

1.6　Las Torres de Serranos, Valencia, 1936, where Prado paintings were housed.

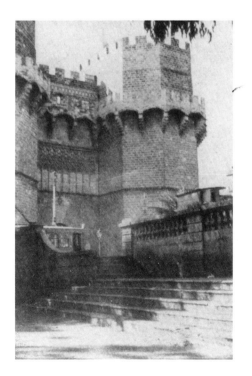

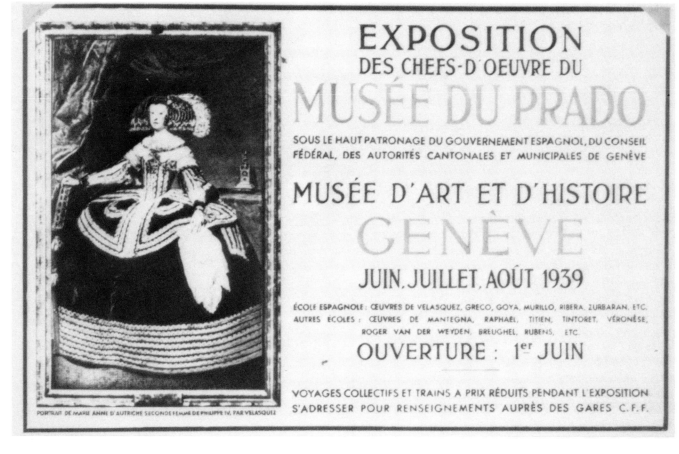

1.7 Poster announcing exhibition of Prado collection, Geneva, June–August 1939.

strafe refugees on the roads. The paintings were finally exhibited in Geneva (1.7), but Picasso's first hope of having them shown at the World's Fair in Paris was never realized: the fair was not continued for a second summer because of French fears over the growing German threats toward Czechoslovakia and Austria.

By the end of 1936, liberals everywhere viewed the Popular Front in Spain as the symbol of active resistance to totalitarianism that was descending over Europe. The French Communist party, eager to foster on France's southern frontier a Popular Front government in which Communist labor unions would hold the power and workers' militias would be the dominant military force, immediately sent supplies, whatever arms they could smuggle, and volunteers to bolster the defense of Madrid. In fact, until strong internal elements forced him to change his policy, the French Socialist Premier Léon Blum unofficially sanctioned the sale of planes and arms and the passage of volunteers across the border to Spain. After he was forced by the terms of the Non-Intervention Agreement to close the border, Paris became both the hub of clandestine arms traffic and the center of Republican Spain's worldwide propaganda campaign.[14]

Many distinguished people involved in the arts served as patrons of various committees, congresses, and rallies organized in the name of peace, democracy, and culture and also for the distribution of medical aid and food to refugees and victims of the war. Despite the active role played by the Communist party, Arthur Koestler writes that its name was almost never used since the director of the Comintern, Willy Muenzenberg, was a genius at drawing idealistic but often politically naive artists into his many projects.[15]

Most of Picasso's literary friends were contributors to these campaigns in support of Spain, and many, such as Larrea, worked for either the Agence Espagne, the Spanish propaganda office in Paris, or its news bulletin, also called the *Agence Espagne,* which was edited by Otto Katz, Muenzenberg's assistant. Agence Espagne had been organized by the Spanish embassy and was heavily supported by the Comintern. Its guiding force was the ubiquitous Muenzenberg, initiator of countless political action groups against war and fascism and of campaigns to raise funds for food, medical supplies, and the care of orphans—always with the aim of rallying liberal opinion to the support of the Republic and, ultimately, to the political goals of the Party. He had formerly either owned or controlled many of the liberal-oriented means of diffusing ideas and culture in Germany, such as leftist illustrated newspapers, magazines, book publishing firms, film studios, and movie houses. He distributed Sergei Eisenstein's films in Germany and, it was said, even produced some of them. As the director of Malik Verlag, he published the radical literary journal *Die Pleite* and books on the politically oriented art of George Grosz, Otto Dix, Käthe Kollwitz, and the artists of both Der Sturm and the Bauhaus. As a result, he succeeded in creating in the minds of intellectuals an association between radical political ideas and the best literature and art.

Koestler, who was initially hired by Muenzenberg as a writer, describes with awe Muenzenberg's charismatic exhortations to produce sensational, hard-hitting—though not necessarily truthful—effects at all costs. "Make the world gasp with horror," Koestler quotes him as saying;

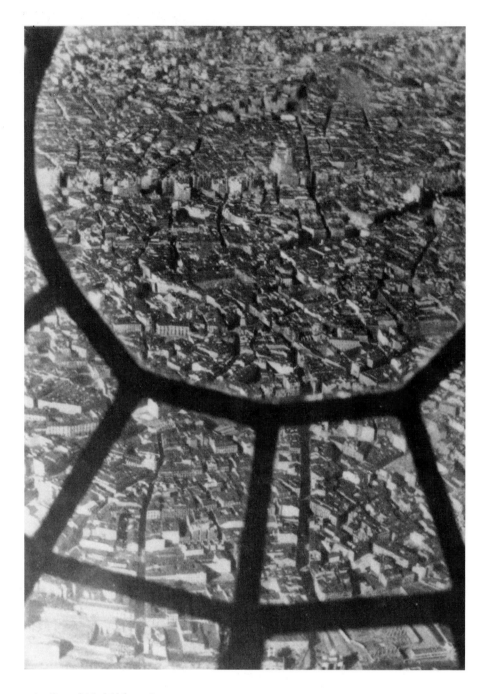

1.8 Central Madrid from the
bombardier's post of a Condor
Legion Dornier 17, 1936,
probably around November.
Puerta del Sol is to upper right.

"never mind the details that have to be interpolated, for we all know the allegations to be true." Koestler also mentions the irony of Muenzenberg's many contradictions, which included campaigning against war (meaning war by the Nazis) while simultaneously discrediting the British peace movement's own antiwar efforts (meaning those against British preparedness). Immediately after Spanish and German Condor Legion planes first bombed Madrid in November 1936—bombing denied vociferously by Nationalist and German spokesmen—Muenzenberg commissioned Koestler to go to Spain as a spy. Dispatched to Seville, his cover that of a journalist sympathetic to the Nationalists, Koestler was to seek concrete evidence that it was German airmen who were bombing Madrid (1.8).[16] Although Koestler recently stated that he had never met Picasso, the involvement of so many of Picasso's close friends in the propaganda activities of Agence Espagne and in the numerous front organizations of the Comintern makes it almost certain that both men's views of the political issues of the civil war would have been shaped by these influences.[17]

Among Picasso's closest friends in 1936, both Eluard and Aragon were wholly committed members of the Party and tireless workers for the cause of the Republic. Picasso was particularly dependent emotionally on Eluard and his new wife, Nusch, especially since he had met Dora Maar through Eluard. The four spent much of their time together, including vacations in Mougins or Juan-les-Pins on the Côte d'Azur. Although Eluard had not succeeded in recruiting Picasso for the Party, his conviction that artists had obligations to utilize their art in the interest of humanity apparently influenced some of the statements Picasso later made about his own art. Eluard wrote that "the time has come when all poets have the right and the duty to declare that they are profoundly involved in the lives of other men and in the communal life."[18] Toward the end of 1936, while Franco's forces were besieging Madrid, Eluard published a scathing poem in *L'Humanité*. It was not so much an idealistic cry against the horrors of modern warfare as a direct attack against the savagery of those who initiated it:

> See at work the builders of ruins.
> They are rich, patient, ordered, black and beastly,
> But they do their utmost to be alone upon the earth,
> They have borne man down and they heap offal upon him. . . .[19]

Less than a month later, on 8 and 9 January 1937, Picasso formulated his own attack on those who had "borne man down and . . . heap[ed] offal upon him" in his mordant prose poem *Dream and Lie of Franco* (*Sueño y mentira de Franco*) (1.9). The title of this poem is unusual for Picasso because of its specific Spanish literary references. Other poems, when they bear a title at all, are generally surrealist in spirit and ambivalent in meaning. *Dream and Lie*, however, is direct and unambiguous in its attack on the Caudillo. The title seems to owe to a popular phrase no doubt drawn from two plays by the seventeenth-century dramatist Pedro Calderón de la Barca: *Life Is a Dream* (*La vida es sueño*) and *In This Life All Is Truth and All Lies* (*En esta vida todo es verdad y todo mentira*). These plays, along with *Don Quixote*, were part of the fabric of

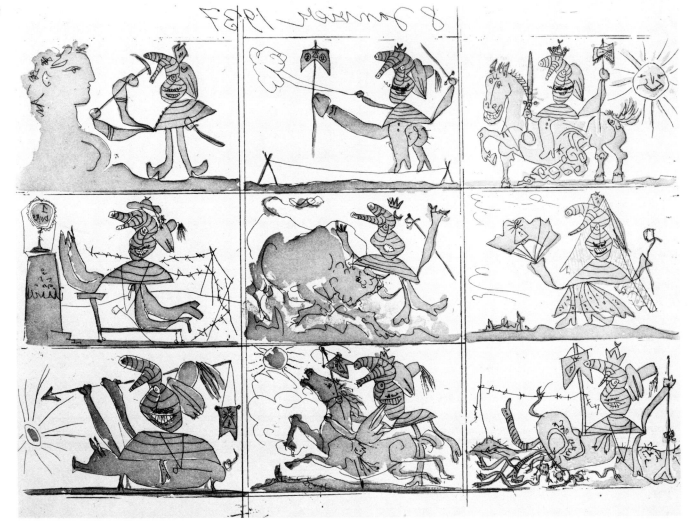

1.9 (*above and opposite*) *Dream and Lie of Franco*, 8 January and (last four panels) 9 January and 7 June 1937. Etching and aquatint. Both sheets 12⅜" × 16⁹⁄₁₆" (31.4 × 42.1 cm). MPM. G. 615, 616. Since etchings are reversed in printing, read sequences right to left.

Spanish literature, were well known to all students, and surely had been discussed by the poets of Picasso's literary circles beginning with the modernismo writers in Barcelona during the last years of the nineteenth century. In the first, Calderón writes that all of life is a dream:

> What is life? A fantasy;
> What is life? An illusion,
> A shadow, a fiction.
> And the greatest good is small,
> Since all of life is a dream,
> And dreams themselves are dreams.[20]

This ambivalence is compounded in the second play when he writes, "In this life all is truth and all lies."[21]

In his bitter satire of Franco with its double-edged title, Picasso took up the familar Spanish theme by accusing Franco of following a dream rather than life and of living a lie rather than the truth. And in the accompanying etching suite comprising eighteen panels, Picasso portrays Franco (1.10; note the toothy grin and mustache) in caricature, his many forms representing various manifestations of evil, his grotesque King Ubu-like gesticulations often evoking the bloodier aspects of the bullfight (1.11). In one instance he becomes a burnoosed Moorish soldier of Franco's Army

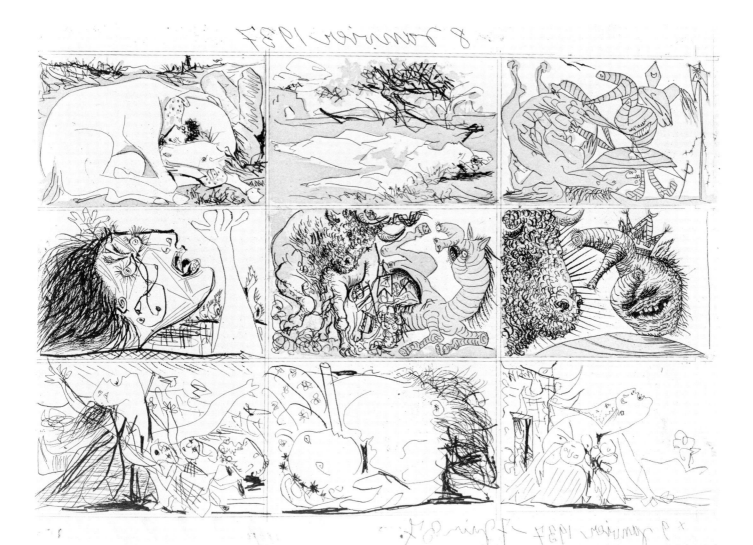

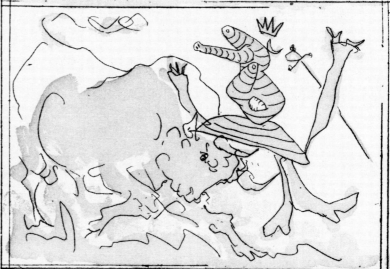

1.10 Photograph of Franco during the war in Morocco, 1922.

1.11 *Dream and Lie* (panel 5). Monster attacked by fighting bull.

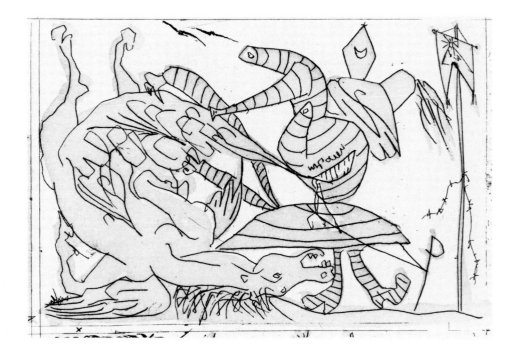

1.12 *Dream and Lie* (panel 10). Monster, in Moorish and Catholic headdress and with sword and religious banner, disembowels horse.

1.16 *Dream and Lie*, fragment of original manuscript handwritten by Picasso. Collection of the author.

of Africa, probing the entrails of a disemboweled horse with his hands (1.12), in another, an arrogant *maja* wearing a mantilla and comb and carrying a fan embellished with an image of the Virgin in one hand and a sword in the other (1.13, 1.14). In another panel, the Caudillo figure is seen praying, and in yet another he is seen smashing a classical bust of a beautiful woman. Transformed into a miserable-looking horse, he is gored by a heroic fighting bull and splits open, releasing a hoard of repulsive animals and Nationalist and religious banners (1.15).[22]

The disgust Picasso manifested in the etchings is equaled in his poem, a collage of unconnected words evoking images of repulsive things, quite unlike the elegant and lucid phrases of Eluard's poetry. Although he violates all the rules of syntax—the juxtaposition of unrelated imagery and the orchestration of dissonant sounds is obviously surrealist in spirit—his choice of verbal imagery to characterize Franco's actions conveys his rage in no uncertain terms (1.16) (Sert later said that he never forgot the force and emotion of Picasso's reading of his own poem):

fandango of shivering owls souse of swords of evil-omened polyps scouring brush of hairs from priests' tonsures standing naked in the middle of the frying-pan—placed upon the ice cream cone of codfish fried in the scabs of his lead-ox heart—his mouth full of the chinch-bug jelly of his words—sleigh-bells of the plate of snails braiding guts—little finger in erection neither grape nor fig—commedia dell'arte of poor weaving and dyeing of clouds—beauty creams from the garbage wagon—rape of maids in tears and in snivels—on his shoulder the shroud stuffed with sausages and mouths—rage distorting the outline of the shadow which flogs his teeth driven in the sand and the horse open wide to the sun which reads it to the flies that stitch to the knots of the net full of anchovies the skyrocket of lilies—[23]

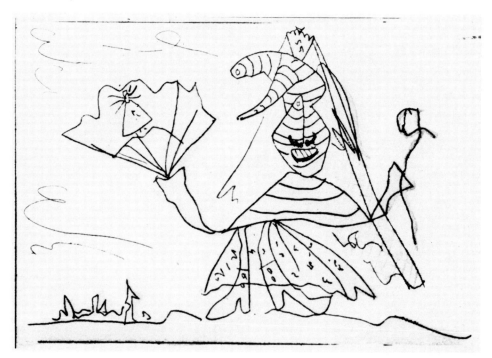

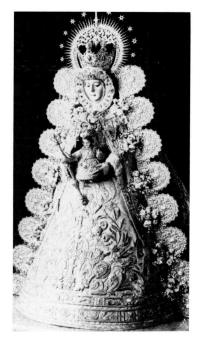

1.13 *Dream and Lie* (panel
4). Caricature of Franco as
maja carrying sword and reli-
gious image. Compare with
photograph of Franco, 1.10.

1.14 Cult image of the Vir-
gin, La Virgen del Rocío.

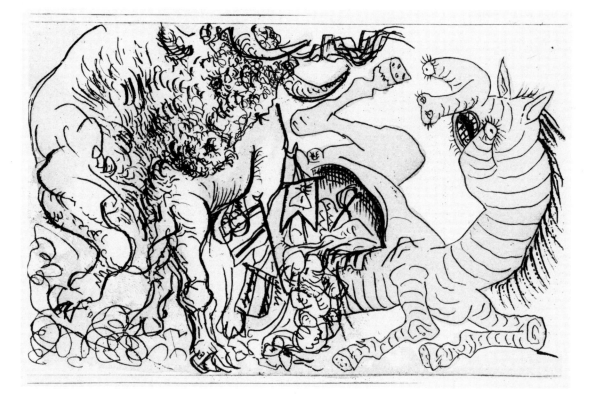

1.15 *Dream and Lie* (panel
14). Gored monster's body
spills religious banners and
swords.

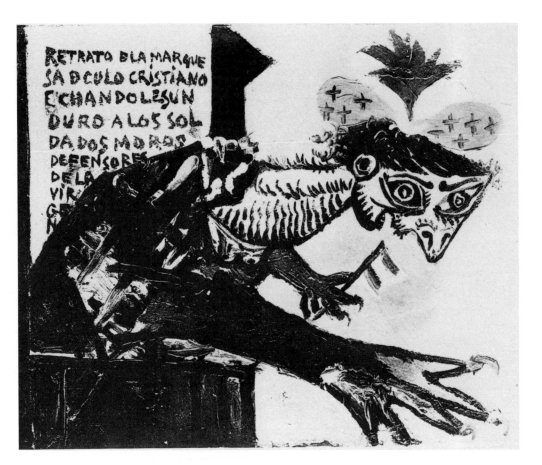

1.17 *Portrait of the Marquesa, a Christian Slut Tossing a Coin to the Moorish Soldiers, Defenders of the Virgin, 1937–1938. Oil. 14⅞″ × 17¹⁵⁄₁₆″ (38 × 46 cm). Z VIII, 375.*

Concluding by evoking even more graphically images of suffering in human beings and objects alike, he echoes images of the etching suite that four months later will provide some of the iconic vocabulary for the sketches of *Guernica:*

> —cries of children cries of women cries of birds cries of flowers cries of timbers and of stones cries of bricks cries of furniture of beds of chairs of curtains of pots of cats and of papers cries of odors which claw at one another cries of smoke pricking the shoulder of the cries which stew in the cauldron and of the rain of birds which inundates the sea which gnaws the bone and breaks its teeth biting the cotton wool which the sun mops up from the plate which the purse and the pocket hide in the print which the foot leaves in the rock.[24]

Some time during the next year (1937–1938), Picasso made a second satire: a painting that attacked an unspecified religious and aristocratic lady to whom he gives a savage face and claws. In the title—which is actually inscribed on the painting—*Portrait of the Marquesa, a Christian Slut Tossing a Coin to the Moorish Soldiers, Defenders of the Virgin* (1.17), he refers with disdain to the financing of Franco's rebellious Nationalist forces by Spanish aristocrats and financiers and alludes to the

bitter irony of Moorish (or Islamic) soldiers defending the Catholic Virgin against Spaniards. This painting and the *Dream and Lie* poem and etching suite are probably Picasso's only works that can be considered true propagandist art.[25] In fact, on the very day he drew *Dream and Lie*—8 January—the news in Paris was about the growing encirclement by Italian and Spanish troops of Málaga, Picasso's home town.

By January 1937 when Sert and his colleagues came to ask Picasso to contribute a mural to the Spanish pavilion, he was, despite his apparent indifference, already involved in the cause of the Republic. But no matter how sympathetic he was to the Republican government or how moved by the tragic events in Spain, his reply to Sert was only that he was uncertain whether he could paint such a picture. He had never conceived a painting to order, so to speak, and the conditions surrounding this one placed him between two opposing emotions: his deep concern for the suffering of his compatriots, on the one hand, and his antipathy toward political dogmas and polemic painting, on the other. It would have seemed inappropriate to simply donate "a Picasso" from the studio, as he had done before, to a historic cause such as this one.[26]

When the delegation departed, its members left Picasso with a difficult problem. The proposed mural was to be both a public monument, standing before the eyes of the world, and part of a pavilion devoted to a propagandist aim. Generally he abhorred this type of public exposure. Moreover, in political significance and physical dimensions, the mural was a far more ambitious task than anything he had previously contemplated. Although the etching suite had been a direct response to the actual personage of Franco and the tragic events his actions precipitated, it was essentially caricature. And the only large-scale projects in painting he had attempted had been the curtains and sets for the ballets *Parade,* in 1917, and *The Three-cornered Hat* (*Le tricorne*), in 1919. In both projects, however, he had collaborated with many other artists with whom he had warm personal associations. Further, both ballets were on themes already familiar to Picasso: The *Parade* curtain depicted a backstage circus scene, and *The Three-cornered Hat* life in the plaza of a Spanish village. The actual production of costumes, sets, and the curtains themselves was, of course, a team effort—the kind of social activity Picasso always enjoyed. Preparing the curtain for his friend Jean Cocteau's ballet *Parade* was a particular pleasure: he was able to include images from his earlier circus-family themes and to profit from working in the exhilarating environment of Rome with an exceptionally talented company of artists, including Erik Satie, Léonide Massine, Serge Diaghilev, Cocteau, and the dancers of the Ballets Russes. Since the curtain was by far the largest surface on which he had ever worked—it measured approximately 35 by 57 feet (10.67 by 17.37 meters), more than six times the area *Guernica* was to cover—he had several painters working under his supervision (1.18).[27]

In Paris in 1937, however, Picasso was confronted by these tragic Spaniards representing their cruel and very real world, who were asking him to devote his art to their cause. All were, in effect, refugees from Nationalist Spain and were endeavoring through their art to affirm the legitimacy of the Republic in the face of bitter and bloody national strife. Never before had the artist been faced with a problem of such magnitude and emotion. Picasso's response to this unusual and moving request was, for the time being, to do nothing.[28]

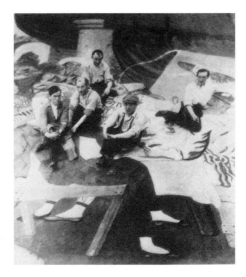

1.18 Picasso and his assistants while working on drop curtain for *Parade*, Rome, 1917.

C I V I L W A R

I N S P A I N

When the military uprising against the Popular Front government in Spain broke out on 18 July 1936, the rebel leaders anticipated that the badly divided government coalitions in Madrid and Barcelona would collapse. They further assumed that the army detachments based in all the major cities would throw their support to the rebels. But the army itself proved divided in its loyalties, and the hastily organized militias of the labor unions and civilian volunteers were able to overpower even some of the army troops and then to seize and hold public buildings. The Madrid government's dispatches at first reported the uprising only as local disorders, which it promised to suppress quickly. Then followed a period of utter confusion during which, before the political issues had been clarified, pitched battles took place in the streets, thousands of persons were killed or executed, and great damage was suffered by the cities. It soon became apparent that the war would not be settled quickly, that the political issues were worldwide and probably could never be resolved conclusively, and that all of Spain was soon to be caught up in a war of attrition. The uncertainty was even greater outside Spain, which possibly explains why Sabartés, in his biography of Picasso, referred to the outbreak of the war that was rocking the country as only "certain events" or "the upheaval" in Spain.[1]

The Intervention of the German Condor Legion

The Germans, who had been watching events in Spain very closely, could not tolerate confusion. Admiral Wilhelm Canaris, chief of the German secret service and a close friend of Franco's, was firmly convinced that the growing Russian presence in Spain would pose a major threat to Germany (2.1). Despite the generally negative opinions within the Wehrmacht of Franco's chances of success, Canaris finally convinced Hitler and Goering, and also Mussolini, that intervention in Spain would be to their own best interests.[2] This prompted Goering to make, on 26 July 1936, the much-quoted statement, which he repeated off the record at the Nuremberg trials in 1946, that this would provide an excellent oppor-

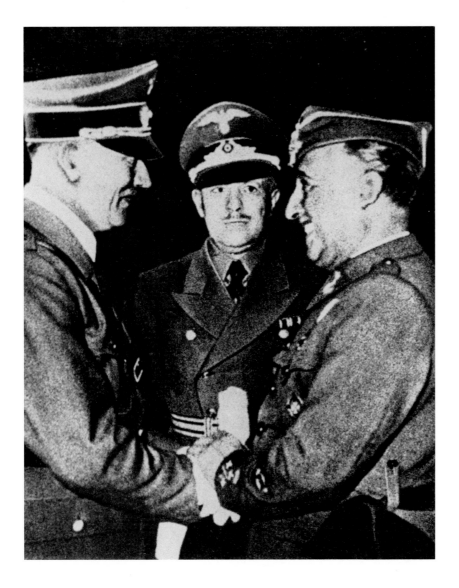

2.1 Left to right: Hitler, Admiral Canaris, and Franco, 1940.

tunity for testing his new and inexperienced Luftwaffe under wartime conditions.[3] Indeed, so effective were Canaris's arguments that within a week of the 18 July revolt that precipitated the Spanish Civil War, Mussolini had promised twelve heavy bombers, and Hitler had already sent the first of twenty Lufthansa transport planes and six fighters. With this small fleet, augmented by their own antiquated planes and commandeered fishing boats, Franco was able to transport his army of fifteen thousand Spanish legionnaires and Moorish regular troops from Tetuán in Spanish Morocco to Seville within a month. This force, highly disciplined and battle-ready, proved to be the deciding factor in sustaining the

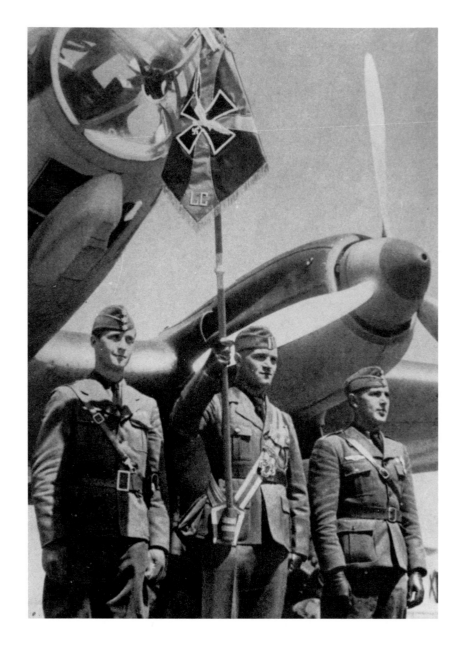

2.2 The Luftwaffe sent its most experienced airmen and newest bomber, the Heinkel 111 B.

momentum of the rebellion after many of the local garrisons in the larger cities had met defeat or had defected to the Republic.

According to Republican sources, within two weeks of the uprising German men and planes began arriving in a steady flow and ever-increasing numbers (2.2). Most of the forces came by sea, disembarking in Lisbon and Cádiz and traveling overland to the aircraft maintenance base near Seville.[4] German planes manned by German pilots wearing Spanish uniforms—the Condor Legion, as it came to be called—were known to have bombed a Republican warship off Málaga in August and to have bombed Madrid heavily as early as November. And in January 1937 they would again bomb Madrid.[5]

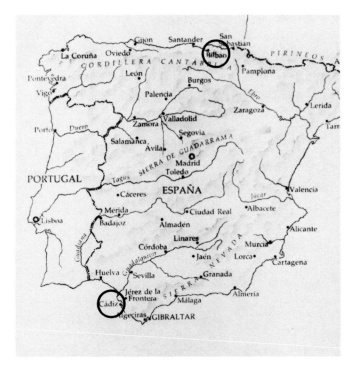

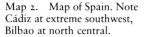

Map 2. Map of Spain. Note Cádiz at extreme southwest, Bilbao at north central.

Although both Hitler and Mussolini were quick to lend aid to Franco in his revolt against the Popular Front government, they exacted a heavy price for it. The agreement drawn up by the three leaders in late October 1936 provided for four concessions.[6]

It required the immediate shipment of large quantities of iron ore, copper, and other raw materials necessary for war production from mines in Morocco, Andalucía, the Asturias, and the yet-unconquered Basque province of Vizcaya. The latter two provinces, which included the largest heavy industry and shipbuilding facilities in Spain, were the goal of the campaign in the north.

It provided that the Condor Legion would operate as an independent unit in every respect and that its commander would be responsible only to Franco. The very nature of the Condor Legion—an air force formed and trained for tactical operations to be closely coordinated with those of the ground forces—required, however, that a clearly defined liaison be maintained between air and ground at all times. (By granting the Condor Legion autonomy, this provision undoubtedly contributed to subsequent confusion over questions of authority and responsibility in the bombing of Guernica.)

It required that Franco, whom the Wehrmacht viewed as too vacillating and too methodical, conduct a "more rational and more active campaign." Indeed, it was thought that if left to his own methods, Franco had very little chance of victory.

The last provision of the agreement required that Franco occupy the remaining major port cities as quickly as possible before they fell into Russian hands. This provision was drafted with Bilbao, the Basque capital, in mind. Located to the north on the Bay of Vizcaya, Bilbao was by far the most valuable military goal after Madrid: it was the center of Spain's mining, heavy industry, and shipbuilding facilities, and it was only about half as far from German ports as Cádiz in the extreme south (Map 2). Because of these vast facilities for the production of materi-

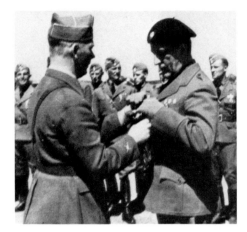

2.3 Lt. Col. Wolfram von Richthofen (left) in awards ceremony.

als basic to the manufacture of armaments, both Hitler and Mussolini wanted to take Bilbao undamaged.

Franco accepted these conditions, and Hitler agreed further that on the day after Madrid was taken, both he and Mussolini would recognize Franco's regime. The Condor Legion was placed under the command of two high-ranking officers, specialists in air warfare against ground targets. General Hugo von Sperrle was commander of all German forces in Spain, which were called the Condor Legion, and Lieutenant Colonel Wolfram von Richthofen (2.3) was chief of staff and commander of all Luftwaffe personnel.[7]

The Concept of Total War

German dissatisfaction with the Nationalists' slow progress was manifest even in Franco's own headquarters, where General Wilhelm Faupel, Hitler's ambassador to the new Nationalist government in Salamanca, reported to Berlin that Franco had neither the training nor the experience to conduct the necessary operations effectively. The German view of the proper conduct of war was expressed by Faupel's staff assistant, Lieutenant Colonel Hans von Funck, who defended the strafing of civilian refugees on the roads by maintaining that among the civilians were retreating soldiers, who were legitimate military objectives. According to George Hills in his biography of Franco, von Funck declared that he had specific instructions from the chief of the German general staff, General Wilhelm Keitel, to order the Condor Legion to bomb and strafe refugees fleeing toward the French border.[8] At this time German military journals enthusiastically proposed a policy of "total war." An article in *Militär Wochenblatt* defined "total war" as war not just between armies but between whole peoples—thus justifying the bombing of civilians as well as of the armed forces.[9] Extracts from this article were widely circulated in accusatory news dispatches of the Spanish government in Valencia and by newspapers in Paris. The press in France expressed considerable fear of the potential might of the growing Luftwaffe, which now was showing the swastika along borders both north and south (2.4). Differences of opinion over what constituted military objectives led to considerable strain and mistrust between the two opposing forces in Spain and eventually exacerbated the bitter controversy over exactly what took place at Guernica.

Franco's drive toward Madrid proceeded rapidly at first but slowed down as Republican resistance became organized. The people of Madrid, inspired by the arrival of the International Brigades, showed remarkable fighting spirit and despite heavy casualties held the attacking ground forces at the edges of the city. Robbed of a promised quick victory, Nationalist generals proposed to subdue instead the chief peripheral areas of resistance, starting with Vizcaya in the north and proceeding to Catalonia in the east. With their high concentration of heavy industry and arms factories, the Basque provinces were the most attractive conquest—especially since Franco had already committed the larger part of their production to Hitler.

General Emilio Mola, commander of the Army of the North, launched his campaign against the Basque defenders of the province of Vizcaya on

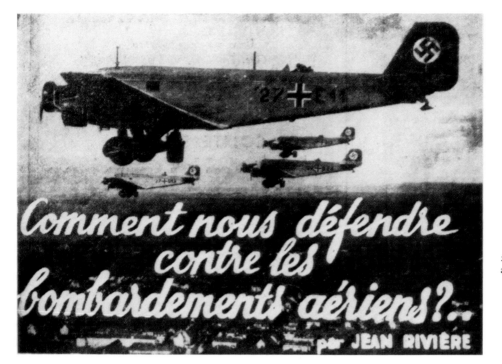

2.4 French fears of bombing attack, 10 April 1937.

31 March 1937 with a bombing attack on Durango, supported by the Condor Legion. Confined to a strip of land about forty miles wide and surrounded by the enemy on three sides and by the Bay of Vizcaya on the other, all of Basque territory was within easy reach of the Luftwaffe planes (see Map 1 and Map 3). After the attack and occupation of Durango, the Nationalist army and their Italian allies halted all activity for about three weeks, in part because of a political power struggle between Franco and his allies, the militantly royalist Carlist troops.

On 20 April, the offensive in Vizcaya was renewed all along the eastern front, and General Mola's forces moved westward and northward, closing in on Bilbao. Within four days, massive air and land attacks forced the Basques to abandon Durango and Eibar and to retreat to the mountains. Eibar was strategically important, for it lay along a railroad line that ran parallel to the front and led directly to Bilbao. The Nationalist advance, however, was slow and costly: the narrow, winding roads followed streams through valleys exposed to the Basque defenders concealed in the heavily wooded mountains.

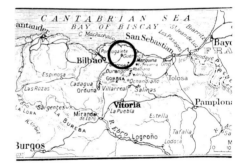

Map 3. The Basque countries, April 1937. Guernica (circled) is between Bilbao and San Sebastián.

While Mola's ground forces moved slowly over mountain roads, the fighters and bombers of the Condor Legion ranged over the entire battlefront from their northern bases at Vitoria and Burgos, quickly achieving air supremacy over all of Vizcaya. They were the "milkmen," according to Lieutenant Count Max Hoyos, veteran bombardier.[10] An accidental crash that cost the life of the Basques' leading air hero, Felipe Del Río, ensured the completeness of their victory; his death so shattered the morale of the few remaining Republican pilots that unless attacked, they usually avoided combat with Luftwaffe squadrons and at the time of the bombing of Guernica had moved back about seventy kilometers westward toward Santander.[11]

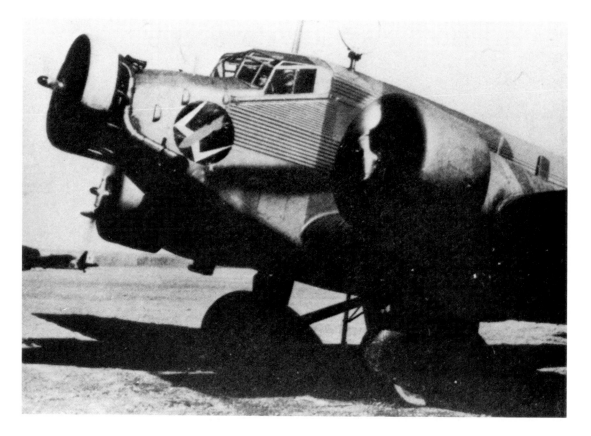

3.2 Junkers 52 showing in-
signia of 3d Squadron, 88th
Battlegroup: white bird and
red bomb on black disc.

3.3 Heinkel 111 B bimotor
bomber.

model of his vastly improved new fighter, the Messerschmitt 109 B. Be-
cause the Spanish Republican pilots stationed at Lamiaco Polo Field, near
Bilbao, had lost their leader, a famous ace, they were transferred to San-
tander about eighty miles to the west and apparently were not ordered to
defend Guernica. Even Russian pilots, when present, rarely confronted
the enemy, for they were under strict orders to avoid at all costs situations
that might result in capture.

Burgos, ninety miles southwest of Guernica, was the base for three
squadrons of large Junkers 52 trimotors, the bomber version of the stan-
dard Lufthansa passenger planes (3.2). Goering had heavily reinforced
this fleet with a squadron of the fast new bimotored Heinkel 111 B
bombers (3.3). With a total of about fifty fighters and bombers, the air
fleet poised to descend upon the crumbling Basque defenses, when sup-
plemented by several Italian SM 79 bombers and Fiat C.R. 32 fighters,
was the most powerful yet to strike in a single coordinated attack since
the Germans had arrived in Spain (3.4).[4]

The operation was planned and directed by Wolfram von Richthofen,
whose headquarters were at Vitoria, adjacent to those of the Nationalist
Army of the North. Bearing the name made legendary by his cousin Man-
fred, the near-mythical Red Baron of the First World War, Wolfram, who
was himself already an ace with eight victories from that war, was eager

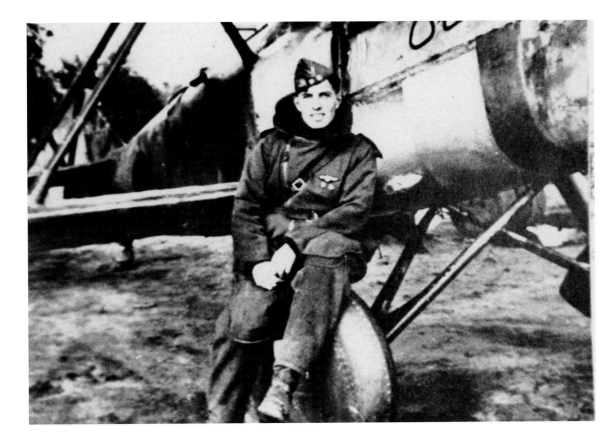

3.4 Lt. Corrado Ricci of the
Aviazione Legionaria in front
of his Fiat C.R.-32, which he
flew over Guernica on 26 April
1937.

to create his own myth as a combat pilot. His assignment as chief of staff,
however, required that he coordinate operations from the ground.

Von Richthofen was particularly impatient with the slow pace that had
brought the campaign to a standstill for nearly a month. The Condor Le-
gion was prepared and eager for battle, but apparently owing to the inde-
cision of the commanders of the ground troops, it had no clearly defined
mission to perform. The crews of the fighters and bombers were poised
and anxious to experience under actual war conditions, some of them for
the first time, what they had been trained for: sudden coordinated air and
ground assault or, as it was soon to be known, *blitzkrieg*. And yet, ac-
cording to the 1975 research of the historian-novelists Gordon Thomas
and Max Morgan Witts, General Mola was not even present at a strategy
meeting on 25 April when the importance of the bridge at Guernica was
discussed, leaving von Richthofen to make his own decision to strike it
with all his force on the next day.[5] Citing his diaries, Thomas and Mor-
gan Witts describe his demand that his aviators make life hell for the re-
treating troops by keeping constant pressure on them. Realizing that the
bridge was the only escape route for vehicles still open and that the town,
even though it had been declared an open city, could be a possible for-
tification, he was determined to deny both to the enemy. He was so impa-
tient for action that the next day, 26 April, after the first squadron of

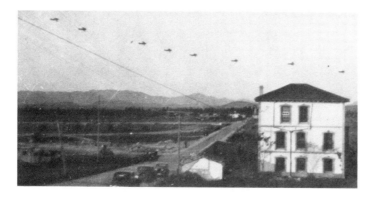

3.5 Heinkel 51 fighters
taking off from base in Vitoria.

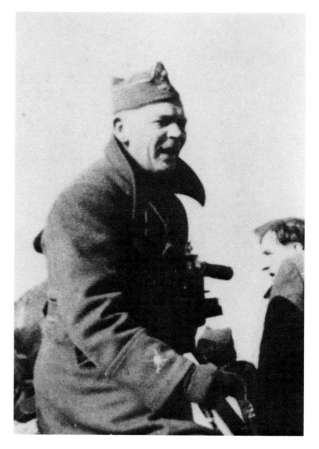

3.6 Von Richthofen on
Monte Oiz observing bombing
of Guernica.

fighters took off from Vitoria and headed north (3.5), he followed in
his Mercedes-Benz sports car, driving it, according to Lieutenant Hans
Asmuth, who accompanied him, as if he were a fighter pilot in the forma-
tion. They reached a vantage point high up on Monte Oiz—from which
the Basques had just been routed—hoping for a view down the wide val-
ley toward Guernica (3.6).

On the previous day photographic reconnaissance missions had re-
vealed a tempting target, soldiers apparently retreating along two roads
that led from the east toward Bilbao. The roads joined just before passing
over the small stone bridge in the Rentería quarter and then turned left to
enter Guernica. Early on the morning of the twenty-sixth when the me-
teorologist reported fair weather, von Richthofen ordered the attack (see
Map 4).

In Burgos, three squadrons, some twenty-six Junkers 52s and the
seven Heinkel 111 B and Dornier 17 bombers were loaded with 3,000
pounds of bombs weighing up to 550 pounds each; in addition, the
Junkers 52s carried several hundred small incendiary cylinders (3.7).[6] In
command was Lieutenant Rudolf von Moreau, the most experienced of
all the bomber pilots (3.8). Within two weeks after the uprising began on
18 July, he was in Morocco ferrying Franco's troops to Spain; he piloted
the plane when his companion and bombardier, Lieutenant Count Max
Hoyos (3.9) successfully bombed the Republican battleship *Jaime I* at

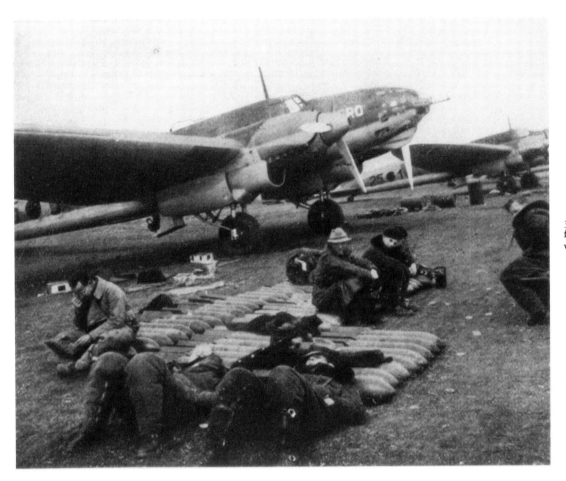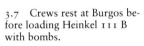

3.7 Crews rest at Burgos before loading Heinkel 111 B with bombs.

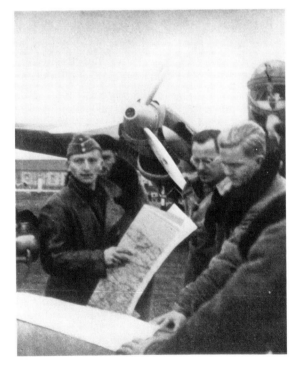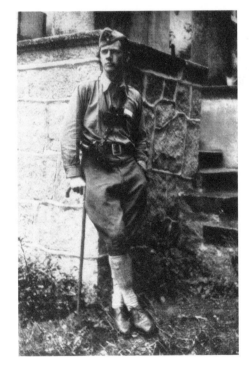

3.8 (*far left*) Lt. Rudolf von Moreau (left), commander of the operation against Guernica, discussing flight plan. The Heinkel 111 B bomber is in the background.

3.9 Lt. Count Max Hoyos, liaison officer and bombardier in Moreau's squadron.

Málaga. They had also succeeded in dropping provisions squarely into the courtyard of the besieged Alcázar at Toledo, where the Nationalist defenders were facing starvation and disease, and von Moreau had made a bombing run over Madrid as early as 28 August 1936. (See the spectacular photo taken over central Madrid from the bombardier's seat of a Condor Legion bomber, 1.8.) Although they did not anticipate opposition in the air over Guernica, the new Heinkel 111 B bombers were accompanied high overhead by about twenty Messerschmitt 109 B and Fiat C.R. 32 fighters from Vitoria for the short run.[7]

First, von Moreau flew his unaccompanied bomber past the town and out to sea to the north before turning to make a reconnaissance of the antiaircraft defenses and to permit his bombardier a trial run. He then made a wide circle and repeated the maneuver. This time his bombardier released his three thousand pounds of heavy bombs. Normal procedure would have been to observe the fall of the bombs and record the exact location of their explosion, but no mention has been found in any of the surviving reports or memoirs of the accuracy of the operation. The consensus, however, based on interviews conducted both at the time and in recent years with townspeople who were watching the attack, is that the first bombs fell in a close pattern, not around the bridge, the declared target, but on the railroad station and the plaza in front of it, about four hundred yards beyond the bridge and squarely within the town.

Von Moreau then circled again, picked up the other bombers of his squadron, and guided them over exactly the same route, where they released their bombs into the smoke and dust raised by the first explosions. The squadron of bombers may then have returned to Burgos for rearming.

In the meantime, the three squadrons of the larger and slower Junkers 52 trimotor bombers had arrived over the town and poured a rain of bombs from the eighteen additional larger bomb bays. By this time, the entire town was obscured by great clouds of smoke, dust, and flames that rose high into the air and could be seen over the mountains as far away as Bilbao. The twenty or more fighter planes, without a single enemy challenge to their dominance of the sky, turned their machine guns on ground targets. These they found mainly on the roads and in the surrounding fields as the peasants and townspeople who had escaped the explosions, fire, and collapsing buildings in the town sought to flee. Although it is believed each bomber made only one attack, eyewitnesses claim that the town was under almost continuous attack from about 4:30 in the afternoon until 7:45 in the evening—a total of three and a quarter hours.

Although the Condor Legionnaires were the best trained and most experienced airmen of the Luftwaffe, they failed to score a single hit on the bridge, their presumed target. Instead, their bombs struck in a compact pattern about a thousand yards long, virtually all of it lying beyond the bridge and centered exactly on the town.[8]

Recent interviews with the few surviving airmen quote them as saying that within a few days of the bombing of Guernica they were ordered to say nothing about it. The official report signed by the commander of the Condor Legion at 8:50 on the night of the bombing certainly avoided stating, if it did not actually misrepresent, the extent of the damage:

> All aviation units of the Condor Legion engaged in multiple attacks on retreating enemy on roads north of Monte Oiz and on the bridge and roads east toward Guernika.

Sander[9]

According to Vicente Talón's research, the orders for the attack came from Berlin and the news reached Franco's headquarters in Salamanca only the next morning in a Reuters telegram.[10] Franco queried General Sperrle, commander of the Condor Legion, who claimed he had no knowledge of it. In Berlin at about the same time, as reported by Thomas and Morgan Witts, General Werner von Blomberg, minister of war, asked Sperrle repeatedly who had bombed Guernica. According to a later interview, the telegraphist on duty said he was ordered to reply only "not the Germans."[11] Although two of the legionnaires participating in the attack, von Moreau and Hoyos, had their memoirs published by the Nazi party in 1940, they avoided any mention of their roles in the destruction. Two weeks later, when Captain Adolf Galland arrived to take command of the fighter squadrons in Vitoria, it was widely reported that he candidly admitted that the attack on Guernica "was an error."[12]

In recent interviews with at least three of the surviving attackers, Thomas and Morgan Witts received varying accounts of who was responsible for ordering the attack. All of those interviewed, however, admitted taking part and spoke candidly of their experiences. The researchers also secured access to the private diaries of von Richthofen, who died in an American hospital in 1945, and they speak of a secret dispatch to Berlin in which von Richthofen stated that the Germans' "concentrated attack" on Guernica "was the greatest success."[13]

Basque militiamen (Gudaris) stationed in the mountains just south of Guernica were apparently the first to observe the approaching bombers. They reported that the bombers were bypassing the town, heading northward to the coast, where they circled and turned south, guided to their target by the little Mundaca River reflecting the late afternoon sun. At Arteaga, two miles north of Guernica, Lorenzo Uriarte (later to become mayor of the village), as reported by Talón, was stopped by the sound of a distant plane; squinting into the sun, he saw a single plane approaching Guernica. Before his horrified gaze the plane dropped a bomb, which exploded, creating a great column of smoke. Since enemy planes had frequently harassed vehicles on the roads with machine-gun fire, Uriarte immediately took refuge in his cellar until the sounds of planes and explosions had ceased several hours later.

In Guernica itself, Faustino Gurruchaga, a Basque soldier, reported that although he had followed what he took to be a single trimotor Junkers 52 with his antiaircraft machine gun, he had withheld fire in the hope that the plane was only observing and would not molest the town. Neither of the other two machine guns believed to have been in the town opened fire. Meanwhile, the bells on Santa María church had already set up a continuous clanging in response to the alarm signal from lookouts on the roof of the convent of Los Carmelites.[14]

The first bomb apparently struck a three-story building located in the central part of town. Nearby in the railroad station, a railway official shouted into the telephone, reporting the attack to Bilbao, about fifteen miles away. Six other bombs were dropped before the single plane disappeared to the south. In the pause that followed, Francisco Utiaga, a doctor practicing in Guernica, made for the convent of Los Carmelites, where an emergency hospital with a supply of blood had been established and where the victims soon arrived. Although the convent, located just outside the central part of the town, was not hit, the supply of water and electricity soon failed and the shock of later nearby explosions caused

3.10 Central Guernica in flames.

plaster to fall from the ceiling onto the staff and the injured. The pause after the first attack also allowed many of the citizens to flee either into the open fields flanking the town on three sides or, even safer, into the heights of the mountain that rose directly from the central plaza, where in the moments before the attack the weekly *feria* and animal market had been taking place.

Father Alberto de Onaindía, en route by automobile from Bilbao to Marquina, about twelve miles further east and at this time very close to the battle front, arrived in Guernica to witness the horror. He was a native of Marquina who because of his Republican sympathies had been relieved of his post in Valladolid, then in Nationalist hands. He told of cattle, sheep, and horses from the interrupted animal market scattering about the countryside and of people fleeing into the hills, pursued by fighter planes. He stated that about ten or fifteen minutes after the first plane dropped its bombs, the pause was broken by the appearance out of the sun of a squadron of seven Junkers 52s, followed closely by a second and third squadron of six and five planes each. Flying at an altitude Onaindía estimated at six hundred feet, they dropped heavy bombs directly into the central part of town (3.10). This operation was repeated regularly during the three hours of bombing, until the central part of Guernica was a solid mass of flames and smoke. A steady wind from the north spread the flames still further.[15]

Soon after the attack ended, three English newspaper correspondents who were with Republican forces in nearby Bilbao arrived. According to their stories, they observed the burning city from the surrounding mountains and entered Guernica about midnight. They were George L. Steer of the *Times* (London), Noel Monks of the *Daily Express,* and Christopher Holme of Reuters News Agency. Steer's account, published in the *Times*

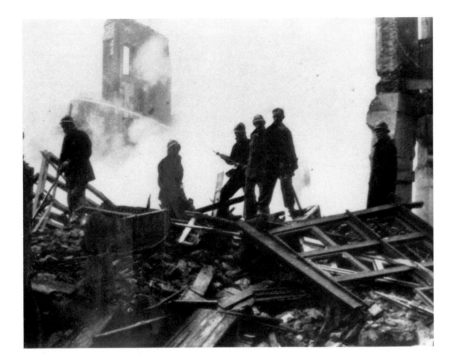

3.11 Firefighters surveying the smoldering rubble.

(London) of 28 April, provides the most complete and the most observant report of the tactics employed by the planes. Steer wrote that at first small groups of bombers dropped both heavy bombs and hand grenades on carefully selected targets. Second, low-flying fighter planes strafed fleeing citizens with machine-gun fire, and, finally, the bombers returned to shower the ruins with small incendiary bombs that set fires in those places not yet burning (3.11, 3.12). He stated that isolated farms as far away as four miles were bombed, and all six roads leading to Guernica were strafed with machine-gun fire.

Although some of the later stories of the event portrayed Guernica as happily involved in the *fería,* with all of the accompaniments of conviviality, *pelota* games, and feasting that characterize Spanish events of this kind, the town, in fact, was under the danger of imminent attack by the Nationalist army. On the very day of the bombing the army had occupied Durango, twelve miles to the south, and during the bombardment had entered Marquina, about the same distance to the east. The danger was such that Francisco Lazcano, the local representative of the Basque government in Bilbao, who was driving toward Guernica from the east on the morning of 26 April, was attacked by a low-flying plane while about ten miles away. This so alarmed him that as soon as he arrived, he ordered the market suspended and posted militiamen on all the roads leading to the town, with orders to turn back any travelers then approaching. He took the further precaution of canceling the *pelota* contest scheduled for the afternoon. Although the market apparently continued on a diminished scale, had it not been for these precautions there would have been many more visitors from the surrounding area (the area represented by the *fería* included a population several times greater than Guernica's seven thousand) and hence many more victims.

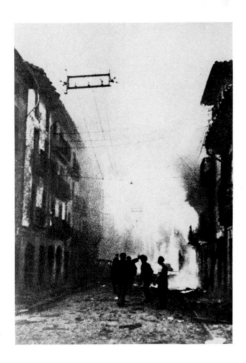

3.12 Guernica burned for several days.

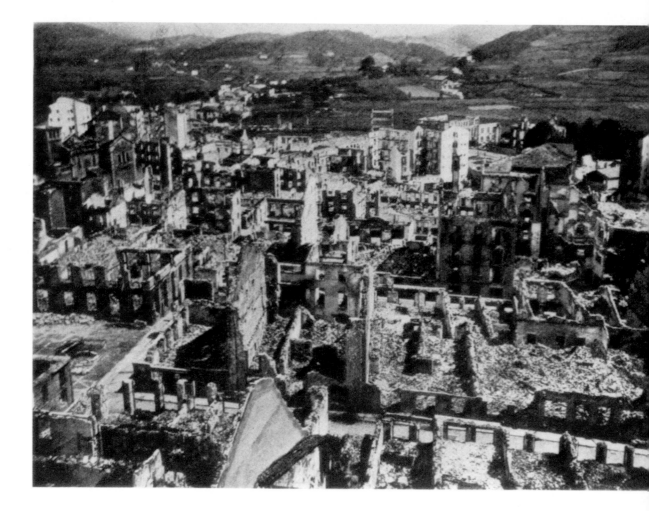

3.13 View of the ruins of
Guernica from the hills.

When the fires had subsided three days later, at about the time the Na-
tionalist troops entered Guernica, it was possible to survey the destruc-
tion (3.13). The entire central part of the town—equivalent to about fif-
teen square blocks—was totally destroyed as well as numerous adjacent
buildings (3.14). Castor Uriarte, the city architect in 1970, reported that
721 dwellings, or 71 percent of the total in the town, were completely
destroyed (3.15).[16] In addition, a substantial number were either dam-
aged beyond repair or were later damaged by rain. Of the churches, con-
vents, and palaces located for the most part either on the slopes of the
adjacent hills or outside the old city, none of the several convents, only
one church, San Juan, and only one palace, Loizago, were destroyed. The
destruction of human life, however, was great. Two shelters were struck
by bombs, one in the Calle Santa María, where forty-five or more persons
were killed, and one in the basement of the Calzada Asylum, where about
thirty-three lost their lives. Several were killed in the shelter of a water
storage tank, and numerous others were killed by bomb fragments or
machine-gun bullets in the streets or open fields. Pedro Calzada, the
custodian of the local cemetery, stated that he had interred seventy-five
victims at one time and a similar number on several other occasions.
Uriarte stated that in view of the destruction elsewhere it was surprising
that several structures usually considered primary military objectives

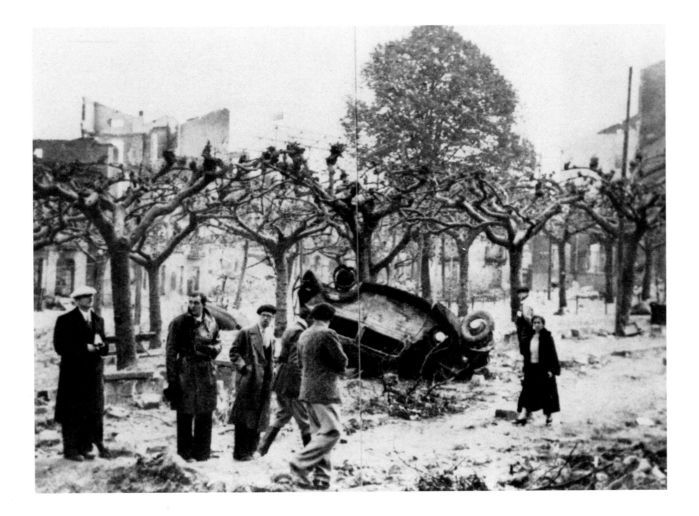

3.14 (*above*) Ruins of central plaza. The wreckage of the overturned automobile is evidence of an explosion, not simply a fire.

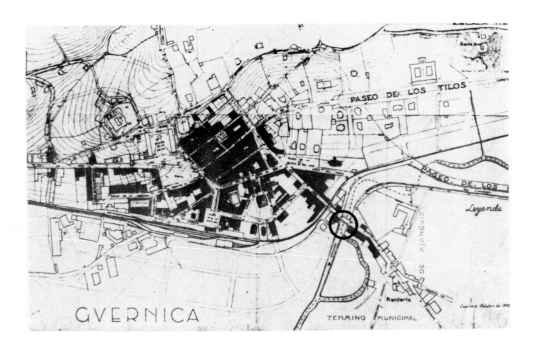

3.15 Plan of Guernica, 1970, drawn by Castor Uriarte, city architect. Structures totally destroyed on 26 April 1937 are indicated in black. Note Rentería bridge (lower right, within circle) is outside the heavily bombed area.

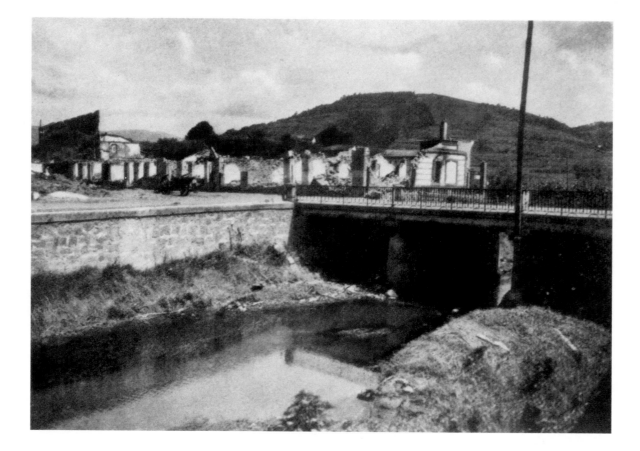

3.16 Although some bombs fell on the opposite side of the stream, none fell on the Rentería bridge, the proclaimed target of the attack.

were left virtually intact. The Astra-Unceta factories manufacturing pistols, machine guns, and bombs, although lying within the town, were not damaged, nor was the only bridge in the town, the Rentería, over which the Nationalist forces eventually entered (3.16). The one hopeful omen was that the ancient sacred oak tree, symbol of Basque independence, remained untouched (3.17).

The Nationalist troops who occupied the still-smoking town were told that Guernica had been dynamited and burned by extremist "Red" elements to cover the retreat of the Basque forces (3.18). This story was created, disseminated, and stubbornly defended by Nationalist headquarters. News broadcasts and newspaper reports in Paris tended to accept one or the other of the two versions, depending on their previously determined political positions on the civil war. The irreconcilable nature of the two stories and the fury with which each was defended polarized world opinion; the horror of the event itself generated worldwide outrage.

3.17 Present-day oak. Photograph by the author, 1972. A monument to victims of the bombing, by the Basque sculptor Eduardo Chillida, installed 26 April 1988, overlooks this spot.

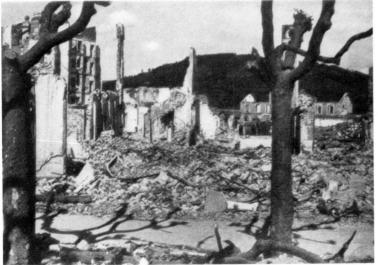

3.18 Although he participated in the attack, Lt. Count Max Hoyos in his book entitled this photograph "Guernica as destroyed by the Reds."

C O N T R A D I C T O R Y

R E P O R T S

I N T H E P R E S S

To understand fully Picasso's first concept of the painting that was to evolve out of his outrage over the bombing, one must assume the position of the artist in his Paris studio, listening to the shocking news on the radio, reading the emotionalized words of the highly partisan newspapers, and excitedly discussing the event with his friends, who almost without exception sympathized strongly with the Republic.

It is clear from all the news reports that the destruction of Guernica shook the entire world, for it was more violent than the attacks on Durango a month earlier, those on Eibar the day before, or those that occurred sporadically and rather ineffectually on the roads, open fields, and forests of the sparsely inhabited countryside. Even the bombings of Madrid, although destructive, were to be expected in a strongly defended city. Moreover, they were irregular and were spread over a large area.[1]

Contradictory news bulletins about the bombing and the suffering of the victims trickled in, exciting a bitter controversy that worsened with what Herbert Southworth was obliged to call the outright suppression of the news.[2] The government-supported Havas news agency, dominant in France, chose (or was forced by the government) to suppress the field dispatches from its own correspondent for about two days. It released them only after the Nationalists' denials and countercharges had been published. In the meantime, the *Times* (London) and the *New York Times* published the Basque charges in full and were beginning to print eyewitness reports.[3] French newspapers—highly politicized and openly partisan—made no attempt to present balanced accounts of this or other controversial affairs in the Spanish Civil War. According to Southworth's penetrating research, of some twenty Paris newspapers, probably only two could be considered wholly favorable to Spain's legally elected government.[4] At first, the majority of them took a politically conservative, if not reactionary, position: they favored the Nationalist rebels and showed an almost universal reluctance to acknowledge the intervention of German and Italian forces in Spain. This owed, in part, to the widespread fear that German and Italian aggression might soon be turned against France. Southworth's chronicle demonstrates, however, the gradual and overwhelming accumulation of evidence for German guilt.

The news first reached Paris on 27 April, the evening following the bombing, in a broadcast by Radio Bilbao. Although Basque President José Antonio Aguirre, in an impassioned speech, initially blamed the Nationalists for the attack, he soon accused the Condor Legion, acting under Franco's orders. Radio Nacional in Salamanca immediately denied both charges, crying "LIES, LIES, LIES" and audaciously declaring that not only had none of their planes been in the air on that day but no German or other foreign troops were even in Spain at the time. Radio Sevilla (Nationalist) went even further, charging that the city had been intentionally destroyed by extremist elements among the retreating "Reds," who first dynamited and then set fire to the town. The German DNB news agency flatly denied that either German planes or pilots were involved. Thus on the first day after the tragedy, before any firsthand reports were available, two contradictory accounts circulated. From that time on, editors frequently chose from the plethora of conflicting reports those that seemed either most in accord with their own politics, most convincing, or even, in some cases, most sensational.

The first newspaper account appeared on the same evening, 27 April (although it was dated 28 April), in *Ce Soir.* It was no more than a brief telegram filed by the newspaper's correspondent in Bilbao, describing the event as "the most horrible bombardment of the war." Picasso's friend Louis Aragon (future editor of *L'Humanité*) was editor of *Ce Soir;* the paper, founded only a month earlier and said to be financed by the Spanish embassy, was, of course, a strong supporter of the Republic.

The first headlines appeared on the morning of 28 April in the communist *Humanité* (4.1):

A THOUSAND INCENDIARY BOMBS DROPPED BY THE PLANES OF HITLER AND MUSSOLINI REDUCING THE CITY OF GUERNICA TO CINDERS

The headlines the next day were equally sensational:

THE MOST HORRIBLE BOMBARDMENT SINCE THE BEGINNING OF THE WAR IN SPAIN

ONLY FIVE HOUSES LEFT STANDING IN GUERNICA! AND MOLA DECLARES HE WILL RAZE BILBAO!

They were accompanied by a close-up photograph of women and children killed in an earlier attack. Among the newspapers Picasso read regularly, the conservative *Figaro,* having no editorial position on the Spanish Civil War, printed only brief, contradictory bulletins from both sides on its back pages. *Le Journal,* a popular newspaper with a large circulation best known for its art reviews, was strongly pro-Franco. It printed none of the accounts of the bombing from Republican sources, only the denials from their opponents. On 28 April, its dispatch from Vitoria, headquarters of the Condor Legion, omitted all mention of the bombing, only describing Republican atrocities in Eibar, which had been bombed by the Germans the day before Guernica. *Le Petit Parisien,* the morning newspaper with the highest circulation, normally pro-Franco, printed an un-

4.1 *L'Humanité,* 28 April 1937.

characteristically straightforward account, accusing German planes in Franco's army of the deed and describing the tragedy as the "HOLY CITY OF THE BASQUES IN FLAMES."

Only on Thursday, 29 April, did the first complete stories appear in Paris, all of them from Republican sources. Many newspapers took no position at all and even avoided the war news as too controversial, featuring instead the great outcry of indignation over the bombing both in the British House of Commons and in America. Curiously, only the communist and leftist press expressed any anger, the more commonly expressed attitude being disbelief or, at best, noncommitment. On the same day *Le Populaire* (pro-Republican) published on its front page photographs of the burning city under the headlines "MASSACRE OF BASQUE PEOPLE." [5] *Le Figaro* impassively printed side by side in its back pages contradictory dispatches originating in Bilbao (Republican) and Salamanca (Nationalist) alongside a story from London of the heated accusations and demands for action in the Commons. *Le Journal* continued to print only the Nationalists' denials of the bombing from its correspondent in Vitoria. Only *L'Humanité* in Paris exhibited great indignation and kept public fervor over the issue aroused for most of the next month. It reprinted in its entirety George L. Steer's long eyewitness account, which had appeared the previous day, 28 April, in the *Times* (London) and which has become almost the only newspaper article to survive as an accurate and impartial history of the event. *L'Humanité* also made the startling discovery that even at the hour that German bombs were falling on Guernica, Hermann Goering, Commander in Chief of the Luftwaffe, and Mussolini were meeting in Rome to discuss means to rapidly end the war in Spain. In its headlines of 29 April, the paper accused the two men of ordering the bombing. On the same day, it also printed the photographs, the Luftwaffe identification cards, and various other documents of three German aviators who had been shot down and captured while on a bombing mission over Bilbao (4.2).

On Friday and Saturday, 30 April and 1 May, the first photographs of the gaunt and shattered walls of the stricken town appeared in several newspapers, including the ones Picasso read, *Le Figaro* and *Ce Soir*. While most of the other newspapers were dropping the subject, *L'Humanité* alone kept the issue alive, first by publishing in the issue of 30 April–1 May the text of the Basque president's impassioned accusation:

4.2 Nationalist pass taken from German fighter pilot captured near Bilbao.

> German aviators in the service of the Spanish Fascists have bombed and burned the historic village of Guernica, object of veneration of all the Basques. They have had no fear of striking at our most profound patriotic sentiments, providing once again the proof of what the Euzkadi can expect from those who do not hesitate to destroy a sanctuary which is a memorial of our liberty and our democracy.

This was followed by a touching picture of the plight of the victims:

> Before God and before history that will judge us I swear that for three and one-half hours German planes bombed with inconceivable destruction the undefended civil population of Guernica, reducing the celebrated city to cinders. They pursued with machine-gun fire the women and children who

were frantically fleeing. I ask today of the civilized world if it will permit the extermination of a people whose first concerns have always been the defense of its liberty and democracy, which the tree of Guernica has symbolized for centuries?

These moving words were contrasted in the same issue with quotations from a belligerent radio broadcast by General Emilio Mola, commander of Franco's forces in the north, who threatened to "raze Vizcaya to the ground." He added, "We must destroy the capital of a perverted people who dare oppose the irresistible cause of our national ideal."

The clamor of denials rose to a frenzied tempo after the text of Franco's own denial was published and after journalists favorable to the Nationalists had been led on a tour arranged by Franco through the ruins of the town. On 30 April, *Le Journal* published Franco's statement in full:

> Basque fugitives passing through our lines told of the terrible tragedy of cities like Guernica which were totally destroyed by the Reds when our troops were still 15 kilometers distant. The indignation of the Nationalist troops could not have been greater because of the lies of the enemy who, after having destroyed by fire the largest villages of the region, accused the Nationalist air force.

On the same day, headlines in *Le Figaro,* strictly following Franco's line, proclaimed: "THE 'HOLY CITY' OF THE BASQUES WAS DYNAMITED AND BURNED BY THE MILITIA BEFORE ITS RETREAT." On 3 May the newspaper's reporter assigned to Nationalist headquarters (who therefore had to submit to its censors), at the invitation of Franco, took the tour of the ruins and wrote an article under the heading, "GUERNICA COULD NOT HAVE BEEN DESTROYED BY BOMBS FROM THE AIR. IT IS THE REDS WHO BURNED IT 'BY HAND.'"

L'Humanité replied on 5 May with the vivid and horrifying eyewitness story of the Basque priest Father Onaindía, who while fleeing from the town on a road crowded with refugees, was strafed by the Condor Legion's low-flying fighter planes (4.3):

> It was Monday and market day. We were passing near the railroad station when we heard a bomb explosion; it was followed immediately by two others. An airplane which was flying very low dropped its load and left, all in a few seconds. It was Guernica's first war experience. The panic of the first moments shocked the inhabitants and the peasants come in to market. . . . There very soon appeared, as if coming from the sea, some eight heavy planes which dropped many bombs and behind them followed a veritable rain of incendiary bombs. For more than three hours there followed waves of bombers, of airplanes with incendiary bombs and of solitary machines which came down to two hundred meters to machine-gun the poor people who fled in fright.[6]

As if to illustrate Father Onaindía's graphic story, the popular picture magazine *Illustration* published on the same day five large photographs of the burning city.[7]

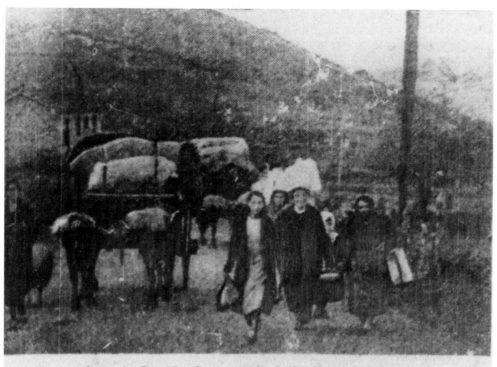

4.3 Refugees fleeing the burning city on the road to Bilbao, fifteen miles to the west.

Femmes en enfants de Guernica fuyant la barbarie fasciste et se dirigeant vers Bilbao

Ignoring the differing stories of the massacre, *L'Excelsior* printed on its front page of 30 April a photograph of the ceremonial oak of Guernica. This photograph served to make more poignant the destruction in the village that symbolized the Basques' democratic traditions and their fierce independence.[8]

If the highly contradictory stories and often outright falsehoods published and broadcast created violent controversy over irresolvable differences of opinion about events at Guernica, the political ramifications were far more complex. Once the false claim that neither the Nationalists nor the Germans knew anything about the bombing became public record, other falsehoods became necessary to reinforce the first one, thus creating a fabric of fictitious events. As Patricia Failing wrote about *Dream and Lie of Franco:*

Such visceral empathy for the Spanish cause was not, for the most part, generated by actual events in Spain, but by newspaper images. For the left- and right-wing European press, the war immediately became a vehicle of doctrine. Only subsequently did it become apparent that the battles, heroes, victories and defeats, which waxed and waned in front page headlines, were not only frequently fictitious, but also far more indicative of international politics than of realities on the Spanish front.[9]

Thus the blunderings and the deceptions of a few newspaper reports, while certainly contributing to the confusion of the issue, were only temporary obfuscations of the truth about the tragedy. Father Onaindía, the most observant and honest eyewitness to the bombing, in 1973 finally protested the distortions and misrepresentations of his simple and direct story:

> The world press published my declarations and presented them, each according to his manner. Each one emphasized the aspect which he found interesting, without always limiting himself to objective truth. Naturally, all the production of journalistic fantasy was placed in my mouth. It was my first experience with international journalism. Then I understood how difficult it was to know truth exactly in its details and specific circumstances.[10]

Even more important for history than the prejudices of the press and the fabrications of the propaganda agencies, Guernica inflamed so many crucial political disputes of the age that it rapidly became a *cause célèbre*. For a few farsighted observers it anticipated the German-Russian war, the German invasion of Western Europe, the cruelty of Franco's vengeance against those who had defended the Republic against him, the unyielding stance of the Spanish Catholic church against even those faithful Catholics who protested against the execution of Loyalist prisoners, and much more. In the history of war, Guernica marked the most sensational case to date of unrestricted attacks by modern bombing and fighter planes for the purpose of terrorizing the populace. Modern total war and *blitzkrieg* both received their baptism on 26 April 1937. The Spanish Civil War acquired an edge of bitterness through the cynicism of the Western democracies that spoke officially for nonintervention because they feared Hitler and felt unprepared to challenge him but refused to condemn the flagrant intervention of Spain's invaders, Hitler and Mussolini.

On Saturday, 1 May 1937, only five days later, the largest May Day demonstration in the history of Paris—with more than a million manifestants—took place along the historic route from the Place de la République to the Bastille. The urgent themes of the demonstration were outrage over the bombing and appeals for aid to the victims. Although its ultimate significance was not yet clearly understood, Guernica aroused worldwide outbursts of passionate indignation.

That very afternoon, in a climate of shock and anger, Picasso, abandoning his custom of spending weekends with Marie-Thérèse and their infant daughter, Maya, at their home in the country, took up a pencil and a small pad of blue notepaper and made a freely drawn summary sketch of a bull, a horse, and a woman—the beginning of *Guernica*.

PART TWO

INCEPTION OF THE PAINTING

A picture is not thought out and settled beforehand. While it is being done it changes as one's thoughts change. And when it is finished, it still goes on changing, according to the state of mind of whoever is looking at it. A picture lives a life like a living creature, undergoing the changes imposed on us by our life from day to day. This is natural enough, as the picture lives only through the man who is looking at it.

—*Picasso*

Spanish Concepts of Death

"Spain is the only country where death is a natural spectacle," said the Andalusian poet and dramatist Federico García Lorca in a lecture on the spirit of Spain delivered to Latin American audiences. "A dead person in Spain," he continued, "is more alive when dead than is the case anywhere else—his profile cuts like the edge of a barber's razor."[1]

This view that death is omnipresent and that life is a constant struggle, balancing precariously on the precipice between survival and annihilation, leads to Lorca's second characterization of the Spanish spirit, *duende*. *Duende* names the Spanish obsession with walking at the brink of death, for it is only when confronting death and exorcizing it by courageous and total disregard that a true nobility of spirit is achieved. Lorca went on to a highly impassioned and poetic evocation of other manifestations of *duende*. It burns the blood like powdered glass, he said, for like the *cante hondo*, it arises from the dark and mysterious sounds and smells of the earth where lie the roots of ancient Spanish culture. This struggle also inflicts wounds that never close, but in the effort to bear these wounds man creates his most original and prodigious works. In the deepest spiritual sense *duende* is the source of what is real in the most moving art; it is what compelled Goya "to paint with his knees and with his fists horrible bitumen blacks."

Duende achieves its most compelling expression, Lorca continued, in the Spanish *corrida*, the *fiesta nacional* that combines a multitude of rich emotional and symbolic associations of courage and nearly superhuman skill.[2] Because of the great spiritual power of *duende*, new heights of rarified emotion may be achieved in the rigidly structured tripartite acts of the *corrida* and its austerely beautiful ritual death, comparable to the ritual of the Catholic mass. The death of the bull—which is pre-ordained—and the death that is ever-present for the man take on the solemn intensity of a sacrifice to an ancient god.

All his life, from childhood until his last months, Picasso was a constant and ardent aficionado of the bullfight. His lifelong friend D.-H. Kahnweiler said that as Picasso grew older and less active, the last event outside the studio that he relinquished was the *corrida*. His regard for its ultimate symbolic meaning was mirrored in a remark he made to his close

5.1 (*right*) Picasso and the matador Luis Miguel Dominguín practicing the bull's attack, 1955. Photograph by Edward Quinn.

5.2 (*below, top*) Bull and horse, 1925. Drawing. 9¾″ × 12⅝″ (25 × 32.5 cm). Z V, 441.

5.3 (*below, bottom*) Furious bull goring horse, 24 July 1934. Drawing. 10″ × 13½″ (25.7 × 34.5 cm). Z VIII, 217.

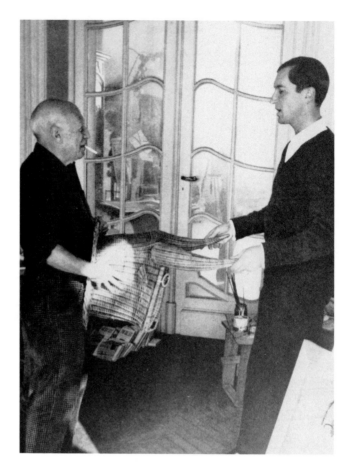

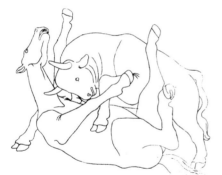

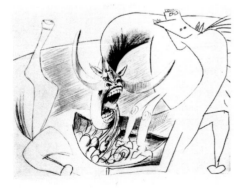

friend the eminent matador Luis Miguel Dominguín (5.1). Dominguín was considering retiring from the arena to devote himself to his business investments, and their conversation turned to the meaning and value of life. With brutal directness Picasso said, "You should just go back down there in the arena and when your time comes, die there."[3]

Lorca was not certain that Picasso's art achieved *duende;* he did not believe that it was a powerful challenge to death but thought rather that Picasso's inspiration came as if from a Muse. Yet the evidence of Picasso's art, and in particular his remembrances of the bullfight and suffering women, reveals his obsession with wounds and the nearness of death to be that of a true Andalusian. Calling him the "toreador of painting," Ramón Gómez de la Serna said that he painted a picture with all the gestures and expressions of a matador engaging a bull.[4]

The obsession with pain so clearly present in Picasso's art—in his choice of subject matter, his forceful manipulation of forms, and sometimes even the lacerating character of his brush strokes—links it to Lorca's concept of suffering as an intensification of emotion. Imagery of wounds appears frequently in his work, particularly during the few years prior to *Guernica* when he was tormented by strife with women. At this time he extracted the bull-horse conflict from the *corrida,* isolated it, and transformed it into a furious battle between male and female (compare 5.2, 5.3).

The Spanish *Corrida* and Death

Picasso, born in the Andalusian city of Málaga, ancient home of the *corrida,* was instinctively fascinated by the great paradox of the bullfight as a severely prescribed ritual that in an instant could be demolished by its antithetical mode, the chaos of animal passions. These symbolic manifestations of reason versus emotion may shift violently in the bullring from a celebration of human artistry, skill, and courage to the misery of a brutal death in the arena's bloodied sands. The range of expressive possibilities inherent in the conflict of man and beast, in aesthetic versus blindly passionate behavior, makes those rare moments when a union occurs between these two antagonists even more dramatic. When the encounter is successful, man and animal become united in the *faena,* the final act of the drama, a rhythmic action that may be compared to the ecstasy of the ultimate act of love (5.4). The will and mastery of the man lures the beast into a series of closely interrelated attacks and evasions that increase in emotional intensity and rhythmic aesthetic power until, like Wagner's *Liebestod,* the tension finally explodes in the thrust of the sword to the bull's heart (5.5).[5] For aficionados this contest between bull and man creates the emotion and gives meaning to the ritual. They call the final and most dangerous act of the matador the moment of truth, when he throws his body between the horns of the bull and with his

5.4 (*left*) The *faena* (Andrés Vásquez, 1973). Photograph by F. Botan.

5.5 The final thrust for the bull's heart (Palomeño, 1978). Photograph by F. Botan.

5.6 *Corrida*, c. 1900. Ink and pencil. $9\frac{1}{8}'' \times 6\frac{3}{4}''$ (23.3 × 17.3 cm). MPB.

5.7 *Blind Minotaur I*, 22 September 1934. Etching. $9\frac{15}{16}''$ × $13\frac{5}{8}''$ (25.2 × 34.8 cm). G. 434. At left, small inverted drypoint, called *Mort de Marat*, 21 July 1934. $7\frac{1}{2}'' \times 5\frac{1}{2}''$ (19 × 14 cm). G. 430.

sword probes for its heart—in Lorca's words, like a young girl slipping a rose between her breasts. For the poet the successful execution of this act is the supreme example of *duende*.

Picasso's early representations of the *corrida*, dating from about his eighth year, had been wholly conventional. Around 1902 he drew many scenes, all of them from the point of view of an onlooker enjoying the entire spectacle—the sand, the sun, and the excitement of the crowds (5.6). Only later, during intense emotional involvement with the most important women in his life, was he to concentrate on the violent episode of the bull's attack on the horse, gradually imbuing it with human sexual overtones. Finally, in 1933, the Minotaur appeared, embodying in a single figure the characteristics of both man and beast. To the purely physical violence of the bull the Minotaur adds the subtleties of human emotion (5.7). Probably inflected by the surrealists' concept of the man-animal, the Minotaur manifests yearning, defeat, pathos, and both physical and psychic suffering.

The first clear example of the humanization of the bull-horse struggle is a series of drawings from 1917 depicting the bull persistently probing with his horns the prone body of the horse (5.8). It was no coincidence that Picasso made these drawings during a visit to Barcelona when once again he could attend the *corrida* in Spain, this time in the company of a beautiful dancer in the Ballets Russes, Olga Koklova, to whom he had become engaged. These drawings have as their subject the first major act of the *corrida*, when the bull has entered the ring, alone, alarmed, and angry—already wounded by tiny lances in his neck. Attracted by the great swirling capes of the toreros, he is led to make several wild but vain charges across the arena when, quietly, the mounted picador enters and takes up a stationary position. The bull, frustrated by the elusive capes, immediately charges the horse, his first large attainable target (5.9).

5.8 Bull and horse, 1917.
Pencil. 9″ × 6″ (23 × 15.5 cm).
Z III, 64.

5.9 Bull, horse, and picador,
1923. Sometimes they become
intertwined like dancers in a
ballet. Pencil. 18¾″ × 24⅝″ (48
× 63 cm). Z V, 145.

5.11 (*above*) Bull, induced to attack horse, is impaled on picador's lance.

5.10 (*above, left*) Goya, too, was drawn to this critical moment. *La tauromaquia,* no. 32 (det.), 1816. Etching and aquatint.

This first act heartens the bull by offering him the great instinctual satisfaction of driving his horns into the body of the horse. This episode, a central one in Goya's etchings, provides tense moments, for while the bull is goring the horse, the picador is in turn driving his lance into the bull's straining neck muscles (5.10, 5.11). For the bull this means that although he is enjoying a moment of ecstatic gratification, he is also suffering grave damage to his offensive capabilities—his powerful neck muscles—that will make him a more ready victim to the matador's sword in the final act. During this dramatic struggle, the horse is only a passive supporting actor. Its neutral role is assured by the practical device of blindfolding—thoughtfully with a red bandana—and by a prior minor operation on the vocal chords to silence it. Even when the strict ritual breaks down and chaos prevails, as when the horse is overthrown and the rider cast on the sand, the fate of the horse is of little concern. Picasso always depicted the horse without the *peto,* or padded coat, required by law after 1927. In fact, he resented the use of the *peto* because he believed that it inhibited the bull's combative spirit and diminished his instinctual satisfaction in attacking the horse. Before 1927 both animals were usually doomed to die in the ring and were always wounded in this encounter, thus giving the first act of the *corrida* a poignant aspect of suffering. It is the *corrida*'s most brutal and, some think, cruelest part and unless executed skillfully and aesthetically may be difficult even for experienced aficionados to witness. A series of photographs of a bull goring the horse of a *rejoneador* (mounted matador) captures some of this poignancy (5.12).

When Picasso came to represent this episode in his art, he usually excluded the picador—the chief antagonist of the bull—as well as the several toreros whose duty, should a mishap occur, is to draw the bull away from the helpless man. Thus removed from the strict context of the *corrida,* the bull's attack on the horse took on added meanings, uppermost

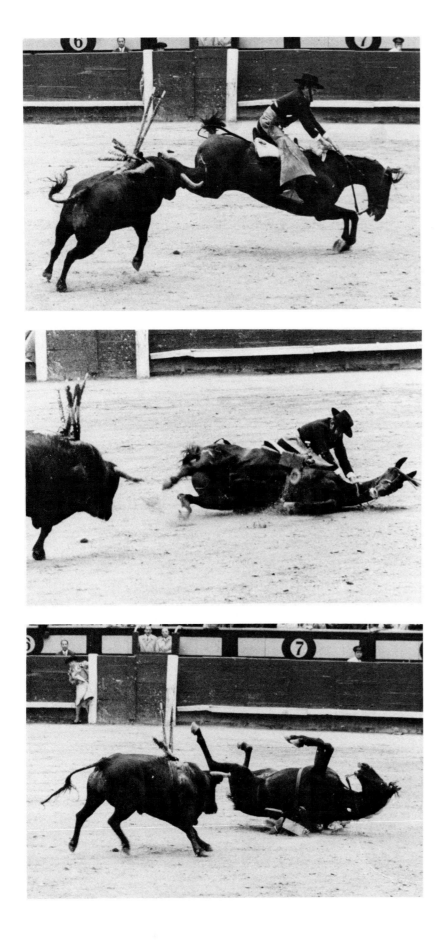

5.12 The strength of the bull and the helplessness of the fallen horse are evident in this series of photographs of a bull goring a *rejoneador*'s horse. Photographs by F. Botan.

5.13 *(top)* Bull and horse,
1927. Etching. 7½″ × 10⅞″
(19.2 × 27.9 cm). G. 125.

5.14 *(middle)* Horse and bull
(det.), 16 July 1934. Pen and
ink. Z VIII, 211.

5.15 *(bottom)* Bull and
horse, 1917. Pencil. 9″ × 6″
(23 × 15.5 cm). Z III, 50. The
horse's wounds are in the belly,
the bull's in the heart.

among them the clear allusion to a human erotic act (5.13). The bull is
the aggressor, the horse the passive partner awaiting his charge; the bull
seeks with all his strength to drive his horns into the body of the horse
(5.14) while the horse grovels in the sand or attempts to run away, often
stumbling over its own entrails. Although male genitalia are often shown
on the horse, its role in the act is a submissive one that when contrasted
with the *machismo* of the bull, can best be understood as female. Further,
as Michel Leiris has observed, the blood of the bull has for centuries been
associated with sacrifice and as such is sacred. It is the heart's blood, the
bull's vital, life-sustaining, force, that spurts over the sands of the arena.
The horse's wound, on the contrary, is in the belly; the blood shed is from
its entrails. It is thus visceral and profane and in its mythic import may be
likened to menstrual blood (5.15).[6]

Thus, beginning as early as 1917 the theme of the bull-horse struggle
was transformed in Picasso's art into a battle of the sexes and in 1937
took on ambiguous but powerful implications as it became the generating
image of *Guernica*. After 1917 the analogy between the physical struggle
in the *corrida* and the human sexual act becomes increasingly evident.
Finally, during Picasso's most difficult period of emotional turmoil in
1934 and 1935, when Marie-Thérèse became pregnant and his wife Olga
took their son and left him, both bull and horse take on human charac-
teristics. Most revealing is the series of furious combats made during the
summer of 1934. Up to this point the bull and horse have been the only
two actors in the drama. Now, in the series of etchings called *Femme To-
rero*, they are joined by a beautiful blonde nude in the image of Marie-
Thérèse. The three protagonists now bear only the most tenuous relation
to the actual spectacle of the arena. In *Femme Torero I* the majestic bull,
unruffled by the combat, tramples in the sand a miserable disemboweled
horse whose head strains upward in anguish while the woman, her volup-
tuous nudity emphasized by the torero's stockings and unbuttoned jacket,
elaborately embroidered, is draped sensuously over the back of the bull
(5.16). That this is a love triangle cannot be doubted when we observe the
glowing faces of the lovers as the bull plants a passionate, moist kiss full
on the lips of the compliant woman (5.17). With this etching Picasso as-
sociates the *corrida* with the myth of Zeus's abduction of Europa. With-
out a role in this classic story, the mangled horse, collapsing beneath the
feet of the entwined and self-absorbed bull and woman, remains only the
cast-off "other" member of the triangle.

These poignantly dramatic scenes of the eternal triangle, as well as the
encounters between bull and horse alone, had for many years provided
Picasso with symbols of personal destructive passion. Even before he be-
gan *Guernica,* Picasso told Juan Larrea that the horse in his art repre-
sented for him the most important women in his life, and he told Fran-
çoise Gilot that her symbol is the horse while his, proudest of all, is
the bull.[7]

The Minotaur

In view of Picasso's propensity for endowing his favorite animals, the bull
and the horse, with human emotions and even human resemblances, it
should come as no surprise to find the frequent merging of animal and
human characteristics. Indeed, in a true surrealist spirit, transformations

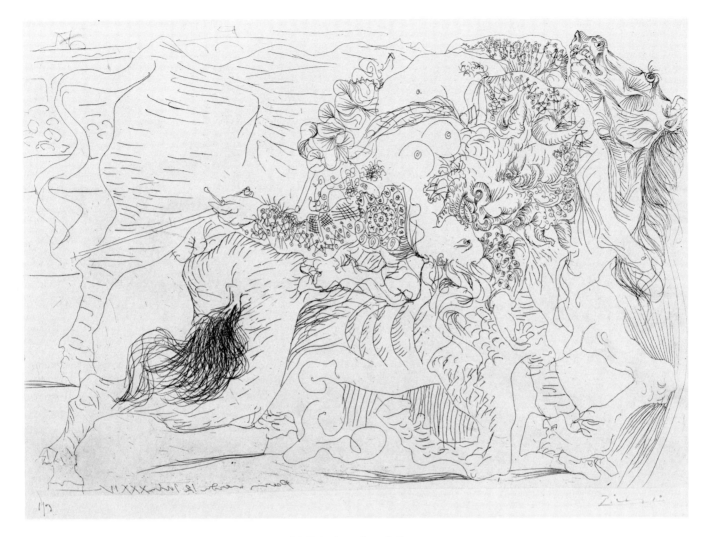

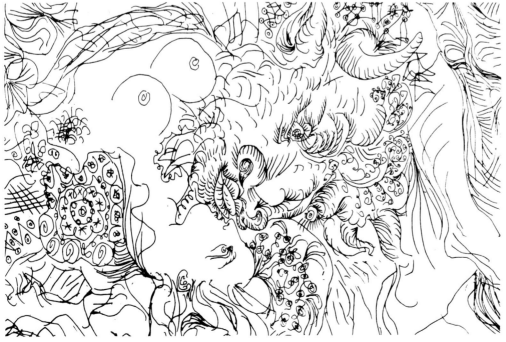

5.16 (above) *Femme Torero I*, 12 June 1934. Etching. $18\frac{7}{8}''$ × $26\frac{3}{4}''$ (48 × 68 cm). G. 425.

5.17 *Femme Torero I* (det.).

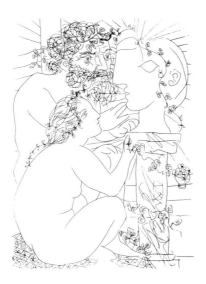

5.18 (*above, left*) *The Sculptor's Studio*, 23 March 1933. Etching. 10½″ × 7⅝″ (26.9 × 19.4 cm). G. 308.

5.19 (*above, right*) *The Minotaur*, 18 May 1933. Etching. 11⅝″ × 14¼″ (29.7 × 36.6 cm). G. 351.

5.20 (*next page, top left*) *The Minotaur*, 23 May 1933. Etching. 7⅝″ × 10⁷⁄₁₆″ (19.4 × 26.8 cm). G. 356.

5.21 (*next page, top right*) *The Minotaur*, 29 May 1933. Etching. 7½″ × 10½″ (19.3 × 26.9 cm). G. 365.

between humans and animals could take place from either side or could exist in constant metamorphosis. The part-man, part-bull being—or Minotaur—was favored by the surrealists and by Picasso, who while scorning the dogma of Surrealism still felt himself instinctively attracted to the Minotaur's fusion of love and hate, eroticism and repulsion, and divinity and bestiality. The Minotaur, furthermore, symbolized for artists and poets alike the Freudian unconscious drives that subverted conventional behavior.

Although never willing to submit to André Breton's authoritarian leadership of the surrealist group, Picasso was drawn to the potentialities of the Minotaur as a symbol of unbridled passions. Thus it came about that the combined brute violence and artistic ritual of the Spanish *corrida* were fused with the partially concealed erotic imagery of the human unconscious to form the ambivalence of the Minotaur.

Picasso himself demonstrated in his etching series of 1933 and 1934, especially in *The Sculptor's Studio* and *The Minotaur*, the wide range of expression between the artist and the beast. Assuming some of the prerogatives of the handsome, regal sculptor in his studio as seen in a preceding series of March and April 1933 (5.18), the Minotaur is shown as the chief reveler in one of the most glorious bacchanals in all of art (5.19). Carried away by passion for his beautiful companion, his bestial side overcomes him (5.20); now reduced to a beast, he is punished for his assault on the woman by a miserable death groveling in the bullring (5.21). He does not even receive the honor of the matador's ritual *espada* (the elegant, curved sword) but is put to a disgraceful death by the *estoque*, the stubby dagger brought out when the matador, through his own ineptness, fails to dispatch the bull with the expected artistry. The Minotaur's metamorphosis is further demonstrated in 1936 when like the bull he is put to death by the picador's lance while his female companion calmly looks on (5.22). In another drawing, the woman, mounted on a horse and brandishing her lance, assumes the role of picador, while the Minotaur seeks death by his own hand by running himself through with a clas-

sical sword (5.23). In both these drawings of 1936, he not only manifests human behavior but also bears a human face in an entirely human body. Only rudimentary horns and ears betray his animal aspect, now reduced to a minor one, as though these attributes were a headpiece or a mask. Only the bull—never the horse—possesses the capability of metamorphosis into a human being. The Minotaur, whose essence, according to the surrealists, is transformation, is capable of assuming not only the personality and the form of human beings or beasts but also all the intermediary stages.

In a separate series devoted to the theme of the blind Minotaur, Picasso undertook to consolidate the person of the Minotaur in a grander symbolic cycle that echoes classical images and epic situations. The first work in the blind Minotaur series dates from September 1934 and depicts a Minotaur stricken with blindness who cries out in anguish as he takes the hand and touches the hair of a beautiful little girl carrying

5.22 (*below, left*) *Wounded Minotaur*, 10 May 1936. Ink and gouache. $19\frac{1}{2}'' \times 25\frac{3}{8}''$ (50 × 65 cm). Z VIII, 288. MPP.

5.23 *Wounded Minotaur*, 9 May 1936. Ink and gouache. $19\frac{1}{2}'' \times 25\frac{3}{8}''$ (50 × 65 cm). Z VIII, 286.

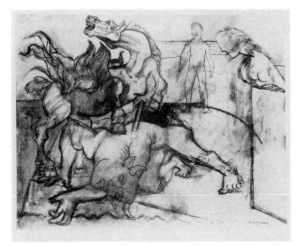

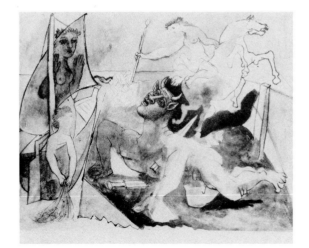

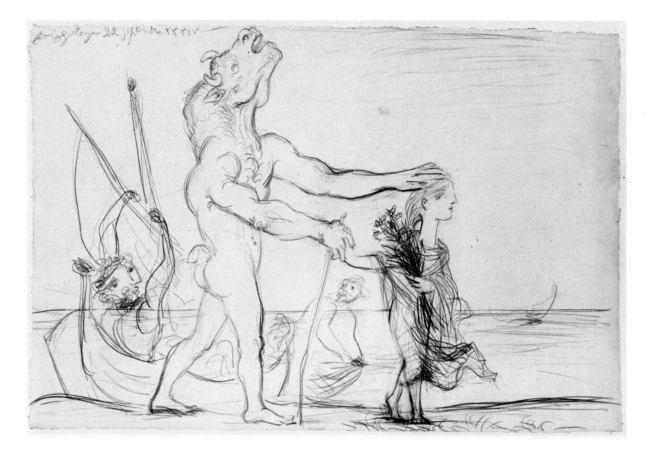

5.24 *Blind Minotaur*, 22 September 1934. Pencil. MPP.

flowers (5.24). Although only a child, she bears the well-known profile of Marie-Thérèse, and she gently guides the stricken man-animal as he disembarks from a boat and walks along an isolated beach.[8] The Minotaur is a tragic figure and his suffering is altogether human, for with the exception of the animal head, he is a sympathetic and athletic youth. Picasso executed three additional etchings on this theme during the next two months, adding a standing young man as observer and providing the young girl with a dove that she clasps in her arms. The girl's resemblance to Marie-Thérèse increases.[9]

Finally, on 23 March 1935 Picasso began work on the *Minotauromachy,* the culminating version of his epic on the suffering Minotaur, apparently spending at least a month in his printer Roger Lacourière's graphic art studio.[10] It was his largest etching, measuring $19\frac{3}{4}$ by $27\frac{1}{2}$ inches (49.8 by 69.3 centimeters), and had been heavily worked over with a *grattoir,* producing many areas of rich blacks that dramatized the highlights (5.25). In this respect, it was not unlike *Guernica.*

The young girl, the sole companion of the beast, still grasps the flowers but now holds high a candle as if to light the way for the apparently still sightless animal. The beast, enveloped in the blackness of his massive hairy head, extends an arm as if to shield himself from the lighted candle. Between these two figures Picasso introduces a motif from the *Femme Torero* series, a disemboweled horse bearing on its back the seminude *torera* whose face is that of Marie-Thérèse. The ritual *espada* she holds in one hand is carefully turned away from the beast, strongly suggesting that he is a sympathetic, not a threatening, being.

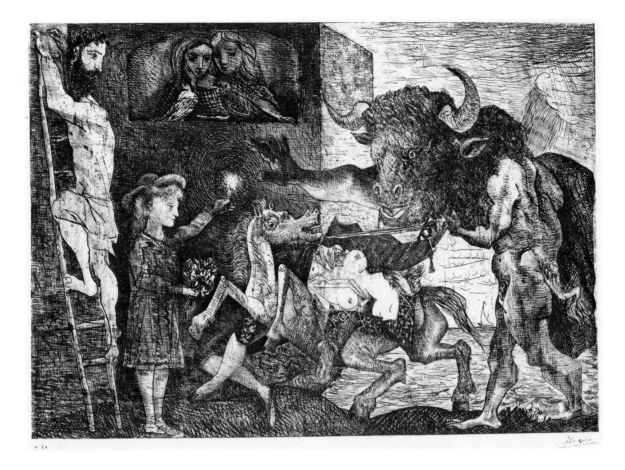

5.25 *Minotauromachy,* end of April 1935. Etching and scraper. $19\frac{1}{2}'' \times 27\frac{7}{16}''$ (49.8 × 69.3 cm). G. 573.

The young man, now bearded, seeks to escape the groping hand of the Minotaur by fleeing up a ladder leaning against the building to the left. From a window, two serene women with two doves look down upon the scene. The fisherman's boat that had deposited the mythical beast on this shore, with sails set, is now disappearing over the horizon.

The women in the window are closely related to the two companions depicted as painting, reading, or sleeping in two series from 1934 and 1935 (before the birth of Maya on 5 September 1935). In the intimacy of their postures, these companions seem to be comforting each other.[11] It should be remembered that Marie-Thérèse, while pregnant and even after the birth of Maya, saw Picasso only at intervals, and thus her need for a female companion could be understood.[12]

The *Minotauromachy,* because of its size, complexity, richness of imagery, and overall quality, may be considered to have drawn together many of the most important images and ideas in Picasso's art from the previous several months. It was a critical time in Picasso's personal life; because of his domestic troubles he had virtually given up painting for writing poetry and for drawing, and there is reason to believe that some of the Minotaur's afflictions were actually Picasso's. The emotional force of this etching therefore stood in the foreground when two years later he took up the project of the mural for the Spanish pavilion. Beryl Barr-Sharrar and others have demonstrated convincingly the extent to which Picasso drew upon his own past art in his major projects.[13]

Like *Guernica,* the *Minotauromachy,* which is very large for an etched plate, is a horizontal rectangle. If the etching is reversed and thus viewed

as it was drawn on the plate, the ways in which it foreshadows *Guernica* become more readily apparent. Many quite dark areas are separated by islands of light on the faces and figures, and the composition is focused on a dramatic central group—the disemboweled horse, the *torera,* and the massive head of the stricken Minotaur. The two serene women look down from the window just over the lighted candle held by the young girl. To the extreme right a bearded youth clings to a ladder. (Although it is a falling woman with clothing aflame who occupies this position in *Guernica,* in sketch 35 Picasso experimented with an alternative image—a bearded, falling man with upraised arms.)

On the one hand, the etching can be seen as a culmination and my-thologizing of numerous themes drawn from the struggle between the bull, horse, and *torera* that had dominated Picasso's art over many years. On the other hand, in its formal structure and dramatis personae, it pre-saged many of the elements that were to emerge in the developing concept of *Guernica* and, significantly, contributed some of its emotional force to the large mural.

The Artist and His Model

It has always been taken as self-evident that Picasso began his mural for the pavilion only when he was overcome by shock and outrage over the bombing of the Basque town of Guernica. This assumption has encour-aged historians predisposed to seek political motivations in works of art to read *Guernica* as Picasso's statement on the issues of the Spanish Civil War. It has stimulated those seeking in art allegories of traditional cul-tural concepts to interpret the principal characters as illustrating themes from classical, biblical, or other commonly accepted bodies of knowl-edge. Some writers, for example, have said Picasso's bull was a brutal ani-mal and thus represented Franco, whereas the horse was passive and hence represented the Spanish people, the victims of Franco's aggression. Other writers, reversing the analogy, have seen in the fighting bull a sym-bol of Spanish strength and courage and in the screaming horse a repre-sentation of Franco on the verge of what they hoped would be a miserable death.[14] Other images in *Guernica* have been seen as personifications of philosophical or mythological attitudes.

Over the years these and similar interpretations have come to domi-nate the ever-increasing mass of writings on the painting, even though careful study of the history of Picasso's art and his remarks on that art has provided little evidence that his mind tended to work in these traditional ways.[15] Indeed, the discovery of a remarkable series of twelve virtually un-known sketches in the archives of the Musée Picasso in Paris provides vi-sual proof against these interpretations.[16] They are clearly preliminary drawings for the promised mural for the pavilion, but they have nothing to do with the Spanish Civil War. Although feeling deeply the agony then racking his own country, Picasso had shut it out of the little kingdom of his art, except in the caricature-like etching series *Dream and Lie of Franco* and in an unused sketch of 13 June 1936 for the curtain for Romain Rolland's play *Le quatorze juillet* (see 6.57).[17] Dated 18 and 19 April 1937, one week before the tragedy at Guernica, these sketches, all but the last lightly drawn in pencil, portray quite simply an artist and a model in a peaceful studio (5.26).

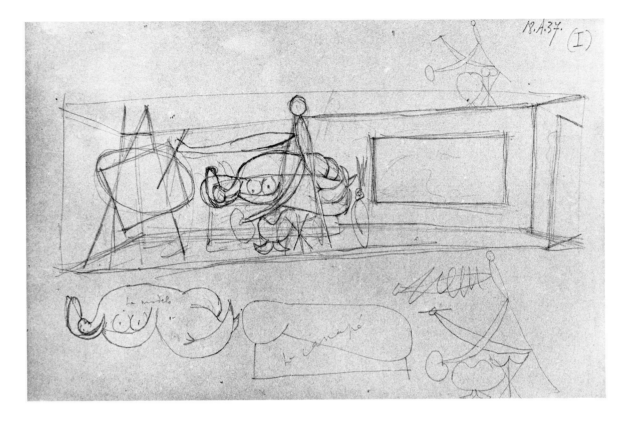

The subject of artist and model has always been a surpassing theme for artists, their ultimate expression of a life centered on themselves in environments of their own creation. It was one that had obsessed Picasso for the decade preceding 1937—ever since Marie-Thérèse Walter became not only his intimate companion but also his habitual model. His first major series on the theme of artist and model came soon after his meeting with Marie-Thérèse on 8 January 1927. It was a group of thirteen etchings used to illustrate an edition of Balzac's *Chef d'oeuvre inconnu*, all of them featuring the artist and his models in informal studio scenes. Although the hero of Balzac's work was an artist struggling with nonrepresentation, Picasso rendered the figures, both male and female, in a graceful classical linear style—a style that became unequivocally linked to the face and figure of Marie-Thérèse, whom he had just enticed into his studio. In one etching, however, he took Balzac's theme to explore a particular concern of his own. Preoccupied with her knitting, a realistically detailed woman—resembling a typical concierge more than an artist's model—poses for the artist, who depicts her on the canvas as an abstract tangle of lines (5.27). This fascination with both the act of transformation and the ease with which transformations of meaning may take place was to become a central feature of Picasso's art and a significant factor in the development of *Guernica*.

By 1932 Picasso had become increasingly obsessed with the theme of artist and model as his relationship with Marie-Thérèse intensified and her face and figure came to dominate all aspects of his work. She appears in his art far more than any other person and was the inspiration for the

5.26 (*above*) *The Studio I,* 18 April 1937. Pencil. 7⅛″ × 11″ (18 × 28 cm). MPP.

5.27 Illustration for Balzac, *Le chef d'oeuvre inconnu,* 1927. Etching. 7⅝″ × 10⅞″ (19.4 × 27.9 cm). G. 126.

5.28 *The Sculptor's Studio*,
17 March 1933. Etching. 10½″
× 7⅝″ (26.7 × 19.4 cm).
G. 300.

5.29 *The Sculptor's Studio*, 3
April 1933. Etching. 7⅝″ ×
10½″ (19.3 × 26.7 cm). G. 324.

great series of female nudes of the early 1930s, where she is depicted in splendidly colored paintings, voluptuous sculptures, and drawings and etchings of extraordinary elegance. *The Sculptor's Studio* of March and April 1933, a magnificent series of forty-five etchings, is a virtual documentary of their life in his sculpture studio at Boisgeloup just outside Paris. In touching scenes they are depicted side by side, gazing intently at the art they have created together (5.28) or engaged in amorous play on the studio couches (5.29). The theme of transformation emerges a month later in another series when a Minotaur, who at first closely resembles the sculptor, takes over his role. The brute aspect of the beast gradually surfaces and overcomes the semidivine character of the artist, and in several dramatic encounters the Minotaur at first woos and then attacks and violates the model (see 5.19 and 5.20). He pays for this transgression in the arena, where he loses his life at the hands of a youthful matador, who resembles the artist himself in the earlier series (see 5.21). The studio theme is therefore much more than a depiction of the artist at work—it is a glorification of his private world where he creates and enjoys his art and pursues amorous adventures with his model.

The artist and model pose of the sketches for *The Studio* series of 1937 is well known in Picasso's past art. A charcoal drawing of 11 January 1933 of two women in a studio is most striking (5.30). Both women bear the characteristics of Marie-Thérèse, the artist in her profile and the model in the ample interlocking curves of her body. The outstretched arm

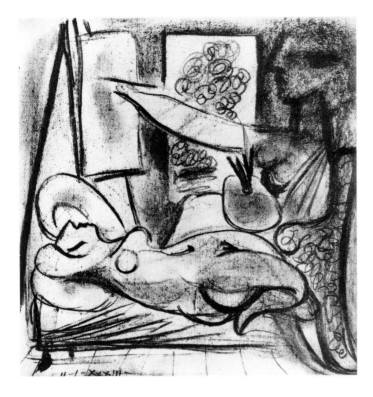

5.30 *Painter and Model,*
11 January 1933. Charcoal.
10$\frac{15}{16}$" × 10$\frac{5}{8}$" (28 × 27 cm).
Z VIII, 76.

5.31 *Woman with a Vase,*
1933. Plaster. Outside Spanish
pavilion, 1937; present loca-
tion unknown. S. 135.

of the artist, which is, after all, the most characteristic gesture of a painter
(see frontispiece), is emphatically delineated in the charcoal drawing that
possibly provided a prototype for *The Studio* series. The image of an art-
ist and model in a studio continued to dominate Picasso's mind, for early
in 1935 he executed in rapid succession a series of more than a dozen
sketches on the same theme, though in a different style.[18] The extended-
arm motif may have had a source even closer to *Guernica,* for a sculpture
by Picasso dating from 1933 of a female figure holding a classical vase
was in 1937 placed in the garden of the Spanish pavilion only a few me-
ters from the space Picasso's as yet unpainted mural was to occupy
(5.31). Just before his death two bronze casts of this figure, greater than
life size, with its commanding gesture, were made. One of them was
stored in the basement of Picasso's villa in Mougins; it bore a statement
signed by the artist himself, declaring that "this sculpture belongs to the
Spanish Republican government."[19] The other one, almost certainly in
accordance with Picasso's wishes, was set up over his tomb in Vauvenar-
gues upon his death (5.32). Today the *Woman with a Vase* is once again
installed together with *Guernica*—this time in the Museo del Prado in
Madrid and this time permanently. Complex associations flow from these
works of art, reinforcing the meaning of *Guernica,* expanding it, and ex-
pressing Picasso's deep feeling for his countrymen and for the Republic.
The outstretched arm itself became an important motif in the concept for
Guernica from the first day to the completion of the painting.

5.32 *Woman with a Vase,*
1933. Bronze. 7'2$\frac{1}{2}$" high
(2.2 m). Erected on Picasso's
tomb in the garden of his châ-
teau at Vauvenargues. S. 135.

5.33 *Nude,* 30 July 1932.
Pencil. 9½″ × 14⅞″ (24.5 × 37
cm). Z VII, 397.

The strong influence of the face and figure of Marie-Thérèse, felt throughout Picasso's work for at least the preceding five years (5.33), now is evident in both the artist and model of 18–19 April. Further, the face of the artist in *The Studio V* (5.34) and in the final pen drawing of the same series (see 5.38) bears the characteristic upturned crescents forming Marie-Thérèse's eyelids.[20] Thus in this first conception of his monumental mural for the foyer of the pavilion of the Spanish Republic, Picasso's thoughts and the images he drew were not of civil war but of his intimate life, his workplace and his woman.

Indeed, as Picasso moved into the series, he began to pay increasing attention to the model. In *The Studio V* she appeared twice in the same drawing. Then, in *The Studio VI* (5.35), he discarded all surrounding elements and focused with a terrible ferocity directly on the model. He scattered her dissected nose, hand, an eye, and a nipple at random over the left side of the sheet. He drew the model herself, again twice, in the same pose as in the previous drawings but in far more detail. Until now the nude models had been marked by an erotic sensuousness; here that is overshadowed by an ambiguous, as yet unnamed, threat or promise of violence. The skin on the upper figure appears to have been lashed, while the lower figure becomes even more contorted, her spine a row of ugly bumps marching down the length of her back and her legs splayed wide apart, displaying her sex, a helpless victim awaiting violation.

But then after completing this highly detailed drawing, Picasso in the final five drawings of 18 April returned to the question of the large composition of the studio, and the model took her place once more on the *canapé,* now only one more accoutrement of the scene. In this whole series of brief sketches *The Studio VI* stands out for its sense of violence.

In seeking an explanation, we note that this brutal treatment of the model has been seen several times before. When in 1935 Marie-Thérèse delivered their baby, Maya, Picasso's attitude even toward her, his closest companion, underwent a profound change. For although he made some of the tenderest and most enchanting drawings of his career of his young daughter, a number of the paintings and drawings of Marie-Thérèse at this time cast her as a wooden, even deformed, person, almost an object of repulsion.

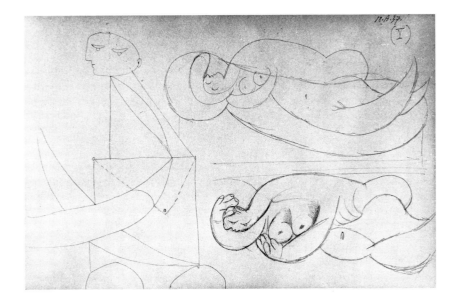

5.34 *The Studio V*, 18 April
1937. Pencil. 7⅛″ × 11″ (18 ×
28 cm). MPP.

5.35 *The Studio VI*, 18 April
1937. Pencil. 7⅛″ × 11″ (18 ×
28 cm). MPP.

Now, in the latter part of April 1937, Picasso, beginning work at last on the long overdue mural project, paused in the midst of his musings on the compositional form the mural was to take and turned to the model. In treating her so violently, was he simply going back to a theme he had used when his own desires and fantasies had been thwarted by the reality and commitment of his new child and its mother, or was he—consciously or unconsciously—aware that the theme of artist and model itself was inappropriate for the pavilion representing his besieged homeland? Was this drawing merely an interlude in the series, and did he concentrate on the aspect of violence only through a sense of frustration that he had not yet found a really suitable theme for the mural? Whatever the answer may be, the violence is immutably there and is a harbinger of what he would do two weeks later as he turned his attention to the suffering figures of the horse and mother and child that he would entitle *Guernica*.

However remote the theme of *The Studio* sketches was from the serious purposes of the pavilion, this series of lightly delineated drawings provided important compositional devices and motifs that Picasso used as starting points when he came to lay out *Guernica*—his final theme—on the large canvas. For example, in *The Studio VII* (5.36) the large window on the right (inscribed by Picasso "*fenêtre*") defines a rectangle, frequently seen in earlier studio views as a window or as a painting, that will be occupied by the Spanish house. The electric light overhead (inscribed "*lumière électrique*"), which is a type seen in studio scenes of 1936 (Z VIII, 309), is transformed into the lamp held by the woman leaning from a window; it is probably also the origin of the image of the dazzling sun at the upper center that with the addition of an incandescent bulb resembles an outdoor street lamp. *The Studio VII* also includes a partially opened door with a doorknob in silhouette, a device familiar in major paintings as far back as *The Three Dancers* of 1925 (see 6.23). Ambiguous in meaning—and possibly evasively metaphoric—this motif continued in a number of still lifes that Picasso was creating at the same time and which he continued to paint until he actually began the sketches for the new and final theme for the mural (see 7.23, dated 19 April 1937). Although imaginative writers have been plagued by the meanings of this and other seemingly ambiguous images, it is no more mystifying than many of Picasso's other (very likely intentional) conundrums, such as whether the mural represented day or night, or an interior or exterior space, or all these opposites simultaneously.

In *The Studio VII,* as also in *The Studio VIII,* there is to the right a door and a flight of stairs with a curved railing that is remarkably similar to the actual stairway that led up to Picasso's studio at 7, rue des Grands-Augustins, the studio where *Guernica* was soon to be painted. In the early states of *Guernica,* this spiral stairway was replaced by a ladder from which a woman appears to be falling.

Finally, in *The Studio XI,* a centrally placed triangle, created in part by the rays of a spotlight resting on the floor, frames the artist and her equipment (5.37).[21] The figure of the artist naturally was not included when Picasso laid out his first sketch for *Guernica* on the large canvas, but the triangle remained as a compositional structure, including a sweeping diagonal carried to the lower corner.

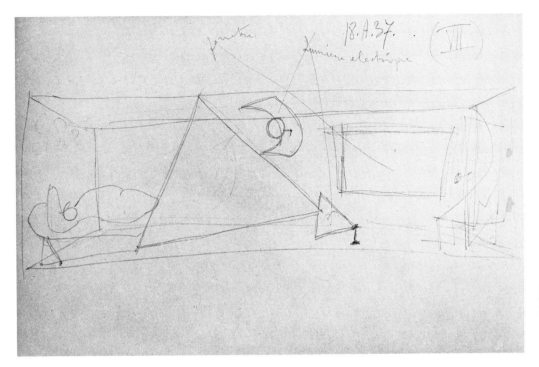

5.36 *The Studio VII*, 18
April 1937. Pencil. 7⅛" × 11"
(18 × 28 cm). MPP.

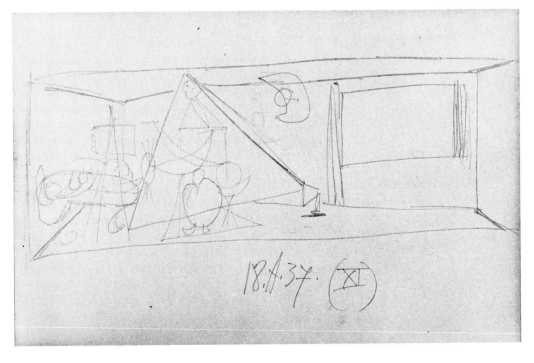

5.37 *The Studio XI*, 18 April
1937. Pencil. 7⅛" × 11" (18 ×
28 cm). MPP.

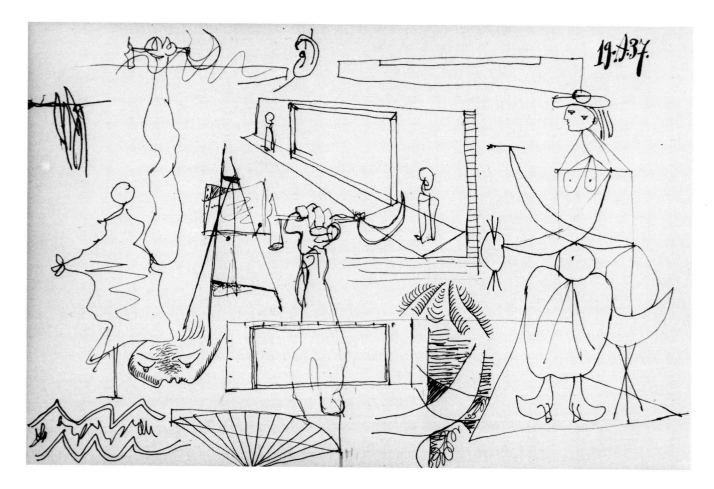

5.38 Sketches for *The Studio*, 19 April 1937. Pen and ink. 7⅛″ × 11″ (18 × 28 cm). MPP.

It may be puzzling indeed that in view of the clearly politicized purpose to which the pavilion of the Spanish Republic was dedicated Picasso could have thought of monumentalizing his private life in his featured mural. Yet most of these pencil sketches suggest that at the time his plan was to devote his great mural to the ivory-tower existence of an artist enamored of his way of life and the charms of his woman. Evidence for the choice of such a theme for the mural indicates that even though he staunchly supported the Loyalists and even though as honorary director of the Prado he was a member of their government, by nature he was unable or unwilling to focus the full power and resources of his art on partisan political issues or on their military aspects. After all, he already had expressed in a manner most vehement, as well as accurate, his extreme repugnance for the prime enemy of the Republic in the *Dream and Lie of Franco,* and these etchings were to be sold as postcards in the pavilion.[22]

On Monday, 19 April, Picasso completed the twelfth and last sketch of *The Studio* series (5.38). It was on the same blue paper as the others but unlike them was drawn in pen and ink, giving it a permanence characteristic of climactic points in his work, although in this case the drawing is a series of notations rather than an organized composition. Within it are a bird's-eye view of the site of the mural and two small renditions of a blank canvas; after extraneous lines are painted out, one of them bears

5.39 Sketch of the final canvas from *The Studio* (det.), with overlapping sketch painted out to show proportions.

5.40 Proposed placement of the final canvas flanked by two sculptures as sketched in *The Studio* (det.).

the exact proportions of the final mural (5.39). This provides convincing evidence that Picasso had decided on this proportion by 19 April; it suggests, moreover, that the project might even have been advanced to the point where the canvas had already been prepared. The other blank canvas is drawn in perspective and, again when stray lines are eliminated, suggests that at this stage Picasso planned to flank the painting with two sculptures, which resemble the cement casts prepared especially for the exhibition after a head and bust of Marie-Thérèse (5.40).[23] I have reconstructed the final studio project as proposed in this last ink drawing with the woman's head (S. 132) to the left and the bust (S. 131) to the right, flanking *The Studio XI,* the last preparatory sketch (5.41). The project remained unrealized, however, for the news of Guernica swept away all thoughts of the studio, and the two female sculptures apparently were then relegated to the gallery of modern art on the top floor (5.42).

New in the pen sketch, the last in the series, are the raised arms with fists clenching a curiously combined hammer and sickle. One overlaps both sketches of the pavilion mural, dwarfing them; the other, to the left of the easel, is attached precariously to a disproportionately small figure. This small figure is drawn after a plaster and wood sculpture by Picasso entitled *The Orator* of 1937 (S. 181), which at this time was still in his studio. It is actually unusually large, measuring 6 feet (1.835 meters) in

5.41 (*right*) Hypothetical arrangement after Picasso's pen drawing (5.40).

5.42 Final location of sculptures in pavilion.

height. Picasso had used this image, almost line for line, the same day in a drawing on the front page of *Paris-Soir,* and with unmistakable intent (5.43). The arm rises up straight through the middle of a headline reporting the speech of Foreign Minister Yvon Delbos, quoting him as advocating France's policy of nonintervention in Spain by saying, "France, in its realistic desire to ensure peace and safeguard security, looks for an understanding with all and neglects no possibility of rapprochement." [24] Delbos was the only member in Léon Blum's cabinet who was cool to aid for the Republic; indeed, he was much influenced by and had worked closely with British Prime Minister Anthony Eden on formulating the policy of nonintervention. His appeasing attitude, strongly at odds with Picasso's defense of the Republic, might well have incited the artist to draw this defiant gesture.

Picasso had last shown a hand raised with a clenched fist, as Sidra Stich has pointed out, in his first preparatory composition (not used) for Rolland's *Quatorze juillet,* a play performed on Bastille Day 1936, the national holiday that in that year had been proclaimed a *fête populaire* by the Popular Front government swept into power in early May (see 6.57). But now, nearly a year later, in April 1937, as if reacting almost automatically to the call for appeasement that he fervently opposed, Picasso scrawled across the headline the long muscular arm firmly grasping the communist symbol.

The arm raised in a fisted salute appears, however, twice more three weeks later on May 9 in a composition study for *Guernica* (see 6.54). One arm projects from a small window of the house on the right; the other rises from the body of a fallen victim. It would be seen again in the first two states of the final canvas, rising from the body of the fallen warrior (see 7.1 and 7.13). Thus it seems possible that Picasso's use of the communist salute in his drawings of April 19 was only a temporary reaction to the words of appeasement by Delbos, one that was not sustained in further images.

The artist and model subject disappeared after 19 April, almost as if Picasso was not satisfied with his progress—after all, there were only minor changes between the first and the twelfth drawings and no appreciable consolidation of the individual images into a comprehensible sub-

ject. Or perhaps he was waiting, hoping that a theme more appropriate for the sober passion of the Republic's cry for sympathy would spring into his mind. In the meantime, indeed up until 1 May, the very day he began the sketches for *Guernica*, he continued to paint several rather conventional still lifes and monstrous but inert nude females on a beach.[25]

But even though the subject of the studio was far removed from the bombing of Guernica, sketches for *The Studio* contributed several important elements to the final version of the mural. The concept of the entire action taking place within a room correctly drawn in perspective was first stated in *The Studio;* the artist and her easel defined the pyramid extending to the corners of the final painting; and the tripartite arrangement of painting and two sculptures in the last sketch of *The Studio* series is reflected in the two female figures—the mother and child to the left and the falling woman to the right—lending a formal, even hierarchical, character to *Guernica*.

All of these are only compositional devices, but reflections of the image of Marie-Thérèse appear in all the states of the painting and in at least two of the four female figures in the final version. Altered only briefly by the model in *The Studio VI,* the role of women in *The Studio* series, serene, quietly sensuous, is transmuted in the *Guernica* studies, in which women are innocent victims of indiscriminate violence. In perhaps one of the greatest transformations in his art Picasso turned his gaze and directed his images away from his studio, focusing all his power on the suffering of his fellow Spaniards. This transformation perhaps has less to do with the physical metamorphosis of elements from *The Studio,* clear as that may be, than with the sense that the transformed images themselves had a mitigating effect on the final expression of the violence so cruelly unleashed by the bombings. For these elements do not come together merely in a scene of war, a traditional picture of a battle, or a propaganda statement; instead they invoke, with overwhelming compassion and devastating and mordant imagery, a universal experience of anguish and torment. Imbued as it is with all the power and force of Picasso's expression, *Guernica* has endured for more than half a century as a beacon against violence, the cry of all humanity for peace and justice.

Stich has aptly described Picasso's political position as a "commitment to the creation of art which is politically informed but not doctrinaire; to art which is reality-based but imaginatively elaborated."[26] Thus it was not so much the politics of the Spanish Civil War that shook him loose from his studio and his models as the very real human tragedy of the terror and suffering at Guernica.

5.43 Clenched fist grasping hammer and sickle, superimposed over argument in *Paris-Soir,* 19 April 1937, for nonintervention in Spain. Pencil.

SIX DAYS

TO GUERNICA

The First Day: Sketches 1 to 6

When on Saturday, 1 May 1937, Picasso finally began the sketches for the mural, he had allowed almost four months to elapse since being asked to contribute a painting to the Spanish pavilion. Only twenty-four days remained before the scheduled opening of the World's Fair on 24 May—hardly enough time to complete a 25½-foot painting (7.75 meters), even if it were already clearly in mind.[1] If this imminent deadline did not impose a sense of urgency on Picasso, the news from Spain did.

His first sketch in response to the bombing of Guernica came only after the terrible stories of human suffering had dominated the headlines for three full days and had preoccupied the radio reports for four (6.1, Pl. 1).[2] On the fourth day, 30 April, photographs of the stricken town were published for the first time. Whether the visual impact of the smoking rubble, shattered walls, and victims finally compelled him to begin, we cannot say. As his first sketches clearly show, however, to illustrate the destruction was not his aim: scenes of the war are noticeably absent. Not the war but the bullfight—a theme of great importance in his life and art since childhood—was the first image that came to his mind.

In sketch 1, in the most cursory fashion, like an elusive thought, Picasso represented both the bull and the horse in characteristic roles. Corresponding to the generally idolizing Spanish view of the *toro de lidia*, the fighting bull, the triumphant animal stands proudly erect. The horse, in contrast, lies on its back, one leg extended stiffly in the air and its limp neck outstretched. It is that moment when the ritual of the *corrida* has broken down and raw, brutal violence dominates, providing a vehicle in which the violence of war could be subsumed in the bullfight.

In this first study for the painting, Picasso removes the scene even further from the bombing and into personal areas of meaning with what appears to be a bird alighting on the back of the bull and a woman, lamp held in outstretched hand, leaning urgently out of a window. Her familiar gesture recalls the theme of intense patriotic fervor related to both the artist's gesture and the clenched-fist salute with hammer and sickle in *The Studio* series of eleven days earlier. Meyer Schapiro has also noted the re-

6.1 Sketch 1. *Composition Study*, 1 May 1937 (I). Pencil. 8¼″ × 10⅝″ (21 × 27 cm).

lation between the outstretched arm and Rude's sculpture *La Marseillaise* and Delacroix's painting *Liberty on the Barricades*,[3] but Picasso's own sculpture *Woman with a Vase* (see 5.31), completed in 1933 and exhibited with *Guernica* in the Spanish pavilion, is another possible source.

It was no coincidence that for his first concept of the mural Picasso chose the only moment in the bullfight when there are no victors, just victims. The selection of this minor but poignant event as the starting point for what was to become *Guernica* strongly indicates that rather than attempt to re-create a disastrous event he had not even witnessed, he was searching for a motif of personal significance that would convey the intensity of his feelings about it. The violence of the bull-horse struggle is an excellent visual analogue of the agony of the human victims of Guernica as well as that of the Spanish people, divided and locked in a suicidal civil war while reeling under the assaults of foreign invaders.

The posture of the dead horse in sketch 1 had already appeared in a drawing, sometimes called *Minotaur and His Family*, dated 5 April 1936: a horse, one rear leg upright, is lying supine in a cart being drawn by the Minotaur, her body torn open to reveal a tiny foal (6.2). Picasso made this drawing—followed by a painting the next day—shortly after he, Marie-Thérèse, and their seven-month-old daughter had fled Paris for the seclusion of the Côte d'Azur. During this period, according to Françoise

6.7 (*above*) Marie-Thérèse Walter, 4 February 1931. Pencil.

6.8 (*right*) Photograph of Picasso (1931) with painting depicting Marie-Thérèse twice.

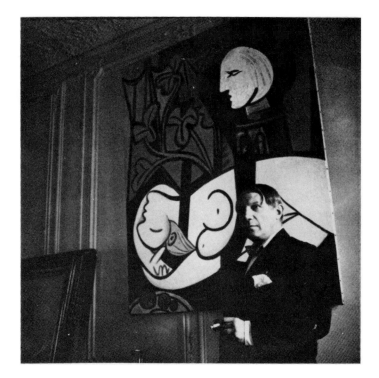

When this most familiar face in all of Picasso's art emerges in this sketch, its close resemblance to Marie-Thérèse's becomes clear. His art, almost anticipating her entry into his life, had included similar classical profiles since the 1920s, especially in the etching series after ancient Greek myths. In the meantime, Marie-Thérèse, who possessed such features, had come into his life in 1927; her distinctive profile and voluptuous body became more and more evident until they finally dominated his art (6.7, 6.8).

An outstretched arm frequently adds a graceful accompaniment to the noble profile. It can suggest compassion, as conveyed by a beautiful observer's gesture toward a dying Minotaur (6.9), or beneficence, as conveyed by the extended hand holding a candle toward the animals struggling in the arena (6.10). The extended-arm motif also appears several times as the gesture of the oath of the Athenian women in the etching series of 1934 illustrating *Lysistrata* (6.11), and it appears again shortly afterward in several charming drawings of Marie-Thérèse wearing a classical helmet and holding a spear, as if she were playing the peacekeeping role of Lysistrata.

Picasso has often shown his predilection for the transformation of images, and as if to emphasize the stages of change in the present series, he not only dated the sketches but also numbered them day by day. Thus we can re-create with remarkable accuracy the first appearance of an image, its metamorphosis, and sometimes its disappearance. We can also study Picasso's manipulation of forms by observing the ways in which individual images are made to coalesce into a total structure. While this process achieves a more coherent visual fabric, it frequently engenders unexpectedly changing meanings.[5]

6.9 *Dying Minotaur*, 30 May 1933. Etching. $7\frac{5}{8}'' \times 10\frac{7}{16}''$ (19.6 × 26.8 cm). G. 366.

6.10 (*above*) Woman with candle (det.), 24 July 1934. Pen and ink. Z VIII, 215.

6.11 (*right*) *Lysistrata*, 15 January 1934. Etching and aquatint. $8\frac{5}{8}'' \times 6''$ (22 × 15.3 cm). G. 387.

6.12 (*right*) Sketch 2. *Composition Studies,* 1 May 1937 (II). Pencil. 8¼″ × 10⅝″ (21 × 27 cm).

6.13 Sketch for backdrop of ballet *Parade,* 1917. Watercolor. 15⅜″ × 10¾″ (39.5 × 27.5 cm). Z II², 950.

Sketch 2 consists of two composition studies based on sketch 1 (6.12, Pl. 2). An important transformation has taken place: the bird with flapping wings on the bull's back has been replaced by a tiny, precisely drawn winged horse seated on a kind of saddle. The winged horse immediately suggests to some writers the mythological beast Pegasus, symbol of poetic inspiration, notwithstanding the absence of anything else in the scene to encourage an allegorical interpretation. More to the point, the histrionic poses of both bull and small horse, as well as the harness on the bull, evoke a circus, as in the scene—including a winged bareback rider—in the curtain for the ballet *Parade* of 1917 (6.13). Since early youth, Picasso had been fascinated by the circus and its performing animals. Furthermore, as Richard H. Axsom has demonstrated, it was common for circus horses to wear wings; in the illustrations he uses, the horses do indeed appear to be flying.[6]

Later the same day in sketch 6 (see 6.17), the tiny horse undergoes another radical transformation, emerging on the wing from a slit in the horse's belly; it then disappears from the sketches forever. This sequence of transformation and disappearance does not suggest the characteristic behavior of this complex ancient symbol but indicates instead that neither bird nor horse was essential to Picasso's tragic theme, thus discrediting the allegorical interpretations.

Although a different bird appears on a table behind the bull's head in the final painting, its presence clearly was not motivated by a need for allegory; quite mundanely, its form was suggested by a white remnant of the repainted bull's neck left over when his body was turned from right to left (compare states III and IV, 7.20 and 7.21). The final denial of an alle-

6.14 Sketch 3. *Composition Study*, 1 May 1937 (III). Pencil. 8¼″ × 10⅜″ (21 × 27 cm).

gorical intent is provided by Picasso's statement to Alfred H. Barr, Jr., in 1947: "There's a sort of bird, too, a chicken or a pigeon, I don't remember now what it is, on a table."[7]

While the miniature horse, tried and rejected, represented an aberration, the horse as protagonist and companion in the dramatic action with the bull is submitted to constant manipulation and transformation. As though it were a human female and the subject of Picasso's passions, its malleable body is elongated, compressed, twisted, and bent. In sketch 2, it is conceived as rigid and metallic. This quasi-abstract horse, repeated in the upper left-hand corner of sketch 3 (6.14, Pl. 3), establishes the style and posture of all but a very few of the later representations of the wounded animal—including the one in the final painting. A curious rectangle is drawn over the horse's abdomen, interpreted by one writer, without further evidence, as the bomb bay of the plane that bombed Guernica. Actual photographs of the planes that engaged in the attack hardly lend credence to this theory. Moreover, Picasso had never seen the planes, nor, I believe, would it have occurred to him to be interested in the details of what they looked like.

On the same small sheet of blue paper, Picasso varied his imagery by depicting several four-legged creatures, fantastic rather than abstract in form, resembling the monstrous polyplike beast associated with Franco in the *Dream and Lie of Franco* etchings (see 1.9). One has the podlike body of an insect, another the spilled entrails of a disemboweled horse, still another only an abstract schematic body and head. Picasso is clearly directing his vast stylistic artillery, already loaded with images of agony, at his favorite target.

6.15 (*above, top*) Sketch 4.
Horse, 1 May 1937 (IV). Pen-
cil. 8¼″ × 10½″ (21 × 26.9 cm).

6.16 Sketch 5. *Horse*, 1 May
1937 (5). Pencil. 8¼″ × 10½″
(21 × 26.8 cm).

Far from having depleted his repertoire of transformations of horse anatomy, Picasso interrupts the sequence and in sketch 4 turns to a primitivistically rudimentary drawing that might well be taken for child's play (6.15, Pl. 4). Only the subtlety in the use of two dots for the eyes and of two circles and a line for the nostrils and mouth, which we have seen many times before in Picasso's drawings, tells us that when this artist chooses to be "childlike" he does so with consummate sophistication and skill.

The highly realistic sketch 5 further demonstrates his enormous stylistic range (6.16, Pl. 5). Composed of loose lines like the first drawings, this one strives to represent an actual horse of flesh, blood, and bones, and it admirably depicts physical agony through the straining muscles and awkwardly collapsing body. As Rudolf Arnheim has observed, one rear leg is already inert, while the others poignantly demonstrate different stages in an effort to maintain solid footing.[8] One foreleg succeeds in keeping upright only by being held awkwardly rigid. The stiffly held limbs and leaden body contrast dynamically with the tensely arching neck and upraised, screaming head. In this series of horses—all of them wounded, just as they often are in the bullfight—Picasso has explored and exploited many aspects of physical suffering. He has also demonstrated his ability to use a wide range of different stylistic and formal devices to embody the powerful emotions evoked by the tragedy in the arena. This drawing is perhaps the most intensely expressionist of all the sketches, but it is still only one stage in the constant metamorphosis of the horse imagery toward a form that will richly realize its emotional possibilities and at the same time function as a part of the whole composition.

Although the idea of suffering probably had its immediate source in the headlines and photographs of the victims of the bombing of Guernica, imagery powerful enough to convey it existed already within Picasso's own art. The motif most appropriate to embody this tragic epic of suffering was therefore to be found not in modern warfare, even if it was at this moment engulfing Picasso's homeland, but in that part of his culture with the power to arouse the greatest emotion—the Spanish bullfight with all its implications of pain and death.

By the end of the first day of work, Picasso had performed a most remarkable feat: in a few hours he had formulated the basic conception of *Guernica*. The sixth and last sketch of 1 May brought together all the elements developed so far (6.17, Pl. 6). The heroic bull towering over the scene of chaos, the agonized horse writhing on the ground and screaming toward the sky, and the female observer surveying the carnage—all were to remain an integral part of the final painting, five or six intervening weeks of continual change notwithstanding.

In sharp contrast to the improvised nature of the first five sketches made on small pieces of blue notepaper, sketch 6 has been accurately drawn in pencil and carefully composed within a rectangle. Following a tradition established centuries ago for important paintings, Picasso prepared a wooden panel 25½ inches wide (65 centimeters) with a hard white gesso ground as if he were now ready to execute the final version of *Guernica*. This image of the first day persisted throughout all the succeeding stages and became essentially the concept of the final painting more than five weeks later. As he said to Christian Zervos in 1935: "Basically a picture doesn't change; the first vision remains almost intact."[9]

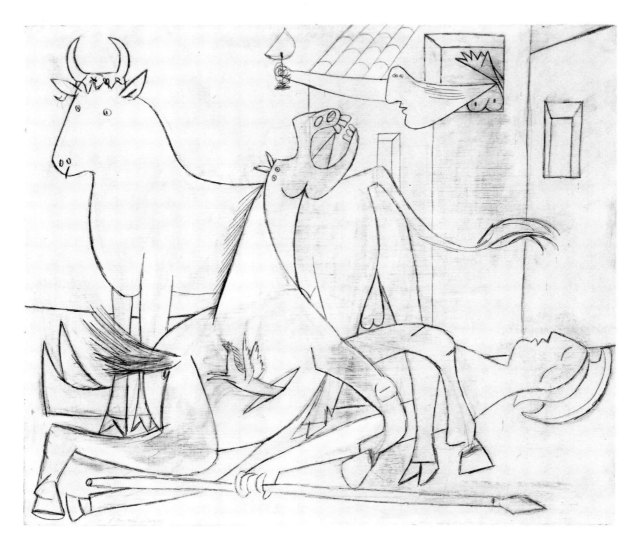

This composition represents Picasso's first attempt to gather his images into a unified theme. He also introduces a new actor into the drama: the supine figure of a fallen warrior who still grasps a spear, a figure so large it extends across the entire panel, providing a base for the pyramid formed by the upraised neck and head of the horse. The addition of this personage complicates more than just the composition, for it creates a triumvirate of bull, horse, and human being analogous to that of the first act of the bullfight just after the mounted picador has incited the bull to charge the horse (see 5.9). This episode, by introducing a human being into the bull-horse encounter, also opens up the possibility of a male-female conflict, like the one featured in the etchings and drawings of 1933 to 1936.

Picasso was closely associated with the Russian ballet troupe from about 1917 to 1925, profiting by making many graceful line drawings of the dancers (6.18). When in 1919 he was made responsible for designing the setting and costumes for *The Three-cornered Hat* (*Le tricorne*), he determined on a bullfight theme for the curtain, for which he made many

6.17 Sketch 6. *Composition Study*, 1 May 1937. Pencil. 21⅛″ × 25½″ (53.7 × 64.8 cm).

6.18 (*above, top*) *Four Ballet Dancers*, 1925. Ink. 13⅞″ × 10″ (35.3 × 25.5 cm). Z V, 422. MOMA. Gift of Abby Aldrich Rockefeller.

6.19 Sketch for curtain of ballet *Three-cornered Hat*, 1919. Pencil. 11¾″ × 9″ (30 × 23 cm). Z III, 308.

sketches of elegant toreros in the arena. The ballet was thoroughly Spanish, with a musical score by Manuel de Falla based on flamenco dances, and included spectacular dancing by Picasso's friend Léonide Massine. Although the ballet itself had nothing to do with the bullfight, he chose for his curtain design the bull-horse-human triangle, choreographed, so to speak, in a harmonious ensemble reflective more of the graceful and rhythmic movements of the dancers than of the mortal struggle of the beings in the arena (6.19).

Returning to this theme about a decade after *The Three-cornered Hat*, Picasso endowed it with a different significance. His pleasant associations with ballet dancers were far behind him; now the bitter tensions of his domestic life tormented him. By 1934, the scene in the arena has become a furious and bloody battle between bull and horse, both now acting and even looking like human beings. And the picador, a relatively neutral participant, has been transformed into a beautiful blonde girl whose serene countenance and voluptuous nude body recall Marie-Thérèse as she was portrayed in so much of Picasso's art of these years. The gentle mien and indolence of the supine figure offer a pleasant respite from the hateful clash of the two animals (see 6.25).

In a series of drawings from July 1934, the theme of conflict reaches a pitch of such menacing violence that it is transposed from the arena to a domestic interior—usually for Picasso the setting for passive and pleasurable activities. On 10 July his gentle blonde companion is viciously attacked by a brunette woman wielding a kitchen knife (6.20). The latter's face, distorted by rage and hate, resembles, in a somewhat abstracted form, one that reappears later in sketch 32 for *Guernica* (see Pl. 32). Her spearlike tongue, a characteristic of the weeping-woman sketches, appears twice in the final painting, perhaps significantly in the images of both the horse and the woman. The unknown assailant has been seen before. In a series of thirteen drawings of early February 1934, a similar figure is shown writhing on a bed like a gored horse in the arena (6.21). As the series progresses, her agonized body degenerates into a surrealist collection of objects until finally all that remains is the spearlike tongue, a snaggle-toothed mouth, and a vulva. By contrast, Marie-Thérèse appears about the same time in a series of drawings (30 April and 1 May 1934) in a wholly different style, as sensuously erotic as she had ever been in the paintings of 1932 and 1933 (6.22).

An ink drawing of a similar knife attack dated 7 July (sometimes erroneously called *The Death of Marat*) portrays a supine blonde woman—whose classical profile closely resembles that of Marie-Thérèse—being attacked by a ferocious, screaming woman.[10] The latter image appears frequently enough to warrant the hypothesis that she is suggested by someone in Picasso's life, probably his vindictive wife, Olga. By 1934 it was commonly known that Marie-Thérèse, not Olga, was the object of Picasso's affections and that he was frequently with her in the apartment he had provided for her just across the street from the Picasso family dwelling on rue la Boétie. Several years later, Françoise Gilot vividly described her own experiences as the victim of Olga's jealousy. On one occasion the outraged wife taunted her and Picasso as they lay together on the beach at Juan-les-Pins, intentionally treading on Françoise's fingers with her high-heeled shoes.[11]

Could it be that the rejected wife, or at least the fury she directed at Picasso, also contributed to the tension and power of the sketches that finally evolved into *Guernica*? It would not be surprising if that were so,

6.20 (*above, left*) Ferocious woman attacking with knife, 10 July 1934. Ink. 13½″ × 19¾″ (34.5 × 50.5 cm). Z VIII, 222.

6.21 (*above, right*) Ferocious woman, 6 February 1934. Ink. 9¾″ × 12½″ (25 × 32 cm). Z VIII, 182.

6.22 Sculptor and model (or sculpture?), 1 May 1934. Charcoal. 10⅞″ × 10½″ (28 × 27 cm). Z VIII, 207.

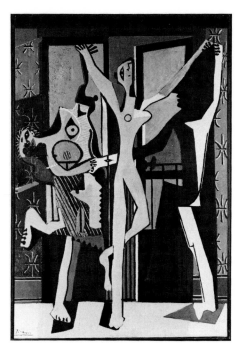

6.23 (*above*) *The Three Dancers*, 1925. Oil. 84⅝″ × 55⅞″ (2.15 × 1.42 m). Z V, 426. The Tate Gallery, London.

6.24 *Femme Torero II*, 20 June 1934. Etching. 11⅝″ × 9¼″ (29.7 × 23.6 cm). G. 426.

for the features of both Marie-Thérèse and Dora are recognizable in many of the sketches, and the strain in Picasso and Olga's marriage had had other effects on his art for at least ten years. Compare, for example, one of the first of his idyllic views of elegant ballet dancers in a drawing of 1925 (see 6.18) with what is believed to be the last painting he made of dancers in Monte Carlo, a tormented trio, also of 1925, entitled *The Three Dancers* but evoking the agony of a crucifixion (6.23).

The knife attacks as well as the most furious struggles between humanized animals occur about the middle of July 1934. In the midst of these depictions falls an important date, 12 July, which Olga observed with all the conventional ceremonies but which was only of casual interest to Picasso—their wedding anniversary. It was, in fact, on this very date a year later that she left Picasso, for on 13 July 1935 Picasso wrote to Sabartés that he was now alone.[12]

The series of etchings called *Femme Torero* from late June 1934 can now be viewed as portraying three characters—derived from the bull, horse, and fallen picador figure groups of the 1920s—juxtaposed in an emotionally charged personal triangle. The Marie-Thérèse figure at its most seductive is carried away on the back of the bull (6.24). A few days later, still as the gentle sleeper, she lies supine beneath the two animals

6.25 *Femme Torero III, 22 June 1934.* Etching. $9\frac{3}{8}'' \times 11\frac{3}{4}''$ (24×30 cm). G. 427. Collection of the author.

6.26 (*below, top*) Sketch 6 (det.). Fallen woman.

6.27 (*below, bottom*) Photograph of bombing victims.

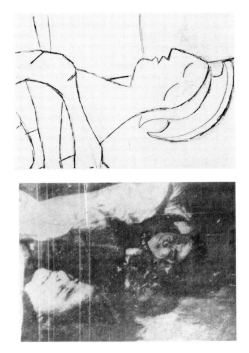

(6.25), her position that of the victim who was to appear three years later in sketch 6 for *Guernica* (6.26). It also corresponds to the position of the victims in the first photograph that accompanied the news of the bombing of Guernica on 28 April, published in *L'Humanité* three days before Picasso was inspired to begin the sketches for the painting (6.27).

The personae of this murderous drama of 1934—like a tragedy by Lorca—make up the characters, and even the composition, of sketch 6 of 1 May 1937, Picasso's first version of the central figure group of *Guernica.* This grouping persists throughout the sketches to become the central image of the final version of the painting.

The Second Day: Sketches 7 to 11

On the second day of work, Sunday, 2 May, Picasso concentrated solely on the horse's head, devoting the next three sketches to solidifying its form and intensifying its expressiveness. In so doing, he turned away from the concept of the composition as a whole and concentrated on this, one of his favorite images, to see, as Arnheim notes, whether it could serve as the

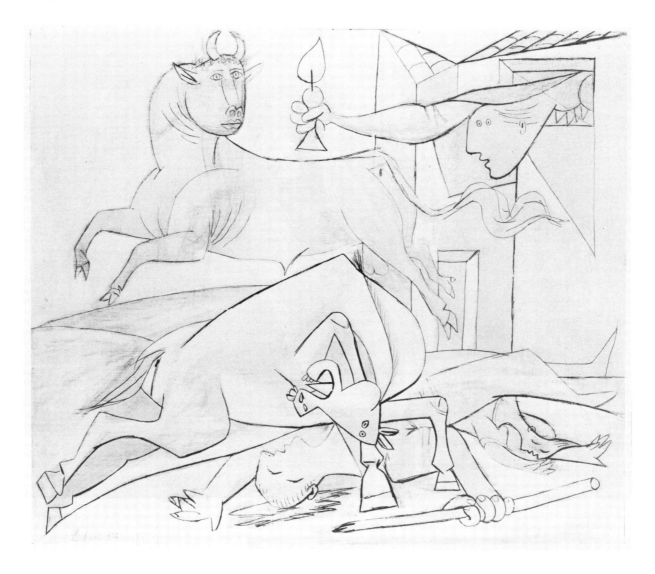

6.32 Sketch 10. *Composition Study*, 2 May 1937. Pencil and gouache on gesso on wood. 23⅝″ × 28¾″ (60 × 73 cm).

After the climax of the series of horses' heads, no doubt at the end of the day, the artist readdressed the problem of composition. Sketch 10 of 2 May, like sketch 6, which had been made at the end of the previous day, is a large composition study carefully drawn in pencil on a wooden panel prepared with a gesso ground (6.32, Pl. 10). Unlike the earlier, slightly smaller, sketch, this one was painted in thin tints of light gray gouache, following the traditional method of laying in numerous thin layers of tempera-based colors. As he selected the traditional technique of painting on a gesso ground—most unusual in this age—Picasso was, of course, aware that it was one of the most permanent techniques known.

In sketch 6, the uniform lines outlining closed areas resulted in a static composition devoid of the excitement of the *corrida*. Sketch 10, by contrast, is all action. The bull leaps lightly into the air, his back arched and head thrown upward. In contraposition, the body of the writhing horse strains downward, at an angle so acute as to suggest a broken back. Even the woman at the window, now alarmed, vigorously thrusts her lamp toward the upper center of the drawing, where it replaces the horse's head

as the focal point. And the Spanish-style house is more complex and angular, like a detail from an early cubist painting. Consistent with the theme of action, the fallen figures—there are now two—appear more like innocent victims of an unseen violent act than like the warriors fallen in battle depicted on an antique vase. They are flattened and shattered into a confusing pile of arms and legs. One lies in a pool of blood, and although he still grasps a spear, it is bent and broken, and he is without a helmet. The second victim appears to be an unarmed woman. Minus classical appurtenances and rendered by angular, clashing lines, the scene evokes the chaos accompanying a catastrophe, perhaps an accident in the arena or the numbing aftermath of a violent explosion. Even the face of the bull—now more like that of a young man than that of a bull—shows alarm, if not actual terror.

Sketch 11 is the only one Picasso neither dated nor numbered (6.33, Pl. 11). It is drawn in pencil on a small irregular scrap of thin ochre cardboard half the size of the blue sheets—possibly already used as a pattern for some other purpose—that may have been picked up somewhere while the artist was away from the studio and his supply of drawing paper. For the first time he depicts only a bull and horse: they seem to be fiercely opposing each other within the confines of the irregular shape of the cardboard. The drawing style, different from that of the other more or less naturalistic sketches, is curvilinear and stylized; it approaches a rhythmic semiabstraction suggestive of the linear tensions of Romanesque manuscript illustration. If this difference of style justifies a search for external influences, they are close at hand.

Picasso had greatly admired the new museum of Catalan art in Barcelona during a visit in the summer of 1934. It contained magnificent frescoes, manuscripts, and sculptures, mostly dating from Romanesque times. He was quoted at the time as greatly praising the "strength, intensity, and sureness of vision" of medieval Catalan art.[14] Many objects from this collection were part of an exhibition that opened in Paris at the Jeu de Paume in March 1937. Significantly, Picasso was one of its organizers, having accepted an invitation to serve on the French committee of the joint Catalan-French project to present medieval Catalan art in Paris as part of the 1937 World's Fair.[15] Since many distinguished French scholars and officials and many of Picasso's friends, such as Sert and Pablo Casals, were also involved, it is reasonable to assume that by May he was familiar with the works in the exhibition.

The show and a book by Zervos published at the same time included several Romanesque illustrated manuscripts portraying fantastic animals in a rhythmic, tense curvilinear style similar to Picasso's in sketch 11: for example, the writing dragon in the altarpiece from the church of Soriguerola (6.34),[16] the demons in the purgatory scene from the same altarpiece,[17] the fantastic animals in the scene of the apocalypse from the tapestry in the Gerona Cathedral (6.35),[18] the seven-eyed lamb of God in the fresco from San Climente de Tahüll,[19] and possibly even *The Deluge* from the Abbey of St. Sever (6.36), preserved in the Bibliothèque Nationale.

Since Picasso was known to be fervently interested in this art and now had many opportunities to study original works as well as the book by his friend Zervos, there is every reason to expect that certain of its characteristics would emerge in his own work in progress at the time. Could the undated, unnumbered scrap of cardboard have been picked up some-

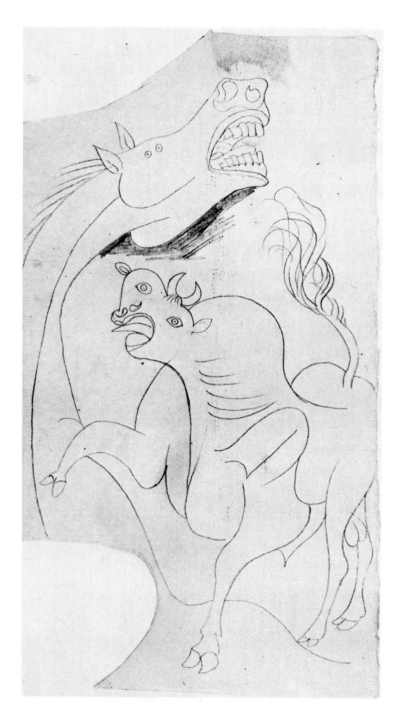

6.33 Sketch 11. *Horse and Bull*, not dated. Pencil on ochre cardboard. 8⅞″ × 4¾″ (22.6 × 12.1 cm).

6.34 (*top*) Angel killing dragon. Altarpiece from Soriguerola (det.), 10th–11th century. Painting.

6.35 Fantastic animals. The Apocalypse Tapestry (det.), 10th–11th century. Gerona Cathedral.

6.36 *The Deluge,* mid 11th century. Abbey of St. Sever. Manuscript page.

where—even while the show was being prepared in the Jeu de Paume—to record a spontaneous impression of the bullfight theme then dominating his imagination, but in a style inflected by the art he was seeing in the museum?

After only two days of work, Picasso had clearly visualized three of his most important actors much as they were to appear in the final painting. They were the triumphant bull, the suffering horse, and the female observer holding a lamp. None of these images was in any way derived from, or even related to, the catastrophe in the Basque town that had stimulated him to begin this work. All three were already well known in his art, and all three had strong emotional associations with his intimate life. Having in this short time laid out two large compositions of the entire concept, made a finished full-scale painting in oil of the horse's head, and clearly formulated a vision of *Guernica* much as it was finally to be, Picasso abandoned work for the rest of the week.

The Third Day: Sketches 12 and 13

Only on the following Saturday, 8 May, did Picasso resume work on sketch 12, his third composition study (6.37, Pl. 12).[20] Beginning about this time, the gradual elongation of the composition, including the choice of a larger size of paper, which he used in a horizontal position, may possibly have been influenced by a visit to the Spanish pavilion while it was under construction. Sert has stated that Picasso was interested in the prefabricated structure and the proportions of the horizontal space assigned to him even before he had chosen the subject for the mural.[21] At any rate, the proportions of the white paper he had now chosen were in a ratio of 1:1.9, almost as long as the proportions of the final canvas he was preparing, which were 1:2.2 (see 5.39 and 5.40, of 19 April 1937, showing the proportions of the yet unpainted canvas).

Composition sketch 12, although incomplete compared with composition sketches 6 and 10, suggests that Picasso held in mind that the painting would be part of a flat wall in an architectural setting. Both the bull and the simplified building in the background have been elongated horizontally and flattened like a screen in a stage set to form a wall behind the chaotic pile of victims' bodies in the foreground.

A new, much more poignant, image appears here to the right: a frightened mother crawling on hands and knees, carrying the limp body of a dead child. She cries out toward the sky, head upturned and neck painfully strained, as she drags herself into the picture. Two different images of female victims in the final painting were to develop out of this study: the mother and dead child to the left and the fleeing woman to the right.

The postures of these figures have also been seen before in Picasso's art. Late in 1932 and in 1933, he made a series of drawings—all entitled

6.37 Sketch 12. *Composition Study,* 8 May 1937 (I). Pencil. 9½" × 17⅞" (24.1 × 45.4 cm).

Le sauvetage—depicting scenes, initially at the beach and later by a swimming pool, in which a woman has apparently been rescued from drowning. In one drawing two nude women appear, one as the rescuer, the other as the rescued. In another, the rescuer is transformed into a bearded man who resembles the sculptor-king featured in the etching series *The Sculptor's Studio* of 1933. But in all the drawings the rescued—and even sometimes the rescuer—calls to mind the familiar profile and pliant body of Marie-Thérèse. Thus, elsewhere there are even suggestions of Picasso and his model, who is seen in a familiar posture, as rescuer and rescued. This possibility is strengthened when the posture of the two figures evolves into an embrace. The backward-turned head of the rescued woman is repeated in later works (6.38) and reflects the inverted head of the dead child in the sketches and in the final painting (6.39).

The image of the anguished mother now becomes as compelling to Picasso as the image of the suffering horse had been a week earlier. Both are the focus of his attention in sketch 13, which contains enlarged and

6.38 Minotaur and women, March 1937. Ink. $8\frac{3}{4}'' \times 10\frac{3}{8}''$ (22.4 × 26.5 cm). Z IX, 97.

6.39 *Guernica* (det.). Mother with dead child.

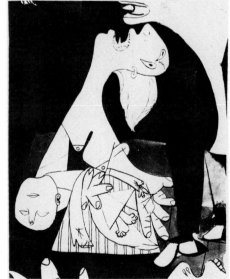

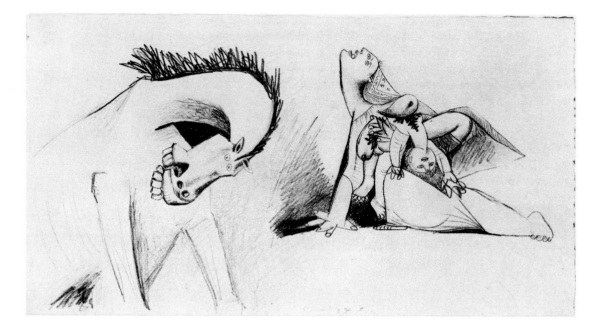

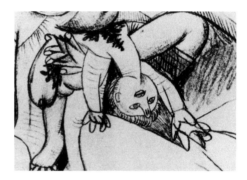

6.40 (*top of page*) Sketch 13.
*Horse and Mother with Dead
Child,* 8 May 1937 (II). Pencil.
9½" × 17⅞" (24.1 × 45.4 cm).

6.41 Sketch 13 (det.).

intensified drawings of both these tragic victims (6.40, Pl. 13). The pathos of the mother and child is dramatized by the blood staining the child's body and flowing through the mother's clenched fingers and down her breast (6.41). The mother attempts to rise while clutching the inert body of the child, whose arms dangle helplessly, eyes stare vacantly, and mouth gapes open in death. His head is inverted, his face carefully drawn to include the wrenching detail of the underside of his nostrils, a gripping motif seen as far back as the drawings for the *Crucifixion* of 1930 (6.42). Goya's many victims in *The Disasters of War* are depicted often in equally poignant postures (6.43).

The protesting, upturned face of the mother constitutes a contraposto to the downturned head of the horse—differing reactions to the same catastrophe. Both the mother and the horse appear again and again in later sketches that develop the themes of physical agony and grief. The frequent similarities in their postures create an analogy, supported by Picasso's statements to Juan Larrea, Françoise Gilot, and others, between the horse and the women in his life.[22]

The mother fleeing with her dead child is the first in the series to reflect the events of the war directly. This image may well have been inspired by the many newspaper photographs and stories of refugee women and children that had appeared during the previous week. From Monday to Sunday, 3 to 9 May, the news from the Basque war front had become even more ominous. With the crumbling of Basque resistance, in large part caused by the shock of Guernica, the news from the front turned from the military aspects of the war to the plight of the refugees. A great wave of sympathy for the victims arose in Paris: support for them became the subject of a campaign for aid of all kinds and one of the themes of the May Day manifestations. After the bombing of Guernica, French and British ships had begun evacuating women and children from Bilbao. It

6.42 Sketch for *Crucifixion* (det.), 26 May 1929. Pencil. Z VII, 280.

6.43 Goya, *The Disasters of War*, no. 50 (det.), 1816. Etching and aquatint.

6.44 (*below*) Refugees fleeing bombardment.

was clear that the Basques could not hold out much longer, and the refugees who doubled the population of Bilbao faced not only frequent bombings but also starvation.

Graphic eyewitness accounts of the suffering borne by the people of Guernica during the attack had appeared on 3 May in *Le Figaro* and on 5 May in *L'Humanité,* whose front-page report was accompanied by the first photographs of refugees fleeing Guernica (see 4.3). On 8 May both the weekly picture magazine *L'Illustration* and *Paris-Soir* published full pages of photographs of the suffering victims and the destruction wrought on the town. Nearly every day for two weeks *L'Humanité* published photographs of the refugees. On 7 May it printed a picture of homeless children; on 9 May both a poignant scene of terror-stricken women, some carrying infants, fleeing down an open road (6.44) and a view of a ship arriving in a French port, its decks crowded with refugee children (6.45). And on 14 May there appeared another photograph of mothers and babies of the Loyalist side who had been freed after being held hostage during the long Nationalist siege of the convent of La Virgen de la Cabeza. In the images of the agonized mother carrying a dead child—sketches 12 and 13 of 8 May—Picasso came the closest to date to visualizing realistically the tragic news from Guernica.

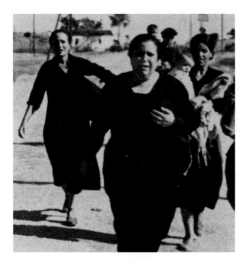

The Fourth Day: Sketches 14 to 16

The momentum Picasso had achieved with the theme of the suffering mother and dead child carried over into the next day, the fourth, when he rendered the sympathetic group in pen and ink. The ragged pen line and the splotches of ink—like blood on the white paper—heighten the pathos

6.45 Basque refugee children arriving in the French port of St. Jean-de-Luz.

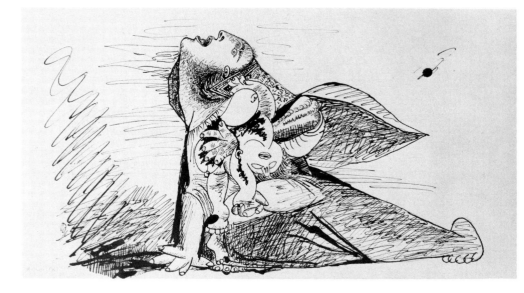

6.46 Sketch 14. *Mother with Dead Child*, 9 May 1937 (I). Ink. 9½″ × 17⅞″ (24.1 × 45.4 cm).

6.47 Sketch 14 (det.).

6.48 Goya, *The Disasters of War*, no. 13 (det.), 1816. Aquatint and etching.

in sketch 14 (6.46, 6.47, Pl. 14). Picasso now isolates the mother and child and, as he had done with the suffering horse, makes these figures more compact and congested, creating an agonized image even more like those depicted in Goya's *Disasters of War* (6.48) and in propaganda photographs and posters of women and children under attack from the air (6.49). In sketch 16 of 9 May he inflicts further torment by suspending the pair precariously on a steep, rickety ladder (6.50, Pl. 16). Whether they are meant to be ascending or descending is difficult to say, but the stricken mass of the mother's awkward body has an inertia that precludes escape in either direction.

The painfully weighty body suspended on a ladder recalls other scenes of extreme suffering in earlier work. The numerous crucifixion studies, especially those of 1930–1931 in which a soldier holds the ladder he used to climb up to spear the crucified Christ, provide an appropriate example (6.51).[23] Ladders associated with scenes of instability and suffering also obsessed Picasso in 1934 and 1935 in *The Blind Minotaur* series. The *Minotauromachy* etching of 1935, which ends this series, depicts a bearded man who resembles the artist depicted in earlier years fleeing the blinded beast-man by climbing a ladder (6.52). In a painting of 6 April 1936, a ladder appears yet again, this time among the Minotaur's pitifully poor possessions, all of which he has thrown into his cart (6.53). Painfully he drags the cart, also laden with a painting and the dead horse with her newborn foal, through the rocky landscape. Thus the ladder had accrued painful associations from several sources.

In the third sketch of 9 May, Picasso continued his procedure of finishing the day's work by gathering his cast of characters in a carefully arranged composition. Sketch 15 was his fourth composition; it is on

¿QUE FAIS-TU POUR
EMPÊCHER CELA?
MADRID

6.50 (*above*) Sketch 16.
*Mother with Dead Child on
Ladder,* 9 May 1937 (II). Pencil. $17\frac{7}{8}'' \times 9\frac{1}{2}''$ (45.4 ×
24.1 cm).

6.49 (*left*) Women and children under air attack, Madrid.
Not dated. Poster. Collection
of the author.

6.51 *Crucifixion,* 1930–
1931. Drawing. Soldier bearing ladder. No dimensions
available. Z VII, 316.

6.52 (*left*) *Minotauromachy* (det.), 1935. Etching. G. 573.

6.53 Minotaur drawing cart bearing dead horse, ladder, and painting, 6 April 1936. Oil. 18⅛″ × 21⅝″ (46.1 × 54.9 cm). Not in Z.

the new longer white sheets he had started using the previous day (6.54, Pl. 15). A much more complex and highly developed composition than the earlier three, it clearly represents a climactic moment in the evolution of the concept of the painting. For the first time he creates a complete environment with a deep, tangible space enveloping the cubelike buildings and the massive volume of the muscular body of the bull. Unlike the earlier compositions, this one is charged with the violence of the bombing attack, for it is packed with solid, vibrant forms activated by sharp angles and flamelike shapes in sharply contrasting blacks and whites. It has something of the appearance of the faceted masses of early cubist paintings, but with far greater intensity and drama.

Although the proud bull with his swelling muscles and the horse with his collapsed and broken body continue to play their *corrida* roles, the addition of the three terrified survivors and the four dead victims has transformed the scene of animals in conflict into a dramatic panorama of human tragedy. For the first time in these sketches there arises a sense of the kind of mass human suffering and destruction pictured in the newspaper photographs. The blinding white illumination is like an explosion or an overwhelming conflagration, and the black night sky throws into sharp silhouette the flames of the burning building. Even the pencil strokes, unlike the firm, clear outlines of the first compositions, are heavy expressionist stabs at the paper (6.55).

The several extended arms with clenched fists in this sketch could create only one association in Paris in May 1937. By this time, the Communist salute had been generally adopted by all factions making up the armed forces of the Republic and by many civilians, even those who opposed the severe Soviet dominance of the military. It was seen, often with the fist clutching a sickle, in films of the war, in photographs in

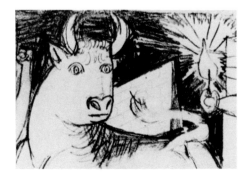

6.54 Sketch 15. *Composition Study*, 9 May 1937 (II). Pencil. $9\frac{1}{2}'' \times 17\frac{7}{8}''$ (24.1 × 45.4 cm).

6.55 Sketch 15 (det.).

L'Humanité, and in propaganda materials and posters circulated by the Spanish embassy (6.56).

A plethora of clenched fists, along with a curiously combined hammer and sickle devised by Picasso, appeared in a pencil sketch of 13 June 1936, made when Picasso was considering participating in a ceremony to celebrate Bastille Day and the first anniversary of the Popular Front in France (6.57). He had been asked to design a curtain for a special performance of Romain Rolland's *Quatorze juillet* on 14 July at the Théâtre du Peuple. As Sidra Stich has convincingly demonstrated, the first theme for the theater curtain sketch might well have been suggested by a photograph on the front page of *L'Humanité* the morning of that same day, 13 June.[24] The photograph was of a crowd of workers who, with fists raised, were celebrating the end of a widespread strike that had resulted in a resounding union victory.

Picasso subsequently rejected this sketch, which actually depicted an attack on the Bastille, and turned back to an earlier work of 28 May that included several images symbolic of and identified with the artist himself. They were a bull in a harlequin costume, a handsome young man with a classical profile, and a bearded mature man similar to images in *The Sculptor's Studio* series of 1933. He therefore rejected both the rather obvious realism of the actual destruction of the Bastille and its equally obvious Communist emblems in favor of personal symbols. This attitude is like that prevailing in *Guernica,* where obvious or banal devices were tried out and discarded in favor of images with personal and multivalent meanings that thereby gain in emotional power. Thus it is not surprising that the clenched fist appeared only in sketch 15 and in the first two states of the final painting, after which it disappeared completely. Picasso had already tried and quickly rejected other commonplace conventional de-

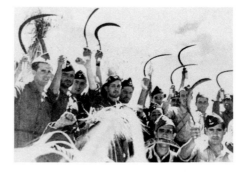

6.56 (*above*) Republican propaganda photograph of militia helping with the harvest.

6.57 First sketch for theater curtain for Romain Rolland's *Quatorze juillet*, 13 June 1936. Pencil. $26\frac{13}{16}'' \times 16\frac{5}{16}''$ (68.1 × 41.4 cm). MPP

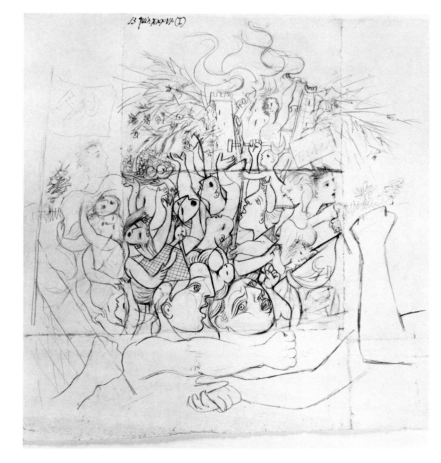

vices for conveying general ideas. The clenched fist, the little horse, and the bird as well as several other fleeting images that in the past may have suggested special meanings ultimately did not survive the artist's fiercely critical sense of what was appropriate to his central idea of the tragedy that had fallen upon the Spanish people.

Despite the generally confused array of bodies in the foreground of sketch 15, the group as a whole seems now to be coalescing into a comprehensible visual idea. The postures of the bull and horse, the building in Mediterranean style, and the cartwheel (often seen in Republican and Anarchist posters but also soon to disappear from the sketches) have appeared in Picasso's earlier work. But the high emotionality and terror shown by all the living creatures and the dramatic contrast of light and dark set this work off distinctly from his other large compositions and point clearly toward the final concept.

The Fifth Day: Sketches 17 to 21

Seemingly impelled by his first complete vision of the final painting in sketch 15, Picasso continued to work, completing five more sketches on Monday, 10 May. This was the first time he had broken his habit of

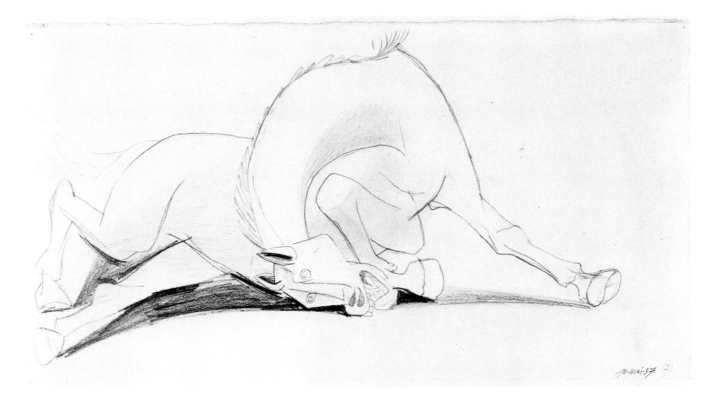

6.58 Sketch 17. *Horse, 10 May 1937* (I). Pencil. 9½″ × 17⅞″ (24.1 × 45.4 cm).

working only on weekends. None of these new sketches, however, dealt with the composition he had just developed; with one exception, all were of individual horses, bulls, or women.

Sketch 17 returns to the familiar motif of the agonized horse (6.58, Pl. 17). Now oriented in the opposite direction from the image in all preceding sketches, it moves from left to right while the neck, coiled like a tight spring, twists in a spiral toward the right and the head—no longer stretching upward—bends to the ground, almost touching the forefoot. (It is wholly unlike the collapsed, inert horse in the bullfight photograph, 6.59.) In sketch 18, Picasso turns away from the action and attempts a meticulous study of the horse's anatomy in two opposing stylistic modes: on the one hand, a highly realistic, detailed study of the foreleg of a horse, defining even individual hairs, and, on the other, two heads of horses suggesting early cubist geometric simplifications (6.60, Pl. 18).

An entirely new subject is taken up in sketch 19, which departs from the direction of all the other drawings. Conventionally titled *Head of Bull*, it is not a bull but in fact the head of an exceedingly handsome youth in the typical pose of the classical hero or king, often associated with the artist himself (6.61, Pl. 19).[25] The sensitive lips and gentle almond-shaped eyes (similar to those of Marie-Thérèse) and the scanty beard of a youth are offset only by the taurine characteristics of the horns and ears. The overall effect is more that of an actor's makeup or of a mask, such as

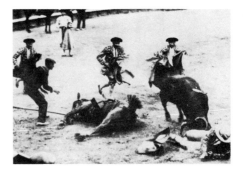

6.59 Bull gores horse and then charges fallen picador.

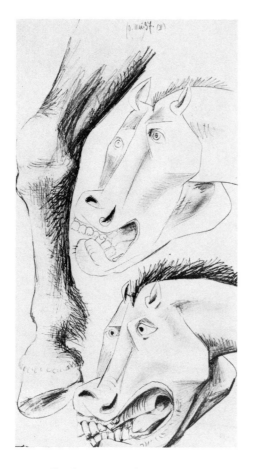

6.60 Sketch 18. *Leg and Heads of Horses*, 10 May 1937 (II). Pencil. 17⅞″ × 9½″ (45.4 × 24.1 cm).

6.61 Sketch 19. *Head of Man with Bull's Horns*, 10 May 1937 (III). Pencil. 17⅞″ × 9½″ (45.4 × 24.1 cm).

the one Picasso enjoyed playing with (6.62), than that of the features of an animal. It serves to present a new aspect in the character of the bull-man that had been a part of Picasso's art for several years but appeared in *Guernica* only in the final states: the concept of the human in the bull and the animal in man—the mythical Minotaur—the man-bull who vacillates between the physical passions of a beast and the intelligence and

6.62 (*left*) Picasso wearing mask used for matador practice (det.), 1959. Photograph by Edward Quinn.

6.63 (*above*) *Guernica* (det.). Eyes of bull.

sensitivity of a man. Picasso continued to dwell on this concept, with the result that the bull image in the final painting emerged with strongly human features, if not his own eyes (6.63, 6.64).

Just before grappling with the problem of enlarging an 18-inch composition study and laying it out on a 25½-foot (7.75-meter) canvas, Picasso spent the last part of the fifth day, Monday, 10 May, on his two most dramatic actors. On the next day both the writhing horse and the screaming mother clutching a dead child will be featured in a highly developed form in the large painting. Most astonishing, however, amid the grayness of the drawings was a sudden outburst of vivid color, unsurpassed in intensity since the great nudes of 1932–1933 (see Pls. 46, 47).[26]

These last two drawings represent the most radical change to date: for the first time in the developing concept of *Guernica,* the brilliant, strident colors of crayons overwhelm the gray pencil lines.[27] The tendency of highly intense colors to transcend natural appearances is further enhanced by the quasi-abstract patterns in which they occur, such as in sketch 20 where collagelike strips of color are laid in across the head and legs of the horse (6.65, Pl. 20). But in sketch 21 an even more complex pattern of different shapes, clashing and lacerating, pointed and clawlike, overwhelms the mother and dead child, who are already positioned precariously on the unstable ladder (6.66, Pl. 21). Bright red and orange strokes vibrate out of a yellow background and contrast with intense, even lurid, dark blue and purple ones. The shininess of the crayon has the raucous quality of overintense lighting in a darkened room, commensurate with the tenseness of the rough, abrupt strokes. Despite the large areas of color, the concept is still linear, even though the breadth, pressure, and density of the lines vary widely. Though these sketches retain the character of drawings in color, the color contributes less to the form than to the intensity of the expression.

Is it possible that this burst of color, when the imminent problem of laying out the first full-size composition must have dominated Picasso's mind, provided an emotional impetus to the large work, even if color was not retained in the final painting? Is it possible that the brief experiment with, and subsequent rejection of, color accentuated the expressive and visionary power of the grays and blacks of the painting at the moment they were developing out of the pencil drawings?

6.64 Picasso in 1937. Photograph by Rogi-André.

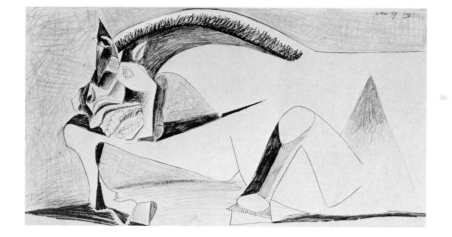

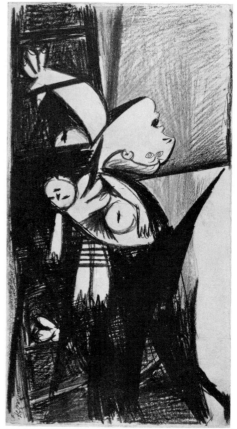

6.65 (*left*) Sketch 20. *Horse,*
10 May 1937 (IV). Pencil and
color crayons. 9½″ × 17⅞″
(24.1 × 45.4 cm).

6.66 (*right*) Sketch 21.
*Mother with Dead Child on
Ladder,* 10 May 1937 (V).
Pencil and color crayons. 17⅞″
× 9½″ (45.4 × 24.1 cm).

As Linda Nochlin has demonstrated in her study of Picasso's use of
color in paintings of Marie-Thérèse made during the idyllic days of 1931
and 1932, portraits of her tended toward delicate lilac tints verging on
violets, together with warm, rich yellows.[28] In the *Nude on a Black
Couch* of 9 March 1932 these colors harmonize closely with the sump-
tuous curves of her fecund abdomen, which appears to have generated a
plant as exotic and sensuous as her flesh (see Pl. 46). Five days later in the
Girl before a Mirror two images of a girl appear, but only the actual girl
is in the style and color of the earlier painting. In contrast, her reflection
in the mirror is, as Schapiro has observed, strident and clashing and com-
pressed within the mirror frame (the painting is visible in 9.8; see color
reproduction in 1980 *Pablo Picasso* [III], 291). Do the next few figures
in the series, which maintain this intensity of color and form that ap-
proaches violence, bear out José L. Barrio-Garay's theory, in his study of
visual imagery in Picasso's poetry, that there are strains of hostility to-
ward Marie-Thérèse even in those periods when Picasso most idolized
her?[29] The intensified purple, yellow, and red; the flailing arms; and the
deformation of the once-beautiful face, as in *Woman with a Flower* of
10 April (Pl. 47), seem to do this (see a similar face that fleetingly ap-
peared in the lower left corner of State IIA of *Guernica,* 7.19). After his
interest in Marie-Thérèse had cooled, most apparent in the portraits
of early 1937, as Nochlin notes, these hues became harsh and dry. By
6 January 1937 the lush sensuous roundness of her nude body had be-

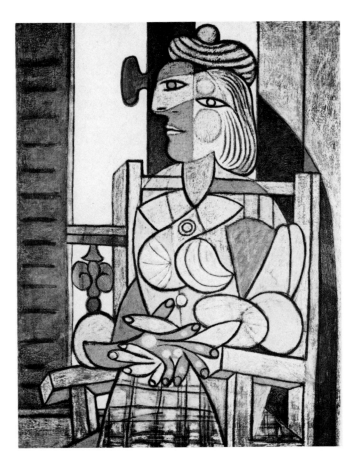

6.67 *Woman Seated before a Window,* 11 March 1937. Oil and pastel. 51⅛″ × 38⅛″ (130 × 97 cm). MPP.

come scarred by ragged, wiry striations, and on 11 March, when Marie-Thérèse self-consciously posed for Picasso fully clothed, which she had rarely done before, he encased her in a grid of harsh dark rectangles in dull colors (6.67).

The striking coloration almost disappeared during the next four years when Picasso was more concerned with etching and drawing than with painting, that is, with working in black and white rather than in color. But if the rejection of the characteristic colors he once so exuberantly reserved for Marie-Thérèse is an indication, she no longer completely dominated his senses or shaped his vision. The weighty lines and often lackluster colors, like the correspondingly rigid compositions and bulky clothing of many of the portraits of 1937 and later, make unrecognizable both the formerly tender hues and the ripe, full curves of her body.

In view of the rather drab colors of early 1937 chosen for the woman closest to him and his art and the grayness of the pencil sketches for *Guernica*, it is startling suddenly to encounter sketch 21 of 10 May 1937, the first full-color drawing for *Guernica* (see Pl. 21). The palette is familiar, but it is Picasso's most expressionist intensification of the idyllic colors of 1932 that could be imagined. Coming in the midst of a long period devoted largely to black and white or monochrome, the colors now seem extraordinarily violent. It is difficult to connect them any longer with Marie-Thérèse in 1932, except as an emotional reaction against her former role in his art.

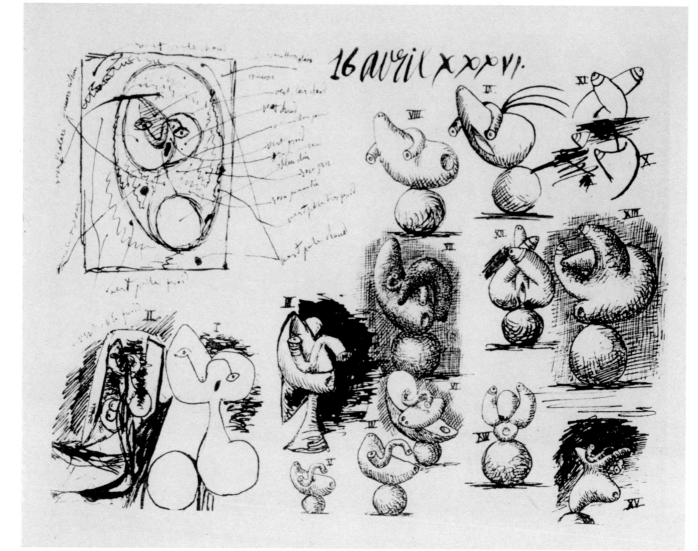

6.68 (*top*) Transformation
of woman's head (Marie-
Thérèse's?) into a polyp,
16 April 1936. Pen and ink.
9$\frac{15}{16}$" × 13$\frac{3}{4}$" (25.5 × 34 cm).
Z VIII, 283.

6.69 Fifteenth and last state
of head (det. of 6.68).

In a poem Picasso wrote as early as the end of 1935 Barrio-Garay
notes a figure he identifies as Marie-Thérèse, portrayed by Picasso as a
jaca, or young female horse, "a nude lion masquerading as a bullfighter"
and "a woman with long blonde hair who is confined behind an iron
door and hides her shame under a tablecloth." In a second version of the
same poem, her "kisses turn sour like lemons" and are bestowed upon a
"chinch bug of the sun." Although she gets the painter out of trouble, she
is the "target of obscene insults" and is ultimately reduced to the miserable
state of the wounded horse in the bullfight, "making the round of the ring
bleeding and dragging its guts."[30]

Although Picasso is rarely so explicit in his art, in a few isolated cases a
parallel change takes place. For example, in a series of astonishing draw-
ings on a single sheet of paper dated 16 April 1936 (6.68), he has gradu-
ally transformed a near-portrait of Marie-Thérèse into a polyplike mon-
ster (6.69) related to, if not the actual model for, the figure of the Caudillo
in the *Dream and Lie of Franco*, made nine months later (see 1.9).

It may be possible to detect a pattern in Picasso's abrupt and surprising
turn to these brilliant and solid colors for the same images he had earlier
several times defined with pencil lines. The subjects selected for this inten-

sification by color crayons—the agonized horse, the screaming mother with her dead child, and the weeping woman—are the most emotionally evocative actors in his cast of characters. They are also those most frequently depicted. Moreover, color appears at the critical moment when he was facing the task of transforming the gray pencil lines on small sheets of white paper into oil paint on an enormous canvas—a step he commenced on the following day, 11 May. After only four drawings in full color on 10 and 13 May (see Pls. 20, 21, 23, and 25), repeating images he had already developed in pencil, he abandoned drawing altogether for nearly a week (from 14 to 19 May), taking up instead brush and grayish paint for work on the first states of the large canvas. Then, once more taking up pencil and paper, for the next week (20 to 27 May) he worked on ten sketches—with one exception all of them heads—three of which were studies incorporated into the large painting (see Pls. 30, 33, 35) and the others at least related to the evolving images of bull, horse, and women on the large canvas.

After the last full-color sketch of the mother and dead child on May 28 (see Pl. 37), the quality of the color seemed to change and its expressive role weakened in the long series of isolated heads of weeping women that continued until the following October.[31] After 28 May (when *Guernica* was presumably close to being finished), the sketches of isolated heads lose their relevance to the large painting both in their subject and in their color.

Since the painting itself remained from the first rough outlines to the final state entirely in shades of gray between white and black (although in places tending slightly to bluish or ochre tints), the several full-color drawings in crayon may be viewed as drastic and challenging, and yet momentary, deviations from the main concept of a visionary scene in a world part real, part dream, as in Goya's great aquatints in shades of gray.[32] Indeed, Goya's *Tauromaquia* and *The Disasters of War* provided Picasso not only with models of the expressive richness possible in black and white but also with many of those motifs close to the soul of a Spaniard.

The Sixth Day: Sketch 22

On the next day, Tuesday, 11 May, probably just before he began laying out the first composition on the large canvas, Picasso sketched a second man-bull even more problematic than the first (6.70, Pl. 22). It is a clearly delineated and very sturdy bull figure on which has been superimposed, as if it were a mask, the face of a handsome young man or woman. The classical features—wide eyes, long straight nose, and delicate lips—may even suggest those of Dora Maar, by now his constant companion, as she appeared in some of the more pleasant portraits or even as engraved on a pebble (6.71). This creature, however, is not, strictly speaking, a Minotaur, who is generally a bull-headed man. Sketch 22 is a man-headed bull; if conventional symbolism is followed, this being possesses the physique of an animal but the soul of a man. This ambivalent creature—created on the same day as the first full-size composition for the final painting—is apparently the first draft for the head of the bull on that canvas (see the faint sketch behind the bull's head in State I, 7.1). The ap-

6.70 Sketch 22. *Bull with Human Head*, 11 May 1937. Pencil. 9½" × 17⅞" (24.1 × 45.4 cm).

6.71 Face of woman (Dora Maar?) as Minotaur, 1937. Engraved pebble. C. 2" × 1" (5.2 × 2.5 cm). Photograph by Dora Maar.

pearance of two bull-men just before State I of the final canvas thus seemed to determine that in the following states the bull was to possess more than a trace of human characteristics.

Later Sketches: 13 May to 4 June

In sketch 25 on 13 May, the third day of work on the full-size painting, Picasso again took up in full color the subject of the mother with dead child (6.72, Pl. 25). This time they seem to be fleeing in terror from a pursuer. A developing cubist geometry enhances the stridency of the scene, a style that is developing at the same time in State II of the large canvas.

There are no sketches for the next seven days, but in the following week Picasso returned to a series of ten black-and-white pencil sketches preparatory to developing figures in the full-size painting (see Pls. 26–35), including two heads of a bull, two heads of a horse, and, on 20 May, the first of a long series of heads of weeping women (see Pls. 30, 31, 32, 34).[33] The last mother with dead child in full color is sketch 37 of 28 May (6.73, Pl. 37), but long before then, similar images in the large painting had already been developed in black and white. Hence, drawing in color continues for Picasso a line of visualization that is now separate from the growing black-and-white concept of *Guernica*. The mother and even the child in sketch 37 seem frantic in their struggles to escape from between two imprisoning buildings, one of them afire. The cubist angles have now

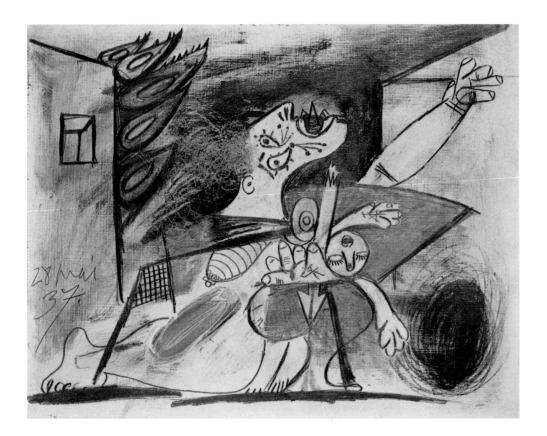

6.72 (*above*) Sketch 25.
Mother with Dead Child, 13
May 1937 (III). Pencil and
color crayons. 9½″ × 17⅞″
(24.1 × 45.4 cm).

6.73 Sketch 37. *Mother with
Dead Child*, 28 May 1937.
Pencil, color crayons, gouache,
and hair. 9¼″ × 11½″ (23.5 ×
29.2 cm).

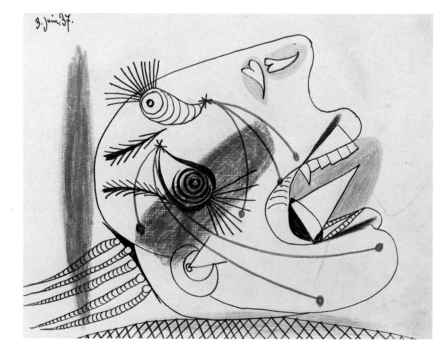

6.74 (*left*) The weeping woman is a common image in Spanish religious art. La Virgen de la Macarena, Seville.

6.75 Sketch 40. *Head of Weeping Woman*, 3 June 1937. Pencil, color crayons, and gouache. 9¼″ × 11½″ (23.5 × 29.2 cm).

become sharp and lacerating, a collage of coarse hair has been added, and several unidentifiable and threatening painted shapes agitate the group. Most horrifying is the spear with a broken shaft that has transfixed the wildly struggling child. This motif, familiar from many earlier drawings, has carried the theme of agony beyond that of the large painting, where the focus is on the horse's head.

Picasso continued to use color crayons for this series of female heads. Although apparently originating with the screaming mother, the heads became over the next four months progressively less related to *Guernica*. The term "weeping woman" is generally used to refer to the tear-stricken women in this series, and Spanish religious images are dominated by faces of the *Mater Dolorosa* (Our Lady of Sorrows), etched with tears (6.74).[34] From 28 May on, these "weeping women" gradually evolved into quasi-surrealist detached heads of extraordinary invention, both in their curvilinear structures and in their color (see Pls. 36–42). The heads are covered with thinly applied wax—now tending toward high-keyed primary colors. They seem amputated owing to their isolation and give the impression of being deformed and undeveloped embryos composed of bulging nodules.

On 20 May, Picasso had replaced the long rectangular drawing paper, which was so well adapted to composition sketches, with smaller sheets more square in proportion (1:1.26) and better suited to the isolated heads of the next series. The hard shiny surface and linenlike texture of this paper permitted a wider range of color density as well as greater intensity with the crayons. Sketch 40 is made up of solid areas of isolated primary

6.76 Photograph of Dora Maar (det.).

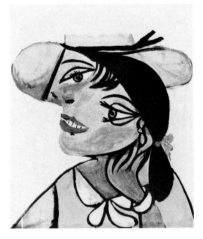

6.77 Portrait of Dora Maar, 29 August 1937. Oil. 24" × 19⅝" (61 × 50 cm). MPP.

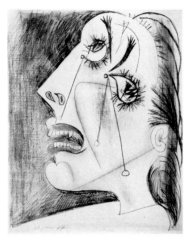

6.78 Sketch 48. *Head of Weeping Woman,* 13 June 1937. Pencil, color crayons, and gouache. 11½" × 9¼" (29.2 × 23.5 cm).

colors (6.75, Pl. 40), sketch 41 of thin overlays of violet and yellow tints (see Pl. 41).

The series of screaming heads continued, independent of the development of *Guernica* and often in full color, until about October 1937. By about 3 June, however, as evidenced by sketch 42 (see Pl. 42), the heads had lost all relevance to those in the mural, which by now had nearly achieved its final form on the large canvas. As if they were organisms caught in an evolutionary process, the heads gradually began to take on the particularities of an individual face with angular features, an agonized expression, and moist eyes. By 13 June the features of Dora Maar (6.76, 6.77), who was then Picasso's constant companion, became evident in sketch 48 (6.78, Pl. 48). Set against a dark ground, the woman's head is rendered in highly keyed tints and shades of red, blue, and yellow. The agony of the mother with her dead child, by a process of transformation well known in Picasso's earlier work, now became a characteristic of the many faces of a weeping woman that continued in his painting even into the following years. Curiously, after sketch 48 (by 13 June *Guernica* is presumed to have been completed), the colors in drawings and paintings alike become dull and often monochromatic (sketches 50–61), a change that continues until at least late October. Portraits of Dora Maar, however, proved to be an exception, for in August (see 6.77) he captured her radiant and sparkling beauty in warm colors, and then on 26 October he painted her as the weeping woman in colors that are unusually rich (6.79). But never again did he achieve the emotional intensity of the small crayon sketches of a mother and dead child made at the moment he began the large canvas for *Guernica*.

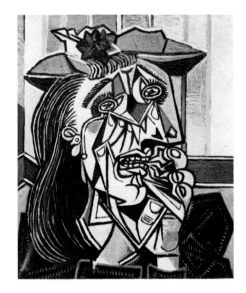

6.79 *Weeping Woman,* 26 October 1937. Oil. 23⅝" × 19¼" (60 × 49 cm). Z IX, 73. Formerly collection Roland Penrose.

On Tuesday, 11 May, even while continuing with the sketches, Picasso laid out his first composition on the full-size canvas (7.1). It was mounted on a stretcher 11'6" high by 25'8" long (3.50 by 7.76 meters), the largest canvas he had ever painted entirely with his own hand—almost three hundred square feet in area.[1] In fact, because of its extreme height—more than twice that of the artist—it had to be inclined to fit under the roof beams of the spacious studio on the first floor of his town house in the rue des Grands-Augustins.

Dora Maar photographed the canvas that same day and on at least nine other occasions during the four or five weeks of its development. She was an experienced photographer, Picasso's frequent companion, and she lived just around the corner in the rue de Savoie. Contrary to his usual habit, Picasso had taken two weekends, time normally spent with Marie-Thérèse and Maya, to make the first fifteen sketches, the last of which was his third and final composition study. Once he had started the large canvas, he apparently worked on it continuously, turning back to the sketch paper only three times during the following week and a half.

Since the canvas underwent many transformations and was repeatedly painted over, we have only the photographs as a record of the major states of its development.[2] Zervos dates the first one 11 May, but the remainder of his sequence is undated.[3] By comparing dated sketches with the appearance of the same images in the painting, however, we can establish approximate dates for some of them.

Picasso's interest in photography as a medium for documenting the development of his imagery is well known, and he surely had much to say about choosing when the pictures were taken. He was interested not so much in defining "states" as in recording the metamorphosis of the picture—in his own words, in discovering "the path followed by the brain in materializing a dream."[4]

Dora Maar's photographs record at least ten known stages in *Guernica*'s development and document some instances in which motifs were tried and then painted out and others in which the pressure of compositional imperatives forced changes in meanings. Zervos immediately published eight of the series and one detail in a double issue of *Cahiers d'Art* devoted to *Guernica*.[5] Since that time, authors generally have not included all the known photographs and sometimes have even arranged them in a sequence different from that of Zervos.[6]

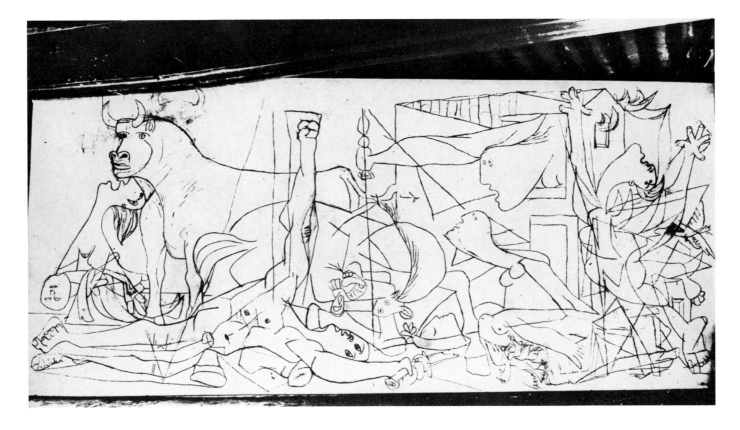

State I

7.1 State I of final canvas,
11 May 1937. Photograph by
Dora Maar.

In the critical act of touching the canvas for the first time, Picasso lightly sketched in the general outlines of all the characters with brush and paint. His concern at this moment was clearly how to deploy them over the surface so as to transmute the small fragmentary sketches onto the enormous elongated canvas and give full attention to its architectonic mural character. Compare State I (7.1) with sketch 15 (6.54) made only two days earlier. For the moment, the intense emotionality of the individual characters—so compelling in the sketches—gave way to the imperatives of composition.

The bull, like a movable "flat" in stage scenery, frames a new version of the mother and dead child image—now a simple triangle nestling within the rectangle formed by the bull's body. The writhing horse with head spiraling downward forms a powerful centripetal force within the large central pyramid.

The figures of the horse and the mother with dead child appear on the large canvas in highly developed form, since during the past two days both had been sketched three times, the last sketch of each in color. The mother, in fact, was the principal source of three of the female figures in the large painting, each of them embodying a distinctly different aspect of shock and suffering. Here as well as elsewhere the female figure, even more than the wounded horse, was Picasso's favored medium for exploring and exploiting torment, both physical and emotional.

7.2 (*left*) Matthias Grüne-
wald, *Isenheim Altarpiece*,
c. 1512 (det. of Crucifixion
panel). Colmar, Musée
d'Unterlinden.

7.3 *Crucifixion* after Grüne-
wald, 19 September 1932. Ink.
13½″ × 19¾″ (34.5 × 50.5 cm).
MPP.

The Mediterranean house dominates the right half, framing the woman
with a lamp; it also encloses three other female victims who are arranged,
respectively, on a vertical, a diagonal, and a horizontal axis. While the
middle- and background forms have been flattened, clarified, and orga-
nized into the rectangle of the canvas, the foreground remains a jumble of
bodies that would be resolved only in the last states of the large canvas. In
the left foreground lies the nude body of a fallen warrior. His massive
form creates a powerful horizontal base for the composition, whereas his
muscular right arm with its clenched fist provides a vertical emphasis.

The warrior's outstretched arms and tightly crossed feet recall the pos-
ture of Christ as in the conventional Deposition from the Cross. By evok-
ing a flood of associations with this traditional theme of extreme suffering
and sacrifice, Picasso elevates the events of both the bullfight and the
bombing of Guernica to the level of epic tragedy.[7] Obsessed with the
image of the Crucifixion since early youth,[8] he began around 1927 to
make sketches for a major work on this theme. The finished painting,
which he completed in 1930, depicts an extremely painful scene replete
with ambiguous surrealist symbols for agony that accompany and re-
inforce the figure of the crucified Christ (Z VII, 287).

During the next two years, his imagination still fired by themes of tor-
ment and freshly fueled by his study of reproductions of the Crucifixion
panel of Grünewald's *Isenheim Altarpiece* (7.2), Picasso executed a series
of highly expressionist ink drawings of the crucified Christ. Taking his
cue from the German master, he stretched and twisted the arms to the
point of separating them from the body (7.3), a feature that now continued
in the several versions of the tormented body of the warrior through the
final painting.

The raised arm and clenched fist, however, in 1937 had only one
meaning: the Communist salute. The symbolic gesture often appeared in
photographs and posters of street scenes, parades, and demonstrations in

7.4 (*far left*) The clenched fist, here adopted by the International Brigades, dominated the propaganda of the Republic.

7.5 (*left*) State IA (det.). Clenched fist and upraised arm.

7.6 State I (det.). Bull and mother and child.

both Paris and Spain (7.4), and the military units in Republican Spain commonly greeted the populace with it, always receiving a chorus of salutes in return (see 6.56, 6.57). Picasso was surely aware of the implications of giving this gesture a prominent location in his painting. But it soon disappeared from the canvas, replaced by images of a wholly different order of meaning, which performed equally well the function of providing a vertical axis in the central part of the painting. One of these is the narrow elliptical black-and-white shape that seemingly transects the horse's body—interpreted by various writers as a wound inflicted by the bull's horns, by the warrior's sword, or by the Condor Legion bombs. In fact, close observation proves that this image is clearly only a remnant of the elbow left over after the arm and fist were painted out in the next state (compare 7.5 with 7.13, State II).

The image of the weeping mother and dead child, which had preoccupied Picasso in so many of the sketches, is the source for three different women in State I. To the extreme left, a simplified version of the mother and child forms a triangle beneath the bull's head (7.6). The weeping woman still throws her head back in a shriek, but the force is in dramatic opposition to that of the face of the dead child, whose head hangs limply backward. Furthermore, the mother's cry is now directed toward the face of the bull, who can be seen in a protective rather than a destructive role, as was the case at first when he was shown confronting the wounded horse. A second woman appears alone on the extreme right; she apparently is falling off a ladder while escaping from a burning building (7.7). A third woman just to the left of her is straining as she flees toward the center, thus creating an important compositional diagonal leading to the lamp in the upper center (7.8).

The placid serenity of the female victim who lies beneath the horse's feet sets her apart from the other three anguished women. Her classical profile, bared breasts, and serene somnolent mien are familiar character-

7.7 (*above, left*) State I (det.).
Falling woman.

7.8 (*above, right*) State I
(det.). Fleeing woman.

7.9 (*right*) State I (det.).
Fallen woman.

7.10 Dedication in book to
Marie-Thérèse, using her ini-
tials as a monogram, 3 March
1937.

istics of the many portraits of Marie-Thérèse (7.9). There appears to be a flower held in the hand above her head and a bird fluttering at her side, two images Picasso frequently associated with her. In fact, he often addressed his letters to her using a monogram that he devised from a flower, a bird, and her initials, M. T. W. (7.10).

State I marks the beginning of the transformation from "object," where each sketch embodies an individual being often with a specific action or meaning, to "idea," where the entire composition as a thematically unified whole integrates the complex interrelationships and associations of the various individual elements. From State I on, the orchestration that takes place across the surface of the canvas will at times feature certain images, suppress others, and, perhaps most perplexing of all, so alter the forms of yet others that they accrue new meanings—or, more accurately, new areas of meanings.

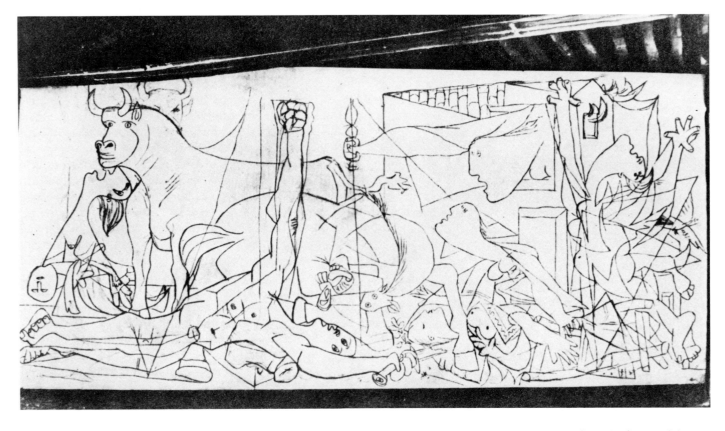

7.11 State IA. Photograph by
Dora Maar.

State IA

The second of Dora Maar's photographs must have been taken very soon
after the first, for only a few minor changes in the painting are apparent
(7.11).[9] Picasso has more fully developed the female victim lying on the
ground to the right by adding strands of hair, a part of a neck, and hands
and arms (7.12).[10] A fragment of embroidered clothing provocatively
conceals her breasts only partially, and the fluttering bird has been trans-
formed into her fingers, which in the many paintings of her relaxed figure
and graceful arms have already frequently echoed the form of birds' wings.
All these elaborations reflect Picasso's continuing dependence upon the
face and figure of Marie-Thérèse. The specific nature of these changes
suggests a growing affinity with the *Femme Torero* series of 1934, in
which the figure of a beautiful sleeping woman is depicted lying peace-
fully beneath the feet of the struggling bull and horse (see 6.25).

7.12 State IA (det.). The fig-
ure of the supine woman re-
calls the *Femme Torero* series
of 1934.

State II

In State II Picasso took up the problem of unifying the disparate shapes he had assembled, in particular those of the somewhat crowded and chaotic foreground, into a coherent composition. For this task he turned to a formal device over which he had complete mastery, the technique from Synthetic Cubism of using a straight line to slice through unrelated shapes and thus to unify them and change their meanings (7.13).

While simultaneously establishing an axis and creating numerous new forms, this device, when worked out in light and dark patterns, in turn added an element of nonfiguration to the painting. These new lines began to draw the composition together in a more subtle manner as, for example, in the outstretched arms and legs of the fallen warrior. The initial similarity of the warrior to the crucified Christ is overcome by other straight lines that break into the forms of the legs and the carefully crossed feet. A large squarish block of black—actually on the body of the horse but also annihilating all but the elbow of the warrior's upraised arm—creates a vertical axis that opposes the horizontal bands of the base.

The dynamics of this purely structural manipulation of forms reveals one of the many illuminating surprises that close study of Picasso's sketches may yield. In State IA the foot at the extreme lower right corner belongs to the woman falling from the burning building, but in State II it has been grafted onto the woman fleeing into the picture (compare States IA and II). This transformation is the result of the artist's response to a compositional imperative—the need for a diagonal movement from the lower right corner toward the central focus high up in the center. Picasso had even anticipated this movement by lightly sketching in such a diagonal in all three of the first states.

His concern with the many problems of composition in the early stages of the large painting may explain why he allowed the obvious device of the huge disc of a sunflower—or a sun—that encircles the fist clenching the clump of wheat stalks to take an overly dominant position. On the other hand, these and similar images were commonly used in the posters and publicity of the Republic (7.14). Both the Catalan Anarchists and the POUM—or Marxist Socialists—had taken as their themes not so much that the war must be fought but, more important for them, that the social revolution should produce communes so that the crops would be brought in.[11] Photomurals and posters honoring peasants at work as well as soldiers at the front were therefore to be seen in profusion in the Spanish pavilion (6.56 is similar to those displayed). Miró's large painting, placed on the staircase landing opposite *Guernica,* featured a Catalan peasant wearing a Phrygian cap and brandishing a sickle. Various titles were applied to it, most commonly *El segador,* a reference to the reapers in a patriotic song who defended their land with their agricultural implements.

Picasso, continuing to rework the figure of the female victim, next added the heavy-lidded eyes often seen in portraits of Marie-Thérèse (see 7.15, Pl. 33). After she had played the role of the passive sleeper and the beautiful matador caught in the furious struggle between bull and horse in the ring, it was entirely in character for her to play the victim lying supine beneath the horse's hooves in *Guernica.* This role had been anticipated even on the first day of sketching (see sketch 6, 6.17).

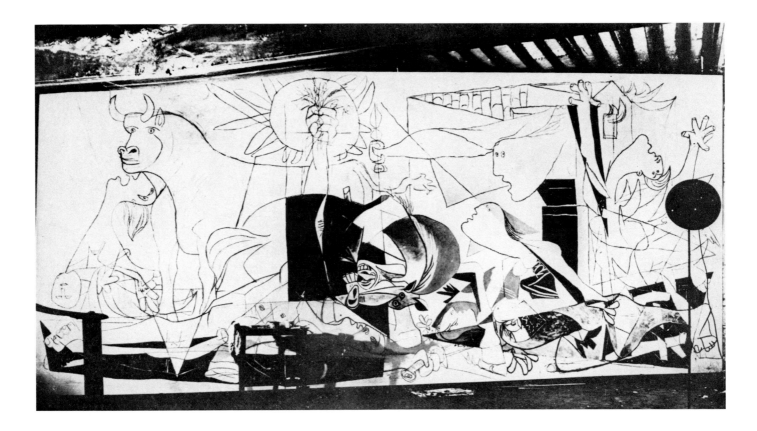

7.13 State II. Photograph by
Dora Maar.

7.14 (*below*) *Victory Will Be Ours.* Catalan air force recruiting poster.

Finally, in a move that substantially altered the meaning of the suffering horse, Picasso added a shaft to the spear protruding from its back. In view of his lifelong tendency to show horses bearing wounds caused by the bull's horns, it was a curious reversal to show the horse suffering a wound ritually destined for the bull. This surprising new motif tends to release the horse in *Guernica* from its traditional role as victim of the bull in the *corrida* and casts it as the victim of an act of man. The bull as well is seen less as the bestial aggressor of the arena and more as the bull-man or the mythical Minotaur.

Already in sketch 19 (see 6.61, Pl. 19) of 10 May, even before starting on the large canvas, Picasso had clearly brought the idea of the Minotaur into the concept of *Guernica,* transforming the fighting bull of the arena into a handsome young man of sensitive mien in the form of Picasso's earlier classical heroes. On the next day, in sketch 22, a completely human face is borne by a completely taurine body, thus demonstrating the two poles of the Minotaur's being (see 6.70, Pl. 22). The complex nature of the creature is further expressed by the reversal of both the traditional synthesis and some of the traditional symbolism, so that in this sketch he has a human head on a bull's body rather than a bull's head on a man's body. A few days later, the dichotomy began to be resolved when in sketches 26 and 27 the previously human form and texture of the

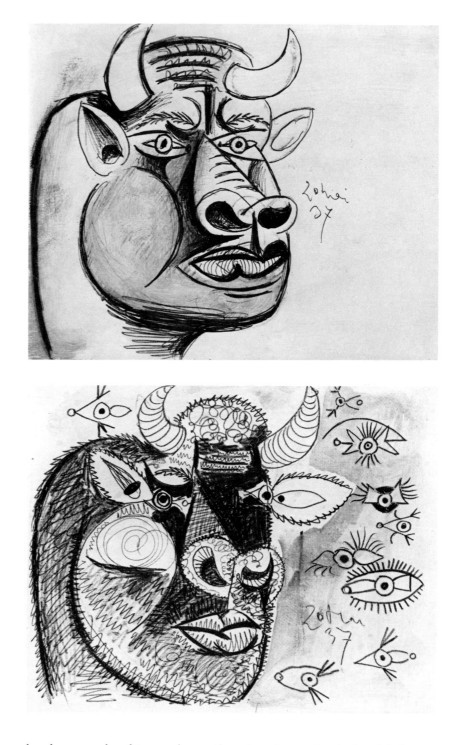

7.15 (*above, left*) Sketch 33.
*Head of Fallen Figure
(woman?)*, 24 May 1937. Pen-
cil and gouache. 9¼″ × 11½″
(23.5 × 29.2 cm).

7.16 (*above, right*) Sketch 26.
Head of Bull-Man, 20 May
1937. Pencil and gouache. 9¼″
× 11½″ (23.5 × 29.2 cm).

7.17 (*right*) Sketch 27. *Head
of Bull-Man with Studies of
Eyes*, 20 May 1937. Pencil and
gouache. 9¼″ × 11½″ (23.5 ×
29.2 cm).

heads are rendered in rough pencil strokes that evoke the bestial charac-
teristics of the bull (7.16, Pl. 26; 7.17, Pl. 27). These transformations can
be traced through to the final state where the semihuman face begins to
relate the bull more and more to the mother and child. He is in all the
states aloof from the chaos and the suffering of the creatures surrounding
him and seems emotionally and intellectually superior even to the human
beings.

State IIA

One of Picasso's most remarkable feats of formal transformation was to completely reorient the horse's head with only a minimum of actual repainting. This intriguing transformation was recorded by Dora Maar in a photograph that in Zervos's sequence comes between States II and III; for present purposes it is designated State IIA. Apparently it records the only time that Dora, surely with the agreement of Picasso, selected a single motif for emphasis. Zervos reproduced it in *Cahiers d'Art* in a full-page spread the same size as the states.[12]

By ingeniously switching the nostrils from the lower to the upper line of the head and by adding new eyes and ears there, Picasso oriented the head rightside up instead of upside down (7.18, 7.19). In consequence, the head not only is more legible but carries much greater expressive force. The teeth, tongue, and most of the structural parts of the head remain exactly as originally conceived, while the new ear and side of the head connect by a faint vertical line with the lamp in the hand of the woman above. This line makes the structure of the central part of the composition more geometrical and at the same time suggests the transformation of several anatomical parts of the horse into quasi-abstract black-and-white shapes. Thus a simple change in the posture of the horse provokes an alteration in style.

7.18 (*left*) State II (det.). Horse's head in original position (inverted).

7.19 State IIA. Horse's head in altered position (righted). Photograph by Dora Maar.

As a further product of this complex thematic-stylistic interaction, within the large black rectangular area on the body of the horse a curiously shaped shaft appears, terminating in a disc with shaggy edges adjacent to the horse's lower (formerly upper) teeth. On the disc Picasso has painted a peculiarly misshapen face with staring eyes. This form has been seen before, in portraits of Marie-Thérèse from 1932 and again in the series of caricatures of April 1936. But as had happened many times before, the misshapen face disappeared when State II was painted over, leaving as a remnant only the shaft with a splintered end that remained until the final version.

State III

In this state the lightly sketched outlines of State II are clarified and unified by the addition of large irregular areas of black (7.20). The entire ground plane is filled in as well as much of the middle plane. This leaves several particularly strong islands of light, especially in the mother and child to the left and the woman with the lamp at the top, markedly increasing the emotional tone of their drama. For the moment, the bull remains in white on white and hence relatively neutral, but the horse—which Picasso had been constantly changing in the sketches—is a tightly knit complex of clashing black-and-white angles, so dense as to be deciphered only with some effort. The quasi-cubist black-and-white areas playing across objects and voids alike tend to unify the composition and highlight the central pyramid, which remains largely a light mass in contrast to the surrounding darks. The dark ground plane extending in a band across the entire composition provides a solid base for the light pyramid.

The overall pattern of angular light and dark planes, sometimes emphasizing the character of individual objects and sometimes arbitrarily suppressing them, has also altered some of the meanings. The warrior's upright arm and clenched fist have been painted over with interlocking geometric black-and-white areas and, with the exception of the odd fragment of a realistically detailed wrinkled back of the elbow, have been totally suppressed. With this gesture vanish all associations with the Communist salute. As I have already noted, some writers interpret the vestige of an elbow as an open wound, but no other grounds than superficial resemblance exist for assuming that this was Picasso's intent. It would be most uncharacteristic of Picasso, however, that a motif so fraught with emotion and potentially so significant as an open wound would enter his iconography simply because of a chance resemblance, especially to such an inexpressive object as the back side of an elbow. Picasso, like his fellow Andalusian the poet and dramatist Federico García Lorca, was deeply obsessed with wounds and with the show of blood. As is clear in his drawings for both the Crucifixion and the bullfight—two themes that have powerful resonances in his art and, indeed, in Spanish culture and religion—intense emotion has its source both in the objects causing the wounds (the nails, the lance, the bull's horns) and in the show of blood itself (see 5.3, 5.15).

The fallen warrior, who has remained unchanged since State I, is now turned completely about so that his head is to the left and faces downward, thus distancing it from the trampling feet of the horse as well as

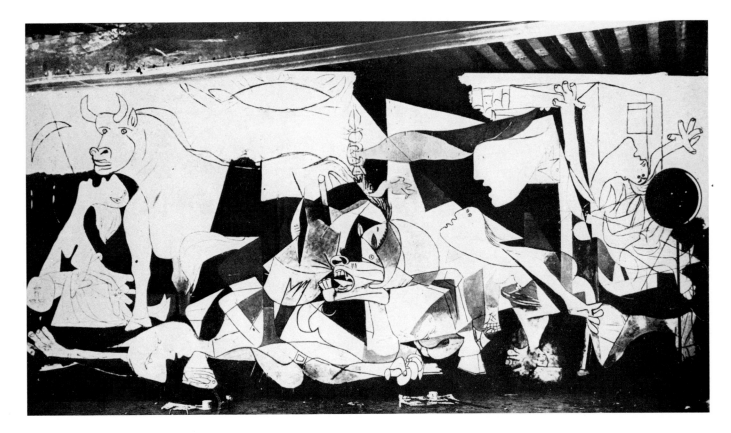

from the horse's screaming head. The warrior's head now stands out in sharp relief from the dark foreground.

The fleeing woman to the right, now also in dark and light, creates a diagonal that constitutes the right side of the central pyramid—that is, it fulfills a compositional function—whereas her leaning posture and her intense gaze, focused on the ellipse of the sun in the upper center, perform a dramatic function. In the meantime, she has completely appropriated the foot in the lower right corner, formerly a part of the falling woman. Considering the solidity with which the foot is embedded in the corner and its importance as a buttress for the powerful diagonal, Picasso's ability as a composer of shapes as well as a dramatist is here brilliantly demonstrated. Thus the preeminence of compositional imperatives in State III sometimes alters the meaning of the sketches while creating new, even unexpected, meanings.

7.20 State III. Photograph by Dora Maar.

State IV

In this state Picasso seems to have achieved a fairly complete vision of the final painting (7.21). There are several dramatic changes in the posture, and hence the meaning, of the bull and horse, and the painting is composed now almost totally of large geometric black and gray areas, leaving little islands of luminous light on the faces.

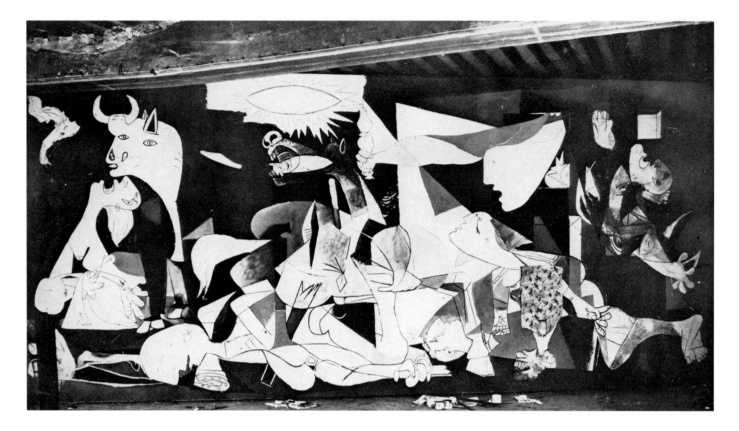

7.21 State IV (with collages added). Photograph by Dora Maar.

The chief protagonists in the scene, the bull and the horse, neither of which had received much attention since State I, now caught the full force of their director's energy. In a bold move, the artist turned the bull completely about so that now his tail is in the upper left corner and his body frames the triangle of the mother and dead child, suggesting that his role is that of protector rather than menacer. Furthermore, his entirely new head is a graceful flat silhouette at the point of the pyramid formed by the bodies of the mother and child and his face, now more human and less animal, has been provided with wide-open and intelligent human eyes similar to those in the final image. They are also much like the wide-set eyes seen frequently since 1931 in portraits after Marie-Thérèse (7.22). The bull's eyes stare squarely out into our space, creating an unsettling rapport between the bull and the observer. This intimacy is enjoyed by none of the seven human beings, so the bull achieves a communication and expressiveness unmatched by any of the other figures, enveloped as they are in their individual distress. The starring role of the bull inevitably has provoked in some observers' minds the possibility that he bears a special message from the artist—indeed, may even suggest the artist.[13]

In many earlier examples Picasso had combined the features of a human with those of a bull. In the sketches, he had produced with equal conviction a man-headed bull and a bull-headed man, thus again broadening the meaning of the Minotaur. His last painting before starting on the sketches for *Guernica* was a still life of 19 April (on the same day he planned an artist and model subject for his mural; see 5.41) depicting the

head of a bull—mounted on a pedestal as if it were a trophy or a sculpture—which bears what is clearly a human face (7.23). Although usually titled *Head of a Bull*, it might more properly be described as an effigy of a man wearing bull's horns, as in sketches 19 and 22 and many earlier works. Although not properly speaking a Minotaur, this image combines taurine and human characteristics that in the art of Picasso embrace the wide range of behavioral possibilities in the extremes between the man as a god and the bull as a beast. According to the surrealists' concept of the Minotaur, which in some ways Picasso shared, the man-bull had also the potentiality of transformation within this broad range. In the etching series of 1933, Picasso had already explored the transcendence and the risks of this dichotomy.[14] Thus the figure of the man-bull in State IV is no longer the fighting bull of the ring, intent only upon goring the horse or the matador, but a being of both beastly and human potentialities, whose protective attitude as he stands over the mother and child in State IV creates new and quite different associations.

Picasso has arrived here at a new, humanized, concept of the bull in a clear image exactly as it will finally appear (see foldout). Ignoring his traditional antagonist the horse, and staring with human eyes straight out at the observer, the bull seems to shield the mother and child, who themselves may suggest the principal victims of 26 April.

By swinging the body of the bull around to the left and turning his gaze outward, Picasso freed a space above the horse, which, almost as if by an automatic response, he filled with its head and neck, straining up-

7.22 (*left*) *The Red Chair* (Marie-Thérèse?), 16 December 1931. Oil. 51½″ × 39″ (131 × 99 cm). Gift of Mr. and Mrs. Daniel Saidenberg, 1957.72. © 1987. The Art Institute of Chicago. All rights reserved. Z VII, 334.

7.23 Still life with bull's head, 19 April 1937. Oil. No dimensions available. Z VIII, 360.

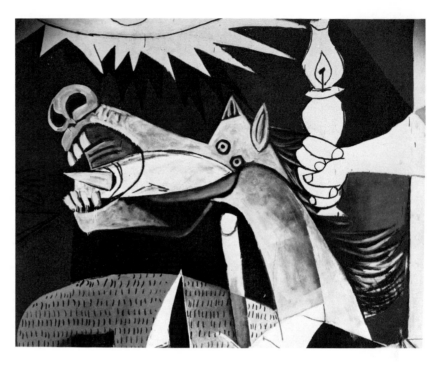

7.24 (*top, left*) Bull attacking horse, 1892. Pencil. $5\frac{1}{16}'' \times 8\frac{1}{8}''$ (13 × 21 cm). Z XXI, 5. MPB.

7.25 (*above, left*) Bull and fallen horse, 25 March 1921. Pencil. $9\frac{1}{2}'' \times 11\frac{13}{16}''$ (24.5 × 30.3 cm). Z IV, 250.

7.26 (*right*) *Guernica* (det.). Horse's agony expressed by paint dripping from teeth.

ward. Picasso had been conceiving the horse in this posture since about 1892 (7.24 and 7.25).

The horse's screaming head, now upturned, suggests defiance rather than the cowering response of the earlier sketches. The horrifying and agonized screaming open mouth reveals the deformation of the sensitive and malleable form of the tongue into a pointed blade and exposes the bare teeth. As will become highly visible in the final state, heavy paint drips from them, magnificently expressing agony so intense that it seems to torment their throbbing nerves (7.26; see also Pl. 50).

Further, the upthrown head now reveals, and even provides, an eloquent frame for a shocking new wound: the spear has completely transfixed the horse's body. The blade protruding from its body, however, is a classical weapon, not a picador's lance (7.27). Thus the scene is removed yet another step from the bullfight arena and relates back to Picasso's longtime absorption with classical motifs and mythological personages (7.28). The lines now radiating from the wound made by the spear have undergone a radical transformation of meaning; in States I to IV they were wrinkles on the inside of the horse's shoulder that remained without a descriptive function when the head was raised and the shoulder painted out.

Picasso next turned his attention to the figure of the falling woman at the extreme right. Derived, as has been suggested, from the studies of mother and child on the ladder (see 6.66, Pl. 21), she has retained to this point the outflung arms, upturned head, and flaming clothing of State I. He now exaggerated even more the structural reinforcement of the lower right corner by the foot that was once a part of two different figures. The flailing legs of the falling woman have been enveloped by the black background, and the torso, now suspended in space, is swung around toward

7.27 (*far left*) *Guernica* (det.). Remainder of warrior's upraised arm (sometimes erroneously interpreted as a wound). Classical spear.

7.28 *Lysistrata*. Peace between the Spartans and Athenians, 13 January 1934. Etching. 8¼″ × 6″ (21.1 × 15.3 cm). G. 391.

the viewer with the arms outstretched in the painful posture of crucifixion. This is the second time this image has been used on the large canvas to heighten dramatically the chaos of the scene and the unremitting agony of the victims. The head of the falling woman, which has now assumed its final form, is still thrown back at an excruciating angle, chin stretched upward. It has been enlarged, and its white-on-black tonality emphasized to reflect the shape of the woman with dead child on the extreme left: by assuming the traditional form of mourners flanking a crucifixion in the center, these two similar figures came to intensify the religious overtones of the scene.

The foreground, once inhabited by a maze of intertwined bodies, is still unclear, though only two figures—the prostrate warrior and a female victim—remain. At this point it appears that Picasso had turned back to the sketches, for a new and more emphatic right hand has appeared on the warrior, replacing the indefinite one in the lower left corner of State III. (Both of his hands seem to be right ones.) Like the foot in the opposite corner, it serves to terminate the soclelike architectural base that provides a stable foundation for the striving forms above. The date of 4 June on sketch 45 (7.29, Pl. 45) gives us a probable date for at least the warrior's hand in States IV and V. Since a new design for the head of the warrior, sketch 44, also dated 4 June, entered the painting only in State VII, we might surmise that progress between State IV and State VII was very rapid. The date of 4 June, however, is the last verifiable date when the painting was dependent upon the sketches, and it gives us a starting point for estimating when the painting was completed.

Of the female victim, who since sketch 6 on the first day of work had been lying supine beneath the horse's feet, only the classical head remains (see 7.15, Pl. 33). This metamorphosis, as well as the imminent disap-

7.29 Sketch 45. *Hand of Warrior,* 4 June 1937. Pencil and gouache. 9¼″ × 11½″ (23.5 × 29.2 cm).

pearance of the head, removes the theme still another step from the bull, horse, and *torera* combat of the bullfight and even from the classical associations carried by the helmet and spear.

Perhaps the most daring, and certainly the most surprising, innovation in State IV is the sudden appearance of two paper collages applied directly over the surface of the fleeing woman to the right (see 7.21). One with a checked design covers her hair and a triangular light area above it, and the other—what appears to be a vertical strip of wallpaper with a floral pattern—hangs down from her shoulder, covering one breast and part of her knee. Since the covered areas were not lacking in design elements, it remains an unanswered question whether Picasso was adding new textures and colors or was trying out a simple rectangle over an otherwise complicated area. His careful arrangement of the wallpaper according to the axes of the painting suggests the latter. At any rate, both paper collages were soon removed; they were temporarily restored in State VI, however, to which Picasso also added two new ones.

From the point of view of composition, the newly simplified foreground begins to function more integrally with the strong black-and-white patterns of the upper part of the painting. The increasing dark-light contrasts now generate a brilliant illumination on certain of the faces, as if this were a night scene lighted either by powerful external sources like a camera flash or by explosions. Where the light strikes the wall to the right of center, it becomes blinding. The heads, however, are silhouetted as islands of light shining out of the darkness. Now that the most expressive features of the various figures are thrown into sharp relief, they seem to relate more to one another, and the viewer is tempted to read the faces—animal and human alike—as responding emotionally to each other as though all belonged to actors playing their individual roles in a highly dramatic scene.[15]

State V

The increased flatness as well as the simplification of the forms has made the painting more like a mural (7.30). By this time (early June) the pavilion walls on the ground floor were probably in place, and Sert has stated that Picasso visited the construction site several times.[16] He could have calculated therefore with some accuracy which environmental conditions—such as adjacent structural forms and the light—would affect the painting once it was in place on a wall immediately to the right of the entrance to the open-fronted building. Although a steel support pier was located directly in front of the painting, Sert was able to remove it to free the space between the painting and the center of the foyer where Calder's fountain was to be located. Since the wall to the right of the painting was open, the crowds on the esplanade and even the foliage of the trees in the garden were within the viewer's field of vision. Only a painting with strong contrasts and a simple geometric structure could hold its own against these distractions.[17] Because the painting was exposed to the activity just outside, Sert had a movable wall set up at right angles to the painting to close off in part the sight of the heavy openwork grill that stretched across the opening only a few feet from it. The southeast exposure of the open front and the low ceiling provided a minimum of light;

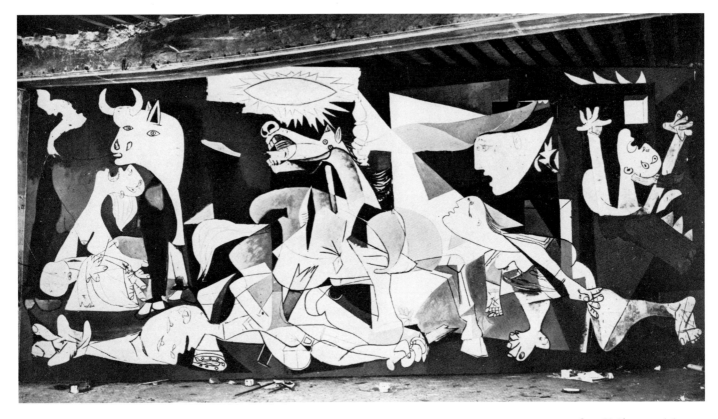

7.30 State V. Photograph by
Dora Maar.

even in summer it was necessary to use spotlights, which must have increased the dark-light contrasts of the painting.

The figure of the falling woman on the right, once one of the most active and least legible of the major figures, was now reduced to a simple rectangular composition combining the figure with the building and a small square window. Of the original full-length falling figure only the head and upraised clutching arms remain, rendering more emphatic her upturned screaming head. Her posture reflects Picasso's accurate knowledge of Goya's images of helplessness and terror in his *Disasters of War* (7.31). The flames that lick at the cornice of the building and at the edge of her skirt add stark drama to her appeals. The sense of falling, so desperately conveyed by her gesture, is made more urgent by the diagonal axis of her skirt (see Pl. 55). The evidence of sketch 35 of 27 May (7.32, Pl. 35), which introduces the possibility of geometrizing this figure, combined with that of sketch 45 of 4 June, which depicts the warrior's hand (see 7.29, Pl. 45), suggests that State V was begun sometime after 27 May and completed shortly after 4 June. The warrior's hand, brought almost to its final compact form in sketch 45, anchors the central pyramid in the lower left corner, now a simple, tightly composed geometric shape.

7.31 (*left*) Goya, *The Disasters of War,* no. 41 (det.), 1816. Etching and aquatint.

7.32 Sketch 35. *Falling Man,* 27 May 1937. Pencil and gouache. 9¼″ × 11½″ (23.5 × 29.2 cm).

In the same spirit of simplification that saw the removal of the textured wallpaper collage, the head of the supine female victim—an important figure that had been reduced to the semblance of a plaster cast—disappears from beneath the horse's hoofs. The space freed increases the legibility of the foreground plane, heretofore only a jumble of anatomical parts, and allows the warrior's sword to be extended.

State VI

Picasso again reversed himself, restoring the two collages he had applied and then stripped off in State IV, in another bold experiment not uncommon in the large painting (7.33). This time he added two others. One, a larger strip of wallpaper with an Empire design in gold on maroon, he attached squarely over the mother mourning her dead child to the left. The pattern was inverted, possibly to discourage a literal reading (7.34). Since both this collage and the one hanging from the shoulder of the fleeing woman (7.35) were rectangular and arranged on a strict vertical axis, they provided, in addition to a textural element, architectural forms reflecting the major geometric axes of the canvas. Had they remained, they would have related also to the strong rectangles of the architecture of the pavilion. A fourth wallpaper collage with large checks suggestive of a restaurant tablecloth was laid over the diagonally arranged rectangle representing the skirt of the falling woman to the right. Superimposed on the dark painted shape, its light tonality substantially altered the silhouette by emphasizing the edges and increasing the dark-light contrast of the figure to the same level as that of the other characters in the drama. Picasso soon removed the checked wallpaper, but as a result of this experiment, he lightened the tone of the diagonal skirt and accentuated the stripes.

Since the collages were only lightly tacked onto the canvas (note the shadows under the curled edges and the different position of the collages on the fleeing woman here as compared with State IV), Picasso possibly used them as a provisional means of judging the simplifying effect of large rectangles on the canvas. This interpretation is given some support when we discover in a large painting-collage of a year later what is surely the same piece of wallpaper that had temporarily covered the mother and child in State VI. This time, however, it is firmly affixed to a brightly col-

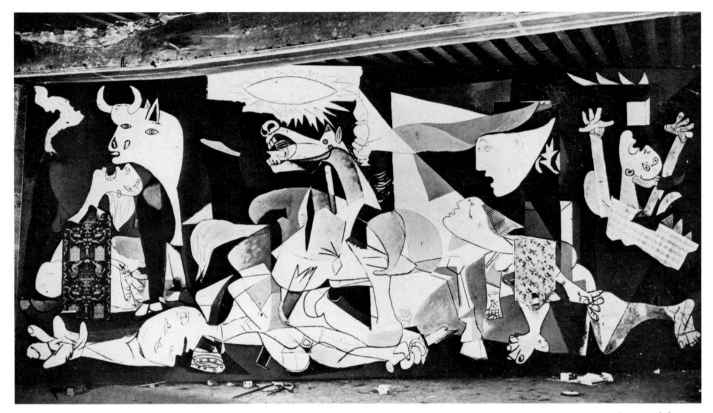

7.33 State VI. Photograph by Dora Maar.

7.34 (*left*) State VI (det.). Mother and child. Wallpaper collage.

7.35 State VI (det.). Fleeing woman. Wallpaper collage.

7.36 *Women at Their Toilette*, 1938. Gouache and collage. 117¾″ × 176⅜″ (299 × 448 cm). Z IX, 103. MPP.

ored composition, *Women at Their Toilette* (7.36), made up largely of wallpaper collages (see the reused one, lower right). The ornate and elegant wallpaper fragment, quite in harmony with the women's languid and colorful air of preoccupation with the sensual titillations of the bath, was, as Picasso surely realized, quite unsuited for a permanent place in the developing *Guernica*.

All four collages were stripped off before Dora Maar made the next photograph, leaving little significant influence on the painted images and no doubt confirming the rightness of the original composition. The sudden appearance and disappearance of the collages, however, could not have been simply a whim. The presence of collage in State IV and then in State VI might well have been stimulated by Picasso's need to be shaken into renewed awareness of the surface of the canvas—to be reminded that he was dealing with painted forms acting upon a flat surface as well as with images of a bull, a horse, and humans in a state of crisis. This thought would have been of especial importance at a time when Picasso was considering the structure of his painting as part of the architecture of the Spanish pavilion. With collage, the tangibility of the surface manifests itself, even if the device risks diminishing somewhat the drama played out by the images. With the wallpaper collages came color, which had already entered into the concept of *Guernica* and been rejected. Both elements, even though not surviving, were part of the experience of the painting as it approached its final form.

State VII

The structure of the painting was now close to its final, more simplified, form (7.37). Only the chaotic collection of shapes making up the fallen warrior in the left foreground remained unclear. Because this figure had remained in this crude form since State III, it appears that Picasso had

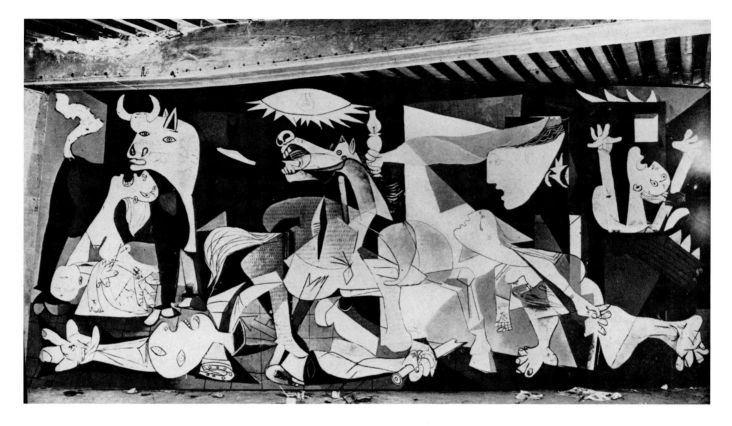

7.37 State VII. Photograph by Dora Maar.

deferred working on it in favor of the more histrionic bull, horse, and anguished women. In a characteristically bold gesture, he resolved the problem of the warrior by painting out the earlier amorphous shapes entwined beneath the horse's hoofs and replacing them with a simple, clear image of the warrior in three separated forms, which remain basically unchanged in the final state. He was guided by two sketches of heads, sketch 43 of 3 June and sketch 44 of 4 June, in which, literally overnight, he rejected the first crude version (7.38, Pl. 43) and arrived at a final image (7.39, Pl. 44). It is a simple spherical head with two rigidly staring eyes, eyes remarkably similar to those in his own self-portraits, except that they are at right angles to each other. The wrenching effect of this device, together with the fixed stare, accentuates the sensation of immobility and death.

Although the head of the warrior is seen as if decapitated, in place of a wound there is a neat edge revealing a hollow interior. Instead of delving into the horror of a beheading scene, Picasso turns back to his experience with classical art to allude to a sculptured or plaster head made to rest on a stand. By suggesting a plaster cast rather than a severed head, Picasso lowers the "reality level" (to use Arnheim's phrase). However, the arm to the right holding the sword appears to be cleanly amputated, and the arm to the left, especially the hand, is marked by ragged, wiry striations that, in accordance with Picasso's basically realist view of suffering, suggest flagellated nerves and pain beyond feeling. This was demonstrated also in some of his many drawings of the Crucifixion. Ironically, the only eyes to

A fragment of white floating in a dark area between the heads of the bull and horse opened up to the artist's imagination the possibility of activating it. Formerly a fragment of the shoulder of the bull, abandoned when the body of the bull was swung around toward the left in State IV, the white strip apparently suggested to Picasso the bird perched on the back of the bull in this exact location in his first rough sketch of 1 May (see 6.1), made more than a month earlier. Following a gesture already developed in some of the women and in the horse, the bird lifts its head in a cry to the heavens (7.41). Another remainder from an earlier form, the triangle, suggested (as it frequently did in cubist still lifes) the top of a common kitchen table, which provided a perch for the bird.

In completing State VII, Picasso increased the vividness of the painting by heightening the dark and light contrasts throughout; he highlighted the flames between the building and the upper right corner and framed the bull's tail within the wall panel to the left. He also increased the clarity of the composition by continuing to enclose active forms within architectural or geometric shapes.

State VIII: The Final Painting

The last photograph of the painting after all the transformations had been made reveals only minor adjustments after State VII. Picasso had worked at making certain areas lighter or darker, thus widening the range of values and increasing the subtlety of the transitions between white and black. These grayer tones, unlike the formerly nearly black background, revealed more clearly some of the drawn images, such as the crying bird. He also made the large elliptical sun more violently explosive by shading the white rays with another pattern of black ones, now so close to the horse as nearly to touch its ear. The effect of the light as a sharp focal point at the climax of a large pyramid is further intensified by the accentuated incandescent light bulb at its center. The further extension of the hatched area downward over the belly and legs of the horse modifies somewhat the dazzling white of the lower central section.

In this last state the ambivalence created by cues suggesting that the scene is both an exterior and an interior one is made even more complex. In the first states the indications of a bull-horse encounter in the arena and the presence of the dwelling clearly created an outdoor environment. But in the final state there are perspective lines in all four corners, clearly indicating the ceiling and walls of a room-size interior space; the light bulb certainly evokes an indoor scene, and the tiles drawn in a perspective scheme extending over the entire ground plane suggest a patio or the floor of a Spanish house. To the extreme right, a door complete with doorknob, similarly depicted in many of Picasso's paintings of interiors from 1925 on, partially opens inward (see Pl. 55).

Perhaps most indicative of Picasso's own devices, however, is the continuous line defining the upper edge of the vertical forms in the background. At the left it distinguishes between a wall and a ceiling, toward the center of the wall it passes *behind* the sun (or the electric light, whose brightness and location suggest an outdoor lamp or streetlight), toward the right it defines a tile roof silhouetted against the sky, further right it

outlines the flames issuing from the roof of the burning building, and at the extreme right, by paralleling the door jamb, it defines once more an interior space.

Although some writers continue to argue that this is either an interior or an exterior scene, it seems apparent that the background and foreground shapes, like a stage set, actually suggest both in different places. Thus Picasso, by indicating at one place one view and at another place another, tells us that there is no single, simple, interpretation. Just as the illumination is both sun and electric (indoor) light, the time both day and night, the place both inside and outside, so the observer is not confined to a specific position in space or even a single level of reality but is imaginatively free to perceive the theme in its widest implications.[19] This freeing of the conventions of representation has been well known in Picasso's work since the early cubist days.

It was no doubt at about this time in the development of the painting that Picasso told Sert that he did not know if it was finished or not but that Sert should pick it up when he was ready.[20]

PART THREE

GUERNICA AS

WORLD HISTORY

Modern Art at the Exposition Internationale

The principal theme of the Paris World's Fair of 1937—officially designated the Exposition internationale des arts et techniques dans la vie moderne—was the glorification of the many rapid advances in modern technology, chiefly in transportation, energy, and the metallurgical industries (8.1, 8.2, 8.3). The Grand Palais was transformed into a Palais de la Découverte, the Gare des Invalides into a Pavillon des Chemins de Fer (8.4), and the spectacular new glass dome near the Pont Alexandre III into a Palais de l'Air, with real planes suspended overhead.

The influence of the architect Le Corbusier was evident in many of the structures. He pronounced himself well satisfied with the way in which much of the painting and sculpture was used not simply to decorate the architecture but to coordinate with it. Although the aim of the fair was not directly to address the social problems of the day, its organizers sought to alleviate the severe unemployment by absorbing some of the jobless into a temporary work force. Artists worked in teams on monumental mural projects. The largest mural, designed by Raoul Dufy, was more than 200 feet long by 60 feet high (61 by 18.3 meters) and was executed by a large crew of painters. Although its style did not reflect the marvels of progress in industry, its theme, *La fée électricité,* paid homage, in dozens of portraits, to the great inventors. The other murals were designed primarily by artists whose own abstract or quasi-abstract styles had developed in the wake of Cubism and bore affinities with industrial and technological products. In addition to Dufy, leading designers included Robert Delaunay, Sonia Delaunay, Fernand Léger, Auguste Herbin, Jean Metzinger, Jean Hélion, Marcel Gromaire, and Albert Gleizes. The director of the national railways, pleased with the colored discs in Robert Delaunay's sketches, presented the artist with an example of the most up-to-date switching signal light, which Delaunay used as a basis for his relief sculpture for the portal of the Pavillon des Chemins de Fer. For the Palais de l'Air, Delaunay was commissioned to create a mural 40 by 60 feet (12.2 by 18.3 meters) to serve as a background for the suspended airplanes (8.5, 8.6). He declared jubilantly that mural art of this kind in the hands of a master artist and a group of artist-assistants was the only true social art.

8.1 (*above*) Entrance to the
World's Fair, seen from the
Trocadéro. German pavilion to
left, Russian pavilion to right,
Spanish pavilion concealed by
trees at extreme left. Photo-
graph by H. Chipault.

8.2 (*right*) Poster promising
gaiety at the World's Fair. Eu-
gène Beaudoin and Marcel
Lods, 1937.

8.3 (*far right*) Postage stamp
on theme of transportation and
the colonies.

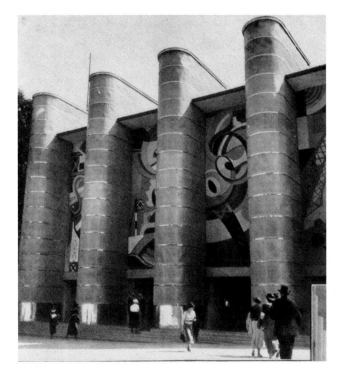

8.4 (*left*) Pavillon des Chemins de Fer. Mural by Robert Delaunay.

8.5 (*above*) Palais de l'Air. Delaunay's team painting the mural.

8.6 (*below*) Palais de l'Air. Mural by Delaunay in background.

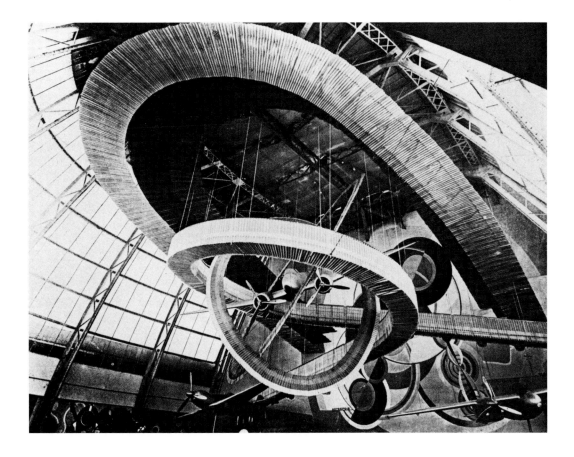

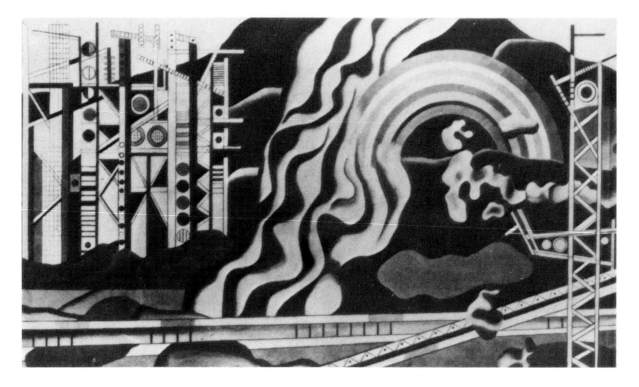

8.7 Palais de la Découverte.
Fernand Léger, *Transmission
of Energy*, 1937. 16′1½″ ×
28′6½″ (4.92 × 8.70 m).

At the time of the fair the role of art in society was a subject of lively
debate.[1] Léger, who was working on his 30-foot (9.15-meter) mural on
the transmission of energy (8.7), went far beyond Delaunay when he con-
ceived the idea for the ultimate social art: teams of unemployed artists
would do nothing less than paint the rest of Paris white and then color the
exposition structures in brilliant varied hues based on his own designs.
He further proposed that artists design shop windows and then sign their
creations as if they were paintings; even buses would be enlivened by bril-
liantly colored designs. Music and song composed by other artists would
ring throughout the entire exposition. At night, motion pictures would be
projected against the sky and onto the walls of the buildings, bathing all
in luminous colors and exerting a powerful psychological effect on the
crowds below. Léger exultantly exclaimed that it would be "Greece on
the banks of the Seine."

Several art exhibitions added sumptuousness to the spectacle. Near the
new Palais de Chaillot, which crowned the heights on the right bank of
the river and provided a grand entry to the fair from the Place du Tro-
cadéro, the new Musée d'Art Moderne gathered a vast retrospective of
French art since medieval times and reassembled the collections of more
recent art formerly held in the Musée du Luxembourg. What at the time
was taken for modern art was assembled under the title Maîtres de l'art
indépendant de 1895 à 1937 at the Petit Palais. Since the director of the
latter had relegated the more avant-garde modern artists, such as Picasso
and Léger, to the basement when he heard the president of the Republic

was to visit the exhibition, Yvonne Zervos (wife of Christian Zervos, editor of *Cahiers d'Art*) persuaded these artists to withdraw their works and then made arrangements for another, larger, exhibition that the director of the Jeu de Paume eagerly agreed to sponsor and to which he contributed the works of numerous other modern masters. Under the title Origines et développement de l'art international indépendant, it was a dramatic survey of the principal modernist movements from Cézanne to nonfigurative art and one of the first attempts in any exhibition to establish a history of modern art movements.[2] Picasso, Joan Miró, Julio González, and Alexander Calder, who were also represented in the Spanish pavilion, were, of course, included.

The feeling within the administration of the fair was optimistic and hopeful, and having accommodated thirty-one million visitors between June and November, it was judged to be a great success as popular entertainment. Few critics, however, related the technological marvels proudly displayed at the exposition to others being produced by the armaments industries of Germany, Italy, and the Soviet Union, whose new planes and tanks were at that moment in action in the Spanish Civil War just across France's southern border. War and preparations for war were in fact being pursued furiously on all of France's major frontiers, and yet neither the fantastic and efficient new machines of destruction nor their consequences were evident in the exposition, nor were the terrible internal conflicts and the tense international relations of 1937 that culminated with the fall of prime ministers in France, Britain, and Spain and the shocking news of the Soviet Union's execution of its senior generals for treason.

During the fair, however, there were violent manifestations by extremists of both the Right and the Left, which led eventually to open conflicts in the streets of Paris. The French economy was in chaos: exports were down by 50 percent, the franc had already been devalued twice in 1937, and unemployment was out of control. France was racked by strikes that did more than merely delay the official opening of the fair: at one point, striking canal boats jammed the Seine between the glittering displays of the marvels of science and industry, and the food distributors at Les Halles joined with the garbage collectors, the metro workers, and funeral-parlor employees to paralyze the city. At one traumatic moment even the restaurants were closed. Yet this vast cloud of complex local problems and issues, to say nothing of international ones,[3] did nothing to dampen the visitors' enjoyment of the modern wonders. It was as if these urgent issues were intentionally shut out from the sight of the millions of pleasure-seekers who flocked to the fair.

In contrast both to the spirit of pleasure and to the spectacular architecture on both banks of the Seine, the Spanish pavilion was devoted to the struggles and suffering of the Spanish people. Opening about seven weeks late, it was mentioned in only the later of the lavishly illustrated souvenir programs and failed to appear on the official maps or to receive any mention in the publicity accompanying the official dedication by the president of the Republic on 24 May. Further, it was assigned a location, along with the smaller and more remote countries, on the right bank at some distance from the central area around the Eiffel Tower, where all of France's Western European neighbors, as well as her political and military allies, were located (8.8). With perhaps unintentional yet cruel irony, the modest structure of steel frames and prefabricated walls (consisting of a *rez-de-chaussée* and two stories) was nestled beside Albert Speer's mon-

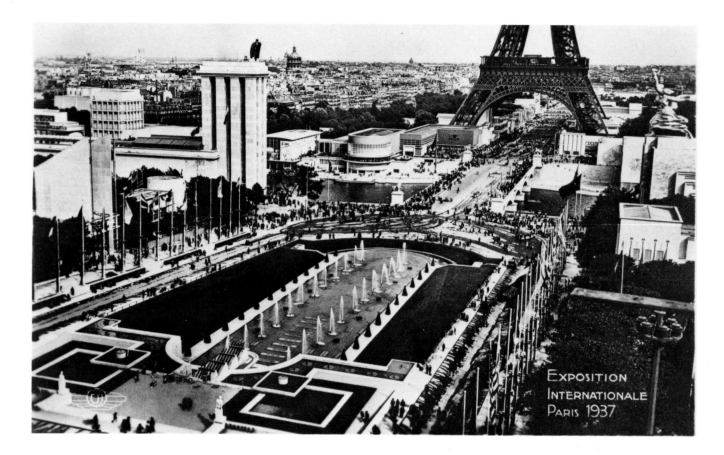

EXPOSITION
INTERNATIONALE
PARIS 1937

8.8 (*above*) View from
Trocadéro. Spanish pavilion is
the low, flat structure second
from left. Photograph by H.
Chipault.

8.9 (*right*) Russian pavilion
seen from German pavilion.
Photograph by A. Steiner.

8.10 Russian pavilion.
Photograph courtesy Commissariat Général de
l'Exposition.

8.11 German pavilion. Albert
Speer, architect. Spanish pavilion just to the left is obscured.
Photograph by H. Roger
Viollet.

strous Nazi neoclassic tower; its entrance was ornamented by belligerent
male nude sculptures (8.11), and, with its crowning eagle, it soared higher
than any other structure in the exposition, including even the enormous
and equally overbearing Soviet tower facing it across the promenade
(8.10). The administration had shrewdly assigned these two representatives of gigantism facing sites along the Seine. Their pavilions, both aggressively jutting forward and upward, grossly out of scale with the other
structures, served thus to negate each other (8.9).

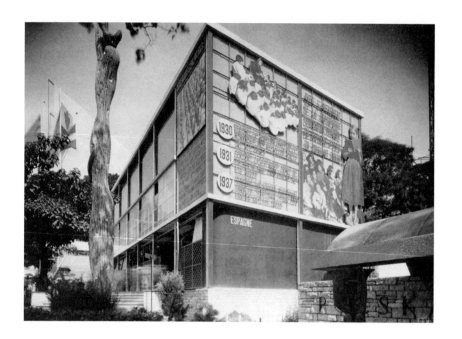

8.12 Entrance to Spanish pavilion. Photomurals depict progress in education and the popular army. Left of center, sculpture by Alberto Sánchez, *The Spanish People Follow a Way That Leads to a Star,* wood, believed lost. Photograph by H. Baranger.

8.13 *Guernica* in place. In foreground (left to right): Calder, Sert, and Picasso. The photograph was probably taken before the opening since the distant pier is still in the process of being removed and Calder's mobile has not been installed.

Guernica in the Spanish Pavilion

The Spanish pavilion itself was planned primarily as a propaganda manifesto to express the social and political aims of the Republic and the suffering imposed on the Spanish people by the civil war (8.12).[4] Located on a wall flanking the entrance, *Guernica* provided a dramatic focus for the Spanish cause (8.13). Except for five female figures by Picasso—three in cement (8.14), one in plaster, and another in bronze on the upper floor[5]—all the art was related to the aims of the Republic. As he lay the cornerstone on 27 February 1937, the Spanish ambassador, Luis Araquistáin, sounded with great eloquence a passionate appeal for the Republican cause:

> If for the past several months our common frontier has ceased to be a geographical expression suddenly to become a military one, the fault lies not at all with the Spanish Republic but rather with those who from within and without have in a criminal manner attacked us. We are now defending ourselves against them in order to reestablish not only the independence and sovereignty of the Spanish people but also the traditional equilibrium of our frontier and all that it symbolized before July 1936.[6]

The main facade facing the promenade that led down from the Trocadéro steps toward the Eiffel Tower was dominated by an enormous photomural of ranks of soldiers, accompanied by slogans:

> We are fighting for the essential unity of Spain
> We are fighting for the integrity of Spanish territory
> We are fighting for the independence of our country and for
> the right of the Spanish people to determine their own destiny.

8.14 (*far left*) Picasso, *Head of Woman*, 1931. Cement. S. 133.

8.15 José María Sert, *Intercession of Santa Teresa in the Spanish Civil War*, 1937. Oil. Represented Nationalist Spain in Vatican pavilion. 19′8″ × 9′10″ (6 × 3 m).

In general, the administration of the fair ignored the existence of Franco's Nationalist regime; with only a few exceptions, it was not accepted as a government by the world community and hence was not invited to participate. The Nationalists' cause, however, was represented by the Vatican (whose pavilion, ironically, lay just behind the Spanish building) in their own painting glorifying the intervention of Santa Teresa de Jesús in the Spanish Civil War, by José María Sert—not to be confused with Josep Lluis Sert, the architect for the Spanish pavilion (8.15).

The first sculpture to meet visitors' eyes as they turned off the promenade and approached the Spanish pavilion was Alberto Sánchez's 39-foot (11.9-meter) quasi-abstract wood column entitled *The Spanish People Follow a Way That Leads to a Star* (see 8.12). Before reaching the entrance, they passed Julio González's *Montserrat*, a life-size figure in sheet iron of a woman protectively holding a child on her left shoulder and wielding a sickle in her right hand (8.16). This figure was generally referred to at the time as *Peasant Woman of Montserrat*, but no commentator failed to note her heroic posture and her firm grip on the sickle.

Opening out laterally, the entrance hall featured in the center Alexander Calder's circular fountain-mobile, *Spanish Mercury from Almaden* (8.17). A shallow bowl spilled the mercury into a narrow channel that then directed the flowing metal against an oscillating disc (painted red, according to Calder, as a symbol of the Republic).[7] To the visitors' right, covering the entire end wall and designed like a theater backdrop, was Picasso's *Guernica* (8.18). As though seeking refuge, the Basque government, now in exile, posed with it (8.19). To the left of the entry and squarely facing the painting was a large photomural depicting the poet Federico García Lorca who, assassinated in the first days of the war, had become a martyr of the cultural Left (8.20). Opposite the entrance was an

8.16 Julio González, *Montserrat*, 1937. Sheet iron. At entrance to Spanish pavilion.

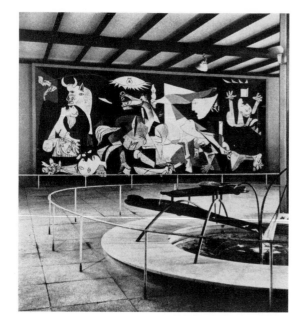

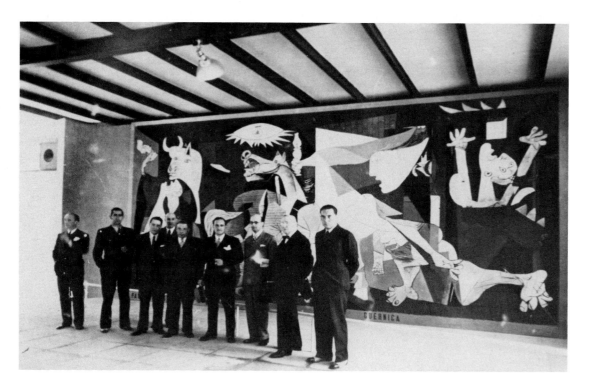

8.17 (*above, left*) Alexander Calder, mercury fountain, *Spanish Mercury from Almaden,* in foyer at entrance to Spanish pavilion.

8.18 (*above, right*) *Guernica.* (Calder's mobile in foreground.) Photograph by Hugo Herdeg.

8.19 Basque Government-in-exile (about August 1937). Photograph courtesy Archivo Histórico Nacional, Sección Guerra Civil; Sección Político-Social, Serie Madrid, Expediente Pabellón Español en París (1937) (legajo 2.760).

open-air auditorium where Luis Buñuel had arranged for the showing of an almost continuous program of documentary films on the war (8.21). Featured were *Spanish Earth* by Joris Ivens and Ernest Hemingway (8.22), *Madrid '36* by Buñuel, *The Heart of Spain* by Paul Strand, and *On ne passera pas* (They shall not pass), which used the slogan made immortal by the French defense of Verdun in 1916 and taken up as ¡*No Pasaran*! by the besieged Madrileños.[8]

FEDERICO GARCIA LORCA
POETE FUSILLE A GRENADE

8.20 (*left*) A large photo-
mural of the assassinated poet
Federico García Lorca oc-
cupied the wall opposite
Guernica.

8.21 (*below, left*) Audi-
torium. *Guernica* to left, Cal-
der's mobile at center.

8.22 (*below, right*) *Spanish
Earth*. Still photo from the
film by Joris Ivens and Ernest
Hemingway.

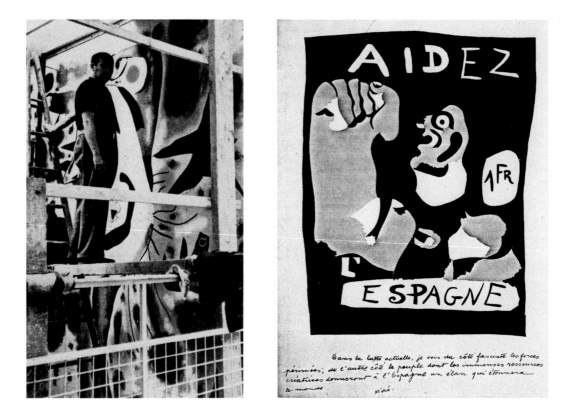

8.23 (*left*) Joan Miró paint-
ing *El segador* in place on
staircase.

8.24 Miró, *Aidez l'Espagne.*
Color stencil.

On the stairway leading down from the galleries Joan Miró's 17-foot-
high mural (5.19-meter) *El segador* (The Reaper) was visible everywhere
(8.23). It is in his characteristic quasi-abstract surrealist style of the time,
although it clearly shows such politically evocative symbols as a Phrygian
cap, a sickle, and a large five-pointed star. It can hardly be a coincidence
that the Catalan national anthem (Miró is Catalan) bears an almost-
identical title, *Els segadors* (The Reapers) and that the lyrics extol farmer-
heroes, armed only with their sickles, battling an invader. The anthem
begins:

> The sickle is both weapon and tool:
> Triumphant Catalonia
> Will again be bountiful and rich . . .
> Praise the work of the sickle
> Defender of our land.

At the same time as the mural, Miró made the color stencil *Aidez l'Espa-
gne,* depicting a Spanish peasant, which he donated, as Picasso had given
the *Dream and Lie of Franco,* to the Republic for refugee relief (8.24).
The figure is related in style to *El segador* but clearly shows the clenched-
fist salute. In an inscription at the bottom of the stencil, Miró made his
meaning clear: "In the present battle, I see on the Fascist side ruinous
forces, on the other side the people, whose immense creative forces will
give Spain an élan that will astonish the world."[9] The two artists were
honored with a ceremony in the presence of their work (8.25).

8.25 Picasso and Miró in the
Spanish pavilion. Photograph
by Dora Maar.

The first floor was devoted mainly to posters on the educational and
social aims of the Republic (8.26, 8.27) and to photomurals on the life of
the people under stress of the war,[10] the second floor, to the work of other
Spanish artists (8.28). Paul Eluard's poem "La victoire de Guernica,"
conceived at roughly the same time as Picasso's painting, was posted on a
wall next to a photograph of the ruins of the town. The fourteen-stanza
poem begins:

> 1.
> Fine world of ruins
> Of mine and of fields

> 2.
> Faces staunch in the fire faces staunch in the cold
> Against denials of the night of curses of blows

> 3.
> Faces always staunch
> Here is the void staring at you
> Your death shall be an example

> 4.
> Death a heart cast down.[11]

8.26 Photomural on education for the people.

8.27 Photomural of audience watching Federico García Lorca's La Barraca troupe.

8.28 Andrés Fernández Cuervo. *Bombardment, 1937.* Woodcut. Many works in the modern art section portrayed the war.

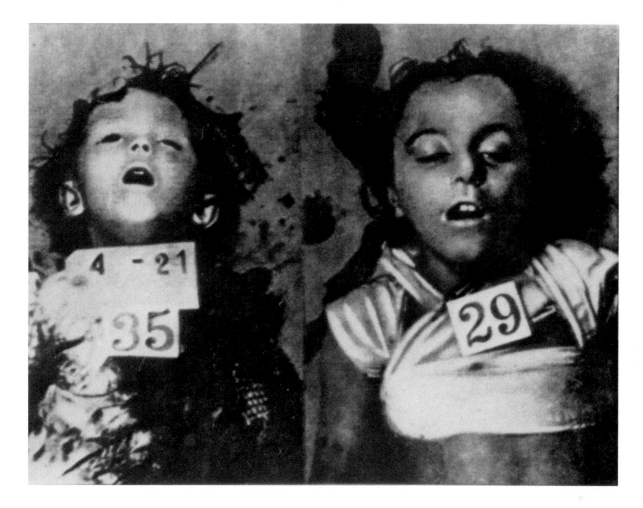

Thus the pavilion—from the photomurals on the facade, to the documentary films of the war, to the photographs of the people at work and at war—was devoted to the trials of the Spanish people. Beginning with *Guernica* in the foyer, visitors received a realistic, if shocking, foretaste of the grim message of the stricken Spanish Republic (8.29).

8.29 Children killed in the bombardment of Madrid. Propaganda photographs.

Critical Responses in Paris

Despite the great prestige attached to Picasso's name, *Guernica* and indeed the entire Spanish pavilion were virtually ignored by the press. Because the building opened seven weeks after the official inauguration of the fair (which itself opened more than three weeks late), mention of it was precluded in all but a few of the illustrated magazines, souvenir catalogues, or publicity notices.[12] Only *L'Humanité* mentioned the opening of the Spanish pavilion, and then primarily to feature the personalities present, most of them Soviet diplomats and French Party officials. It illustrated *Guernica* just once, three weeks later. The main objection to the painting, according to Le Corbusier in one of his critical reviews, was that the exposition was devoted to entertainment, and whereas most of the murals, such as Dufy's *La fée électricité,* demonstrated "la belle pein-

ture," Picasso's did not. Because of this, wrote Le Corbusier, *Guernica* "saw only the backs of the visitors, for they were repelled by it."[13]

The official German guidebook to the fair reflected Hitler's views on modern art as expressed in his speech in Munich at the time of the infamous Degenerate Art Exhibition. By an ironic coincidence, the Munich exhibition, which ridiculed works by most of the masters of modern art, opened the week after *Guernica* was first revealed in the Spanish pavilion. The German guidebook, dismissing the pavilion of "Red" Spain as containing nothing of importance, noted only one unnamed painting (surely *Guernica*), which it said seemed to represent the dream of a madman, a hodgepodge of parts of bodies that a four-year-old child could have painted. Even *L'Humanité* could find nothing to say for *Guernica*, although of all the politically polarized journals, for weeks it alone had been hammering on the horrors of the terror bombing that had precipitated Picasso's painting and on the guilt of the German Condor Legion that had caused it. Even Louis Aragon, Picasso's friend and a contributor to *L'Humanité*, avoided any mention of the artist or *Guernica* and only repeated his earlier attacks on the insipidity of artists who created palliatives for the walls of the rich and the powerful. In accordance with the theme of the exposition, he urged artists "to be engineers of the soul," but his own tastes demonstrated that he meant they should paint "social" themes in the "realist" style as defined by the Party.[14]

A powerful defense of *Guernica* and the cause of the Spanish pavilion was almost immediately marshaled by the artists, writers, and poets of the *Cahiers d'Art* circle, who devoted almost an entire double issue of the summer of 1937 to Picasso's mural. It is an exhaustive publication, heralding a painting virtually unknown except to Picasso's friends. All the sketches and preliminary paintings were published, including Dora Maar's photographs of the progressive stages of the painting and of Picasso at work on it.

In a remarkable display of unified action, the writers joined on short notice to discuss *Guernica* and Picasso from many points of view. They contributed essays on the painting, on Picasso, on his Spanish characteristics, on Franco, on Goya and El Greco, and they wrote several poetic evocations of the themes in *Guernica*. All the authors were, of course, staunch supporters of the Spanish Republican cause, and although they were generally lyrical rather than analytical when it came to the painting, they provided important insights into the ideological climate of Picasso's environment. Among the authors were the leading poets and writers on art in Paris: Christian Zervos, Jean Cassou, Georges Duthuit, Paul Eluard, Michel Leiris, José Bergamín, Juan Larrea, and Amédée Ozenfant. They not only glorified *Guernica* as a political document but also ridiculed the Communist party's stand on art. Ozenfant attacked the platitudes of what the Party called "correct thinking," noting that "because they ignored the poetic or musical values, they failed to achieve any social effects at all. . . . Our epoch is grand, dramatic, and dangerous, and Picasso, because he is equal to his circumstances, makes a picture worthy of them." *Guernica* is about our times, for it is an "appalling drama of a great people abandoned to the tyrants of the Dark Ages. . . . All the world can see, can understand, this immense Spanish tragedy."[15] One of the deepest insights into *Guernica*'s meaning was gained by Leiris, the

poet and ethnologist: "Picasso sends us our letter of doom: all that we love is going to die, and that is why it is necessary that we gather up all that we love, like the emotion of great farewells, in something of unforgettable beauty." [16]

Deeply moved by the message of the Spanish pavilion, Luc Decaunes warned that it was no place for the

> connoisseur of the picturesque who came expecting to see beribboned bull-fighters and flamenco dancers. . . . From the ferocious *Guernica* to the tragic face of the assassinated poet Federico García Lorca . . . to the scenes cut from the living flesh of martyred people all is war, war, war. . . . Like a sword of Damocles dripping blood . . . the entire pavilion was a terrible indictment by a people face-to-face with their assassins. [17]

Despite the intense controversy from the first over the meaning of *Guernica,* Picasso steadfastly avoided committing himself to any specific interpretation of its symbolism, speaking instead only of his repugnance for the Nationalists and of his support for the Republic. When interviewed by Georges Sadoul during the installation of *Guernica,* Picasso declined to explain the painting. He would talk only of the war, the grave news of the destruction of the Basque forces, and the plight of the refugees at that moment fleeing by sea to French ports on the Bay of Vizcaya. He was proud of his role in supervising measures for the protection of the paintings of the Prado now sheltered in Valencia, but he minimized his own position as honorary director, stating that "the true conservators of the Prado cannot be the scientists or artists but those in the day-by-day reality, the tank crews, the aviators, all the soldiers of the popular army who fight before Madrid." [18]

The Exposition Closes

When the exposition formally closed on 1 November 1937, there was general hope that because of its great popularity it would open again the next summer. But Hitler's threats against Austria aroused French anxieties over being surrounded on all sides by armies on the march, and in January 1938 the decision was made to demolish all the pavilions. The French fears were justified when the German army invaded Austria two months later, annexing it in April to the Greater German Reich. Similar and equally successful actions that followed immediately against Czechoslovakia resulted in the Munich conference in September 1938 and the dismemberment of that country at the hands of its allies and Hitler.

The specter of a similar betrayal by Britain and France was grimly contemplated by the Catalan militia, then retreating to the Mediterranean in the face of concentrated attacks by Nationalist troops heavily supported by the Condor Legion and by Italian troops and aircraft. As Franco drove to divide the remaining portion of Republican territory, Italian bombers based on Majorca executed on 16 March the heaviest bombing raid of the war: forty-eight hours of continuous attacks on the waterfront area of

Barcelona. By now, however, such an event excited no special mention in the Paris press, nor did the hundred thousand Catalan refugees fleeing into France to escape what for many would have been prison or death.

The bombing of Guernica in April 1937 had been only the beginning of the gradual crushing of resistance in the Basque countries that led in June to the fall of Bilbao, in August to the flight of the Basque government, and finally in October 1937, with the fall of Gijón, to the Nationalist occupation of all of northern Spain. With the defeat of the Basques and the Asturians, Franco had not only conquered the most fiercely independent Republicans but had gained control of Spain's greatest concentration of coal and iron mines and heavy industries. His success led Britain promptly to recognize him as the ruler of Spain. While this strengthened Britain's hand in the competition to regain its old dominion over Spain's rich mineral resources, it weakened its resolve to continue opposing German and Italian intervention. At the same time, Soviet military aid to the Republic was dwindling. Hugh Thomas describes the coincidence of the conclusion reached independently by Hitler in Germany and by the Politburo in Russia that it was to each nation's advantage to continue the war in order to keep the other involved in a foreign adventure while conserving its own soon-to-be-needed resources. The end of 1937 saw the beginning of the war of attrition—as Thomas termed the battles around Teruel in the east—that early in 1938 resulted in a Nationalist force reaching the Mediterranean, isolating Barcelona, and leaving a single precarious road connecting Madrid with Valencia on the coast and, through it, the rest of the world.[19]

When the Spanish pavilion was disassembled, the mural by Miró and the sculpture by Sánchez, along with posters, photographs, and artifacts shown in the pavilion, were returned by sea to Valencia. In the meantime, however, the Republican government had fled from Valencia to Barcelona, where it joined with the Catalan Generalitat. No doubt owing to the chaotic conditions during the preparations for the defense of both these cities, neither Miró's work of art nor Sánchez's was ever seen again.[20] The paintings and sculptures made by those artists living in Paris—Picasso, Calder, and González—were returned to them. It was then for the first time that Picasso declared to Sert and his Spanish friends his oft-repeated wish that *Guernica* should go to Madrid. Only later, when Madrid had fallen, did he clarify that it was to be returned after the Republican government had been reestablished (see chapter 10).

Picasso was later quoted many times as saying that *Guernica* should eventually go to Madrid, a statement he eventually put in writing; but what he surely meant at that critical period in 1937 was that it should return to the care of the Republican government that had commissioned it. Indeed, he himself, as honorary director of the Prado, was a member of that government. In June 1937 he had donated his most specifically political statement of all, the *Dream and Lie of Franco*, as well as paintings, money, and statements of support to the Republican government. His loyalty to the Republic was further demonstrated by what was probably his first direct gift to Spain—the large etching *Minotauromachy* of 1935—donated to the Museo d'Arte Moderna in Barcelona. Most significant is the date of the gift—30 September 1938—a time when the Republic was suffering its most devastating, ultimately mortal, blows. In August the International Brigades were withdrawn from the battle lines, and on 22 September a tearful farewell parade took place in Barcelona. The crowd,

overcome with emotion, was swept away by the oft-quoted fervent cry of La Pasionaria (Dolores Ibarruri): "We shall not forget you, and when the olive tree of peace puts forth its leaves again, mingled with the laurels of the Spanish Republic's victory—come back!" At this moment, when the Republic seemed doomed and Premier Juan Negrín was frantically seeking a truce that would avoid annihilation, Picasso chose to demonstrate his support of Republican Spain by this gift.

It is well known that even during the last days of the Republic Picasso kept himself informed on conditions in Spain, not only through his friends who were working for the government or in refugee relief but also through leftist newspapers and the pamphlets and bulletins of Agence Espagne. He was a regular reader of *L'Humanité*,[21] where articles by two of his closest friends, Aragon and Eluard, appeared. Another friend, Larrea, was director of Agence Espagne, which published a daily international news bulletin on the events in Spain. That Picasso read this can be proved by a drawing he made on the back of this mimeographed news sheet— one of his most charming depictions of his three-year-old daughter, Maya. It was dated 19 November 1938, almost the day that France learned of the Anglo-Italian accord of 16 November that marked the end of British efforts for nonintervention in Spain and, in effect, London's abandonment of hope for the Republic.

By the summer of 1938, since the fortunes of the Republic were going badly and there was no longer any possibility of using the refugee art from the Prado on its behalf, it seemed reasonable to engage *Guernica* in the struggle to alleviate the suffering of the victims. From the very beginning of the war, English and American relief agencies with offices in Paris and close contacts with Republican officials had taken the lead in providing ambulances, medical personnel, and supplies for the Republican troops; but by the end of 1938 their efforts were devoted mainly to sending food for the relief of growing throngs of refugees. In the past, the American agencies alone had been able to send an average of about ten thousand dollars a month, used principally for the support of orphanages in Spain, for food for the refugees in France, and for assisting Americans who had fought in Spain. Herman Reissig, chairman of the two American agencies providing most of the aid, also served as director of the Comité internationale de coordination et d'information pour l'aide à l'Espagne républicaine, whose members included such masters in influencing public opinion as the English author Norman Angell and the French Communist leader Jacques Duclos. Picasso's friends among Republican officials, leftist intellectuals, and Communist party members were active in the various relief agencies, and they joined Picasso in seeking all the possible means by which *Guernica* could continue to serve the Republic.

To the crowds at the Paris Exposition, the painting had appeared only as a reminder of a horrifying event, soon to be forgotten. Only in the offices of various propaganda agencies, such as the committees against war and fascism and for aid to Spain, most of them creations of the fertile mind of Willy Muenzenberg, was the propaganda value of *Guernica* fully realized. They sought to keep alive the bitter charge that the German Condor Legion, operating in the service of Franco, was responsible for the terror bombing of Spanish civilians. When the exposition ended, *Guernica* was available to serve abroad, as many Spanish officials and war heroes had already done. Now the Basque claims were to be supported on an international scale by a world-renowned painting.

THE ODYSSEY

OF GUERNICA

Guernica in Scandinavia and Britain, 1938

Even before it was finally decided that the World's Fair would not be continued for a second summer, Picasso lent *Guernica* to a large traveling exhibition of four French artists arranged by Paul Rosenberg. Comprising 118 paintings by Henri Matisse, Picasso, Georges Braque, and Henri Laurens, the exhibition toured Norway, Denmark, and Sweden between January and April 1938. Opening at the Kunstnernes Hus in Oslo, it moved to the Statens Museum for Kunst in Copenhagen and then to the Liljevalchs Konsthall in Stockholm. Its last stop before returning to Paris was the Konsthallen in Göteborg. Scandinavia in 1938 seemed far removed from the intense political issues and military threats that were undermining whatever trust still remained among the countries of Western Europe: the terror bombing in Spain that had launched *Guernica* and all the dramatic events that ensued were barely mentioned. Thus it is not surprising that *Guernica,* placed among largely retrospective works by artists who were at least as well known as Picasso, did not raise the heated controversy it had in Paris.

After its return from Sweden in April, *Guernica* apparently remained in Picasso's studio until September, when Picasso shipped it, together with many of the preparatory drawings (which had not been exhibited in either Paris or Scandinavia), to the National Joint Committee for Spanish Relief in London. It was shown at the prestigious New Burlington Galleries, a private gallery off Regent Street, from 4 to 29 October 1938 (9.1, 9.2).[1] The *Guernica* show drew the relatively low attendance of three thousand persons (compared with the fifty thousand who attended the next Burlington exhibition, a retrospective of the late Christopher Wood).

Guernica then moved to the Whitechapel Art Gallery in the East End, where it drew twelve thousand persons during an even briefer showing. The exhibition was held there largely through the vocal support of the Labour party and, in particular, the active encouragement of its leader Clement Attlee, who had recently toured Republican Spain in support of its struggle. Attlee arranged a formal preview of the painting in Whitechapel, where he delivered a tribute to the social ideals of the Republic to a largely leftist, working-class audience (9.3). The artist David Hockney relates that his father remembers the price of admission to the exhibition

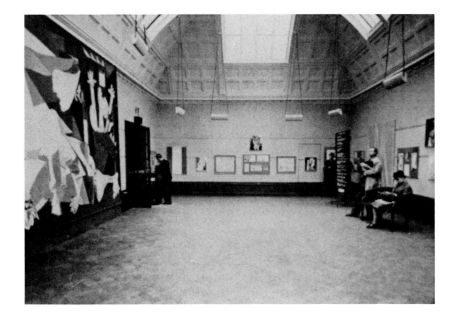

9.1 *Guernica* and the sketches in the New Burlington Galleries, London, October 1938.

9.2 Announcement of the exhibition, 4–29 October 1938.

9.3 *Guernica* in the White-chapel Art Gallery, London. November 1938. Clement Attlee speaking, Roland Penrose far right.

being a pair of reusable boots; the painting itself was displayed behind rows of boots waiting to be repaired and shipped to the Republican troops.[2] The last exhibition of *Guernica* in England was in Manchester, where the joint committee had arranged for a showing from 1 to 15 February 1939 in a rented automobile showroom on Victoria Street. It had been widely publicized that the proceeds from this exhibition were to go to a "Manchester foodship to Spain," and this introduction may have influenced the critics to discuss the painting in terms of the civil war. The *Evening Chronicle*'s headline announced, "'NIGHTMARE' PICTURE OF GUERNICA BOMBING COMES TO CITY." The large working-class audience was deeply moved, especially since the poem and etching *Dream and Lie of Franco* and the sketches for *Guernica* were included. The critic of Manchester's *Evening News* wrote, "The picture does not do justice to the studies, but no one could fail to be impressed by a tremendous work which more than any words, condemns the crime of war."[3]

In Paris *Guernica* had been seen and appreciated mainly by a small group of poets and artists—and of course by many of the Republic's sympathizers. The British exhibitions, although attracting wide public attention—just as the bombing of the city had aroused nationwide outrage—drew severe criticism from conservative critics and artists. Roger Hinks in the *Spectator,* ignoring the political issues of the war and turning to art, charged that by using cubist techniques Picasso "introduced all sorts of intellectual puzzles and period oddities into a work which ought to make a frontal attack on the emotions."[4] On the other hand, Stephen Spender, recently returned from Madrid, staunchly defended *Guernica* in the *New Statesman and Nation:* "It is the picture of horror reported in the newspapers . . . one of the dominating realities of our time."[5] W. H. Auden's poetry resounded with the force and tragedy of the Spanish Civil War: "Tomorrow for the young the poets exploding like bombs," and yet he returned from service at the front ever after to remain silent on the war.[6] In contrast, T. S. Eliot avoided the theme altogether: "At least a few men of letters should remain isolated and take no part in these collective activities."[7]

Led by Anthony Blunt, several English commentators condemned Picasso for taking up a social theme. In a lively exchange in the *Spectator,* Blunt charged that Picasso had isolated himself in the temple of art and appeared pathetic when he ventured out into the real world. He accused him of failing even to understand the issues of the Spanish Civil War. In rejoinder, Herbert Read cited *Guernica* as convincing evidence that Picasso was not at all as detached from the Spanish struggle as Blunt tried to make out. He pointed out that Picasso was an active participant, for he was not only serving as honorary director of the Prado for the Republican government but had painted *Guernica* for that government. Further, the painting had certainly gone before the public, where Blunt had said art should be judged—in this case on the grounds of the Paris World's Fair—and was now in central London, where thousands of people had seen it.[8]

Underlying this debate was a long battle between, on the one hand, the modern artists—mainly the surrealists and the abstract painters—and, on the other, the Marxist theoreticians and social-realist artists. Blunt, along with a coterie of Cambridge graduates and several artists of the conservative Slade School, followed the Marxist line that the primary duty of art was to serve the ends of a social or political movement. He charged Picasso with living his entire life in an ivory tower—a "Holy of

Holies"—together with a circle of aesthetes who ignored the realities of the contemporary world. Under the title "Picasso Unfrocked," he attacked *Guernica* as "abstruse circumlocutions" with no meaning for serious people and then proceeded to advise Picasso that he should see more than just horror in war and should avoid producing work so complex or esoteric that ordinary people had not time or energy to decipher it.[9] He had written earlier that *Guernica* "is the same as Picasso's bullfight scenes. It is not an act of public mourning, but the expression of a private brain storm which gives no evidence that Picasso has realized the political significance of Guernica."[10]

Read, in turn, attacked Blunt as one of the "middle class doctrinaires who wished to use art for the propagation of their dull ideas," clearly a reference to the social realism promoted by Soviet and other totalitarian regimes. He took the occasion to define his view of the modern spirit in art, defending *Guernica* as a profound expression of this spirit. "The monumentality of Michelangelo and the High Renaissance cannot exist in our age," he wrote, "for ours is one of disillusion, despair and destruction." *Guernica* "is a monument to destruction—a cry of outrage and horror amplified by the spirit of genius." And he continued prophetically:

> Not only *Guernica,* but Spain; not only Spain, but Europe, is symbolized in this allegory. It is the modern Calvary, the agony in the bomb-shattered ruins of human tenderness and frailty. It is a religious picture, painted, not with the same kind, but with the same degree of fervour that inspired Grünewald and the Master of the Avignon Pietà, Van Eyck and Bellini. It is not sufficient to compare the Picasso of this painting with the Goya of the "Desastres." Goya, too, was a great artist, and a great humanist; but his reactions were individualistic—his instruments irony, satire, ridicule. Picasso is more universal: his symbols are banal, like the symbols of Homer, Dante, Cervantes. For it is only when the widest commonplace is infused with the intensest passion that a great work of art, transcending all schools and categories, is born; and being born, lives immortally.[11]

After the showing in Manchester, Picasso asked that *Guernica* be returned to him for shipment to New York.[12]

Guernica in America, 1939–1981

On Monday morning, 1 May 1939, the French liner *Normandie*, arriving from Le Havre, docked at New York's Forty-eighth Street pier. Later that same morning a long wooden case containing Picasso's *Guernica,* rolled on a wooden cylinder, was laid out on the dock along with three small flat cases containing seven paintings and a bundle of drawings (see Appendix, Doc. 8). The date was two years to the day after Picasso had started the first sketch for the painting that after three and a half months at the Paris World's Fair had become his most famous work. The stay in America, planned for a few months, was to last for forty-two years; during this time *Guernica* became recognized not only as one of the great monuments of modern art but also as a unique example of the role a powerful work of art could play in forming our view of the condition of the modern world and even in shaping political history itself.

one of them before the painting in the gallery and another at the newly opened Museum of Modern Art, led by Walter Pach and including artists Arshile Gorky and Peter Blume and critics Malcolm Cowley, Leo Katz, and Jerome Klein. The symposia added forty-one dollars to the relief fund.

New York critics, unlike the Parisians, tended to see *Guernica* as a work of art more than as a document of the Spanish Civil War. One reason was that it was shown in the familiar environment of a Fifty-seventh Street art gallery where Picasso's work had been seen for many years; the other was that the addition of the sixty-odd sketches and drawings reminded viewers of the painting's origin and development in the studio and made it more accessible. Further, the war in Spain had ended a month before, and current newspaper reports focused on refugees living on the beaches in southern France. *Guernica* "began as propaganda," said Henry McBride, "but it ended as something vastly more important—a work of art." McBride concluded that it was, "from any point of view, the most remarkable painting to be produced in this era."[20] Like McBride, Jerome Klein seemed surprised but greatly impressed by Picasso's theme: "The heroic tradition from which artists had been retreating for more than a century was to be rededicated by the painter who was the very symbol of unbridled fantasy."[21]

A vocal minority, however, ignoring the import of the subject, attacked *Guernica* on aesthetic grounds. Peyton Boswell, editor of the influential *Art Digest,* wrote a well-balanced summary of the controversy under the title "*Guernica* Misses the Masses, but Wins the Art Critics," a phrase that was widely repeated.[22] But the true enemies of the painting were not the masses; rather, as in London, they were often people of culture and refinement who opposed modern art, believing that it threatened traditional values. Edwin Alden Jewell of the *New York Times* was perhaps the most influential of these, bemoaning the "foreign values" of modern European art and castigating the "grotesque shapes, human and animal, flung into a sort of flat maelstrom" in *Guernica.*[23] The representative of the masses, the Communist *New Masses,* could accept Picasso's painting for its vigorous protest against the action of "fascist bombers" but could say nothing for the painting itself. Instead, even as late as 1945, it printed articles questioning aspects of Picasso's art, such as Rockwell Kent's charge that the bull was only a "stuffed and dead-eyed trophy."[24] The editor of the journal, when questioned by Alfred Barr on her ambivalent attitude toward Picasso, is said to have replied quite simply that art was art and politics was politics.

On the whole, however, extensive comment and discussion of *Guernica* awaited the Museum of Modern Art's great exhibition of Picasso's work beginning in November 1939. With this forty-year retrospective, *Guernica* became assimilated into the first broad view of Picasso's entire art, and it was judged as the most recent, but not always as the greatest, of his major works. By this time Britain and France were at war with Germany, and the Spanish Civil War and the plight of its victims were relegated to history. *Guernica*'s imagery could now be seen as prophesying the fate of all the Western world. Nevertheless, the painting was consistently addressed in terms of its formal qualities. Stuart Davis praised it but could say only that it was "one of the greatest formal syntheses of all time," reflecting the predilection of most of the leading American modern artists for abstraction.[25] Still, both critics and artists recognized that the emotional power of *Guernica* derived from Picasso's first attempt, in the

words of Elizabeth McCausland, to turn his gaze outward, "away from the depths of subjective experience to the tragedies of social experience."[26] She added poignantly:

> He has found his soul not in the studio, not in the laboratory of plastic research, but in his union with the people of his native land, Spain. In the painting, *Guernica,* he functioned not only as a son of Spain but as a citizen of the democratic world.
>
> And how did he function in this new unusual capacity? By bringing to it the cumulative experience of the previous 40 years' experiments.
>
> He wants to cry out in horror and anguish against the invasion of and destruction of the Spain of his love. He wants to protest with his art against the betrayal accomplished by Franco and his fascist allies. He wants to awake in the breasts of all who see *Guernica* an inner and emotional understanding of the fate of Spain.

Sidney Janis's energetic efforts on behalf of the relief committee resulted in a nationwide tour for the Picasso exhibition, beginning at the Stendahl Art Galleries on Wilshire Boulevard in Los Angeles (9.5) and moving to the San Francisco Museum of Art and the Arts Club of Chicago before returning to New York in time for the Modern's Picasso retrospective. The Motion Picture Artists' Committee for Spanish Orphans sponsored an elaborate preview on 10 August at the Stendahl Galleries that drew luminaries of the film world, many of whom, such as Fritz Lang, Galka Scheyer, George Balanchine, Ernst Lubitsch, Luise Rainer, and Ernest Toch, had been refugees themselves. California Governor Culbert Olson, Walter Arensberg, Bette Davis, Dashiell Hammett, Dorothy Parker, Edward G. Robinson, and, in fact, most of the movie community attended. In the gallery the local chapter of the American Artists' Congress arranged a panel discussion, which included the critic Merle Armitage, the collector Preston Harrison, and the artists Lorser Feitelson and Stanton Macdonald-Wright. This event and the painter Fletcher Martin's brilliant defense of modern art caused the press in Los Angeles generally to ignore *Guernica*'s meaning and to focus instead on the protests against all modern art by the conservative portraitists and California scene painters. The *Herald Express* proclaimed "PUBLIC REACTING AGAINST 'CUCKOO' ART," the *Los Angeles Examiner* headlined "'MODERN ART' CLASSED AS 'BUNK,' 'REVOLTING,' 'UGLY,'" and the *Los Angeles Times* heralded the news—at that time untrue—that Picasso was a Communist.[27] Meanwhile, the critics waged their own battle, the *Los Angeles Evening Herald and Express* venting outrage over Picasso's painting with approval of the ultraconservative regionalist movement Sanity in Art: "ART SANITY PROPONENTS FOR PROGRESS, RESEARCH; FIGHT FOREIGN INFLUENCE."

When on 29 August *Guernica* and its sketches were hung at the San Francisco Museum of Art, a controversy over modern art was already raging. Members of the Sanity in Art movement had mounted an exhibition of their work in the neighboring de Young Museum to counter the modern tendencies of the art then on view in the Golden Gate International Exposition on Treasure Island and, in particular, to protest the first prize in painting awarded to a still life by Georges Braque. Titled *The Yellow Tablecloth,* Braque's work had already antagonized the Sanity people by receiving first prize at the Carnegie International Exhibition in 1937.

After the outbreak of the war, and especially when newspaper photographs of the destroyed cities of Poland were seen as resembling *Guernica*, the protests of the enemies of modern art began more and more to dwindle.

On 3 October, *Guernica* opened the fall season with great celebration at the Arts Club of Chicago facility in the Wrigley Tower. The exhibition was the focus of several social events and received more comment in the press than it had in any of the preceding cities. Most of the comments were the usual antimodern attacks, possibly because of the strength of the Sanity in Art movement in its home territory of Chicago. The editor of the *Chicago Herald and Examiner* raised the cry "BOLSHEVIST ART CONTROLLED BY THE HAND OF MOSCOW," and he included as Communists such unlikely artists as Rouault and Cézanne, who along with Picasso were among those being manipulated.[31] In contrast, C. J. Bulliett, well known in both New York and Chicago as a severe critic of the current realist-political art wave, avoiding the battle over modernity and abstraction, praised Picasso's involvement with the realities of the Spanish Civil War: "Here, instead of being a lofty adventurer in pure and cold form, as is his custom, [he] was frankly a 'propagandist' doing his level best to express all the indignation of his soul against the rape of Guernica and the horrors of war generally."[32]

After the many expenses were paid, funds raised by the tour seem to have been somewhat less than Picasso had hoped for. According to the campaign leaders, he expected around $10,000, possibly based on the average monthly contributions that the American campaign had been sending to relief agencies in France. The showing in Hollywood, which he particularly wanted, drew an audience of 735 and netted $240; in San Francisco the net was $535, and in Chicago $208. Estimates of the longer New York showing, where there was a twenty-five-cent admission charge, put attendance after the preview at 2,000 and total income at $1,700. Of this, Larrea's Junta de Cultura Española received $700, as Picasso had wished.[33]

Although the showings were brief (from one to three weeks) and all of them on short notice and without much advance publicity, they generated considerable controversy on both artistic and political levels. In large part owing to its subject matter, *Guernica* became the most discussed work of art of the time, and the story of the tragic defense of the Republic might have faded from world consciousness much sooner had it not been for Picasso's powerful imagery.

Guernica Enters the History of Art

Guernica assumed a new role when on 15 November 1939 it joined curator Alfred Barr's great retrospective at the Museum of Modern Art, Picasso: Forty Years of His Art. For the first time the painting could be seen and discussed not only as a document of political strife and war in Europe but also as an important stage in the development of Picasso's art, along with *Les Demoiselles d'Avignon* (1907), just acquired by the museum, and *Girl before a Mirror* (1932), already in the collection. Ninety-five of the 364 works in the show, including *Guernica* and the preparatory sketches, were lent by Picasso. Thus in this retrospective *Guernica* be-

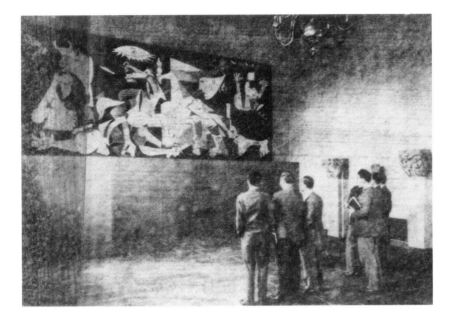

9.7 *Guernica* in the Fogg Museum, Harvard University, 1941.

came integrated for the first time into Picasso's total oeuvre; having already become part of the history of the Spanish Civil War, it now became a part of the history of art.

New York critics, evidently influenced by the context of a retrospective exhibition, saw *Guernica* mainly as the latest chapter in his work. Viewing it from the point of view of nineteenth-century idealism and ignoring the theme of war, Edwin Alden Jewell saw it as no more than a grotesque social tract,[34] whereas Royal Cortissoz failed even to take an interest in Picasso's drawings, accusing him of "groping in the void."[35] In contrast, Emily Genauer sensed in the painting the "brutality and frenzy of the world today,"[36] and James Thrall Soby declared it "the most forceful achievement of art in our century."[37] *Guernica* provoked C. J. Bulliett into scolding the artists of the American Artists' Congress for their "social significance art," which he thought lacked formal strength, even as he praised *Guernica*'s "linear structures," which he placed in the tradition of Raphael, Dürer, Michelangelo, Ingres, and Matisse. Furthermore, he continued, *Guernica* conveyed "a far more complete sense of the horror, the fury and even the locale of the war than does Delacroix' representational stage-piece . . . the *Massacre of Scio*."[38]

The outbreak of the Second World War in September, as well as Picasso's own wish, determined that *Guernica*, along with the other works loaned for the retrospective, should remain for the duration of the war in the custody of the Museum of Modern Art, where the painting would be well cared for and given exposure appropriate to its importance. In accordance with Picasso's wishes, although sometimes in conflict with advice from the conservation department (the painting had to be taken off the stretchers and rolled each time it was moved), Alfred Barr occasionally allowed *Guernica,* and often the preparatory works, to be shown elsewhere. In January 1940, along with the sketches, drawings, and related small paintings, *Guernica* traveled to the Chicago Art Institute with the retrospective; in the fall of 1941 and the summer of 1942 it went to the Fogg Museum at Harvard (9.7); and during 1941 it was exhibited at the Columbus (Ohio) Gallery of Fine Arts. It was honored at

Harvard by being hung above the medieval capitals in Warburg Hall in the Fogg Museum, where it was visited by classes led by Benjamin Rowland, Jr., and Frederick C. Deknatel. Rowland, an Orientalist by profession, delivered lectures on *Guernica* remarkable for their perceptions of its meaning. He compared its expressive abstraction with that of the medieval art located in the same room, defined the Spanish characteristic of merging the dream world with the real world, and interpreted the distortions in the painting as signifying the "breakup of mind and spirit that takes place in such a catastrophe as the air raid on Guernica, a catastrophe symbolical of the ruin threatening to overwhelm the whole of western civilization." [39]

Guernica remained on view at the Museum of Modern Art almost continuously until October 1953, when it returned to Europe for the first time to join a large Picasso exhibition at the Palazzo Reale in Milan. From there it traveled to São Paulo, where from December 1953 to February 1954 it hung in the Museo de Arte Moderna during the second Bienal de São Paulo. After spending only a year back in the Museum of Modern Art, *Guernica* and the preparatory sketches left New York once more for a tour of European museums. From May through September 1955, they were shown in the Musée des Arts Décoratifs in Paris, the first time the sketches had ever been seen on the Continent. In contrast to the 1937 showing, the 1955 exhibition of sketches, gouaches, crayon and pen drawings, etchings, and a few small studies in oil presented the painting primarily as a work of art—the culmination of the various stages through which it passed during its development. The environment of the museum on the rue de Rivoli, with its elegant and colorful collections of turn-of-the-century *objets d'art,* was unlike the austere Spanish pavilion, with its slogans and propaganda, that eighteen years before had dramatized the struggle of the Spanish people. After Paris, the exhibition moved to the Haus der Kunst in Munich, site of Hitler's infamous attack of July 1937 on "degenerate" artists. The exhibition was shown twice more in Germany—at the Rheinisches Museum in Cologne and at the Kunsthalle in Hamburg—to enormous crowds eager to taste the kind of art denied them for so long. It then traveled to the Palais des Beaux-Arts in Brussels, the Stedelijk Museum in Amsterdam, and the Nationalmuseum in Stockholm before returning to New York at the end of 1956. Early in 1957 a second large Picasso retrospective exhibition including *Guernica* was arranged by Alfred Barr under the title Picasso: Seventy-fifth Anniversary. After being shown at the Museum of Modern Art, it traveled to the Art Institute of Chicago and the Philadelphia Museum of Art, afterward returning to the Museum of Modern Art, to the spacious gallery that had been prepared for it in 1947. There, with only *Les Demoiselles d'Avignon* and the *Girl before a Mirror* on the side walls, specially illuminated in the semidarkness, it seemed like a votive piece in a chapel for meditation (9.8). According to his archivist, Alfred Barr stated in a memo that in 1958 Picasso renewed his indefinite loan of *Guernica* to the Museum of Modern Art but asked for the return of the preparatory drawings. [40] These, however, remained in the museum, although often loaned, until both the painting and the drawings were sent to the Prado in 1981.

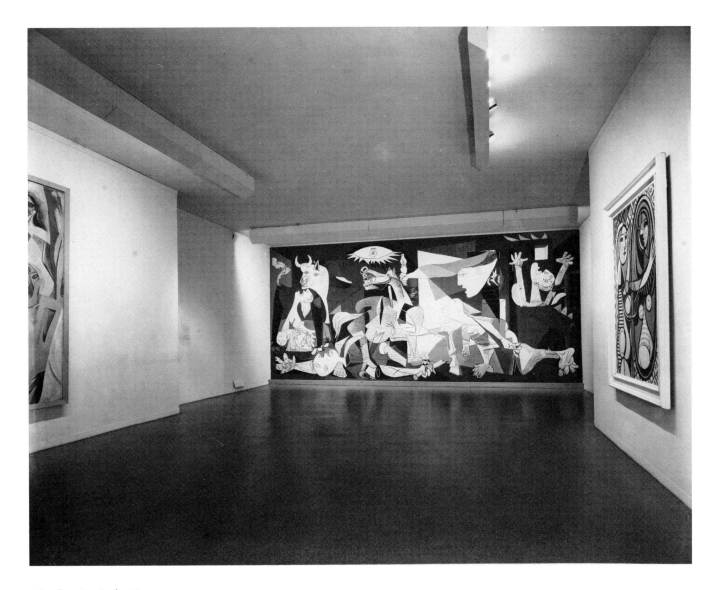

9.8 *Guernica* in the Museum
of Modern Art, 1947.

FRANCO DIJO "SI" AL "GUERNICA" DE PICASSO

10.1 Franco says yes to Picasso's *Guernica.* Headline to an article by Joaquín de la Puente in *Blanco y Negro,* 14 February 1976.

In 1968 Franco himself launched the movement to secure *Guernica* for Spain by approving the campaign of his vice president, Luis Carrero Blanco, for its transfer to Madrid (10.1).[1] By that time, it had become so closely associated with the Museum of Modern Art in New York—it had been integrated into the collections of the museum, extensively studied, widely published, given excellent conservation treatment, and seen by more viewers than it might have been in any other museum in the world—that Spain's overtures came as a great surprise. A formal request followed, initiated by the director general of fine arts, Florentino Pérez Embid, who called the painting a national treasure and gave fervent assurances that there were no official objections to its subject.[2] Javier Tusell has discovered evidence that Pérez Embid even contemplated offering Picasso the unlikely temptation of the Gold Medal of Fine Arts.

The immediate impetus for Spain's request seems to have been the planned construction of a new museum of contemporary art in Madrid, a large part of which would be devoted to Picasso. In his recent biography of Franco, however, Vicente Pozuelo writes that while dedicating the new museum, the Caudillo expressed his contempt for the paintings on exhibition.[3] A more compelling reason was undoubtedly the opening early in 1968 of a museum in Barcelona devoted solely to Picasso. Although the government avoided using the name Picasso by officially entitling the museum the Fondación Sabartés, it was from the first commonly called the Museo (now Museu) Picasso. It contained nearly six hundred works by Picasso donated by Jaime Sabartés and, after Sabartés's death in the same year, his private collection as well. Picasso subsequently set up a memorial to his friend, promising from that time onward to donate one example of every print he made to the museum. He also gave all forty-four of his series of paintings after Velázquez's *Las meninas.* Other gifts, mostly of early works made in Barcelona, followed from both local collectors and the Picasso family. The Fondación Sabartés soon became, in fact if not in name, the Picasso museum for Spain.

Despite the campaign of 1968 for the possession of *Guernica,* the painting was still anathema to Franco's government. A letter bearing a Czechoslovak stamp of 1966 reproducing *Guernica* to honor the thirtieth anniversary of the International Brigades was returned to its sender

10.2 The Equipo Crónica artists Manuel Valdés and Rafael Solbes used *Guernica* as an anti-authoritarian protest in *La visita,* 1969. Acrylic. 46¹³⁄₁₆″ × 46¹³⁄₁₆″ (120 × 120 cm).

as doubly illegal under the provision of Article 28, Section 1d of the Universal Postal Union Treaty of Vienna of 1965.[4] Meanwhile, public protests were growing, and two Valencia artists working under the name Equipo Crónica used images of *Guernica* to satirize the rigidity of a regime they considered bourgeois and stagnant (10.2).[5]

When the government's request for *Guernica* was made public, Picasso, through his lawyer, Roland Dumas, issued a written response.[6] Although for the moment the answer was essentially no, both Picasso and Dumas made clear the artist's intention that *Guernica* should eventually go to Spain. *Le Monde,* however, quotes Dumas as writing that "the painting shall be turned over to the government of the Spanish Republic the day when the Republic shall be restored in Spain."[7] This condition, entirely reasonable in 1937 when the Republic was the legal government and was fighting for its existence, seemed less so in 1969. Accordingly, a year later, on 14 November 1970, Picasso himself issued a signed statement addressed to the Museum of Modern Art. In it he corrected the clause "when the Republic shall be restored," substituting "when public liberties will be reestablished in Spain."[8] This change had the effect of sweeping away the obstacle of Spain's form of government but opened up the

the widow donated to the Prado the large sculpture *Woman with a Vase* (1933) that had been exhibited with *Guernica* in the Spanish pavilion in Paris (see 5.31). A photograph by David Douglas Duncan of this sculpture in Picasso's studio shows a label attached to the work, stating that it belongs to the Spanish Republic.[14]

While the struggle over the inheritance (and even over who were to be the heirs) dragged on and while the inventory of Picasso's works slowly proceeded, the French government announced in January 1975 the formation of a Musée Picasso in Paris to house the thousand or more selected works that were to be accepted in lieu of taxes. In November 1975 Franco's death introduced both legal and moral issues into the question of repatriating the painting. The question was no longer if *Guernica* would go to Spain but when the conditions would be such that Picasso's wishes could be fulfilled. This issue created intense and widespread speculation in Spain and the United States and a new round of demands in Spain for action. José Bergamín, a close friend of Picasso's and his curator when Picasso was honorary director of the Prado, wrote that several times since 1969 the government had made official and unofficial claims for possession.[15] José Mario Armero, Director of Europa Press, led the battle in journals of all political convictions by simply declaring that "the painting belongs to the Spanish people" in the Catholic *Ya*, 19 June 1974; the uncommitted picture magazine *Sábado Gráfico*, 7 December 1974; the Falangist *Arriba*, 4 August 1977; and the liberal *El País*, 11 August 1977. Both leftist political parties modified their positions, in part because of the wave of popular feeling that associated the growing democracy in Spain with the advent of *Guernica*. Santiago Carillo even dropped Lenin's name from the Communist party's program, and the Associated Press headlined the story: "SPAIN'S REDS DUMP LENIN." The Socialist party soon overtook the Union of the Democratic Center in the elections and replaced Prime Minister Adolfo Suárez with their leader, Felipe Gonzáles. Jacqueline Picasso had in the meantime given her own interpretation of Picasso's wishes when she told *La Vanguardia* (Barcelona), 25 February 1977, that *Guernica* would be returned to Spain "when it had free elections."

The division of the estate, officially agreed upon late in 1976, was not made final until September 1977, almost four and a half years after Picasso's death. In August a new Spanish parliament, elected in the first free elections of June 1977, held its first meeting since before the civil war. One of the first resolutions considered was a sweeping gesture of reconciliation. Made by Senator Justino Azcárate, a Basque and former refugee, it proposed the formal repatriation of three historic exiles: the remains of the last king, Alfonso XIII; the remains of the first president of the Republic who replaced him, Manuel Azaña; and *Guernica*, which by now was fast becoming a symbol of the new, post-Franco, Spain.[16] Led by Pió Cabanillas, minister of culture, all factions enthusiastically joined in supporting the resolution. The headline in the Catholic newspaper *Ya* was a challenge, "TODAS A UNA"; that in the Falangist *Arriba* was a statement: "SPAIN IS NOW A DEMOCRACY."[17] The liberal journal *Cambio 16* (12 February 1978) termed *Guernica* "SPAIN'S LAST EXILE," and because of an intemperate reaction by the curator of the Museum of Modern Art, *Arriba* charged that *Guernica* had become "Gibraltarized."[18]

In April 1977, Spanish Prime Minister Suárez made an official visit to President Carter, who in glowing terms praised the progress of Spain, the

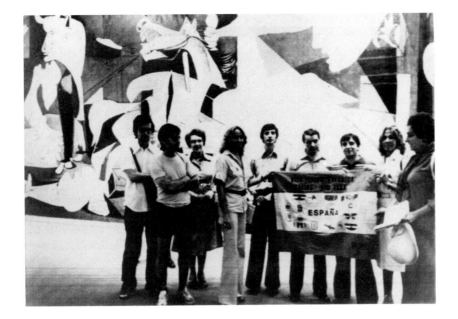

10.3 Spanish students courteously but firmly take symbolic possession of *Guernica* in the Museum of Modern Art (note guard, his shoe and head visible behind the students on the far left), 4 September 1978.

ability of Suárez and his government, and the direction the government had taken. Several months later, on 27 October 1977, the Spanish Cortes made a formal request for the painting, specifying point by point how Spain had met all Picasso's requirements (see Appendix, Doc. 12). The United States Congress followed suit a year later by approving a resolution supporting the return of *Guernica* to a democratic Spain. This resolution was formally enacted on 7 October 1978 (see Appendix, Doc. 13). In ratifying a friendship treaty with Spain originally made only two months after the death of Franco, the Congress added a section expressing the view that given Spain's progress toward a stable democracy, *Guernica* "should, at some point in the near future and through appropriate legal procedures, be transferred to the people and Government of a democratic Spain" (10.3).[19] In a telegram to Vice President Mondale, the president of the Spanish Senate, Don Antonio Fontán, formally proclaimed that Spain now enjoyed "public liberties and democratic institutions," the same words that had been used since 1970 to describe the requirement for transferring the painting to the Prado.[20]

The burning question of actual ownership of the painting can be answered in part by looking at the conditions under which the art for the Spanish pavilion was first commissioned. Josep Lluis Sert has stated that the artists were paid a fee that covered all their expenses more than adequately. In the case of *Guernica*, he recalls that Picasso received 150,000 francs, a figure that was corroborated by Max Aub, who had been the cultural counselor at the time.[21] According to Sert, Picasso was unequivocal as he "repeatedly stated the painting belonged to the Spanish *Republican* Government" and said that "the painting is being held in trust by the family until the Republic is reestablished."[22] All the art commissioned for the pavilion remained the property of the artists, Sert says, citing the cases of Julio González, whose sculpture went on the market and was sold to the Stedelijk Museum in Amsterdam, and of Calder, whose fountain was eventually donated to the Fondación Miró in Barcelona. Picasso always said that *Guernica* belonged to the Spanish Republic; but at the

time of his death the Republic no longer existed, and it was inconceivable that in 1973 anyone connected with his estate would have considered sending it to the Spain of Franco.

After Franco's death in 1975, tentative claims arose once again, but they were subverted when the heirs, the Museum of Modern Art, and at one point Picasso's lawyer, Dumas, introduced the wholly new issue of the *droits morals*, or moral rights, of the heirs—the widow, the children, and the grandchildren—who were at that time engaged in a prolonged struggle over the division of the estate. If the painting was to go to Spain, then the individual agreements of all six of the legal heirs had to be secured—a complicated task in view of their alienation from one another. In 1973 when Picasso died intestate there were numerous claimants to a share of the estate. Eventually, when questions of legitimacy were settled and the state took 20 percent of the estate in art, the widow and the five surviving legal heirs shared the remainder, as tabulated by the *New York Times,* 15 December 1976:

Name (relationship)	Age (in 1973)	Share of estate
Jacqueline (widow)	47	34.375%
Paolo (son)	52	(died in 1975)
Maya (daughter)	38	9.375%
Claude (son)	26	9.375%
Paloma (daughter)	24	9.375%
Marina (granddaughter)	23	18.75%
Pablito (grandson)	24	(died in 1973)
Bernard (grandson)	14	18.75%

Legitimate progeny were determined to be eligible for twice the share (18.75 percent) of the illegitimate (9.375 percent).[23] These mostly very young people suddenly found themselves in the position not only of protecting the moral rights of the deceased artist but of judging the Spanish government. Some of them responded by threatening to withhold their permission until certain personal causes were satisfied, for example, the establishment of a modern divorce law or the release from prison of a certain troupe of actors guilty of insulting the army.

But there was an alternative. Aub, Bergamín, Larrea, and many others involved in the wartime propaganda efforts of the Spanish embassy in Paris understood that its payment of a fee to Picasso constituted an agreement that the government would receive the painting. Their task was apparently to keep it out of the hands of the Nationalists, who surely would have destroyed it. After Franco's death in 1975, when many voices were raised demanding the painting be "returned" to the new Spain of King Juan Carlos, the issue was further complicated, for Spain had become a constitutional monarchy, not a republic. This seemed to rule out a transfer, unless it could be proven that "republic" meant a democratic Spanish

government that showed marked liberal traits, although a monarchy in form. In addition, the restoration of an elected Cortes and of personal liberties seemed to prove concrete democratic tendencies.

At this point Rafael Fernández Quintanilla (son of the artist Luis Quintanilla, a friend of Picasso's), who was a lawyer and diplomat in his own right, was appointed ambassador-at-large with the sole charge of solving these legal difficulties. In a series of investigations worthy of a spy novel, he finally traced and eventually placed his hands on several documents in the possession of former government officials; although incomplete, these proved nonetheless that *Guernica* had been donated by Picasso to the Spanish government. Most significant were a letter and a statement, both dated 10 January 1953, from J. A. del Vayo, former prime minister, to Luis Araquistáin, former ambassador of Spain in Paris. The statement affirmed that del Vayo had actually held in his hands a receipt signed by Picasso for the sum of 150,000 francs "to cover the expenses Picasso underwent in the creation of his work *Guernica* that he was donating to the government of the Spanish Republic."[24] The letter explained that the archives of the ministry, which had, for the most part, been lost or destroyed in the final retreat of the government from Figueras toward the French border in early 1939, contained the documentation of the negotiations of 1937, including proof of the existence of a receipt for the money, signed by Picasso (see Appendix, Doc. 5). As Quintanilla relates in his adventurous book *La odisea del "Guernica,"* Dumas, who had been designated by Picasso to determine when the painting should go to Spain, was convinced and immediately (20 February 1981) declared that now was the time for the transfer.[25]

Even the question where to place *Guernica* when it was restored to Spain had political implications. Although the prime minister's letter of December 1968 requested only that it should come to the Spanish state, he was assumed to mean it should come to the capital and, many presumed, to the projected museum of contemporary Spanish art in the Ciudad Universitaria in Madrid (completed in 1975). Later, according to press reports, again with the approval of Franco, the offer was made more attractive—a choice of rooms in the Prado where *Guernica* would receive treatment equal to that of Goya's *May 3, 1808* and Velázquez's *Las meninas,* paintings Picasso greatly admired and had studied while a student. When the artist's death revived the question, the mayor of Guernica, Gervasio Guezuraga, gave an interview to *New York Times* correspondent Henry Giniger in which he stated that he would be delighted to have the painting come to the city of its name.[26] Both he and the curator of the local historical museum assured Giniger that its presence would not awaken bad memories, and they were pleased, in fact, that it would focus world attention on their city. In 1977, on the fortieth anniversary of the bombing, the city constructed a full-size replica of the painting as a background for a memorial mass for the victims of 1937 (10.4). This gesture invoking the authority of the famous painting was, however, less an attempt to recall the past than a manifesto in favor of present demands for Basque autonomy. Reproductions of Picasso's painting had been displayed for years in bars and restaurants of the city, both as an appeal for possession and as a symbol of Basque aspirations. In 1977 the mayor of Guernica made a formal request for the painting directly to Jacqueline Picasso, but he received no reply.

Of the existing facilities, the Museu Picasso in Barcelona, the only museum bearing the artist's name and housing an extensive collection of his work in Spain, was also the institution technically best prepared to accept and conserve *Guernica*. Catalans recalled that Picasso had donated his art only to Barcelona and that he had made his first of many gifts—his etching *Minotauromachy* of 1935—as early as the painful days of 1938 when Catalonia was being split off from the rest of Spain by Franco's forces. And only in Barcelona did there remain people, associations, and places connected with Picasso's life and work as a mature artist.[27]

After the Cortes had in 1977 formally requested the return of the painting,[28] claims from other cities arose. A journalist in Málaga, recalling that Picasso's birthplace had suffered more in the attack and rout of January to February 1937 than Guernica had in April, claimed the painting for the city's Museo de Bellas Artes, which contained only a few pieces of juvenilia by Picasso and copies of works by other artists.[29] Actually, the *Dream and Lie of Franco*, started the very day the Paris newspapers announced the Italian march on Málaga, may possibly have been a response to it. Then the tiny village of Horta de Sant Joan (formerly Horta de Ebro), where Picasso had lived in 1898 and 1909, seized the opportunity to propose a museum to house the paintings Picasso had made there as well as those of his boyhood friend Manuel Pallarés who was born there, to replace the collection of reproductions it was assembling.[30]

But after the new government took the initiative for the return of *Guernica,* it was generally understood that it should go to the Prado, which, under a new director more sympathetic than his predecessors, planned extensive modernization, including air conditioning. The most interesting solution to the debate came from the well-known historian Javier Tusell, then director general of fine arts. He proposed to install *Guernica* in Madrid's Casón del Buen Retiro, which belongs to and adjoins the Prado and formerly housed nineteenth-century Spanish art, a solution that would at once fulfill promises made to Picasso and relieve those who felt there is a natural dividing line between the old masters and modern art.

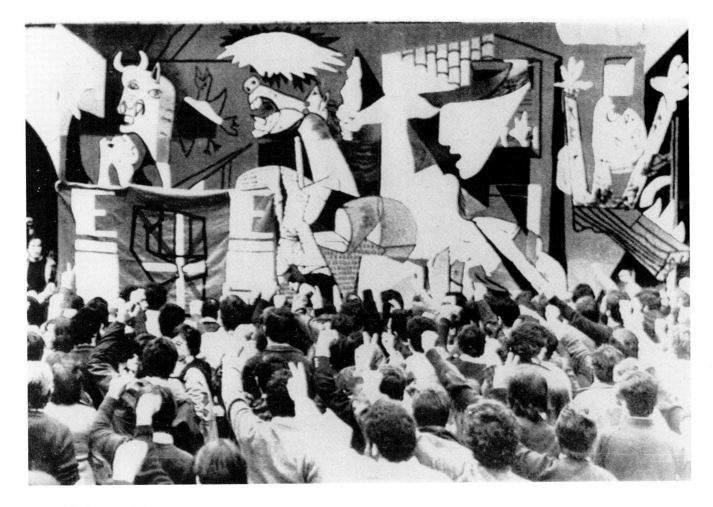

10.4 Full-size copy of *Guernica* set up in the town of Guernica as a memorial on the fortieth anniversary of the bombing, 26 April 1977.

ELEVEN

GUERNICA

COMES TO

THE PRADO

by Javier Tusell

In 1980 public opinion surveys finally resolved the heated issue of *Guernica*'s permanent location. Only a few recalcitrants, among them the poet Rafael Alberti, a Communist, continued to warn that the new centrist government was still too unstable to deal with an issue as emotional as the return of *Guernica*.

In May, Madrid's evening daily *Pueblo* asked an important group of intellectuals, politicians, and artists about the installation of the painting. The opinion expressed most frequently favored the Prado Museum (11.1). During the summer, when the remodeling of the Casón del Buen Retiro to accommodate the painting actually was under way, a survey conducted by a Madrid magazine showed that almost 40 percent of Spaniards interviewed wanted the work installed in the Prado, while 20 percent favored Barcelona, 10 percent Guernica, and 7 percent Málaga. Thus the decision concerning its location in Madrid seemed ratified by public opinion itself.

More important, the issue no longer divided Left and Right: all political groups approved *Guernica*'s arrival and installation in Madrid, a consensus transcending political differences. The agreement of the regional extreme Left was important; the Basques could have made the location of the work a political issue if they had insisted, for example, that the work be installed in the town of Guernica itself. As it was, the Communist deputy for Madrid, Ramón Tamames, proposed, albeit unsuccessfully, that *Guernica* be installed in the Azca Center in Madrid, a plaza in the capital dedicated to Picasso.

At the end of July, a Madrid newspaper published for the first time a photograph that showed *Guernica* in the Casón del Buen Retiro in a situation similar to its present one. A week later, the Casón was closed to be remodeled for the painting's installation. The old Villanueva, the building just behind the Prado, had been dropped from consideration since *Guernica* was so unlike the old master paintings already housed there and since protection could not be provided against either vandalism or extremes of climate. But the large rectangular central gallery of the Casón del Buen Retiro permitted viewers to see the painting from an appropriate distance, a perspective that had not been possible in New York. Finally, the Casón's two elongated side galleries allowed effective installa-

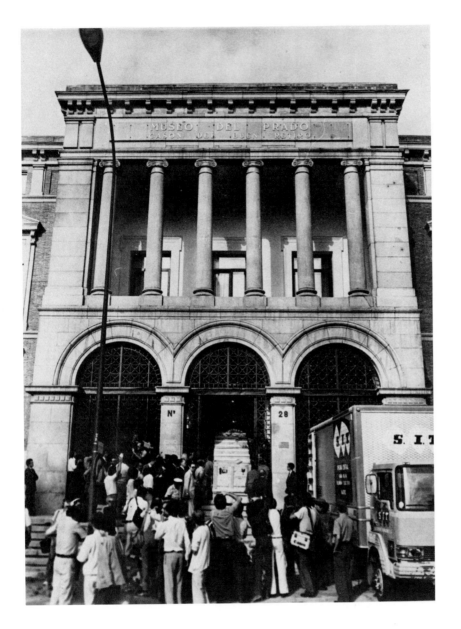

11.1 The Casón del Buen Retiro is part of the Prado, which it faces, and is consistent with it in style. As *Guernica* entered the portal, the crowd burst into applause.

tion of the preliminary sketches. Some interior remodeling was still necessary to replace the elaborate wall ornamentation with plain white walls and, above all, to install the climate control system.[1]

Before the painting could be sent to Spain, it was necessary to solve an additional problem, posed by the artist's descendants. From the summer of 1980 on, and while the Casón was being prepared to receive the painting, the Spanish negotiators interviewed different members of Picasso's family. They invited Picasso's descendants to join the committee of honor of the artist's centenary celebrations in Spain and explained to them the plans for *Guernica*'s installation. Acknowledging the careful conservation of the work by the Museum of Modern Art, they asked Picasso's heirs to write to the museum, emphasizing their acquiescence to the transfer of the painting.

Although most of the heirs favored the transfer, a few raised questions, asking, for example, whether some of the preparatory drawings could be left in the Museum of Modern Art. These questions and objections, however, proved to be merely a delaying tactic and, coupled with the intervention of the heirs' lawyers, created a difficult situation; Marina Picasso, through her lawyer Guy Ferreboeuf, expressed a wholly new resistance to the transfer of the painting. But the major obstacle arose in October 1980 when Maya (who was less than two years old when Picasso painted *Guernica*) stated that her father's stipulated conditions for the transfer had not been met and that the painting should not go to a non-Republican Spain. Maya considered herself especially responsible for the painting, claiming that her association with dissident groups while she had been living in Spain had given her a special vision of Spain's past. (She did not attend the meeting in December when the artist's descendants gathered to discuss the subject of the *droits morals* because she had already expressed her objections in writing to the Museum of Modern Art.)[2]

Naturally, such determined resistance delayed negotiations and provoked heated protests in the press. In October at least one Spanish weekly stated that it had given up on *Guernica*'s return, even though informed opinion held that the painting would be in Spain's possession by the end of the following September (1981). The Spanish authorities then received reconfirmation from the Museum of Modern Art that it intended eventually to surrender the painting.

In the fall of 1980, a Spanish interministerial commission was organized, its members the minister of culture, the secretary of state for foreign affairs, the director general of fine arts, and Rafael Fernández Quintanilla, together with the subsecretary of the presidency of the government, Alberto Aza. Three parties were now negotiating, and the press and members of the government were growing impatient over the many delays. Something had to be done to accelerate negotiations.

Fortuitously a persuasive official document was discovered: a group of letters and receipts definitively proving Spain's ownership of the painting; Quintanilla had just secured them from the archives of the wartime ambassador, the late Luis Araquistáin (see Appendix, Docs. 4, 5, 6, and 9). Because its interests were purely political, the foundation was readily persuaded to let the Spanish state take the initiative; until that moment, state representatives had seen only defective photocopies of these texts. After considerable bargaining over the price, the Spanish state finally acquired the documents, giving it an important instrument for initiating legal action promptly if it were judged necessary.

In mid-December, I went to New York, accompanied by the director of the Institute of Restoration, to arrange the details of transferring the painting. Its condition, confirmed by both Spanish and North American experts, was very good; the canvas had been treated with wax in the museum, and it was fit for transport. The transfer required only a new frame for the picture and a new, larger, shipping tube. The museum advised transferring it by air.[3]

While the final conditions for *Guernica*'s transfer to Spain were being settled, the Spanish negotiators continued to pressure Picasso's heirs. They decided to ask the prime minister of Spain to write to them and to the painter's widow. In January 1981, Prime Minister Adolfo Suárez ad-

dressed a letter to all of them, linking the transfer of the painting with the centenary of Picasso's birth:

> The highest point of this celebration should be the arrival of *Guernica*, Picasso's most outstanding work. . . . Its historical links and Spanish destiny were also the artist's constant wish, and its return had been put off because of political circumstances that have been successfully overcome at the present, thanks to the constitution approved by an immense majority of Spaniards and universally recognized as free, democratic, and sovereign.[4]

Suárez asked for the heirs' cooperation and invited them to participate in the commemorative ceremonies in Spain.

Quintanilla and I, as the Spanish negotiators, delivered this letter to those who had claimed "moral rights" over the Spanish artist's work, urging the heirs to respond promptly to avoid further delays in returning the painting. Picasso's widow Jacqueline wrote to Suárez:

> I was very satisfied and moved upon reading your letter . . . at last Pablo Picasso's wish, so many times written, spoken, and written and spoken again, will be fulfilled. It is evident that *Guernica*'s return to Madrid will be an occasion of great historical intensity, and you have more than earned my cooperation.[5]

And as for Marina, the prime minister's letter probably helped to change her opinion. She too answered Suárez's letter, no longer maintaining the position endorsed by her lawyer. "At the present I give my definitive agreement so that *Guernica* can be returned to Spain, which was my grandfather's greatest wish."[6] During my own interview with her, Maya revealed that if her posture was still apparently negative, it was not inflexible. She expressed her opposition to *Guernica*'s return in arguments that had nothing to do with the state of Spanish democracy. She argued that the police continued to be pro-Franco and pointed to the absence of legislation regarding divorce and illegitimate children (an issue directly affecting her); she even cited an unfavorable Amnesty International report about political prisoners. Subsequently, however, she seemed satisfied with the news of legal changes that had occurred in family law in Spain.

If a solution to the problems detailed by Maya could be found quickly, the other descendants' positions only became more antagonistic to the Spanish case. Claude Picasso's opposition clearly seemed to be a delaying technique; Paloma followed her brother's lead in not answering Suárez's letter, although verbally she professed a sympathetic view. Bernard, the artist's twenty-one-year-old grandson, who had been invited to Madrid by the Spanish government, returned to France convinced that Spanish democracy was unstable and that in consequence up to ten years might pass before he would consider granting his permission for transfer of the work.[7]

At the same time that Suárez wrote to the heirs, I sent them an extensive report on the remodeling of the central hall of the Casón del Buen Retiro. By the end of February 1981 almost all the work, supervised by

architects José Luis Picardo and José Luis García de Paredes, had been completed. The climate control in the hall allowed the temperature to be kept between 24 and 22 degrees centigrade and the relative humidity at 50 percent. Detectors were installed to warn against explosives, and radio and television circuits and antiriot and antisabotage protection systems were prepared. *Guernica* would be enclosed in a large glass case with independent climate control and would be accessible only by means of a magnetic card. The total cost of the construction was forty million pesetas (nearly a half million dollars). When the new construction was completed in January, thus eliminating one of the objections that had been made by the Museum of Modern Art,[8] I, as the director general of fine arts, announced the news.

Maya Picasso chose this moment, however, to proclaim in a Madrid newspaper that she still opposed the painting's return. The press was outraged. *Pueblo* charged that her posture was "almost blackmail"; *Diario 16* used the term "imprudent" for the artist's daughter; and *ABC* asked sarcastically if she thought Spain did not deserve the painting because it had not been sufficiently bombed. I stated the government's position, emphasizing that the heirs had no right to demand anything not referring strictly to the ownership of the painting. Some officials considered filing suit in court against the Museum of Modern Art, but the Spanish negotiators opposed the idea, judging that such a suit would be a long, costly, and unnecessarily polemical process.[9] Moreover, to criticize Maya's resistance might only cause a confrontation difficult to resolve.

Declarations made by the office of the director general of fine arts at the end of February mentioned the possibility of legal action. Although the painter's actual receipt for payment for the painting did not exist in the Araquistáin archive documents (it had evidently been destroyed during the Republican retreat to the French border in 1939), other documents proved that it had once existed and, further, that the Spanish state indeed owned the painting. Soon after, nevertheless, another grave incident produced a delay. The attempted coup d'état of 23 February 1981, in which Guardia Civil troops actually invaded the Cortes while it was in session and forcibly held it hostage, understandably increased the reticence of those who, for whatever reason, had maintained that Spanish democracy either did not exist or was threatened. Rafael Alberti again objected that the moment was not opportune for restoring the painting to Spain.[10]

Spanish officials now feared that any further delay in the recovery of the painting would become indefinite. And so at the beginning of March a demand for the immediate transfer of the work was made upon the Museum of Modern Art. Minister of Culture Iñigo Cavero, assisted by Joaquín Tena, a special legal secretary, played an important role in establishing his ministry's claim.

In the first week of April 1981 the Spanish consul in New York, Rafael de los Casares, signed a formal petition and, accompanied by Quintanilla and Tena, presented it to the director of the Museum of Modern Art. Beginning with an acknowledgment by the Spanish people of the "excellent way in which the museum had taken care of and exhibited Picasso's painting *Guernica* and related works during more than thirty years,"[11] the petition noted that the Spanish claim was made not only in agreement with the well-known wishes of the artist but also in accordance with the property rights of the state. The document further stated that the painting

would be installed in the Prado Museum, which would be its permanent home. Along with the petition, the Spanish negotiators presented confirming documentation from the Araquistáin archive. The museum's authorities expressed some doubts about the Spanish state's property rights, given the lack of absolute proof in those documents, but above all they wanted to demonstrate, once and for all, at least their willingness to play an intermediary role between the Spanish claim and Picasso's heirs. The director of the museum proposed that a meeting be held at the end of June in France with the director of the planned Musée Picasso in Paris, Dominique Bozo, and the heirs, along with a representative of the Spanish government. The Spanish authorities approved this arrangement.[12]

At the meeting, the heirs' resistance to the Museum of Modern Art's proposal was finally and decisively broken. (Oddly enough, news of the meeting was leaked to the press, no doubt by one of the heirs whose attitude had been the least favorable to the return of the painting.) In May an important exhibition of Picasso's prints had opened in Madrid, and coinciding with the meeting in June of the heirs in France, the new rooms at the Casón del Buen Retiro were opened and the future installation of *Guernica* was finally announced. At the end of June an installation rehearsal with a life-size photograph of *Guernica* was conducted in the hall of the Casón.[13]

The rest of the story is relatively simple. In August a final agreement with the Museum of Modern Art was reached concerning details of the painting's transfer. The Spanish government acknowledged that the works of art were in satisfactory condition, agreed that no other claim would be made, and relieved the museum of any responsibility regarding conservation of the work during its custodianship. The museum promised to pack the painting in the presence of a Spanish representative. On 6 September 1981, Minister of Culture Cavero and I arrived in New York. On 9 September the museum and the Spanish government signed a document formalizing the transfer of ownership of the painting and the preparatory and other related works. That night *Guernica* finally left for the Prado Museum in Madrid.

Guernica's journey (11.2–11.4) was kept secret by Spanish authorities. The same day that the document with the Museum of Modern Art was signed, a Spanish newspaper speculated that the painting would be handed over to King Juan Carlos on the occasion of his future visit to New York. Cavero and other Spanish authorities had tried to give the impression that the time was not yet right for the actual delivery. The reason for such caution was the painting's highly symbolic significance—Spanish democracy itself could be threatened if either the extreme Right or extreme Left acted violently. As a result, special security measures were taken, and both the inspector general and the director general of the police, Generals Saez de Santamaría and Fernández Dopico, were in charge. The painting traveled under only the designation "large painting," without any mention of its title.[14]

Word of *Guernica*'s secret journey came as a surprise that increased the joy of its arrival in the Spanish capital. All the local editorials linked Spain's new civil liberties with the recovery of the painting. For *Pueblo*, *Guernica* signified "the consolidation of democracy." *El País* (the only daily to criticize the transport of the picture without insurance) declared that with its arrival "THE WAR HAS ENDED." It also published my article,

11.2 Preparing *Guernica* for shipment, 8 September 1981, at the Museum of Modern Art. Photograph by Leonardo LeGrand.

11.3 Awaiting the appearance of the painting at Barajas Airport, Madrid, on 10 September 1981. Two Guardia Civil are prepared for any eventuality. Photograph by Marisa Florez.

defining the homecoming as the final transition to a democracy. When some dissent arose about the transfer, *Diario 16* headlined its editorial "ONE PAINTING FOR ALL." In effect, *Guernica,* once the witness of bitter Spanish division during the civil war, was now converted into a symbol of national reconciliation. *ABC* again defined it as "THE LAST REFUGEE OF THE CIVIL WAR." The international press also emphasized the symbolic character it had acquired since 1937 and the meaning the picture had for a democratic Spain.[15]

In reality, there were more than a few protests about the picture's arrival and its installation in the Casón del Buen Retiro. Its rapid and unannounced transfer, coupled with the decision on its permanent location, led to some conflicts of opinion. The extreme Right treated it disparagingly, reiterating that the bombardment it referred to had been carried out by the Germans and not by Franco himself, who had ordered no such action. The strongest objections, however, were to its installation in Madrid. The Basque Nationalist party stated, "We gave up the dead and they have the picture"; the installation in Madrid was thus "an authentic cultural kidnapping done by the Madrid government." Nevertheless, protests shortly faded, and the original insistence upon its installation in the Basque city of Guernica was maintained only as a politicizing issue, even by the Nationalists (11.5).[16]

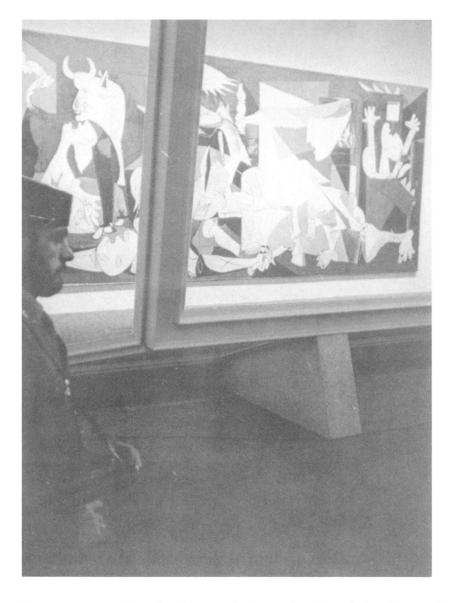

11.4 The sealed and locked glass chamber is protected by the armed Guardia Civil. Note the guard's finger on the trigger of his gun, faintly visible at lower left.

Protestas en Euskadi por la instalación del "Guernica" en el Casón del Buen Retiro
Todas la fuerzas políticas vascas piden que el cuadro vaya a la villa que lo inspiró

Casa de Juntas de Guernica. RICARDO MARTIN

11.5 Demonstration in Guernica: Basques protest the installation of *Guernica* in Madrid. Photograph by Ricardo Martin. From *El País*, 12 September 1981, under the heading "All Basque political powers demand that the painting come to the town that inspired it."

11.6 Josep Renau, José Mario Armero, Roland Dumas, and Blanche Mahler Weisberg.

Guernica remained in a closed room in the Casón del Buen Retiro until its protective case was ready. In keeping with the rest of the painting's history, the installation provoked debates: the director of the Prado Museum resigned in the middle of October, arguing that he had not been consulted about its installation. The remodeling, however, received the general approval of experts, including those of the Museum of Modern Art.

The official preview of *Guernica*'s installation was held on 23 October 1981 for Spanish officials and the national and foreign press (11.6–11.8). At the end of a meeting of the Spanish cabinet that afternoon, President of the Council of Ministers Leopoldo Calvo Sotelo, together with four of his ministers, visited the installation. Prime Minister Suárez reaffirmed the exhibition's character of national reconciliation, saying he thought that a good title for the painting would be "horrors of war" (perhaps alluding to Goya's *Desastres de la Guerra*) and that *Guernica* had apparently been enclosed in a protective glass case by a unified wish that itself was a moving petition for peace.

The feeling of national reconciliation that the painting's installation offered became more obvious the following day, 24 October, on the occasion of the official inauguration. Although of all the artist's heirs only Paloma Picasso was present (11.9), a majority of Spanish political leaders attended, some of whom had fought on opposing sides during the civil war. In the same hall, gathered in homage to Picasso's great painting, it was possible to see the renowned Duchess of Alba and former collaborators of Franco together with Dolores Ibarruri, the legendary Communist party official and spirited leader of the wartime defense of Madrid

11.7 Javier Tusell and
Rafael Quintanilla.

11.8 Justino Azcárate,
Armero, Iñigo Cavero, Dumas,
the author (rear), and
Quintanilla.

11.9 Paloma Picasso.

(11.10). Minister of Culture Cavero emphasized the work's character as a symbol of national reconciliation:

> *Guernica* is a cry against violence, against the horrors of war, against barbarism and against civilized society's negation which supposed a confrontation among men. . . . Nobody should interpret the work as a flag for any sector—let us look at *Guernica* as a pure and simple rejection of brutal force.[17]

On the centenary of Picasso's birth, 25 October 1981, Spain carried out the best commemoration possible: the return of *Guernica* to Picasso's native soil and the acceptance of it by the Spanish people as a testimony of national reconciliation.

11.10 Dolores Ibarruri (La
Pasionaria).

THE MEANINGS

OF GUERNICA

A close study of *Guernica* that takes into account not only its artistic value but also its historical, political, and personal context shows clearly that it occupies a unique position in Picasso's oeuvre. It is his only work motivated directly by a specific historical event—an event about which he knew almost nothing firsthand but one that generated immediate worldwide controversy. The painting, therefore, took its place on the world's stage at once because of its politicized title and the anticipation of atrocities to come.

Both the event and the painting were borne along on the tide of emotion of the oncoming Second World War. Although the event in Spain paled beside the atrocities at Warsaw and Rotterdam, Picasso's painting survived and rapidly gained force, not only as a protest against the bombing of Guernica but as a cry of sympathy for the victims of terrorism everywhere. Even after the war had subsided, leaving Europe prostrate, Picasso's painting was often symbolically conscripted by campaigns opposing war and promoting peace and liberty (12.1).

Conceived on May Day 1937 in the midst of fiercely contradictory and distorted news reports on the destruction of the Basque town, *Guernica* could hardly be expected to conform in style to Picasso's earlier work of that year—the altogether conventional studio subjects: portraits, still lifes, and figure groups.

Picasso's essential ambiguity, however, determined that as late as a week before the bombing of Guernica he had planned for his mural for the Spanish Republic a peaceful studio scene with artist and reclining nude model. This uncompleted project represented a highly personal theme for an artist and although quickly forgotten in the outrage over Guernica, it still left a strong impression on the mural. Incongruously, it was to determine several compositional features in the final version of the mural, the *Guernica* that we know. This transformation of one mode of feeling into its opposite is not uncommon in Picasso's work, for at times he took delight in the double entendre that revealed opposing or conflicting aspects of his personality. But it appears probable that the studio sketches and their accompanying associations exerted a humanizing influence on what could have been a bitter scene of violence.

12.1 Poster, 1966, New York.

Of his other works, only the etching suite *Dream and Lie of Franco* of January 1937 grows largely out of a political situation. In it he selects as his target the Caudillo himself; in creating a monster who is part insect but who still bears the facial characteristics of Franco, Picasso draws upon his own iconography of repulsive creatures and actions to convey his disgust. Moreover, since the monster attacks all the other living beings, including the horse three times, it appears that Franco himself is the enemy and all the creatures his victims. This reading of the etching would tend to contradict the speculative statements of writers who have interpreted the bull and the horse in *Guernica* as allegories of the conflict between the Republicans and the Nationalists.

In both *Dream and Lie* and *Guernica,* Picasso transformed the emotions aroused in one case by a person and in another by an actual event into new images based on those already present in his art. He turned inward, so to speak, rather than toward the exterior world as a journalist would have done, and found familiar images that he forged into emotional equivalents of the ugliness and horror of the world of 1937. Because the representations are poetic and not literal and because they are often deliberately ambivalent in the surrealist spirit, some writers, not fully understanding the subtlety of Picasso's imagery, have seized upon chance associations or have fashioned conventional, rigid interpretations for the images that in *Guernica* are open, allusive, and subject to metamorphosis.

Thus images appear and disappear in the sketches—the miniature horse, the bird, and the clenched fist; moreover, meanings themselves are transformed, as when the sculptor metamorphoses into the Minotaur, the beautiful blonde woman into the *torera,* the bull into a man and vice versa, and evanescent images into certain women in Picasso's life. Concomitantly, the style of drawing readily shifted from a detailed realism to a childlike spontaneity, as in the horse in the first sketches. When projected onto the large canvas, massive geometric cubist black-and-white shapes flattened the spaces and created architectural harmonies with the forms of its future environment in the foyer of the pavilion.

Political Aspects

Once *Guernica* had left the studio and commenced a public life, it continued to undergo changes in meaning—now mainly political. In the pavilion of the Spanish Republic, facing the monumental photograph of the martyred Federico García Lorca and flanking the auditorium where Buñuel's documentary films of the war were shown, Picasso's work served, like the entire main floor of the structure, as an instrument of propaganda. Within days of 12 July 1937, when *Guernica* was first seen publicly in the pavilion, it was realized that Picasso had evoked, as the souvenir postcard sold at the pavilion proclaimed, "a disintegrated world afflicted by the horrors of war." Picasso himself had already stated in a message to American artists, quoted earlier, that in "*Guernica,* and in all my recent works of art, I clearly express my abhorrence of the military caste which has sunk Spain in an ocean of pain and death." [1]

As *Guernica* was being hung, Georges Sadoul questioned Picasso on its meaning. Somewhat evasively, Picasso replied that he associated himself with the true defenders of the Prado—the Republican tank crews, aviators, and soldiers—not with the artists and scholars. [2] Thus by his own words Picasso again affirmed a political motivation for *Guernica.* At the same time Picasso answered Sadoul, Luc Decaunes said that *Guernica* was a scene cut from the flesh of a martyred people face-to-face with their assassins, and Michel Leiris wrote that Picasso's message of doom was that all that we love is going to be lost.

Although virtually ignored by the press—including the Communist party newspaper, *Humanité*—and even opposed by some of the members of the Spanish government who had commissioned it, *Guernica* was most bitterly attacked by the political opponents of the Republic. In their guidebook to the Paris World's Fair, the German delegation called it the dream of a madman and, contradictorily, something any child could do; another enemy of the Republic, the Vatican, scorned it as a violent pictorial literary diatribe.

Nevertheless, Picasso's painting was enthusiastically acclaimed by his own circle of friends, the poets and writers of the *Cahiers d'Art* group. Liberal in their thinking and fervent in their support of the Spanish Republic, they published the most influential international art journal of the 1930s. Within a few weeks of the completion of *Guernica,* the journal devoted an entire issue to it, including most of the preliminary sketches as well as Dora Maar's series of photographs of the stages of the painting's genesis. Thus Picasso's work soon became known internationally to the leading artists and intellectuals of the time. Christian Zervos astutely observed that *Guernica* was about neither war nor politics but about what was real in our world. He understood that Picasso was incapable of expressing himself by such conventional and pedestrian means as the simple syllogisms of traditional war pictures.

A year later, in 1938, when the painting was exhibited in London, the surrealist poets, more detached from the war than Picasso and his friends, welcomed *Guernica* as a monument of abstract art in opposition to the prevailing uninspired realism of the English academic painters. The poet Herbert Read, comparing it with world masterpieces of religious art, wrote that its great power was the result of the widest commonplaces being infused with the intensest passion. Read's review of the 1938 show in London still offers one of the most perceptive insights into both the historical and artistic meanings of the painting.

Stephen Spender, close to the surrealists, discerningly noted that Picasso had put the viewers of the painting in the unusual role of the victims of the bombing attack. But Anthony Blunt, then art critic for the *Observer* and a supporter of ultra-conservative artists, wrote a sharp attack on Picasso, accusing him of knowing nothing of the real world of political events and curiously citing both *Dream and Lie of Franco* and *Guernica* as evidence of his detachment from the real world.

In 1939 *Guernica* traveled to New York, where its audiences tended generally to be more remote from the issues of the Spanish Civil War and less aware of how recent events were leading to the Second World War. Although the critic Henry McBride wrote admiringly that what had started as propaganda became a great work of art, Edwin Alden Jewell called *Guernica* simply a trivial social tract. Only Elizabeth McCausland saw clearly that it was an expression of the tragic fate of the people of Spain and eventually all of Europe. With a few exceptions, critics in the American West tended to allow local issues, generally antimodernism or the reactionary Sanity in Art movement, to deflect Picasso's tragic message.

On the East Coast *Guernica* became a subject of controversy between the abstract and the more representational "social consciousness" painters. Even though both groups were nearly unanimous in their praise of Picasso's sketches and were certainly aware of the political issues involved, they were reticent when it came to the complex theme of the large painting. Jackson Pollack, however, seeing an affinity between the violence of Picasso's bullfight imagery and his own swirling lines, began in 1939 and 1940 a transition that was to result in his characteristic tense linear tangle of drips (12.2). But Stuart Davis, who often expressed the feelings of the leading members of the American Artists' Congress, would only admit when pressed that *Guernica* was one of the greatest of formal structures.

12.2 Jackson Pollack, drawing, 1939–1940.

Art Historical Evaluation

When in November 1939 *Guernica* joined the Museum of Modern Art's first Picasso retrospective exhibition, it could be judged for the first time in the context of Picasso's earlier art and related to his artistic career as a whole. The exposure afforded by the Museum of Modern Art gave Picasso's painting and its sketches a worldwide audience; they soon became the subject of books and numerous articles. Some of the most judicious were the catalogues published by the museum and written by its director, Alfred Barr.

Toward the end of the war, two publications appeared that proved to be influential in determining future thinking about the painting. The first was an article by Jerome Seckler, an American soldier in Paris just after the Liberation. Seckler was deeply impressed by Picasso's announcement of his adherence to the French Communist party. When news of this appeared on the eve of the opening of the Salon d'Automne in 1944, where Picasso was to be honored with a large retrospective exhibition of his newest paintings, there was worldwide discussion and controversy. Taking advantage of the euphoria of the times, Seckler interviewed Picasso for the *New Masses* magazine of New York, interrogating him especially on the influence of communism on his art. Himself a sympathizer, Seckler sought to coerce Picasso into admitting that his art was Communist and

that the animals and figures in *Guernica* represented the warring factions of the Spanish Civil War (the bull the brutality of Franco and the horse the suffering of the Spanish people). Turning to the exhibition and confusing the inert head of a dummy bull on a table in a still life painting with the bull in the drama of *Guernica*, Seckler nearly drew Picasso into admitting that the red color of the bull's head in the still life was symbolic of his communism.

The second publication, in 1947, was by Juan Larrea, a Spanish poet and the former director of information for the embassy of the Republic in Paris. A close friend of Picasso's, he was asked by Curt Valentin to write a book on *Guernica* to be published in English (in 1977 it was revised and translated into Spanish). The first full-length work on *Guernica*, it is an eloquent and imaginative account of the political, cultural, and mythological sources of the painting in Spanish life. Larrea, in contradistinction to Seckler, concluded that the heroic bull in the painting, like the bull in Spanish life, represented the courageous and stalwart Spanish people, whereas the miserable suffering horse predicted the ultimate end of the Francoist regime.

There is a grain of truth in each of these contradictory theories. But the controversy, which was seemingly irresolvable, lead to a methodological deadlock that incited many other writers over the succeeding two decades or so to seek other simple answers to the complex questions posed by *Guernica*. In their search, writers have drawn upon such diverse fields as psychiatry, topology, and even astrology; looking for clues, they have examined Picasso's intimate life, his infantile memories, motifs from classical art, and ancient Mediterranean culture.

Despite public interest in Picasso's private life, which was rich in amorous episodes, it was not until 1959 that Jan Runnqvist wrote in Swedish a thoughtful study relating the bull, horse, Minotaur, and other images in Picasso's art to certain events in his emotional life. Avoiding psychoanalysis, Runnqvist found transformations of mood and theme in Picasso's art that corresponded to events in his relations with women, in particular when women were shown being transformed from ideal, usually classical, form to aggressors. Although later many of us by our own study of the art came to believe that the bull-horse conflict and also the Minotaur-woman struggle were often closely related to male-female encounters, Runnqvist was the first to formulate a clear, comprehensive theory of these relations. Among the works of writers pursuing similar lines of thought, his account remains the simplest and clearest. His study opened up the possibility of recognizing not only that the origin of *Guernica* lay more in the *corrida* than in the war but also that the actors in the painting are both the cause of the violence and its victims. In accepting that neither victory, nor defeat, nor good, nor evil is the theme of the painting, Runnqvist demonstrates the fallacy of reading it as either an allegory of the Spanish conflict or a partisan and propagandistic argument for any cause except the peace, dignity, and freedom of human beings.

It was not until 1962 with Rudolf Arnheim's meticulous study of all the sketches and states of the painting that a complete and methodical study of its development was undertaken and that *Guernica*'s genesis could fully be understood. For the first time, the preparatory sketches were numbered chronologically and, with the assistance of the staff of the Museum of Modern Art, a technical description of each sketch was formulated, data that became the standard for all subsequent writers. But

Arnheim's greatest contribution was in establishing a method of analysis broad enough to encompass an enormously complex painting. Probably alluding to the earlier imaginative interpretations of *Guernica*, he stated that an exact meaning can be neither proved nor disproved. By studying the art itself, he sought rather to define a "level of meaning," or the position of the art between physical reality and abstraction. From this he could judge the levels of interpretations and the possibilities for meanings appropriate to the individual images. This method in practice provided an insightful view of changes in forms and consequent changes in meanings as the images were drawn into the matrix of the painting, which itself was undergoing an organic evolution.

Disappointing some critics, Arnheim ruled out an exploration of the artist's biography for clues to the meaning of the painting, believing that the painting is "not a statement about Picasso but about the condition of the world." Even though focusing only on what is visible and not covering history, culture, politics, or the later role of *Guernica* in the world, his insights and conclusions constitute the soundest view of its development.

In 1979 in an article entitled "Art as Autobiography: Picasso's *Guernica*" (followed in 1980 by a book on his art), Mary Mathews Gedo made a strong case for the personal quotient, relating the passion of *Guernica* in part to two great crises, one in the life of Picasso's country and one with the women in his own life. In fact, for many years before *Guernica* his art clearly demonstrated both great ecstasies and anxieties in its subject matter as well as its emotional tone. As I infer after my own studies, many of the images in his art around the time of *Guernica* are so closely related to women and events in his life as to suggest actual personal experiences. Close study of his early works confirms Beryl Barr-Sharrar's observation in 1972 that Picasso was prone to repeat motifs, even from the earliest years, transformed, of course, in both form and meaning.

The vast body of literature on *Guernica* that has appeared over the past twenty years, including the most imaginative interpretations (what Alfred Barr once deprecatingly called "coincidences" of appearances) could be the subject of a book in itself, but it would need to be combined with a history of taste, a study of art and propaganda, and a political history of the time. Recent books and articles, far too numerous and wide-ranging in method to encompass in this book, should be read by the serious student. Most of them will be found in the bibliography. The most complete critical summary of these many interpretations is probably to be found in the footnotes of Frank D. Russell's book (1980), itself a source of thoughtful observations by an artist, illustrated with his own analytical diagrams. In this book, I have studied the development of the painting against the background of those historical and political events that may have inflected its meaning, referring simultaneously to the artist's personal life.

A Painting That Shaped History

Although *Guernica* was firmly established as the star of the brilliant galaxy of masterpieces in the Museum of Modern Art, it had by no means been forgotten in Spain. Franco's express wish in 1968 to claim it was

one of the first indications, and certainly a clear one, that his regime was abandoning its hostility toward the work and possibly toward Picasso as well. We cannot say how much this change owed to the artistic qualities of Picasso's painting and how much simply to the fame of the expatriate Spanish painter. But we can say that the possibility of possessing a world-famous Spanish painting helped to ameliorate the formerly rigid stance of the Franco regime toward foreign culture, if not modern art.

A situation unique in the history of art thus arose—an artist's wishes concerning the future of his painting became instrumental in encouraging a government, and indeed a whole people, to adopt a path toward a free society and, eventually, a democratic government. After Picasso's death in 1973, when the disposition of his estate was argued, and after Franco's death in 1975, when a new government sought acceptance in the community of Western democracies, *Guernica* emerged as a symbol of the new Spain. Its possible "return" was discussed fervently in the Cortes, and newspapers of all political convictions, from Falangist to Communist, in a most unusual show of agreement, impatiently demanded that steps be taken to secure the painting. The high regard in which it was held in Western cultural circles strongly influenced the new Spanish leaders to realize that, as Juan Marichal reportedly said, "the Spanish Civil War was really the Battle of Spain, the first episode of Europe's war against Fascism. Spain fought *for* Europe."[3]

The United States Senate's resolution of 1978 praising the success of the Spanish government in its course toward democracy included a paragraph to the effect that *Guernica* should soon be sent to Spain. Thus Picasso's painting, born from the agony of the civil war, was now a significant force both in the reconciliation of the old hatreds and in the final healing of the wounds from that war.

Picasso transformed his shock and outrage over the bombing terror into images of violence and suffering, most of which were already present in his earlier art and hence carried an unusual emotional weight and a wide range of personal meanings. An especially strong quotient of personal emotion in the images derives from his attachment to the ritual of the bullfight and from his intimate relations with the women in his life at the time. He never attempted to represent the event of the bombing or to allegorize or symbolize the war, but on many levels of meaning and emotion, in human as well as artistic terms, he created a powerful painting that would stand for them.

He infused commonplace images of misery and death with a passion born of both political conviction and sympathy with the human victims, and by such means he achieved a universal image. This image revolutionized the idea of a historical theme in modern art; after *Guernica* it was hardly possible to glorify armed conflict itself or the exploits of its leaders in conventional heroizing terms. To paraphrase Herbert Read, art long ago ceased to be monumental, for there is no glory in our age. *Guernica* is the very opposite of monumental: it portrays a tragedy as seen and felt by the victims, not the victors, for it is without victory and without hope. Although the forces of evil responsible for the catastrophe are not shown in *Guernica*, they are implied by the title, a word that has entered history as a lasting symbol of a wanton terrorizing attack on an innocent populace. As Hilton Kramer expressed it,

A great painter had placed his talents at the service of a great political cause, and thus—for this one splendid moment of history, at least—the treacherous gap separating the hermetic concerns of modernist art from the larger and more compelling interests of society was triumphantly bridged.[4]

It is doubtful that the more strident aspects of political struggle and the Spanish Civil War could have actually shaped Picasso's art, yet they must have provided the intense passion that led him suddenly on 1 May 1937 to sweep away thoughts of the artist and model and to take up the subject of a terror bombing. Further, the history of the painting ever since it left the studio and began its odyssey on behalf of the Spanish victims is allied with the eventual resolution of the hatreds of the civil war and their replacement by an upsurge of democratic feelings.

Picasso looked into the chaos and suffering of his time and responded by creating a great work of modern art that was able to find its theme in and even give meaning to the harsh and compelling realities of twentieth-century life.

quently gave him a check for 150,000 French francs, for which he signed a receipt. Although this sum is rather symbolic, considering the inestimable value of the painting, it nonetheless virtually represents the acquisition of the painting by the Republic. I consider that this was the most feasible method of establishing property rights to the painting.

Next Monday after I return from Brussels I will personally give you the receipt, which I have meanwhile deposited in the embassy's safe. Picasso wants us to visit his studio in the rue des Grands-Augustins and afterwards have dinner with him.

See you soon, yours
Max Aub
[Cultural Counselor, the Spanish Embassy]

Source: *Legado Picasso,* 153.

5. J. A. del Vayo's Letter to Luis Araquistáin Concerning Picasso's Receipt, 10 January 1953

Paris, 10 January 1953
J. A. del Vayo
Hotel Madison
143, Blvd. Saint-Germain
Paris (6ᵉ)

Mr. Luis Araquistáin
22, Avenue de Champel
Geneva, Switzerland

Dear Araquistáin:

In answer to your question, raised in your letter dated 20 December of last year, about the destiny of the receipt that Picasso signed in Paris to Max Aub for the sum that the latter gave to him (150,000 French francs) on 28 May 1937—I do not recall the exact date as it was a long time ago—I present to you my statement about the event.

As you probably remember, when Negrín decided to evacuate our government precipitately from Barcelona (23 January 1939), I was in Geneva attending a meeting of the League of Nations. So for me it was impossible to be present in the city during those tragic moments and to take care of transferring the archives of the Ministry of State and to get my and Luisy's personal belongings from our house in Bonanova. But, as I say in my certification, and despite the tireless efforts that the personnel of this ministry put forth to save those archives, they were for the most part lost or destroyed in the general chaos and disorder of Figueras. The loss of the complete documentation was irreparable, particularly the records of this case and the letters and statements that you had sent me during your negotiations in Paris. Among those papers—as I have indicated in my statement—was Picasso's receipt.

But I do not doubt, not for a second, that if we restore the Republic one day, this friend will confirm the donation of *Guernica,* which he had made for the Republican government. On the other hand, I believe that the proof that exists in the records of the embassy in Paris about the sum that was paid to Picasso will help your statement, as it was

juridically and practically equivalent to the acquisition of the painting by the Republican government. Max Aub, who as you know now lives in Mexico, can give his testimony about this event as well.

That is all I can tell you about this question. I absolutely agree with you about the urgent necessity to make clear this point, for should Picasso or ourselves disappear, the future Republican state could claim the ownership of this magnificent painting for Spain.

In a couple of days, Luisy and I will go to Geneva. See you soon.

Un abrazo
Vayo

Source: *Legado Picasso*, 156.

6. Ledger of the Spanish Embassy in Paris Showing Expenses for *Guernica* ("gastos 'Guernica'") Paid to Picasso on 28 May 1937 (amounts in French francs)

"Reservado"

- 2 -

EMBAJADA DE ESPAÑA
EN
PARIS

SUMA ANTERIOR 2.396.285,10

MARZO	19	COHEN	20.000,00
"	19	JEAN LAURENT	150.000,00
"	23	SCATO DIBUJANTES U.G.T BARCELONA .	6.000,00
ABRIL	2	LUIS BUÑUEL	70.000,00
"	5	JEAN LAURENT	150.000,00
"	5	COHEN	10.000,00
"	12	SUSCRIPCION SUD-OUEST de BAYONNE...	25.000,00
"	13	CARL RUSSEL	150.000,00
"	15	JEAN LAURENT	100.000,00
"	15	JEAN LAURENT	100.000,00
"	16	EXPOSICION P.N.T.	6.000,00
"	16	CARL RUSSEL	60.000,00
"	27	CARL RUSSEL	100.000,00
"	30	COHEN	53.000,00
"	30	JEAN LAURENT	150.000,00
MAYO	3	JOSE ONRUBIA	15.000,00
"	4	LUIS BUÑUEL	70.000,00
"	13	JEAN LAURENT	100.000,00
"	14	JEAN LAURENT	150.000,00
"	19	JEAN LAURENT	150.000,00
"	19	COHEN	69.566,00
"	20	JEAN LAURENT	50.000,00
"	28	P. PICASSO *gastos "Guernica"*	150.000,00

TOTAL 4.300.851,10

Paris, 31 de mayo de 1937.

Max Aub.

Vº Bº

Luis Araquistain

(A la cuenta de propaganda)

Source: *Legado Picasso*, 155.

7. Statement of Expenses for Installations in the Spanish Pavilion
 Submitted to Josep Lluis Sert, Architect

RECEIPT

Empresa Labalette Frères, Cie.	30 November 1937
Mercury fountain	7,200 French francs
Framing (Picasso)	1,500
Socle for iron statue [González]	
Socle for Picasso (busts)	
Socle for Picasso (woman)	
Paint for Picasso's picture	2,500
Foundation and socle for statue by Alberto	5,842.80
Drilling socle for statue	2,026.39
6 July wooden pedestal (Picasso)	17,900

Source: Original document in archives of Josep Lluis Sert, Cambridge, Mass. (copied by hand and translated by author).

8. Statement of Expenses for Shipping *Guernica* and the Sketches to
 New York, 3 May 1939

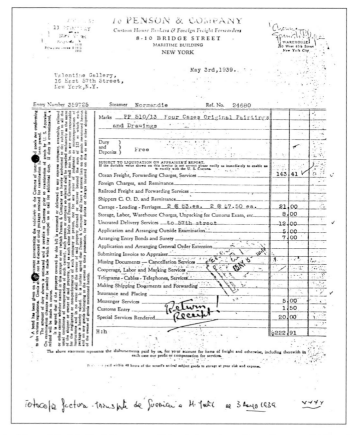

Source: Archives of the Medical Bureau and North American Committee to Aid Spanish Democracy. Rare Book and Manuscript Library, Columbia University, New York.

9. Luis Araquistáin Encourages Picasso to Protect *Guernica* from
 Franco by Retaining Possession As Long As the Caudillo Is Alive
 (excerpts)

Geneva, 3 April 1953
Don Pablo Picasso
Villa "La Galloise,"
Vallauris (France)

. . . In the first days of June 1937, I collected all the papers and confidential documents (concerning the purchasing of arms, military transportation, secret reports, status of accounts, etc.) and, among them, the receipt that you signed for Max Aub for the sum he gave you—despite your reluctance to accept it—for the expenses you underwent in the realization of the above-mentioned enormous painting. As a matter of fact, the sum in question (150,000 French francs) had only a symbolic meaning, that of the acquisition of the painting by the Government of the Republic, considering its inestimable value on the world market. However, this at the same time confirms in itself your desire to donate the painting to the Republic, as you had repeatedly expressed to me on the few occasions we met (in May 1937, in the restaurant Chez Francis at the Place de l'Alma, in Paris) as being your intention. . . .

In sum: except for the above-mentioned amount given by the embassy of Paris for purposes of propaganda, my personal testimony and the testimonies of Mr. Alvarez del Vayo and Mr. Max Aub, no traces remain of the agreement you made with the latter. Thus the fate of *Guernica* will partially depend on you. What is important in this case is that throughout the vicissitudes of our war and the last world war, the painting remained in your possession and never actually reached Spain, where it probably would have been destroyed in an auto-da-fé because of its historical and political meaning.

I also recall that in those moments during the . . . meeting we had in April 1939 you repeatedly insisted that *Guernica* only should form part of the artistic patrimony of Spain when the Republic is reestablished in our country. I agreed absolutely with you at the time, that is to say, that the delivery of the painting to the Francoist regime had to be avoided by all means, although this regime could have claimed its property, being the legitimate heir—whether we like it or not—to the Republican state. Today, after the passage of time, I do not agree as completely with your point of view as I did in 1939. Let me explain: I agree that the painting should stay in your custody while Franco is alive. But what should be decided when the Generalissimo or we ourselves disappear and a real constitutional state is established in Spain? Will that necessarily have to be a regime with the character of an institutional republic? About this particular, I do not doubt that you know quite well my natural republican leanings, as I have proved throughout my life, being a member of the socialist ranks. However, another historical alternative could conceivably arise, not a reconstructed Republic from 1936, but a constitutional and democratic monarchy. And if this happens, we will be obliged to respect it, although this is only because of that "del lobo un pelo". . . . In this case,

I am therefore convinced that the future political regime will confirm and ratify the nomination that the Government of the Republic would have given to you to assume the position of Director of the Museo del Prado, requiring of you no more, dear Picasso, than to come to Madrid to take over this appointment, and be able to personally place *Guernica* in the "Picasso Gallery" of this museum. . . .

<div style="text-align: right">

[Signed by Luis Araquistáin,
former ambassador of Spain in Paris]

</div>

Source: Ministerio de Cultura, Archivo Histórico Nacional, Sección "Guerra Civil"; Sección Político-Social, Serie Madrid, Expediente Pabellón Español en París (1937) (legajo 2.760), Madrid.

10. Picasso's Statement to the Museum of Modern Art That *Guernica* Must Be Returned to the Spanish People, 14 November 1970

. . . You have agreed to return the painting, the studies and the drawings to the qualified representatives of the Spanish government *when public liberties will be reestablished in Spain.*

You understand that my wish has always been to see this work and its accompanying pieces return to the Spanish people.

To take into account your intention, as well as my wish, I ask you to consider carefully my instructions on this subject. The request concerning the return of the painting and its accompanying pieces can be formulated by the Spanish authorities. But it is the duty of the museum to relinquish *Guernica* and the studies and drawings that accompany it.

The sole condition imposed by me on the return concerns the advice of an attorney.

The museum must therefore, prior to any initiative, request the advice of Maître Roland Dumas, Avocat à la Cour, 2 avenue Hoche, in Paris, and the museum must comply with the advice that he will give.

<div style="border: 1px solid black; padding: 1em">

<div style="text-align: right">Mougins, le Novembre 1970</div>

Messieurs,

En 1939 j'ai confié à votre Musée le tableau connu sous le nom de «GUERNICA», qui mesure 11 pieds 5 1/2 sur 25 pieds 5 3/4, *qui est mon œuvre ainsi que les études ou les dessins y afférents (dont la liste est jointe à la présente) et qui ne peuvent être séparés de l'œuvre principale.*

Depuis de longues années j'ai également fait donation de ce tableau, des études et des dessins à votre Musée.

Parallèlement vous avez accepté de remettre le tableau, le études et dessins aux représentants qualifiés du Gouvernement Espagnol *lorsque les libertés publiques seront rétablies en Espagne.*
Vous savez que mon désir a toujours été de voir cette œuvre et ses annexes revenir au peuple espagnol.

Pour tenir compte de votre intention, comme de mon désir, je vous prie de bien vouloir noter mes instructions à ce sujet. La demande concernant le retour du tableau et de ses annexes pourra être formulée par les autorités espagnoles. Mais c'est au Musée qu'il appartiendra de se désaisir de «GUERNICA» et des études et dessins qui l'accompagnent.

L'unique condition mise par moi à ce retour concerne l'avis d'un juriste.

Le Musée devra donc préalablement à toute initiative demander l'avis de Maître Roland DUMAS, Avocat à la Cour, 2 avenue Hoche, à Paris, et le Musée devra se conformer à l'avis qu'il donnera.

Maître Roland DUMAS aura la faculté de désigner par écrit telle autre personne qui aurait la même tâche que lui, au cas où lui-même serait empêché de l'accomplir pour une raison quelconque.

L'avis que le juriste devra donner portera sur la condition même du retour du tableau aux autorités du Gouvernement espagnol.

Il s'agira pour lui, ou ses successeurs, d'apprécier si les libertés publiques ont été rétablies en Espagne.

Dès réception par votre Musée d'un avis favorable de Me DUMAS; où de la personne désignée par ce dernier ou son remplaçant, vous remettrez le tableau et ses annexes dans un délai raisonnable, et au plus tard six mois après la réception de l'avis, au représentant à NEW YORK de l'Etat Espagnol.

Picasso ./.

le 14.11.70.

</div>

Source: *Legado Picasso,* 160.

11. Picasso's Last Statement of His Wish That *Guernica* Should Go to
the Spanish Republic, 14 April 1971 (Anniversary of the founding
of the Spanish Republic)

Je confirme à nouveau que «GUERNICA» et les études qui l'accompagnent ont él confiés
par soi en dépôt, depuis 1939 au Musée d'Art Moderne de New York el qu'ile sont destinés
au gouvernement de la République Espagnole.

PABLO PICASSO
MOUGINS LE

14. 4. 71

Picasso.

Source: *Legado Picasso,* 160.

12. Spanish Cortes Declares That Spain Has Fulfilled All Conditions for
the "Return" of *Guernica* (excerpt)

27 October 1977
OFFICIAL BULLETIN OF THE CORTES No. 24

. . . "Considering that the Cortes, freely elected by the Spanish people,
is in power in Spain, that it is in the process of preparing a democratic
constitution, and that the exercise of freedoms is guaranteed, in conse-
quence it is in reality a functioning democratic government;

Considering that Pablo Picasso stipulated that the painting *Guer-
nica* should remain in the custody of the Museum of Modern Art in
New York until a democratic Spanish government has been restored, it
is at that moment that *Guernica* should be returned to our country;

The Senate agrees to ask the government to present—through the
most adequate procedures—to the directorate of the Museum of Mod-
ern Art in New York and to other competent authorities their so-
licitude for the return of the painting entitled *Guernica,* by Pablo
Picasso, which is in the custody of the aforementioned Museum. . . ."

Palace of the Cortes, 20 October 1977

Source: *Legado Picasso,* 164.

13. United States Congress Declares That *Guernica* Should Be Transferred to the People and Government of a Democratic Spain, 7 October 1978

PUBLIC LAW 95–426—OCT. 7, 1978 92 STAT. 987

SPANISH DEMOCRACY

SEC. 605. (a) The Congress finds that—
 (1) the Senate, in rendering its advice and consent to ratification of the Treaty of Friendship and Cooperation between the United States and Spain (signed on January 24, 1976), declared its hope and intent that the Treaty would serve to support and foster Spain's progress toward free institutions;
 (2) this declaration reflected the strong desire of the United States Government and the American people to see a restoration of democracy in Spain and an expansion of mutually beneficial relations between Spain and the democracies of America and Europe; and
 (3) political developments in Spain during the past two years constitute a major step toward the construction of a stable and lasting Spanish democracy.
(b) The Congress finds further that—

"Guernica," by Picasso, transfer to Spain.

 (1) the masterpiece "Guernica", painted by Pablo Picasso, has for four decades been a powerful and poignant symbol of the horror of war;
 (2) this treasured painting, while universal in its significance, holds special meaning for the people of Spain by its representation of the tragic civil war which destroyed Spanish democracy;
 (3) Pablo Picasso, having painted "Guernica" for the Spanish Republican Government and concerned for Spain's future when that government fell, stipulated that the painting should remain in the custody of the Museum of Modern Art in New York until Spanish democracy had been restored; and
 (4) the United States and Spain, in a Supplementary Agreement entered into with the Treaty of Friendship and Cooperation, have committed themselves to expand their cooperation in the fields of education and culture.
 (c) It is therefore the sense of the Congress, anticipating the continuance of recent promising developments in Spanish political life, that "Guernica" should, at some point in the near future and through appropriate legal procedures, be transferred to the people and Government of a democratic Spain.
 (d) It is further the sense of the Congress that the American people, having long benefited from this treasure and admiring Spain's achievement, would wish, as an expression of appreciation and congratulation upon the transfer of "Guernica" to Spain, to assist in the preparation of facilities for the permanent display of the painting, if such assistance is found to be appropriate by the elected leaders of Spain.

Source: Public Law 95–426, 95th Congress, 7 October 1978, 92 Stat. 987, Sec. 605 (a).

NOTES

Bracketed roman numerals I, II, and III
in the notes refer to sections of the
Bibliography, where full information is
given for each title cited.

Preface

1. Southworth [I], *Guernica! Guernica!* x.

1 Picasso's Politics and the Spanish Republic

1. Franco's Nationalist regime, although claiming to represent traditionalist Spain and even carrying on relations with Germany, Italy, Portugal, and the Vatican, was, of course, not invited to participate in the World's Fair of 1937.

2. Although the Neutrality Act, which outlawed the shipment of war materials to either side in the Spanish conflict, had been passed by the American Congress at the end of 1936, it proved easy to transship planes to the Loyalists by way of Mexico and other countries sympathetic to their cause. In March 1937 the Nationalists captured a Republican ship loaded with American planes off the Basque coast and summarily executed all the Spanish crewmen. At that time, owing to a recent American law that provided that only two-engined and larger planes could carry passengers for hire, there were many large fast single-engined former transport planes on the market. These planes, when converted, made excellent light bombers, for they were sturdy and even faster than existing fighter planes in Spain. For two fascinating accounts of the politics of evading the Neutrality Act, see the two-part article "Soldiers of Fortune" by Laureau [I], in *Airpower* (September 1982) and in *Wings* (October 1982).

3. See Miró's statement in *LP*, 5; and Renau's article, "Connotaciones testimoniales sobre el 'Guernica,'" in *LP*, 8–22. See also Renau's essay on political and social themes in poster art (a riposte to Ramón Gaya's attack on art as propaganda): Renau [I], "Contestación a Ramón Gaya."

4. See Javier Tusell, "El *Guernica* y la administración Española," in *LP*, 32–78. See also chapter 11, "*Guernica* Comes to the Prado," in the present book. During his tenure as director general of fine arts, Professor Tusell was instrumental in bringing about the "repatriation" of *Guernica* in 1981.

5. The date of his mother's letter is unknown, although the events she described most likely occurred at the beginning of the civil war. See Penrose [II], *Picasso: His Life and Work*, 296.

6. His friends, especially Jaime Sabartés and Gertrude Stein, frequently wrote of his desire to remain Spanish.

7. Sabartés [II], *Picasso: An Intimate Portrait*, 134.

8. Penrose [II], *Picasso: His Life and Work*, 289–91.

9. As cited in Cabanne [II], *Le siècle de Picasso*, 440. Also discussed in *Le Crapouillot* [II].

10. For example, Jerome Seckler, an American soldier who visited Picasso in Paris just after the Liberation, during the only intensive questioning on *Guernica* that Picasso ever permitted, finally got him to admit that the bull represented brutality. Picasso stubbornly resisted Seckler's attempts to make him say that the painting was symbolic or that the red color on a mounted bull's head in a still life of 1938 was symbolic of the Communist party. See Seckler [II], 4–7. No one has yet taken Seckler to task for comparing the bull in *Guernica* and the mounted head in the still life, as though both were only symbols, and nothing more, of the partisan political struggle in Europe. Seckler missed the point that the bull, in the first case, was part of a complex and symbolic image representing a tragic event in the Spanish Civil War and, in the second case, was only a stuffed trophy in a tabletop still life.

11. A personal anecdote may illustrate this. When I told Picasso that I was writing a dissertation on Cubism, he sought out in his studio a small sculpture of the cubist school. It was a heavily faceted, somewhat mannered imitation of his own work as seen in the *Head of Fernande* of 1909. He had used a soft brush to make thick sensuous lines, thus obliterating the sharp edges of the facets. Holding it aloft and shouting with glee, he demanded if that was what I meant by Cubism.

12. The letter was dated 19 September 1936 and probably reached Picasso in Paris. Azaña [I], however, does not mention this appointment in his *Obras completas*.

13. For a report of the damage to the Prado and of the protective measures taken in Madrid and Valencia, see the special issue of *Mouseion* [I] on the protection of works of art against war damage.

14. The standard history of the conflict is by Hugh Thomas [I]. Another useful work that gives a broad account of the political and historical implications of the Spanish Civil War for France is Pike [I], *Les Français*.

15. This discussion is based on information in Koestler [I], *The Invisible Writing*, chap. 29.

16. Koestler [I], *Dialogue with Death*. Koestler's candid account of his activities as a spy and his capture and imprisonment appears in this book, whereas his relations with Comintern and Spanish government officials in Paris are described mainly in *The Invisible Writing*.

17. Correspondence with the author.

18. Parrot and Marcenac [II], *Paul Eluard*, 47.

19. *L'Humanité*, 17 December 1936.

20. Pedro Calderón de la Barca, *La vida es sueño* (Madrid, 1870), 178. Translations by Radiça Ostojíc.

21. Pedro Calderón de la Barca, *En esta vida todo es verdad y todo mentira* (Madrid, 1879), 72.

22. *Aleluya*, or satiric drawings in a series not unlike a comic strip, were a common form of popular art in Spain. Picasso used this form to tell the story of his first trip to Paris in 1900. See Penrose [II], *Portrait of Picasso*, 33. Phyllis Tuchman [II], in her article "Guernica and *Guernica*," examines the small masthead cartoons that appeared daily in *L'Humanité*, which we know Picasso read regularly. While she does not go so far as to claim them as a source for specific images in *Guernica*, they are the kind of thing Picasso would have enjoyed and can convincingly be taken as a model for one way to comment upon the events of the day. The satire of *Dream and Lie of Franco*, however, is different in spirit from the playful cartoon style of René Debosc, the Communist paper's artist.

23. This translation from Barr [II], *Picasso: Fifty Years of His Art*, 196. The following is the original 1937 text as printed on the folio accompanying the etchings:

> fandango de lechuzas escabeche de espadas de pulpos de mal agüero estropajo de pelos de coronillas de pie en medio de la sartén en pelotas puesto sobre el cucurucho del sorbete de bacalao frito en la sarna de su corazón de cabestro—la boca llena de la jalea de chinches de sus palabras—cascabeles del plato de caracoles trenzando tripas—meñique en erección ni uva ni breva—comedia del arte de mal tejer y teñir nubes—productos de belleza del carro de la basura—rapto de las meninas en lágrimas y en lagrimones—al hombro el ataúd relleno de chorizos y de bocas—la rabia retorciendo el dibujo de la sombra que le azota los dientes clavados en la arena y el caballo abierto de par en par al sol que lo lee a las moscas que hilvanan a los nudos de la red llena de boquerones el cohete de azucenas—.

24. From Barr [II], *Fifty Years of His Art*, 196. The original text from the folio, as cited above, is as follows:

> —gritos de niños gritos de mujeres gritos de pájaros gritos de flores gritos de maderas y de piedras gritos de ladrillos gritos de muebles de camas de sillas de cortinas de cazuelas de gatos y de papeles gritos de olores que se arañan gritos de humo picando en el morrillo de los gritos que cuecen en el caldero y la lluvia de pájaros que inunda el mar que roe el hueso y se rompe los dientes mordiendo el algodón que el sol rebaña en el plato que el bolsín y la bolsa esconden en la huella que el pie deja en la roca.

25. In 1973 the French Communist party newspaper *L'Humanité* edited a book entitled *Picasso: 145 dessins pour la presse et les organizations démocratiques* [II]. It would be difficult to justify calling any of these drawings political art; their style is that of Picasso's familiar art, even though their subject refers to causes of the Party. These are portraits of officials, posters announcing mass meetings, and countless doves and classical figures, mostly from the decade after World War II, but none that through the medium of art grasps a political concept in the way that *Dream and Lie of Franco* or even *Portrait of the Marquesa* does. And *Guernica* itself is absent, represented only by two of the early sketches. Picasso's position, however, is explained in the introduction by Roland Leroy, who describes him as "a man who, although not playing politics in the common sense of the term, is always one of the greatest of political men, not just to be one but because it is in his nature."

26. A week before the bombing of Guernica, however, he had made several sketches on the theme of an artist and model that because of their unusual format and images seem to have been intended as preliminary sketches for the mural. See the discussion of this first project in chapter 5.

27. For an account of Picasso's experiences with the ballet, together with reproductions of his work and other photographic documentation, see Cooper [II].

28. Jaime Sabartés, in his account of Picasso's life from November 1935 to January 1937 when they shared the apartment in the rue la Boétie, presents Picasso as not very deeply involved in supporting the cause of the Republic. Sabartés describes the outbreak of the war on 18 July 1936 only as "disturbances in Spain" and then, surprisingly, tells of visits and discussions with compatriots from both sides who were flocking to Paris: Sabartés [II], *An Intimate Portrait*, 134. Sabartés next saw Picasso on 5 July 1937 in Picasso's studio in the rue des Grands-Augustins, where he had painted *Guernica*. It is possible the painting was still there, but Sabartés makes no mention of it. He writes only that Picasso was then preparing to leave with Eluard for a vacation in Mougins. Picasso probably did not attend the formal inauguration of the Spanish pavilion and *Guernica* on 12 July (*An Intimate Portrait*, 139).

2 Civil War in Spain

1. Sabartés [II], *An Intimate Portrait*, 124. My sketch is based on several of the most reliable histories of the Spanish Civil War: Thomas [I], *The Spanish Civil War;* Payne [I], *The Civil War in Spain;* London [I], *Espagne;* and Gabriel Jackson, ed. [I], *The Spanish Civil War.*

2. Brissaud [I], *Canaris: La guerra española y la II Guerra Mundial,* 71–72.

3. See Hugh Thomas [I], 228.

4. London [I], *Espagne,* 121 ff.

5. Several of the German pilots and bombardiers wrote romantic memoirs of their adventures in Spain, which were published and widely distributed by the Nazi party. Some of these books were even placed in the Bibliothèque Nationale in 1940, soon after the occupation of Paris. The books most relevant to this study are: Hoyos [I], *Pedros y Pablos;* Beumelberg [I], *Kampf um Spanien;* and Trautloft [I], *Als Jagdflieger in Spanien.* For other valuable books and archival sources, see the bibliographies in Maier [I], *Guernica 26.4.1937,* and in Salas Larrazábal [I], *La guerra de España.* See also Thomas and Morgan Witts [I], *Guernica: The Crucible,* and Talón [I], *Arde Guernica!*

6. Beevor [I], chap. 11.

7. Both men were to profit by their experience in Spain; only three months after the Condor Legion had returned to Germany, the same force was launched, its *blitzkrieg* tactics now perfected, against Poland. One year later, in 1940, Sperrle launched the massive air fleets of Luftwaffe bombers, and von Richthofen the fighters, against Britain.

8. Hills [I], 293 n. 39. Hills espouses the official pro-Franco view, which places all the responsibility on the Germans.

9. *Le Figaro* on 10 May 1936 carried a résumé of the article in the current *Militär Wochenblatt* (Berlin), clearly defining this concept of "total war" and defending bombing and other attacks on nonmilitary targets: industries, transportation, dwellings, and noncombatants. General Erich von Ludendorff [I], the World War I hero, had presented this theory in a book published in 1935: *Der totale Krieg.*

10. Hoyos [I], 113.

11. Salas Larrazábal [I], *La guerra de España,* chap. 4. Talón [I], 184 ff.

3 The Bombing of Guernica: 26 April 1937

1. Maier [I], *Guernica 26.4.1937,* 119 ff. See the military chart of the region, opposite 40.

2. Thomas and Morgan Witts [I], *Guernica: The Crucible,* chaps. 4, 8. Talón [I] in *Arde Guernica!* was the first author to investigate thoroughly the military aspects of the bombing of Guernica. He had the advantage of access to both Spanish archives and Basque survivors. Although published during the Franco regime, his book was remarkably rich in documentation of the Condor Legion and the events of the war and included the author's interviews with eyewitnesses and photographs of the aviators, their planes, and ruins of the town.

Two German sources are important: Ries and Ring [I], *Legion Condor,* is the most complete and best illustrated history; Maier [I], *Guernica 26.4.1937,* a history based mainly on German archives, includes the relevant text of von Richthofen's diary ("Anlage 1," pp. 75–112). The best reconstruction of the event is Salas Larrazábal [I], *Guernica: El bombardeo.*

3. Seventeen Chatos had been assigned to Lamiaco airfield, a converted polo ground on the heights north of Bilbao, now the site of the Bilbao airport. These planes were effective in attacks against bombers, especially the slow and unwieldy Junkers 52s, but they had also suffered heavily from bombing and air combat.

4. Because of the violent accusations in the French press over the bombing and the equally violent denials and countercharges, years elapsed before anyone admitted to responsibility for the act. And even in recent years, some partisans have denied that the bombing took place at all, claiming that the destruction was caused by arson on the part of the Republican defenders.

The controversy was especially bitter and divisive because no one before Talón had ever proved how many planes were involved or even positively which nation's forces had actually perpetrated the assault. After the first few days the Spanish air force was exculpated, for it was apparent that Franco himself was at first unaware of the act; but the Condor Legion, because German planes had been observed in action many times in Vizcaya, was often named as the attacker. Evidence of German guilt has been provided from time to time, most recently in 1985 with the uncovering of an unexploded German bomb complete with markings: *New York Times,* 15 February 1985. Italian sources were consistently silent, with the exception of Belforte's standard history [I], 148, which mentions briefly that Italian bombers from Soria and fighters from Logroño attacked a series of targets, including "the bridge of Guernica." A more recent Italian work, Ricci [I], 60–64, was the first to actually cite both places and the names (including Ricci's own; he was there as a fighter pilot) of Italians involved in offensive air operations over Vizcaya and Guernica. When in 1977 Salas Larrazábal, the leading Spanish military historian (see his comprehensive *La guerra de España*), undertook an analysis of Italian participation, however, he became convinced that a small detachment had joined Condor Legion planes in the attack. Basing his findings on newly discovered fragmentary reports of the crews and on his recent conversations with survivors, he determined that three Savoia 79 bombers, operating from an airfield at Soria to the south of Guernica, had joined the German bombers over the target and that ten Fiat C.R. 32 fighters from Vitoria, where the German fighters were also based, assisted in providing escorts for the German Junkers 52 bombers. This greatly enlarged estimate of the size of the fighter force protecting

the bombers would, if correct, explain why the tiny Republican air force made no attempt to defend the town. See Salas Larrazábal [I], "Guernica: El mito y la realidad," 613–27.

I am indebted to Thomas Sarbaugh for discovering and providing me with this text and other articles, to Paul Whelan for sharing his encyclopedic knowledge and sound judgment, and to Patrick Laureau for sharing his extensive research on the whole of Spanish Civil War aviation. See Laureau [I], *La aviación republicana española*. Additional volumes by him on Nationalist aircraft are forthcoming.

5. These developments are discussed in Thomas and Morgan Witts [I], *Guernica: The Crucible*. See chap. 25 and especially 150–54, 172–81, 185–94, and 204. Although they fictionalized their reconstructions of detailed discussions of plans for the attack and the actual preparations of the planes, their accounts seem to have been based on official reports, von Richthofen's diary, and their own recent interviews with survivors. Thus the general situation they portray is probably true to events.

6. According to Sarbaugh's research, there were probably eighteen Junkers 52s, from two to four Heinkel 111s, one Dornier 17, and three Italian Savoia-Marchetti 79s in Burgos.

7. These two new planes, sent to Spain for testing under actual battle conditions, were so successful in action that they were used to lead German bombing attacks throughout the Second World War.

8. No one has satisfactorily answered the question why incendiary bombs were dropped if the target was actually the stone bridge over a small stream. The aviators, however, knew from their recent experience over neighboring Durango on 31 March of the devastating effects of incendiary bombs on structures composed mainly of wood and already shattered by bombs.

9. Talón [I], after p. 264. Note the misspelling of Guernica: Guernika—partly Spanish, partly Basque. "Sander" was the code name for General Hugo Sperrle, commander of the Condor Legion from its formation in November 1936 until 31 October 1937. See Appendix, Document 1.

10. Talón [I], chap. 6. But see Appendix, Document 2.

11. Thomas and Morgan Witts [I], *Guernica: The Crucible*, 240.

12. Galland [I], *Die Ersten und die Letzten*. The British edition deleted photographs of German fighters in Spain; the American edition of 1954 deleted both the photographs and the text on Spain. (Why was German intervention still a debatable issue fifteen years after the war?)

13. Thomas and Morgan Witts [I], *Guernica: The Crucible*, chap. 32.

14. Thomas and Morgan Witts [I], *Guernica: The Crucible*, chap. 3. This account of the bombing from the perspective of the townspeople has been compiled from the most reliable published accounts, based in large part on eyewitness interviews that took place within hours of the event. George L. Steer of the *Times* (London) wrote the most

complete and accurate account, published on 28 April 1937 and reprinted in Paris, New York, Chicago, and other leading cities of the world. See Steer [I], *The Tree of Gernika*. Although the account by Noel Monks [I] of the *Daily Express* was not published until eighteen years later, it is in general accurate. Only two years after the bombing, however, when events of the day were still fresh in his mind, Monks wrote a summary of his reports for the *Daily Express* from 28 April and after; this summary, more accurate and still fresh, is reprinted in Hanighen [I], 77–93. Military historians say that Monks was the only foreign correspondent capable of correctly identifying the nationality and types of planes on both sides of the Spanish struggle.

A single native eyewitness, the priest Alberto de Onaindía [I], wrote his own account, but his book *Hombre de paz* did not appear until 1973, long after the controversy over what had happened and who was responsible had subsided. His story, however, was quoted widely and at length in interviews within a few days of the bombing, often distorted, unfortunately, according to the prejudices of the individual reporters.

Two important works on the bombing were published in the seventies. The first was Talón [I], *Arde Guernica!* (see n. 2 to this chapter). The second was Thomas and Morgan Witts [I], *Guernica: The Crucible* (see n. 5 to this chapter).

Exact information concerning the number and nationality of the planes, the number of casualties, and so forth is still being debated, but new documents, mainly from Italian sources, have added many facts that seem to be reliable.

15. Father Onaindía's story appeared in Paris in an interview in *L'Humanité*, 5 May 1937, 3, and then in various forms, in whole or in part, throughout the world.

16. Talón [I], opposite 256.

4 Contradictory Reports in the Press

1. According to Hugh Thomas [I], the first heavy bombing campaign against Madrid began on 29 October 1936.

2. See Southworth [I], *Guernica! Guernica!* This detailed and intensively researched study of the press reports on the bombing, including the disputes, is by far the most complete. It includes analyses of the political positions of the leading French newspapers and, by means of a day-by-day account of what was written, defines clearly the course of the controversy and the reactions of the partisans. The one hundred pages of notes are particularly valuable. See in particular the detailed account of the first news of the bombing in all its complications, 11 ff; the denials, 31 ff; the controversy in the French press, 137 ff. See

also Pike [I], *La presse française* as well as *Conjecture, Propaganda, and Deceit.*

3. See especially issues of 28 and 29 April and 6, 15, 22, and 24 May 1937.

4. Southworth [I], *Guernica! Guernica!* bk. 2, chap. 2. He states that there were no French correspondents in Bilbao, the Basque capital, all of them having been assigned to the Nationalist side (137).

5. Southworth [I], *Guernica! Guernica!* 407–8.

6. Southworth [I], *Guernica! Guernica!* 138. Southworth translates 238–40 of Onaindía [I], *Hombre de paz.* See chapter 3, n. 15. His story was first mentioned in the Paris press in *L'Aube,* 30 April–1 May 1937. A highly emotional version (which Onaindía as a good Catholic priest immediately disclaimed) was published in the Communist *Humanité* on 5 May 1937. As Southworth points out, so many aberrations exist in some of the newspaper quotations that they can be attributed only to deliberate alterations. Because the 1973 text is in accord with both the *L'Aube* and *L'Humanité* versions as well as with Southworth's own interview of 1973, it can be taken as the most accurate.

7. Further confirmation of Onaindía's eyewitness story came from Noel Monks's account in the *Daily Express* of 28 April. On his way to the front, Monks had the unique experience of passing through Guernica only an hour before the bombing and then of seeing from a distance the bombers in action over the town. He was unaware of the extent of the damage until that evening, however, when back in Bilbao having dinner with the two other English correspondents, George L. Steer and Christopher Holme, and Captain Roberts of the British food ship *Seven Seas Spray,* he heard that the town had been destroyed. At about 9:30 P.M., all the journalists hurried to visit the town, which was still burning fiercely. See also Monks [I], chap. 6.

8. *L'Excelsior* may have used the photograph of the oak to evade taking a position on the war. Primarily a picture newspaper, it included very little news or comment on the Spanish Civil War. What little coverage there was soon disappeared in favor of photographs of general news interest such as the abdication of the Prince of Wales (5 May), the exploding Graf Zeppelin (12 May), the coronation of George VI (13 May), and the inauguration of the World's Fair (25 May). Concrete proof of German guilt, however, continued to appear from time to time when bomb fragments bearing German markings were discovered in the town.

9. Failing [II], 55–64.

10. Onaindía [I], 246–47. Translation from Southworth.

5 Transformations of Themes and Characters

1. "The Function of the *Duende,*" trans. J. L. Gili, in Gili [I], 133, 129.

2. One of Lorca's greatest epic poems, written in 1935, memorialized the particularly shocking death in the arena of his close friend Ignacio Sánchez Mejías, a playwright and fellow poet as well as a matador. Written in a paroxysm of grief after his friend was killed in an attempted comeback, Lorca's lament evokes his own powerful emotions in four parts that focus on the shock of the goring, the paralyzing silence of the mourning, the glorification of the man, and finally the gradual return of the body to its mysterious ancestral sources in the Spanish earth. The poem, "Llanto por Ignacio Sánchez Mejías," trans. Stephen Spender and J. L. Gili, is in Gili [I], 133–53.

In the first part of the poem, horror at the sudden appearance of fresh human blood, with all its symbolic overtones, leads to dizzying emotional summits. After the goring and the sudden death, Lorca recoils in the second part, "The Spilled Blood," from what he has seen:

> I will not see it!
> Tell the moon to come
> for I do not want to see the blood
> of Ignacio on the sand.
>
> I will not see it!
> I do not want to hear it spurt
> each time with less strength.

The third part, "The Laid-Out Body," is suffused with the emptiness Lorca feels as he realizes that his friend is gone. And finally the last part, "Absent Soul," explores Lorca's awareness that his friend's existence has ceased:

> The bull does not know you, nor the fig tree,
> nor the horses, nor the ants in your own house.
> The child and the afternoon do not know you
> because you have died forever.

Thus, contradictorily, as in much Spanish art, the concrete realism and violence of the actual goring is transformed into the spiritual state of the ultimate flight and disappearance of the soul.

3. Daniel-Henry Kahnweiler, in conversations with the author, 1951–1952. See also *Paris Match,* 21 April 1973, 72.

4. Gómez de la Serna [II].

5. Leiris [II], "La tauromachie est plus qu'un art," in *Miroir de la tauromachie,* 28–39.

6. Leiris [II], 42 ff.

7. Gilot and Lake [II], 362.

8. See a similar scene in one of the *Lysistrata* illustrations also from 1934, G. 390.

9. See G. 435, 436, 437.

10. The title *Minotauromachy* is not exactly accurate since the scene portrays not a battle but the solitary anguish of a single Minotaur. It is not known who gave the etching its title, but it was almost certainly not Picasso. Elsewhere in this book I discuss the confusion caused by a multiplicity of titles applied by different persons in different languages, usually leading to general acceptance of the

one that appears in print first or most frequently (see chapter 6, n. 10).

11. See Z VIII, 190–94, 248–64.

12. See the many passionate letters Picasso addressed to her, even from nearby in Paris, explaining why he could not come to see her: 1982 [III], *Picasso intime*, 49–62.

13. Barr-Sharrar [II].

14. A single notable exception is the *Dream and Lie of Franco* (1937), which clearly expresses Picasso's contempt for Franco, but through means that are characteristic of his art at the time. The concept, however, employs a surrealist ambiguity that allows drastic transformations of form and meaning within his personal chosen vocabulary. Nowhere can it be truly said he resorts to outright political propaganda or other devices, such as conventional allegory.

15. The opinions expressed here are based upon several conversations I had with Picasso in 1952, when Picasso's art and ideas were still related to the concerns of 1937; in the intervening fifteen years *Guernica* was followed by other works that indicate, though without the same artistic power or intellectual and emotional force, his continued involvement with universal problems facing humanity. Consider, for example, *The Charnal House* (1945), the *Monument aux Espagnols* (1946), the *Massacre in Korea* (1951), and his Dove of Peace poster (1949). He also contributed to exhibitions and manifestations in memory of the resistance of 1940–1945. Finally, Picasso participated in Communist party peace conferences in Warsaw (1948) and Sheffield (1950). These and other activities led the Franco government in 1951 to compile a dossier on Picasso. Among the sources of information cited in his file was *Life* 30, no. 5 (29 January 1951): 95. According to the story in *Life*, Picasso adored the Reds, and the communists, in turn, idolized Picasso.

16. I am grateful to the curator, Madame Marie-Laure Besnard-Bernadac, for showing them to me, for discussing the theme with me, and for giving me permission to reproduce certain of them. Sketch 12 was published and commented upon by her in 1985 in the museum's general catalogue. It was reproduced by Sidra Stich [II], "Picasso's Art and Politics in 1936." Eight of the twelve sketches appeared in Ludwig Ullmann's "Zur Vorgeschichte von Picasso's *Guernica*," part 2: "Entwurf zu einem Atelier-Bild, April 1937," *Kritische Bericht*, Jahrgang 14, Heft 1, 1986, 4–26. Dr. Ullmann kindly sent me a copy of both parts of his article, which I received after the text for my book was in press. I am pleased to acknowledge his useful work.

17. Stich [II], "Picasso's Art and Politics."

18. See also Z VIII, 76–82, 85, 92, January 1933, and 248–64, February 1935.

19. Duncan [II], *The Silent Studio*, 61.

20. These eyelids subsequently recur in *Guernica* in the fallen female figure in States II, III, and IV and then in the fallen male warrior in States II, IV, V, and VI.

21. The spotlight was a common feature of an artist's studio; see the silhouette of Dora Maar's spotlight in the photographs of States II and III (7.13, 7.20).

22. Eighteen of these postcards were available, as well as one of *Guernica* with the following description on the back: "The great Spanish painter Picasso, who founded cubism and who has so powerfully influenced contemporary art, has sought to express in this work the disintegration of a world afflicted by the horrors of war."

23. There is still some uncertainty over which of his sculptures were included in the pavilion and exactly where they were placed. Sert stated in a conversation with me that he and Picasso visited the sculpture studio several times before finally deciding which works to take and that even after the sculptures were transported to the exhibition, they were moved about within the pavilion. Even Spies's excellent detailed catalogue of 1983 (German edition), which lists one bust (S. 131), two heads (S. 132, 133), and the figure *Woman with a Vase* (S. 135) as having been among the works on display, does not mention the presence in the pavilion of a bronze figure (S. 108) that is clearly identifiable in the comprehensive official report on the exhibition by Edmond Labbé [II], 9: 169–76. See also the article in *El País*, 4 December 1985, 28, in which Spain's claim to ownership of the bather is discussed.

24. *Paris-Soir*, 19 April 1937, 1.

25. For the still lifes, see Z VIII, 325–35, 352–62, 364–67, January–30 April 1937; for the nude females, see Z VIII, 336, 337, 339, 351, February 1937; Z IX, 217, 1 May 1937.

26. Stich [II], "Picasso's Art and Politics," 117.

6 Six Days to *Guernica*

1. Although the opening of the fair had originally been scheduled for that very day, 1 May, it had been postponed until 24 May. While most of the other exhibits were ready by the twenty-fourth, the Spanish pavilion did not open until 12 July (see *Life* 3, no. 4 [26 July 1937]: 64).

2. Sketches 1 to 45 will be found reproduced in color in the color plate section of the book. In addition, each sketch discussed will be illustrated in black and white near the corresponding text, usually on the same page. Because sketches 46 to 61 were made after *Guernica* was essentially completed—about the first week of June 1937—and are concerned with images other than those appearing in the painting, they will not be included here (with the exception of sketch 48). Most of the later sketches may be found in Arnheim [II], *The Genesis of a Painting*; Larrea [II], *Guernica: Pablo Picasso* (1947, 1977); and *LP* (1981). Actually, there may be nearly a hundred sketches in all, most of the later ones dealing only with the theme of the weeping woman and produced during the six months following completion of the painting.

3. Schapiro [II], 253.

4. Françoise Gilot emphasizes this characteristic behavior pattern of Picasso's, one that recurred in his relations with several different women, in Gilot and Lake [II], 235–42.

5. For an important discussion of the role of transformation in his art, see Schapiro [II], 249–54. See also Arnheim's concept of changes in levels of reality, Arnheim [II], *The Genesis of a Painting*, 10.

6. Axsom [II], Fig. 72.

7. Alfred H. Barr, Jr., in an unpublished paper read at a symposium on *Guernica* (Museum of Modern Art, New York, 25 November 1947).

8. Arnheim [II], *The Genesis of a Painting*, 38.

9. Zervos [II], "Conversations avec Picasso," 173–78.

10. Although Zervos ignores the violence of the knife attacks, calling the first one "Composition" and the second one "Personnages," some writers have entitled them "Death of Marat." The title probably comes from a drypoint of 21 July 1934 (G. 430) depicting another knife attack, which was inexplicably called "Death of Marat" (by Geiser?). The drypoint was printed in twenty-four copies as a frontispiece for Benjamin Péret's volume of poems *De derrière les fagots* [II]. Its title, however, relates to nothing in the text and probably was suggested by a superficial association with Jacques-Louis David's painting of that name. Furthermore, the drypoint was only a marginal sketch on a larger etching, *Blind Minotaur Guided by a Girl*, 22 September 1934 (see upside-down image in left corner of illustration 5.7).

11. Gilot and Lake [II], 211.

12. Sabartés [II], *Picasso: Documents iconographiques*, 68.

13. Arnheim [II], *The Genesis of a Painting*, 42, 44.

14. *La Publicitat* (Barcelona), 6 September 1934.

15. This exhibition was held initially at the Jeu de Paume des Tuileries, March–April 1937; see the 1937 [III] exhibition catalogue, *L'art catalan du Xe au XVe siècle*. The exhibition, which was reviewed in the critical art journals, was continued in a private art gallery until the end of the year.

For a detailed examination of possible influences on Picasso, both then and later, see Gioseffi [II].

Medieval Catalan art was already well known in Picasso's circle, for in 1931 Zervos had featured it in his *Cahiers d'Art* in a review article illustrated with numerous photographs; see Folch i Torres et al. [I], "Les Miniatures des commentaires d'Urgell," 329–34. At the time of the Jeu de Paume exhibition in 1937, Zervos published a large, lavishly illustrated art book; although it featured the objects in the exhibition, it was so expansive in its scope as to become in effect a history of medieval Catalan art. See Zervos [I], *L'art de la Catalogne*.

16. Included in the exhibition, it was illustrated in the 1937 [III] exhibition catalogue, *L'art catalan du Xe au XVe siècle* and in *Konstrevy* 13 (Stockholm, 1937–1938), where it was reviewed by Greta Knutson-Tzara, daughter of Tristan Tzara; see Knutson-Tzara [I], "Katalansk konst," 93–95.

17. Included in the exhibition, it was illustrated in the catalogue, in *Konstrevy*, and in Zervos [I], *L'art de la Catalogne*.

18. Included in the exhibition, it was illustrated in the catalogue, in *Konstrevy*, and in Zervos [I], *L'art de la Catalogne*.

19. Illustrated in Zervos [I], *L'art de la Catalogne*.

20. According to Sabartés, Picasso habitually spent weekdays in Paris, where he frequently saw Dora Maar, and weekends in the country with Marie-Thérèse and Maya. Since no known works date from this week, either in the series of sketches for the mural or in others, it is not possible to determine Picasso's activities precisely. In general, the dated works on which places are noted support the schedule described by Sabartés.

21. In conversations with me in December 1978. The foundation was laid on 6 March 1937 and the main structure and walls were erected beginning 29 April. See Labbé [II], Vol. 9.

22. Larrea [II], *Guernica: Pablo Picasso*, 33; revised and expanded in the Spanish edition, 29 ff. Gilot and Lake [II], 243.

23. See Kaufmann [II], 553–61.

24. Stich [II], "Picasso's Art and Politics in 1936," 114.

25. Many authors continue to call this drawing simply a bull, apparently without having closely observed the face. A perceptive curator at the Museum of Modern Art, however, changed the museum's label to read simply *Man*. Two recent publications by Spanish authorities also recognize the human character of this head. The Prado catalogue *Legado Picasso* entitles it *Cabeza de toro con rostro humano*, and Joaquín de la Puente [II], in *Guernica: Historia de un cuadro*, calls it *El deífico toro androcífalo*.

26. See the 1980 [III] exhibition catalogue, *Pablo Picasso: A Retrospective*, 290–304.

27. The only complete set of color plates of the sketches appears in *Legado Picasso* [III].

28. Nochlin [II], 105–23, 177–83.

29. José L. Barrio-Garay's study [II], entitled "An Inquiry into Picasso's Poetic Imagery," was written in 1973 but remains unpublished.

30. For a facsimile of the original manuscript of Picasso's poem, see *Cahiers d'Art* 10, nos. 7–10 (1936): 225–38.

31. Nearly all the sketches made after 11 May, when Picasso laid out the large canvas, were made in the middle of the week, in contrast to the first sixteen—the most important preparatory sketches—which were made during two weekends. If Sabartés's statement holds—that Picasso habitually spent weekdays in Paris and weekends in the country with Marie-Thérèse—Picasso must have utilized the two weekends with Marie-Thérèse to start *Guernica*, presumably passing much of the remainder of the time in Dora Maar's company. This may help to explain Dora's likeness in so many of the sketches after about 28 May 1937 and the portraits of her in oil on canvas beginning early in June and continuing throughout 1937. Apparently in the weeping woman series, which depended upon Dora's facial expression, Picasso responded to her actual appearance and her emotionality.

Based on his portrayals of the two women in his art, it would seem that Picasso's passion for Marie-Thérèse began to flag in the spring of 1936. This was borne out

within a month of their return to Paris in May 1936, when Dora Maar assumed first place in both his life and art. It is illuminating to consider Picasso's changing views of Dora as reflected in his portraits of her or images resembling her during 1936–1937, especially considering that his idyllic view of Marie-Thérèse during the same period was waning. See the drawing of 1 August 1936 of a woman resembling Dora entering the room where the artist-god awaits (Z VIII, 295). One month later, on 1 September 1936, nude and reclining, she awaits an impassioned Minotaur (Z VIII, 296), and on 11 September, during an absence from Mougins, he sketched out a freely drawn portrait of her (Z VIII, 299). By mid-June her features are clearly recognizable in the long series of weeping women heads (see sketch 48 of 13 June, 6.78) that developed out of the early mother and child sketches for *Guernica.* His portraits of her during the fall of 1937 sometimes even give her the radiant beauty of the earlier Marie-Thérèse portraits (Z VIII, 331). On 2 August 1937, Picasso and Dora left together for Mougins (see chapter 1, n. 28).

32. Color in the sketches may have functioned like the collages of wallpaper introduced in States IV and VI of the large painting (see chapter 7). Neither left an identifiable influence on the finished painting, yet both were a part of its evolution.

33. I have chosen to continue a chronological discussion of some sketches after sketch 45 even though the large canvas was then undergoing its transformation through the various "states" to the final image.

34. See Picasso's many religious processions, devotional figures, and deathbed scenes, especially those from around 1900, Z XXI (1892–1902).

7 Ten States of the Final Canvas

1. Size as measured when it was mounted and installed in the Museum of Modern Art in November 1939; see the 1939 [III] exhibition catalogue, *Picasso: Forty Years of His Art.* In the museum's 1980 [III] exhibition catalogue, *Pablo Picasso: A Retrospective,* and in the Museo del Prado's 1981 [III] *Legado Picasso,* however, the dimensions are given as 11′5½″ by 25′5¾″, a difference that can be explained by wear on the edges of the canvas during numerous mountings and dismountings.

2. Although in the "states" Picasso was working with oil paint on canvas, he began by sketching out the main lines as if he were drawing. This is in accordance with his usual practice and reflects his preference for drawing on paper. In 1946 he told Anatole Jakofsky that he liked to paint on paper because he felt that things could more easily be changed; see Jakofsky [II], 3–12. The linear, sketchy character of the first states of *Guernica* made it susceptible to frequent change.

3. See *Cahiers d'Art* 12, nos. 4–5 (1937).

4. From Zervos [II], "Conversations avec Picasso," 173. Instructed in photography by Dora Maar during 1936–

1937, Picasso completed a series of portraits of her by painting over his own negatives; see *Cahiers d'Art,* nos. 6–7 (1937): following p. 165. Zervos was the first to arrange Dora Maar's photographs in sequence, Larrea was the first to use the term *states,* and to Arnheim we owe the sequential numbering of the first sixty-one sketches.

5. *Cahiers d'Art,* nos. 4–5 (1937): unpaginated.

6. The most complete are the publications by Zervos (his issue of *Cahiers d'Art* 12, nos. 1–3 [1937], and *Pablo Picasso* [catalogue raisonne], Z IX); Larrea [II], *Guernica: Pablo Picasso* (1947, 1977); Arnheim [II], *The Genesis of a Painting* (1962); and the Museo del Prado's 1981 [III] exhibition catalogue, *Legado Picasso.* In these publications, seven, eight, or nine of the photographs are reproduced. To avoid ambiguity, all ten of the known photographs are included in the present work, and the two most frequently omitted have been assigned their most logical positions and designated State IA and State IIA.

7. In the posture of their central figure other paintings by Picasso had created subtle but important allusions to the Crucifixion. See in particular *The Three Dancers* (6.23) of 1925, painted just after Picasso's last visit to the headquarters of Olga's ballet troupe in Monte Carlo. According to Roland Penrose, this painting was one of Picasso's favorites, and only after much persuasion from Penrose did he relinquish it to the Tate Gallery in London.

8. See Z XXII, 6 (1903).

9. Although this photograph is now in the possession of Dora Maar, Zervos did not include it when he published photographs of the other eight states in 1937. Apparently it appeared for the first time, replacing Zervos's State I, in Larrea [II], *Guernica: Pablo Picasso* (1977). With the exception of the Museo del Prado's complete catalogue of all the sketches and details of the painting, all other publications on the painting have omitted it. The Prado catalogue, however, replaced Zervos's State I with the new version, 1.ª Fase (or my State IA); see *LP,* 98.

10. Most observers interpret this figure as a male warrior, even though in States I and II she is clearly female.

11. The political and ideological issues are given special attention in Beevor [I]. He sets out to explain factors not fully realized at the time and not even adequately covered in the general histories: "The three basic forces of conflict: right against left, centralist against regionalist, and authoritarian against libertarian."

12. This curious phenomenon has generally been overlooked by writers on *Guernica.* Frank D. Russell [II], 258, describes it briefly, but since he does not reproduce Dora Maar's detail, he cannot show the original version of this ingenious image, which was partially painted out in State III. Arnheim [II], whose book is so rich in perceptions concerning changes of form, passes over this image with only a brief mention; see *The Genesis of a Painting,* 122.

13. See Gómez de la Serna [II], 124–25.

14. See the Minotaur series, nos. 83–90 of the Vollard Suite, May 1933.

15. A study of Picasso's monumental paintings supports this view, namely that the scenes suggested represent a unified, even though vague or ambiguous, theme. Further, because

these scenes evoke human emotions and responses more than ideas, they tend to negate the theories proposed by writers who seek to find specific political or allegorical meanings in them.

16. In conversations with me in December 1978.

17. Phyllis Tuchman [II] believes that these environmental factors influenced the design and even account for the lack of color of the painting; see "Guernica and *Guernica*," 45.

18. Carlton Lake quotes Salvador Dalí as saying that during a visit to Picasso's studio while the painting was in progress, the painter told him that he was seeking the effect of real sweat; see Carlton Lake, *In Quest of Dali* (New York: Putnam, 1969), 46.

19. This point had been visualized dramatically years before not only in Cubism but in the theater sets of Bertolt Brecht and Erwin Piscator, with which *Guernica,* in its multiple levels of reality and synthesis of diverse experiences, may be said to have an affinity.

20. Sert, in conversations with me in December 1978. Actually, *Guernica* was in place before the work on the Spanish pavilion had been entirely completed and before Calder's mobile had been installed (see 8.13).

8 *Guernica* in Paris: July–October 1937

1. A thoughtful evaluation of the artistic and social meaning of the fair is given in the Centre Pompidou 1979 [III] exhibition catalogue, *1937: Exposition internationale*. It includes *in situ* photographs and short essays by Le Corbusier, Léger, Aragon, Robert Delaunay, André Breton, and Amédée Ozenfant. For the argument over social realism and politics in art, including the positions of these artists, see Aragon et al. [II], *La querelle du réalisme*. For photographs and maps see *L'Illustration,* 29 May 1937, and the many souvenir catalogues published under the official title. Although these are valuable for their numerous illustrations, they say little about the Spanish pavilion since most of them were published before it opened on July 12. For Sert's Spanish pavilion, see *Cahiers d'Art* 12, nos. 4–5 (1937) and Bastlund [I].

2. This ad hoc alternative exhibition did not open until 31 July, even later than the Spanish pavilion.

3. See especially *1937* in the series *Nos 20 ans*. In March Hitler sent General Wilhelm Faupel as a personal emissary to Franco; on 21 March the Communists in Paris fought violently with Colonel de la Roque's French Fascists; on 12 May open war between the Anarchists and the Socialists broke out in Barcelona; on 16 May Prime Minister Cabellero was forced out of office; on 31 May German warships bombarded the undefended Spanish city of Almería (substantially strengthening the evidence for German guilt at Guernica); on 12 June came the news of the trials and executions of the Russian generals; on 21 June Prime Minister Léon Blum resigned; and on 7 July French Royalists rioted in the streets of Paris.

Even the world of art was rocked: on 1 June a large exhibition of modern French art opened at the Prussian Academy in Berlin, and Zervos wryly noted that only one German leader—Chief of the Luftwaffe Hermann Goering—attended the state ceremony. (See also Zervos's analysis of Nazi hostility toward modern art in "Réflexions sur la tentative d'esthétique dirigée du IIIᵉ Reich," *Cahiers d'Art* 12, nos. 1–3 [1937]: 51–61.) Only six days after *Guernica* was revealed to the public in Paris, Hitler's virulent manifesto against all modern art was issued in Munich. He had devised a cunning means of demonstrating to the public the superiority of "true German art" over what the Nazis called "degenerate, Bolshevik and Jewish art." This speech was delivered at the dedication of the Haus der deutschen Kunst (now the Haus der Kunst), whose opening exhibition featured the German nineteenth-century romantic masters, together with approved modern artists who generally painted in a pallid academic or popular anecdotal style concerned with Nazi themes of heroism in battle, familial piety, and work on the land. In contrast, the infamous Degenerate Art Exhibition, in which work by virtually all the truly significant modern German artists mingled with paintings by the insane, was presented in slovenly fashion in a minor gallery and was the subject of vicious ridicule by the controlled press.

4. Published material on the Spanish exhibition and the pavilion was extremely sparse until 1986, when Catherine B. Freedberg's dissertation [I] appeared. In that same year the ministry of culture found, safely stored in the Palacio Nacional de Monjuic in Barcelona, a group of eighty-four paintings and forty sculptures and artifacts that had been on display in the pavilion, works last seen when they were shipped back to Spain in 1937 (see *El País,* 18 April 1986, 39).

Two large exhibitions commemorating the fiftieth anniversary of the 1937 World's Fair were held in 1987. The one in Paris featured the architecture of the fair by means of models and photographs together with some of the paintings and sculpture. The other, in Madrid, was devoted solely to the Spanish pavilion and presented most of the art shown there and believed lost for the intervening half century. Included were five sculptures by Picasso, one by Julio González, and Calder's mobile. The maquette by Alberto Sánchez survived, but not the original. A large detailed model of the pavilion showed the location and scale of the art both inside and outside the building. Both exhibitions were accompanied by catalogues extensively documenting the objects on exhibit and the structures: 1987 [III], *Cinquantenaire de l'exposition internationale* and 1987 [III], *Pabellón Español, 1937,* by Josefina Alix Trueba.

5. One of the sculptures in the pavilion, the head of Marie-Thérèse of 1931 (S. 133), and the larger-than-life-size figure of 1933 usually called *Woman with a Vase* (S. 135), were said to have been selected by Picasso and Sert at the last minute, during a visit to the studio at Boisgeloup before the pavilion opened. *Cahiers d'Art* 12, nos. 4–5 (1937) reproduces photographs of both works (see 5.31).

The present location of the plaster cast of *Woman with a Vase* is unknown, but two bronze casts of it were made just before Picasso's death. He intended one, according to a signed note attached to it, for the Spanish Republic; see the photograph in Duncan [II], *The Silent Studio*, 61. The other is apparently the one now standing over Picasso's tomb in Vauvenargues (see 5.32). This suggests that in his last year of life he made a significant gesture: duplicating this sculpture, whose ritual posture suggests the figure of Marie-Thérèse, he destined one cast for the Casón del Buen Retiro in the Prado (to accompany *Guernica*), the other for his own funerary monument.

6. *LP*, 151.

7. The largest in the world, the Almaden mines produced mercury for the munitions industry and at this moment were under assault by Nationalist forces. Before the exposition closed, they had fallen to the enemy. In his autobiography, Calder describes a visit, probably in late April, to the site of the pavilion. He states it was then no more than a skeleton. Only later, when Sert had rejected the fountain proposed by the Spanish government—a prizewinner in the 1929 Barcelona World's Fair—did he ask Calder to provide one. Calder remembers that the one rejected looked like a drinking fountain; in addition, it could not handle the heavy liquid mercury. Although he installed his piece before the fair opened—and he notes that *Guernica* was already in place at the time—he could not put it into operation until the day the Spanish pavilion was inaugurated, when the mercury supply arrived. See Calder [I], *An Autobiography with Pictures*, 158–65.

8. Other films were shown that like *Guernica* presented forcefully and dramatically the suffering of the people. They included such documentary film classics as *Madrid—Verdun de la démocratie* by Tristan Tzara and *Spain in Flames* by John Dos Passos and Archibald MacLeish.

9. *Cahiers d'Art* 12, nos. 4–5 (1937): unpaginated.

10. For examples of the posters, see Miravitlles et al. [I], *Carteles de la República*.

11. "La victoire de Guernica," *Cahiers d'Art* 12, nos. 1–3 (1937): unpaginated. It was published together with a musical score bearing the same title by Georges Auric.

12. A large illustration of *Guernica* accompanied by a brief editorial comment was published in *Life* (3, no. 4 [26 July 1937]: 64) only fourteen days after the official opening of the Spanish pavilion. This was probably the first appearance of the painting in the international press.

13. Le Corbusier, "A propos des peintures murales à l'exposition de 1937" (Paris, 14 December 1937), in 1979 [III] exhibition catalogue, *1937: Exposition internationale*, 12–13.

14. Aragon et al. [II], *La querelle du réalisme;* "Réalisme socialiste et réalisme français Europe," quoted by Patrick Weiser in 1979 [III] exhibition catalogue, *1937: Exposition internationale*, 4.

15. "Notes d'un touriste à l'exposition," *Cahiers d'Art* 12, nos. 4–5 (1937): 247.

16. "Faire-part," *Cahiers d'Art* 12, nos. 4–5 (1937): 128.

17. Decaunes [II].

18. Quoted by Sadoul [II], 8.

19. Hugh Thomas [I], 557, 594, 604, 642.

20. See note 4 above.

21. During a visit to the rue des Grands-Augustins studio in 1952, I observed several high stacks of newspapers, including *L'Humanité,* but did not deem it appropriate at that moment to attempt to search for the 1937 issues. Later, the editor of the newspaper kindly provided microfilms.

9 The Odyssey of *Guernica*

1. Ignacio Zuloaga's *Siege of the Alcázar* of 1936, honoring the Guardia Civil troops who successfully held out in the Toledo Alcázar against a siege by Republican troops in the first weeks of the war, was hung in an adjacent gallery in January 1939. According to Roland Penrose, in conversation, it attracted little attention.

2. *Artnews* 82, no. 1 (January 1983).

3. *Evening News* (Manchester), 1 February 1939.

4. *Spectator*, 28 October 1938, 712.

5. *New Statesman and Nation*, October 1938, 567–68. This first mention of newspapers as a source for *Guernica* may have been responsible for the suggestion that the striations on the horse *represented* newsprint. Spender, at the time a member of the Communist party, had gone to Spain primarily, it is said, to search for a missing friend but soon returned home. Hugh Thomas tells with amusement of the many ironies inherent in the diverse and conflicting interests of the volunteers, as, for example, when Spender found himself rising to honor the playing of *God Save the King* and giving the only salute he knew at the time—the clenched fist! See Hugh Thomas [I], 496; Spender [I], *World within World*.

6. Hugh Thomas [I], 222.

7. Hugh Thomas [I], 222 n. 1.

8. *Spectator*, 8 October 1938, 504.

9. *Spectator*, 8 October 1938. Blunt made his charges at the very time when he kept secret his own participation in political affairs—the time when he was actively recruiting university students as Soviet spies, just before he himself, from a high position in the British secret service, began his career as a "mole" providing the Soviet GPU with British military and diplomatic secrets. See George Steiner, "The Cleric of Treason," *New Yorker*, 8 December 1980.

10. *Spectator*, 6 August 1937, 241.

11. Herbert Read, "Picasso's *Guernica*," *London Bulletin*, October 1938, 6.

12. There is much uncertainty about the actual movements of *Guernica* in Britain. Penrose [II], *Picasso: His Life and Work*, 320, writes that it was first shown in Norway before going to London and then on to Leeds and Liverpool. He does not mention Manchester, where it was shown and aroused great enthusiasm among Labour party mem-

bers. When I asked him, he did not, in fact, remember Manchester. I have not been able to locate records of the National Joint Committee for Spanish Relief in Britain, and no mention of any of these exhibitions appears in the archives of the American committee.

13. The following account is based upon conversations with these two leading participants as well as with Sidney Janis and Margaret Scolari Barr and upon the archives of the Spanish Refugee Relief Campaign and related committees, presently housed in Butler Library, Columbia University.

14. Quoted in the *New York Times*, 19 December 1937.

15. On an information sheet posted in the San Francisco Museum of Art, reprinted in *Art Digest*, 15 October 1939.

16. In a conversation with me, Sidney Janis gave credit also to the assistance of Christian Zervos and Mary Callery in persuading Picasso to send the painting and the drawings to New York to raise money for refugee relief (December 1978). In 1939, Janis had not yet founded his own gallery, which eventually became the leading showplace for Picasso and artists of the Paris avant-garde.

17. From documents in the archives of the Spanish Refugee Relief Campaign and related agencies and from a conversation in December 1978 with Margaret Scolari Barr, who had accompanied her husband on a trip to Europe in the summer of 1939 when the matter was discussed with Picasso. Mrs. Barr added that at that time Picasso "claimed for himself full responsibility" for all negotiations regarding *Guernica*.

18. The American Artists' Congress included by invitation most of the influential artists and critics and some art historians. While their political stance was actively leftist, they were also intensely concerned with showing their art. The group was held together by men of sound judgment and cautious action, such as Stuart Davis, Max Weber, Lewis Mumford, and Meyer Schapiro. The congress broke up in 1940 in a bitter controversy over the Russian invasion of Finland. For their political ideologies, see their own privately printed publication, American Artists' Congress [II], *First American Artists' Congress*. For a concise account of their journal, *Art Front*, see Monroe [II]. For additional insights and a useful bibliography, see Horrigan [II].

19. The 1939 [III] Museum of Modern Art exhibition catalogue, *Picasso: Forty Years of His Art*, edited by Barr, lists a total of sixty preparatory works and postscripts (drawings, etchings, paintings); Larrea [II], in *Guernica: Pablo Picasso* (1947, 1977), included seventy-two; Arnheim [II], in *The Genesis of a Painting* (1962), sixty-one; and *Legado Picasso* (1981), sixty-one. The receipt for the transfer of the painting and the sketches to the Spanish state in 1981, however, numbered sixty-two sketches. There may be as many as thirty later sketches of the weeping woman made after *Guernica* was finished and therefore not specifically related to its development.

20. *Art Digest*, 15 May 1939. The review is unsigned but was undoubtedly the work of Henry McBride.

21. *New York Post*, quoted in *Art Digest*, 15 May 1939.

22. *Art Digest*, 15 May 1939.

23. *New York Times*, 11 May 1939.

24. *New Masses*, 15 May 1945.

25. *Art Front*, October 1937, and Museum of Modern Art symposium, 27 November 1947.

26. *Springfield Republican* (Massachusetts), 19 November 1939.

27. *Los Angeles Examiner*, 3 and 7 August 1939; *Herald Express*, 3 August 1939; *Los Angeles Times*, 13 August 1939.

28. *San Francisco News*, 26 August 1939.

29. *San Francisco Chronicle*, 3 September 1939.

30. Information sheet posted in the San Francisco Museum of Art, reprinted in *Art Digest*, 15 October 1939.

31. *Chicago Herald and Examiner*, 17 August 1939.

32. *Chicago Herald-American*, 4 October 1939.

33. An additional, unexpected, debit was later incurred by many supporters of the relief campaign; because their names had appeared as sponsors and contributors, they fell under suspicion during the Cold War of having served the ends of the Communist party and were sometimes relentlessly investigated and questioned.

34. *Art Digest*, 1 December 1939. In letters in a similar vein to the *New York Times*, the painters Reginald Marsh, Thomas Hart Benton, and Paul Cadmus called *Guernica* the "quintessence of ugliness" and an example of the "disorders of the age," claiming that in these matters Paris could not compete with Picasso (17 December 1939). In a response to such attacks, the museum's Kenneth Donahue presented a lecture, "The Fantastic in Picasso's Later Paintings."

35. *Art Digest*, 1 December 1939.

36. *Art Digest*, 1 December 1939.

37. *Parnassus*, December 1939.

38. *Art Digest*, 15 February 1940.

39. Quoted in an explanatory label in the Fogg Museum's exhibition, 1941, 1942.

40. The memo is said to be in his private papers but I have not seen it.

10 Spain Claims Its Refugee

1. For an English translation of Blanco's original letter, see Appendix, Document 3. For a study of the letter, see Joaquín de la Puente, "Franco dijo 'sí' al *Guernica* de Picasso," *Blanco y Negro*, 14 February 1976.

2. *New York Times*, 29 October 1969.

3. Pozuelo [I].

4. *Linn's Stamp News* (Sidney, Ohio), 30 November 1981, 81.

5. The Equipo Crónico artists, Rafael Solbes and Manuel Valdés, founded their movement, based on a struggle for artistic and political freedom, in 1965 when they were both in their mid-twenties. They satirized and adopted for their own purposes images of the old masters, who they felt were stifling their own efforts to deal with modern life, and used fragments from *Guernica* to protest both Spanish conservatism and political oppression. They soon enjoyed wide success in Spain.

6. *Le Monde,* 14 November 1969.

7. *Le Monde,* 14 November 1969.

8. Published in the original French in *LP,* 160.

9. It is probably not a coincidence that Picasso should have dated this letter 14 April 1971, the fortieth anniversary of the proclamation of the Spanish Republic. For a facsimile, see Appendix, Document 11.

10. Malraux [II], 247. According to reliable reports, Santiago Carillo, the head of the Spanish Communist party, visited the artist's widow in support of the Spanish request, but she was noncommittal.

11. Complicating matters further, in 1972 Spanish Republicans living in exile in Mexico circulated the claim that because they represented the Republic, *Guernica* should be returned to them. See *Excelsior* (Mexico, D.F.), 24 August 1972.

12. Among the evidence generally cited to prove the beginning of democratic procedures and public liberties in Spain was the acquittal on 3 March 1967 of a priest charged with calumny of the national movement: he had written in a book that the Nationalist air force was responsible for the destruction of Guernica. As Elena de la Souchère has shown (*Figaro Litteraire,* 18 December 1967), this was the first government disavowal of the official charge that the Republican army itself had intentionally set fire to the town. (N.B. The priest was not entirely accurate, however, for impartial investigators unanimously assign responsibility to the German Condor Legion, not the Nationalists.) In 1974 the longtime ban against female matadors appearing in public arenas was lifted. Political tensions were greatly relaxed when the new king, Juan Carlos, awarded pensions and disability allowances to war veterans who had fought for the Republic and against Franco (7 April 1976). The Communist party was legalized on 1 April 1977, just in time for it to participate in the first general elections. In its first national meeting a year later, the Party reacted by declaring its adherence to the Eurocommunism of France and Italy and its rejection of the class war and other revolutionary concepts of Lenin as out of date. It was pointed out that ever since the rise of Hitler the Comintern had named fascism rather than capitalism as the primary enemy. A constitution guaranteeing human rights, among other things, was approved in a national referendum on 6 December 1978 and signed by the king three weeks later.

13. *Le Monde,* 5 December 1975, 35.

14. See chapter 8, note 5.

15. See *La voz de Galicia* (La Coruña), 4 November 1973, and *Tele-Expres* (Barcelona), 4 October 1973.

16. *El Correo Catalan,* 3 August 1976.

17. "Todos a Una: Que venga el 'Guernica'," *Ya,* 21 August 1977. It was a sure sign that political antagonisms were relieved a little when Catholic, Liberal, Falange, and Communist editors could present nearly identical desires for the acquisition of this national symbol.

18. *Arriba,* 6 August 1977.

19. Public Law 95-426, 95th Congress, 7 October 1978, 92 Stat. 987, Sec. 605(a). See Appendix, Document 13.

20. *Ya,* 27 May 1978; *Arriba,* 27 May 1978.

21. *LP,* 153. Letter of 28 May 1937 to Ambassador Luis Araquistáin. See Appendix, Document 4, as well as Documents 5, 6, 7, and 9.

22. In a letter from Sert to me, in an interview, December 1976, and in a statement at the symposium at the Museum of Modern Art on 26 November 1947.

23. Jacqueline Picasso's suicide on 15 October 1986 aroused once more the bitter controversy over Picasso's estate that had raged for four years. She had lent a group of sixty-one paintings of his from her own inheritance to the Museo Español del Arte Contemporaneo (MEAC) in Madrid for an exhibition to open on the 106th anniversary of his birthday, 25 October 1987. The director of the museum, Aurelio Torrente, had become an intimate friend of hers; he claims that she had led him to believe she intended to donate to Spain at least this group and possibly her entire inheritance—some sixty-five thousand works in all media. At 1:30 A.M. on 15 October she telephoned him and, according to his account, in a voice quavering with emotion told him she had decided to give him the entire collection of sixty-one paintings. But later that morning she died by her own hand from a pistol shot. An exhaustive search of the museum files failed to discover a written confirmation of the donation and although several witnesses, including a writer in *Paris Match,* testified that they had heard Jacqueline declare her intention to make such a gift of her collection, the Spanish authorities finally deferred to growing pressure both from the French government and from lawyers for Jacqueline's daughter and sole heir, Catherine Hutin (about forty years of age at the time of her mother's death) for the return of the collection to France.

The problems of the Spanish government were not yet over, however, for the four other heirs declared that Jacqueline had no right to lend her paintings, a position strengthened by the French government's accusation that no export license had been issued. The heirs claimed that all the artist's rights were represented by S.P.A.D.E.M. (an agency for the protection of art, drawings, and monuments), which the four of them controlled. They demanded as the artist's share 30 percent of all proceeds of the exhibition, such as admission fees, catalogues, posters, postcards, and so forth. Finally, the remaining matter of inheritance taxes may well result in the acceptance of many of the works in lieu of taxes, thus further enriching the collection of the Musée Picasso in Paris. From *Diario 16,* 16 October 1986; *El País,* 17, 21, 22 October 1986; *El País* (International edition), 19 January, 4 February 1987; *New York Times,* 20 January 1987.

24. Confirmed by Perpetua Barjau de Aub, widow of Max Aub, in a letter to me dated 9 June 1980 from Mexico City. Facsimiles of the letter and the statement, both written in Spanish, are published in *LP,* 156–57. For a translation of del Vayo's letter, see Appendix, Document 5.

25. Quintanilla [II], 224.

26. *New York Times,* 14 April 1973.

27. A newspaper poll published in *Diario de Barcelona* on 7 August 1977 showed the surprising result that Catalans, asked where the painting should go, preferred Guernica

as a permanent home, with Barcelona only their second choice and Madrid their last. At the same time, a poll in Madrid showed, as might be expected, a strong preference for that city.

28. For a translated excerpt of the Official Bulletin of the Cortes, see Appendix, Document 12.

29. Still one more dissent arose when in 1977 a spirited debate was arranged on national television on this question. All the cities were represented by their mayors except Barcelona, which was represented by Rosa María Subirana, director of the Museu Picasso (now under its Catalan name). The passion with which all the panelists pressed their claims was a clear demonstration of the powerful meaning *Guernica* was assuming for Spaniards. But during the next four years until *Guernica* actually arrived, public opinion gradually swung back toward the Prado.

30. *Solidaridad Nacional,* Barcelona, 26 June 1978.

11 *Guernica* Comes to the Prado

1. *El País,* 27 July 1980; *ABC,* 5 August 1980; *Blanco y Negro,* 14 December 1980.

2. Tusell to Paloma Picasso, 3 October 1980; Ferreboeuf, 6 November 1980; report from Quintanilla, 22 November and 24 December 1980, Archivo del Ministerio de Cultura, Madrid.

3. *Sábado Gráfico,* 22 October 1980; Tusell to Cavero, 11 December 1980, Archivo del Ministerio de Cultura, Madrid.

4. Letter of Adolfo Suárez, January 1981, Archivo del Ministerio de Cultura, Madrid.

5. Letter of Jacqueline Picasso, 12 January 1981, Archivo del Ministerio de Cultura, Madrid.

6. Marina Picasso, 29 January 1981, Archivo del Ministerio de Cultura, Madrid.

7. Maya Picasso, 14 January and 11 February 1981, Archivo del Ministerio de Cultura, Madrid; Quintanilla [II], 164.

8. Report by Tusell, 5 January 1981, Archivo del Ministerio de Cultura, Madrid; *ABC* and *Diario 16,* 20 January 1981.

9. *Diario 16, Pueblo,* and *ABC,* 21–28 January 1981; *El País,* 19–20 January 1981.

10. *ABC,* 27 February 1981; *El País,* 12 March and 30 April 1981.

11. Rafael de los Casares, 7 April 1981, Archivo del Ministerio de Cultura, Madrid.

12. Richard E. Oldenburg, Director, Museum of Modern Art. Letter, 24 April 1981, Archivo del Ministerio de Cultura, Madrid; *ABC* and *El País,* 7 and 9 April 1981.

13. Quintanilla [II], 187–89; letter of Maya Picasso to Tusell, 28 June 1981; *El País,* 24 and 30 April 1981.

14. *El País,* 9 September 1981.

15. *El País,* 9 and 11 September 1981; *Diario 16,* 10 September 1981; *ABC,* 10 September 1981; *New York Times* and *Washington Post,* 11 September 1981.

16. *El Alcázar,* 12 September 1981; *El País,* 1 September and 25 October 1981.

17. Cavero's statement was published in *ABC,* 16 October 1985.

12 The Meanings of *Guernica*

1. Quoted by Elizabeth McCausland in the *Springfield Republican* (Massachusetts), 18 July 1937.

2. Sadoul [II], 8.

3. Carlos Fuentes paraphrasing Juan Marichal, *Los Angeles Times,* 3 August 1986, sec. 5, p. 6.

4. *New York Times,* 10 January 1971.

I. Spain: Art, Culture, and History

ABC 1936–1939 Doble diario de la guerra civil. Madrid: Prensa Española, 1979. Javier Tusell, Director.
 Vol. 28: Madrid-Sevilla, 15 al 27 de Abril de 1937.
 Vol. 29: Madrid-Sevilla, 28 de Abril al 8 de Mayo de 1937.
 Vol. 30: Madrid-Sevilla, 9 al 19 de Mayo de 1937.
 Vol. 31: Madrid-Sevilla, 20 de Mayo al 2 de Junio de 1937.
 Vol. 45: Madrid-Sevilla, 15 al 26 de Octubre de 1937.
Abendroth, Hans-Henning. *Hitler in der spanischen Arena.* Paderborn: F. Schoning, 1973.
Agence Espagne, Paris, 1937. Daily bulletins on events in Spain.
Aguirre, J. M., P. Erroteta, J. M. Garmendia, R. Miralles, and A. Viñas. *Historia general de la guerra civil en Euskadi.* Vol. 3. Bilbao: Naroki, 1979.
Alvarez del Vayo, Julio. *Freedom's Battle.* London: W. Heinemann, 1940; New York: Knopf, 1940.
American Committee to Aid Spanish Democracy Archives. Butler Library, Columbia University, New York.
Armero, José Mario. *España fue noticia: Corresponsales extranjeros en la guerra civil española.* Madrid: Sedmay, 1976. See chap. 2, 225–75.
Aub, Max. *Hablo como hombre.* Mexico, D.F.: Joaquín Mortiz, 1967.
Azaña, *Obras completas,* 4 vols. Mexico, D.F.: Oasis, 1966–68.
Bande, José Manuel Martínez. *Por que fuimos vencidos.* Madrid: Prensa Española, 1974.
Bastlund, K. *José Luis Sert.* Zurich: Ed. d'Architecture, 1967.
Beevor, Anthony. *The Spanish Civil War.* New York: Peter Bedrick, 1983.
Belforte, F. *La guerra civile in Spagna.* Vol. 3. Milan, 1939.
Bernanos, Georges. *Les grands cimetières sous la lune.* Paris: Plon, 1938.
Beumelberg, Werner. *Kampf um Spanien: Die Geschichte der Legion Condor.* Oldenburg: Stalling, 1940.
Beust, Hans Henning von. *Die deutsche Luftwaffe im spanischen Krieg.* Stuttgart: Militärarchiv Freiburg, 1955.
Bilbao: Gobierno de Euzkadi. *Guernica.* 1937.
Bley, Wulf, ed. *Das Buch der Spanienflieger: Die Feuertaufe der neuen deutschen Luftwaffe.* Leipzig: Hase und Koehler, 1939.

Bolín, Luis A. *España: Los años vitales*. Madrid: Espasa-Calpe, 1967. English ed.: *Spain: The Vital Years*. London: Cassell, 1967; Philadelphia: Lippincott, 1967.

Borkenau, Franz. *The Spanish Cockpit*. London: Faber and Faber, 1937.

Bowers, Claude G. *My Mission to Spain: Watching the Rehearsal for World War II*. New York: Simon and Schuster, 1954.

Bozal, V., et al. *España. Vanguardia artística y realidad social: 1936–1976*. Barcelona: Gustavo Gili, 1976.

Breker, Arno. *Hitler et moi*. Paris: Presses de la Cité, 1970.

Brenan, Gerald. *The Spanish Labyrinth*. Cambridge: Cambridge University Press, 1943; New York: Macmillan, 1943.

Brissaud, André. *Canaris*. Paris: Librairie Academique, 1970. Spanish ed.: *Canaris: La guerra española y la II Guerra Mundial*. Barcelona: Noguer, 1972.

Broué, Pierre, and Emile Témime. *Revolution und Krieg in Spanien*. Frankfurt am Main: A. R. L. Gurland, 1962.

Calder, Alexander. *Calder: An Autobiography with Pictures*. New York: Pantheon Books, 1966.

———. "Mercury Fountain." *Indicator* 55, no. 3 (May 1938): 3–7.

Carr, Raymond. *The Spanish Civil War*. New York: Norton, 1986.

Castillo, Alberto del. *José María Sert, su vida y su obra*. Barcelona-Buenos Aires: Argos, 1947.

Cataluña. In *Tierras de España*. Publicaciones de la Fundación Juan March. Barcelona: Noguer, 1974.

Cierva, Ricardo de la. *Leyenda y tragedia de las brigadas internacionales*. Madrid: Prensa Española, 1973.

Cleugh, James. *Furia española*. Barcelona: Juventud, 1964.

Cocteau, Jean. *La corrida du premier Mai*. Paris: B. Grasset, 1957.

Comissariat de Propaganda. "Le sauvetage du patrimoine historique et artistique de la Catalogne." Barcelona: Comissariat de Propaganda de la Generalitat de Catalunya, 1937.

Comité Franco-Espagnol. *La déstruction de Guernica*. Paris, 1937.

Comité Internationale de Coordination et d'Information pour l'Aide à L'Espagne républicaine. *La mainmise hitlérienne sur la pays basque*. Paris, 1937.

Cowles, Virginia. *Looking for Trouble*. London: H. Hamilton, 1941; New York: Harper and Row, 1941.

Crozier, Brian. *Franco: A Biographical History*. London: Eyre and Spottiswoode, 1967.

Dahms, Hellmuth Günter. *Der spanische Bürgerkrieg, 1936–1939*. Tübingen: H. Leins, 1962.

Duval, General. *Les leçons de la guerre d'Espagne*. Paris: Plon, 1938.

Einhorn, Marion. *Die ökonomischen Hintergründe der faschistischen deutschen Intervention in Spanien 1936–1939*. Berlin: Deutsche Akademia der Wissenschaften zu Berlin, 1962.

Elstob, Peter. *The Condor Legion*. New York: Ballantine Books, 1973. Spanish ed.: *La Legión Condor, España 1936–39*. Madrid: Librería Editorial San Martín.

Eluard, Paul. "Novembre 1936." *L'Humanité* (17 December 1936): 8a.

Embajada USA Bureau of Information, Spain. *Incontrovertible Facts Regarding the Destruction of Guernica*. Washington, D.C., 1937.

Folch i Torres, Joaquín, et al. *L'art Catalá*. 2 vols. Barcelona: Aymà, c. 1955, 1957–1958.

————. "Les Miniatures des commentaires aux apocalypses de Gerona et de Seu d'Urgell." *Cahiers d'Art* 6 (1931): 330–334.

Foreign Wings over the Basque Country. London: The Friends of Spain, 1937.

Forrell, Fritz von. *Mölders und seine Männer.* Graz: Steirische Verlagsanstalt, 1941.

Fraser, Ronald. *Blood of Spain: An Oral History of the Spanish Civil War.* New York: Pantheon Books, 1979.

Freedberg, Catherine B. *The Spanish Pavilion at the Paris World's Fair of 1937.* 2 vols. New York: Garland, 1986.

Fry, Varian. *Surrender on Demand.* New York: Random House, 1945.

Führing, Hellmuth. *Wir funken für Franco.* Gutersloh: Bertelsmann, 1939.

Galland, Adolf. *Die Ersten und die Letzten. Die Jagdflieger im zweiten Weltkrieg.* Darmstadt: F. Schneekluth, 1953. American ed.: *The First and the Last: The Rise and Fall of the Luftwaffe: 1939–45, by Germany's Commander of Fighter Forces.* New York: Henry Holt and Co., 1954.

Garriga, Ramón. *La Legión Condor.* Madrid: G. del Toro, 1975.

————. *Las relaciones secretas entre Franco y Hitler.* Buenos Aires: J. Alvarez, 1965.

Gaya, Ramón. "Carta de un pintor a un cartelista." *Hora de España* (Valencia) año 1, no. 1 (January 1937): 54–56.

————. "Contestación a Josep Renau." *Hora de España* (Valencia) año 1, no. 3 (March 1937): 59–61.

Gerahty, Cecil. *The Road to Madrid.* London: Hutchinson, 1937.

Gerahty, Cecil, and William Foss. *The Spanish Arena.* 1939.

Gili, J. L. *Lorca.* Harmondsworth: Penguin, 1960.

Goebbels, Joseph. *Die Wahrheit über Spanien.* Munich: Zentralverlag der NSDAP, Franz Eher Nachfolger, 1937.

Goering, Hermann. Testimony recorded in *The Trial of Major War Criminals. Proceedings of the International Military Tribunal Sitting at Nuremberg.* London: H.M. Stationery Office, 1945–50.

Goma, José. *La guerra en el aire.* Barcelona: Editorial AHR, 1958.

Gómez de la Serna, Ramón. *Obras Completas.* Barcelona: Editorial AHR, 1956.

Goya, Francisco. *Los Desastres de la Guerra.* Madrid: Publicala Real Academia de Bellas Artes de San Fernando, 1906.

————. *"Los Disparates" de Goya y sus dibujos preparaciones.* Barcelona, 1951.

————. *Tauromachie.* Munich: Delphin-Verlag, 1911.

Guernica. (The Official Report of the Commission Appointed by the Spanish National Government to Investigate the Causes of the Destruction of Guernica on April 26–28, 1937.) London: Eyre and Spottiswoode, 1938.

"Guerra y revolución en España 1936–1939. Esta obra ha sido elaborada por una comisión presidida por Dolores Ibarruri." *Editorial Progreso* (Moscow) 3, 1971.

"Guerre ou Paix?" *La nouvelle critique: Revue du Marxisme militant,* no. 129 (September–October 1961).

Hanighen, Frank, ed. *Nothing but Danger.* New York: National Travel Club, 1939.

Hart, Kerwin K. *America, Look at Spain.* New York: Kennedy, 1939.

Haycraft, James B. "Messerschmitts Over Spain." *Military Journal Special* 1. Bennington, Vt., International Graphics Corporation, 1979.

Hemingway, Ernest. *Death in the Afternoon.* New York: Scribner, 1932.

Hernandez, Jesús. *Yo fui un ministro de Stalin: Memorias de la guerra civil española 1936–39.* Madrid: G. del Toro, 1974.

Hidalgo, Ramón. *La ayuda alemana a España 1936–39.* Madrid: 1975.

Hills, George. *Franco: The Man and His Nation.* London: Hale, 1967; New York: Macmillan, 1967. Spanish ed.: *Franco: El hombre y su nación.* Madrid: Librería Editorial San Martín, 1969.

Hoyos, Max. *Pedros y Pablos: Fliegen, erleben, kämpfen in Spanien.* Munich: F. Bruckmann, 1939.

Ibarruri, Dolores. *El único camino.* Paris: Editions Sociales, 1962. American ed.: *They Shall Not Pass: The Autobiography of La Pasionaria.* New York: International Publishers, 1966.

Information Service, Spanish State Tourist Office. *Fascism Destroys Spain.* N.p., n.d.

Jackson, Gabriel. *A Concise History of the Spanish Civil War.* London: Thames and Hudson, 1974; New York: John Day, 1974.

———. *The Spanish Republic and the Civil War, 1931–1939.* Princeton: Princeton University Press, 1965.

———, ed. *The Spanish Civil War.* Chicago: Quadrangle Books, 1972.

Janssen, Karl-Heinz. "Wer bombardierte Guernica? Der Streit um die deutsche Verantwortung." *Die Zeit* (25 January 1973): 5.

Jardi, Enric. *Eugeni d'Ors: Vida i obra.* Barcelona: Aymà, 1967.

Julian, Inma. "El cartelismo y la gráfica en la guerra civil." In *España. Vanguardia Artística y Realidad Social: 1936–1976.* Barcelona: Gustavo Gili, 1976.

———. "Los carteles republicanos." *Comunicación* (Madrid), nos. 31–32 (1977): 61–76.

Kindelan, Alfredo. *Mis cuadernos de guerra.* Madrid: Editorial Plus-Ultra, 1945.

Klotz, Helmut. *Militärische Lehren des Bürgerkrieges in Spanien.* Paris: Selbstverlag, 1938.

Knightly, Phillip. *The First Casualty: From the Crimea to Vietnam: The War Correspondent as Hero, Propagandist, and Myth Maker.* New York: Harcourt Brace Jovanovich, 1975.

Knutson-Tzara, Greta. "Katalansk konst." *Konstrevy* (Stockholm) 13 (1937): 93–95.

Koestler, Arthur. *Dialogue with Death.* New York: Macmillan, 1960.

———. *The Invisible Writing.* London: Collins, 1954.

———. *Spanish Testament.* London: Gollancz, 1937.

Kohl, Hermann. *Deutscher Flieger über Spanien.* Reutlingen: Ensslin, 1941.

———. *Feuer fällt vom Himmel.* Reutlingen: Ensslin and Laiblin, n.d.

Kohler, Karl. *Guernica.* Freiburg: Materialsammlung, Militärgeschichtliches Forschungsamt Freiburg.

Lacasa, Luis. *Escritos: 1922–1931.* Madrid: José Porrús Turanzas, 1976.

Landis, Arthur. "American Fliers in Spanish Skies." *Air Combat* 3, no. 2 (March 1975).

Larios, José, Capt., Marquis of Larios, Duke of Lerma. *Combat Over Spain: Memoirs of a Nationalist Fighter Pilot, 1936–1939.* London: Spearman [c. 1964].

Laureau, Patrick P. *La aviación republicana española: 1936–1939.* 2 vols. Madrid: printed privately [c. 1982–1984].

———. "Soldiers of Fortune." *Airpower* 12, no. 5 (September 1982).

———. "Soldiers of Fortune. Part II. Running the Blockade and Flying Combat for the Spanish Loyalists in Grumman Dolfins and Vultee V-1-A Airliners. A Tale of Espionage, Sabotage and Old-fashioned Courage during the Spanish Civil War." *Wings* 12, no. 5 (October 1982): 10–17.

Lent, Alfred. *Wir kämpfen für Spanien.* Oldenburg: Stalling, 1939.

London, Arthur G. *Španělsko, Španělsko. . . .* Prague: N.P.L., 1963. French ed.: *Espagne. . . .* Paris: Editeurs Français Réunis, 1966.

Ludendorff, General Erich von. *Der totale Krieg.* Munich: Ludendorff Verlag GmbH, 1935.

Madariaga, Salvador de. *Essays with a Purpose.* London: Hollis and Carter, 1954.

Maier, Klaus A. *Guernica 26.4.1937: Die deutsche Intervention in Spanien und der "Fall Guernica."* Freiburg: Verlag Rombach, 1975. Anlage 1: Dr. Ing. Wolfram Frhr. von Richthofen: *Spanien-Tagebuch des Oberstleutnant i.G. (später Generalfeldmarschall).* (Auszug). Bundesarchiv-Militärarchiv Freiburg. Luftwaffe Lw 107/1. Text of April 1937 diary, 75–112.

Malraux, André. *L'Espoir.* Paris: Gallimard, 1937. American ed.: *Man's Hope.* New York: Random House, 1938.

Markham, James. "Spain—after Forty Years of Fear." *New York Times Magazine* (5 June 1977).

Matthews, Hubert. *Half of Spain Died.* New York: Scribner, 1973.

Mattioli, Guido. *L'aviazione legionaria in Spagna.* Rome: L'Aviazione, 1938.

Merkes, Manfred. *Die deutsche Politik im spanischen Bürgerkrieg 1936–1939.* 2nd ed., Vol. 18. Bonn: Bonner Historische Forschungen, hrsg. Stephan Skalweit, 1969.

Miralles, R. "Bombardeos de Durango y Guernica." In Aguirre, J. M., et al., *Historia general de la guerra civil en Euskadi,* Vol. 3, 57–164. Bilbao: Naroki, 1979.

Miravitlles, Jaume. *Episodios de la guerra civil española.* Barcelona: Portie, 1972.

———, et al. *Carteles de la República y de la guerra civil.* Barcelona: Centre d'Estudis d'Historia Contemporania; La Gaya Ciencia, 1978.

Monks, Noel. *Eyewitness.* London: Muller, 1955.

Moreau, Rudolf Von. "Hilfe für den Alkazar" and "Mit Bomben Kreuz und Quer durch Spanien." In *Wir kämpften in Spanien.* Berlin: Oberkommando der Wehrmacht. Sonderheft "Die Wehrmacht," O.K.W., 30 May 1939.

Mouseion. 39–40, nos. 3–4 (1937). Special issue on the protection of works of art against war damage.

National Sozialistischer Deutscher Arbeiter Partei Reichspropaganda Leitung. *Legion Condor.* Munich: Zentralverlag, NSDAP/Ebernach [1940?].

Neuss, Wilhelm. *Die Katalanische Bibelillustration um die Wende des ersten Jahrtausends und die altspanische Buchmalerei.* Bonn: Kurt Schroeder Verlag, 1922.

New York: Spanish American Committee to Aid Spanish Democracy. *The Crime of Guernica,* 1937.

Onaindía, Alberto de. *Hombre de paz en la guerra.* Buenos Aires: Editorial Vasca Ekin, S.R.L., 1973.

Ossoria y Gallardo, A. *Mis memorias.* Buenos Aires, 1946.

Paoli, Jacques, et al. *Nos vingt ans 1937*. Paris: André Balland, 1968.

Pascual de Orkoya, Juan. *La verdad sobre la destrucción de Gernika. Réplica a Monseñor Gustavo J. Franceschi*. Buenos Aires: Sebastián de Amorrortu, 1937.

Payne, Robert. *The Civil War in Spain*. New York: Putnam, 1962.

Peers, E. Allison. *The Spanish Tragedy*. New York: Oxford University Press, 1936.

Pike, David Wingeate. *Conjecture, Propaganda, and Deceit and the Spanish Civil War in the French Press*. Stanford, Calif.: Institute of International Studies, 1968.

———. *La presse française à la veille de la seconde guerre mondiale*. Paris: Richelieu, 1973.

———. *Les Français et la guerre d'Espagne*. Paris: Presses Universitaires de France, 1975.

Pozuelo, Vicente. *Los últimos 476 dias de Franco*. Barcelona: Planeta, 1985.

Pritchett, V. S. *The Spanish Temper*. New York: Knopf, 1954.

Probst, Volker G. *Arno Breker: 60 ans de sculpture*. Paris: Jacques Damase.

Renau, Josep. *Arte en peligro 1936–39*. Valencia: Ayuntamiento de Valencia and Fernando Torres, 1980.

———. "Contestación a Ramón Gaya." *Hora de España* (Valencia) 1, no. 1 (January 1937): 54–56; 1, no. 2 (February 1937): 57–60.

———. *Función social del cartel publicitario*. Valencia, 1937.

———. "L'Organisation de la défense du patrimoine artistique et historique espagnol pendant la guerre civile." *Mouseion* 39–40, nos. 3–4 (1937): 7–66.

Ricci, Corrado. *Vita di pilota*. Mursia-Milano: 1976.

Ries, Karl, and Hans Ring. *Legion Condor, 1936–1939: Eine illustrierte Dokumentation*. Mainz: Verlag Dieter Hoffman, 1980.

Rojas, Carlos. *Diálogos para otra España: Una llamada a la conciencia de todos*. Barcelona: Ariel, 1966. 2d ed., 1968.

———. *Diez figuras ante la guerra civil*. Barcelona: Nauta, 1973.

———. *¿Por qué perdimos la guerra?* Barcelona: Nauta, 1970.

Rossman, Michael. *Winds of the People: The Poetry of the Spanish Civil War*. Berkeley, Calif.: Rossman, 1986.

Salas Larrázabal, Jesús M. *Guernica: El bombardeo*. Madrid: privately printed, 1981.

———. "Guernica: El mito y la realidad." *Revista de Aeronaútica y Astronaútica*, no. 441 (August 1977).

———. *La guerra de España desde el aire*. Barcelona: Ariel, 1969; 2d ed., revised, 1972. English ed.: *Air War over Spain*. London: Ian Allen, 1974.

Salinas, Pedro. "Lorca and the Poetry of Death." *The Hopkins Review* 5, no. 1 (Fall 1951): 5–12.

Seville, Museo de Arte Contemporáneo. *Alberto Sánchez*, 1980. Pablo Picasso, preface.

Shores, Christopher. *Las fuerzas aereas en la guerra civil española*. Madrid: San Martín, 1979. English ed.: London: Osprey Publishing, 1977.

Simone, André. *J'accuse! The Men Who Betrayed France*. New York: Dial, 1940.

———. *The Nazi Conspiracy in Spain*. London: V. Gollancz, 1937.

Soria, Georges. *En desenlace.* Vol. 5, *Guerra y revolución en España, 1936–1939.* Barcelona: Grijalbo, 1978.

Southworth, Herbert R. *La destruction de Guernica: Journalisme, diplomatie, propagande, et histoire.* Paris: Ruedo Ibérico, 1975. American ed.: *Guernica! Guernica!: A Study of Journalism, Diplomacy, Propaganda, and History.* Berkeley: University of California Press, 1977.

Speer, Albert. *Inside the Third Reich.* New York: Macmillan, 1970.

Spender, Stephen. "Pictures in Spain." *Spectator* (London) (30 July 1937): 199.

————. *World within World.* New York: Harcourt, Brace, 1951.

Sperrle, Hugo. "Die Legion Condor." In *Wir kämpften in Spanien.* Berlin: Oberkommando der Wehrmacht. Sonderheft "Die Wehrmacht," O.K.W., 30 May 1939.

Stacher, Rudolf. *Armee mit Geheim Auftrag: Die deutsche Legion Condor in Spanien.* Bremen: Burmester, 1939.

Stackelberg, Karl-Georg von. *Legion Condor: Deutsche Freiwillige in Spanien.* Berlin: Verlag die Heimbucherei, 1939.

Steer, George L. "The Future in Spain." *Spectator* (London) (2 July 1937): 7.

————. "Lessons of the Spanish Civil War." *Spectator* (London) (23 July 1937): 138.

————. *The Tree of Gernika.* London: Hodder and Stoughton, 1938.

Talón, Vicente. *Arde Guernica!* Madrid: Librería Editorial San Martín, 1970.

————. *El holocausto de Guernica.* Madrid: Plaza y Janes, 1987.

Taylor, F. Jay. *The United States and the Spanish Civil War.* New York: Bookman Associates, 1956.

Téry, Simone. *Front de la liberté.* Paris: Editions Sociales Internationales, 1938.

Thadden, Adolf von. *Guernica: Gruelpropaganda oder "Kriegsverbrechen." Ein Bombenschwindel.* Augsburg: Dreiffel Verlag, 1982.

Thomas, Gordon, and Max Morgan Witts. *Guernica: The Crucible of World War II.* New York: Stein and Day, 1975. English ed.: *The Day Guernica Died.* London: Hodder and Stoughton, 1976. Spanish ed.: *El día en que murió Guernica.* Barcelona: Plaza and Janes, 1976.

Thomas, Hugh. *The Spanish Civil War.* London: Eyre and Spottiswoode, 1961; New York: Harper and Row, 1963.

Tisa, John, ed. *The Palette and the Flame.* New York: International Publishers, 1979.

Trautloft, Hannes. *Als Jagdflieger in Spanien.* Berlin: A. Nauck and Co., 1940.

Trotsky, Leon. *The Lesson of Spain: The Last Warning!* London: Workers' International Press, 1937.

Urarte, Antonio de. *Los ultimos días del Batallón Amayur.* Caracas, 1956.

Uriarte, Castor. *Bombas y mentiras sobre Guernica.* Bilbao, 1976.

Valencia: Servicio Español de Información. *La destrucción de Guernica.* 1937.

Viñas, A. "Guernica: Quién lo Hizo." In Aguirre, J. M., et al., *Historia general de la guerra civil en Euskadi,* Vol. 3, 165–214. Bilbao: Naroki, 1979.

Wilson, Arnold. *Guernica: The Official Report.* [Nationalist]. London: Eyre and Spottiswoode, 1938.

Wyden, Peter. *The Passionate War: The Narrative History of the Spanish Civil War, 1936–1939.* New York: Simon and Schuster, 1983.

Zervos, Christian. "A l'ombre de la guerre civile: L'art catalan du Xᵉ au XVᵉ siècle au Musée du Jeu de Paume des Tuileries." *Cahiers d'Art* 11, nos. 8–10 (1937): 213–56.

———. *L'art de la Catalogne.* Paris: Editions Cahiers d'Art, 1937.

II. Picasso: His Art and *Guernica*

Abril, Manuel. "El viaje incógnito de Picasso por España." *Blanco y Negro* (Barcelona) 44 año, no. 2253 (23 September 1934).

Alberti, Rafael. *Los 8 nombres de Picasso y no diga más que lo que no digo (1966–1970).* Barcelona: Editorial Kairos, 1970.

Alley, Ronald. *Picasso: The Three Dancers.* Newcastle-upon-Tyne: University of Newcastle-upon-Tyne, 1967.

Almanach Hachette, petite encyclopédie populaire, édition complète. Paris: Hachette, 1936, 1937, 1938.

Alpatov, Michael. "Picasso's *Guernica* is One of the Two Most Underrated of All Works of Art." *Artnews* (November 1977): 108.

"American Artists and Spain." *Art Front,* no. 20 (October 1937).

American Artists' Congress. *First American Artists' Congress.* New York: American Artists' Congress, 1936.

Amon, Santiago. "El escultor Picasso." *ABC Sábado Cultural,* no. 49 (31 October 1981): 1–2.

Anguera, A. Oriol. *Guernica.* Barcelona: Ediciones Polígrafa, 1979.

Angulo, Javier. "Protestas en Euskadi por la instalación del *Guernica* en el Casón del Buen Retiro." *El País* (12 September 1981): 25.

Aragon, Louis. *Pour un réalisme social.* Paris: Denoël et Steele, 1935.

———, et al. *La querelle du réalisme.* Paris: Editions Sociales Internationales, 1936.

Archambault, G. H. "Picasso: The Painter Who Defied the Germans Finds Himself the Hero of a Revolutionary Mood." *New York Times Magazine* (29 October 1944).

Aristophanes. *Lysistrata.* New York: Heritage Press, 1934. Illustrations by Pablo Picasso.

Arnheim, Rudolf. *Picasso's Guernica: The Genesis of a Painting.* Berkeley: University of California Press, 1962 (paperbound edition: *The Genesis of a Painting: Picasso's Guernica,* 1973).

———. "Psychological Notes on the Poetical Process." In *Poets at Work.* New York: Harcourt Brace, 1948.

Arrabal, Fernando. *Guernica and Other Plays.* New York: Grove Press, 1969.

Arrival of *Guernica* in New York. *Time* (8 May 1939): 19.

"Art's Acrobat." *Time* (13 February 1939): 44–46.

Art in America 68, no. 10 (December 1980). Special issue on Picasso. Essays by Rosalind Krauss, Michael Brenson, Roberta Smith, Linda Nochlin, Theodore Reff, Sarah McFadden and Jeffrey Deitch, and Jed Perl.

Arts Canada 24 (March 1967). Special Issue, "More About Picasso."

Auric, Georges. "La victoire de *Guernica.*" *Cahiers d'Art* 12, nos. 1–3 (1937).

L'Avant Scène, no. 500 (August 1972). Special number on Picasso.

Axsom, Richard H. *Parade: Cubism as Theatre.* New York: Garland, 1979.

Bandmann, Gunter. *Les Demoiselles d'Avignon [von] Pablo Picasso.* Werkmonographien zur Bildenden Kunst, no. 109. Stuttgart: Reclam, 1965.

Barcelona, Museu Picasso. *Catàleg de pintura i dibuix.* Barcelona: Ajuntament de Barcelona, 1984.

Baroja, Pío. "Picasso, el gitano artista y mixtificador." *Informaciones* (Madrid) (1 May 1951). Included in his *Memorias,* 689–95. Madrid: El Minotauro, 1955.

Barr, Alfred H., Jr. *Cubism and Abstract Art.* New York: Museum of Modern Art, 1936.

———. *Picasso: Fifty Years of His Art.* New York: Museum of Modern Art, 1946.

———. *Picasso: Forty Years of His Art.* New York: Museum of Modern Art, 1939.

Barr-Sharrar, Beryl. "Some Aspects of Early Autobiographical Imagery in Picasso's *Suite 347.*" *Art Bulletin* 54, no. 4 (December 1972): 516–33.

Barrio-Garay, José L. "An Inquiry into Picasso's Poetic Imagery." Unpublished article.

Barry, Joseph A. "The Two Picassos: Politician and Painter." *New York Times Magazine,* 6 May 1951.

Becraft, Mel. *Picasso's "Guernica": Images within Images.* New York: Vantage, 1983, 1986.

Bell, Clive. "Picasso." *New Statesman and Nation* 17.1, 2d ser. (11 March 1939): 356.

Berger, John. *The Success and Failure of Picasso.* Harmondsworth: Penguin, 1965.

Berger, René. *La découverte de la peinture.* Lausanne: Editions des Fauconnières, 1958. American ed.: *The Discovery of Painting.* New York: Viking, 1963.

Bloch, Georges. *Pablo Picasso.* Vol. I of *Catalogue of the Printed Graphic Work, 1904–1967.* Bern: Kornfeld et Klipstein, 1968–1975.

Blunt, Anthony. "From Bloomsbury to Marxism." *Studio International* 186, no. 960 (7 November 1973): 164–68.

———. *Picasso's "Guernica."* London: Oxford University Press, 1969.

———. "Picasso Unfrocked." *Spectator* (London) (8 October 1937).

———. "The Realism Quarrel." *Left Review* 3, no. 3 (February–June, 1937): 169–71.

Blunt, Anthony, and Phoebe Pool. *Picasso, the Formative Years: A Study of His Sources.* Greenwich, Conn.: New York Graphic Society, 1962.

Boeck, Wilhelm, and Jaime Sabartés. *Picasso.* New York: Abrams, 1955.

Boyeure, Claude. "*Guernica:* Une colère de Picasso." *Jardin des Arts* 184 (March 1970): 14–23.

Bramsen, Henrik. "*Guernica* Again." *Apollo* 92 (November 1970): 372–73.

Brassaï. *Conversations avec Picasso.* Paris: Gallimard, 1964. American ed.: *Picasso and Company.* Garden City, N.Y.: Doubleday, 1966.

Brendel, Otto J. "Classic and Non-classic Elements in Picasso's *Guernica.*" In *From Sophocles to Picasso: The Present Day Vitality of the Classical Tradition,* edited by Whitney Jennings Oates. Bloomington: Indiana University Press, 1962.

Brenner, Anita. "Picasso versus Picasso." *New York Times Magazine* (12 November 1939): 12–13.

Breton, André. "Interview d'indice." In *Position politique du surréalisme*, 74–75. Paris: 1935.

―――. *Le surréalisme et la peinture.* Paris: Editions Gallimard, 1965. English ed.: *Surrealism and Painting.* London: Macdonald, 1972.

Cabanne, Pierre. "Picasso et les joies de la paternité." *L'Oeil*, no. 226 (May 1974): 2–11.

―――. *Le siècle de Picasso.* Paris: Denoël, 1975.

Cahiers d'Art. An extensive publisher of articles on Picasso and illustrations of his work. See, for instance, special issues in: 7, nos. 3–5 (1932): 85–196; 10, nos. 7–10 (1935): 145–261 ("Picasso de 1930 à 1935." Essays by Christian Zervos, Paul Eluard, André Breton, Salvador Dalí, and others); 12, nos. 1–3 (1937); 12, nos. 4–5 (1937); 12, nos. 8–10 (1937); 13, nos. 3–10 (1938): 73–140; 15–19 (1940–1944): 1–86.

Cantelupe, Eugene G. "Picasso's *Guernica*." *Art Journal* 31, no. 1 (Fall 1971): 18–21.

Carlsund, Otto G. "Muraldekoren på Expo 37." *Konstrevy* (Stockholm) 13 (1937): 165–69.

Carosso, Roberta. "The Published French and Spanish Writings of Pablo Picasso with English Translations." Master's thesis, Hunter College of the City University of New York, 1964.

Castresana, Luis de. *El otro árbol de Guernica.* Madrid: Prensa España, 1968.

Chamberlain, Ken. "*Guernica:* Poster and Painting." *Arts Canada* 24 (March 1967): 5–10, 15–16.

Champris, Pierre de. *Picasso: Ombre et soleil.* Paris: Gallimard, 1960.

Chipp, Herschel B. "El Guernica, en USA." *ABC* (Madrid) (29 July 1979).

―――. "*Guernica:* Love, War, and the Bullfight." *Art Journal* 33 (Winter 1973–1974): 100–115.

―――. "*Guernica:* Once a Document of Outrage, Now a Symbol of Reconciliation in a New and Democratic Spain." *Artnews* 79, no. 5 (May 1980): 108–12.

―――. "La 'modernización' del Museo del Prado facilitaría el emplazamiento del *Guernica*." *El País* (31 August 1979).

―――. "A Time for *Guernica*'s Repatriation." In Letters to the Editor, *New York Times* (26 November 1975); *Times* (London) (26 November 1975); *International Herald Tribune* (26 November 1975).

Cirici Pellicer, Alejandro. *Picasso antes de Picasso.* Barcelona: Iberia, 1946. French ed.: *Picasso avant Picasso.* Paris: Pierre Cailler, 1950.

Cirlot, Juan-Eduardo. *El Nacimiento de un Genio.* Barcelona: Gustavo Gili, 1972. American ed.: *Picasso: Birth of a Genius.* New York: Praeger, 1972.

Clark, Vernon. "The *Guernica* Mural—Picasso and Social Protest." *Science and Society* 5, no. 1 (Winter 1941): 72–78.

Coates, Robert M. "Picasso—Cézanne—Some Americans." *New Yorker* (25 November 1939): 44–47.

Cocteau, Jean. *Ode à Picasso: Poème 1917.* Paris: Belle Edition, 1919.

―――. *Picasso.* Paris: Stock, 1923.

―――. "Picasso." In *Le rappel à l'ordre.* Paris: Stock, 1926. English ed.: *A Call to Order.* London: Faber and Gwyer, 1926.

―――. Untitled article on the *Dream and Lie of Franco. Nueva España* (Paris) (September 1937).

Cooper, Douglas. *Picasso théâtre*. Paris: Editions Cercle d'Art, 1967. American ed.: *Picasso Theatre*. New York: Abrams, 1968.

Cordon, Antonio G., Vicente L. Cenal, and Victor P. Escolano. "El Pabellón Republicano de 1937, hoy." *Comunicación* (Madrid), nos. 31–32 (1977): 61–76.

Costello, Anita C. *Picasso's "Vollard Suite."* New York: Garland, 1979.

Courthion, Pierre. "Quelques aspects d'Eluard et de Picasso." *Labyrinthe* (Geneva) 1, no. 9 (15 June 1945): 5.

Cowley, Malcolm. *The Dream of the Golden Mountains: Remembering the 1930's*. New York: Viking, 1964.

Crane, Theodore R. *The Art Criticism of Pablo Picasso in the New York Times from 1911 to 1953*. Master's thesis, University of California, Berkeley, 1954.

Le Crapouillot, n.s., no. 25 (May–June 1973). Special volume: "Farceur ou genie: Le petit Picasso illustré."

Crespelle, Jean-Paul. *Picasso, les femmes, les amis, l'oeuvre*. Paris: Presses de la Cité, 1967. American ed.: *Picasso and His Women*. New York: Coward-McCann, 1969.

Crozier, Brian. "Picasso and *Guernica*." *Economist* (London) (5 May 1973): 4.

Daix, Pierre, and Georges Boudaille. *Picasso, 1900–1906*. Neuchâtel: Editions Ides et Calendes, 1966. American ed.: *Picasso: The Blue and Rose Periods; A Catalogue Raisonné of the Paintings, 1900–1906*. Greenwich, Conn.: New York Graphic Society, 1967.

Danz, Louis. *Personal Revolution and Picasso*. New York: Longmans, Green, 1941.

Darr, William. "Images of Eros and Thanatos in Picasso's *Guernica*." *Art Journal* 25, no. 4 (Summer 1966): 346–88.

"Death, Destruction, and Disintegration: Theme of Picasso Mural." *Art Digest* 11 (August 1937): 19.

Decaunes, Luc. Review of the Spanish pavilion and exhibition. *Regards* (Paris) (5 August 1937): 17.

de Zayas, Alfred M. "Getting at the *Guernica* Myth: Four Revisionist Approaches." *National Review* (31 August 1973): 939.

de Zayas, Marius. *Pablo Picasso*. New York: Photo Secession Gallery, April 1911.

del Castillo, Michel, André Fermigier, Jean Grenier, Paul Guinard, Denis Milhau, Gaetan Picon, Claude Roy, and Dora Vallier. *Picasso*. Paris: Hachette, 1967.

Diamonstein, Barbara Lee. "Caro, de Kooning, Indiana, Lichtenstein, Motherwell, and Nevelson on Picasso's Influence." *Artnews* 73 (April 1974): 44–46.

Dillenberger, Jane. "The Man with a Lamb and the *Corrida Crucifixion* by Pablo Picasso." In *Secular Art with Sacred Themes*, 77–98. New York: Abington Press, 1969.

———. "Picasso's *Crucifixion*." In *Humanities, Religion, and the Arts Tomorrow*, edited by Howard Hunter, 160–84. New York: Holt, Rinehart and Winston, 1972.

Dominguín, Luis M. *Toros y toreros*. New York: Abrams, 1961.

Du 8 (August 1958): Special issue: "Picasso tauromaco."

Duncan, David Douglas. *Goodbye Picasso*. New York: Grosset and Dunlap, 1974.

———. *Picasso's Picassos*. New York: Harper, 1961.

———. *The Private World of Pablo Picasso*. New York: Harper, 1958. French ed.: *Le petit monde de Pablo Picasso*. Paris: Hachette, 1959.

———. *The Silent Studio*. New York: Norton, 1976.

Ehrenburg, Ilya. "Pablo Picasso." In *Chekhov, Stendhal, and Other Essays*, edited by Anna Bostock et al., 221–32. New York: Knopf, 1963.

———. *People and Life, 1891–1921*. London: MacGibbon and Kee, 1961.

Elgar, Frank. *Picasso: Epocas azul y rosa*. Barcelona: Gustavo Gili, 1968.

"El *Guernica* en el Prado." *ABC* (Madrid) (11 September 1981).

"El regreso del ultimo exiliado." *ABC* (Madrid) (10 September 1981).

Eluard, Paul. *A Pablo Picasso*. Geneva-Paris: Editions des Trois Collines, 1947. American ed.: *Pablo Picasso*. New York: Philosophical Library, 1947.

———. "Entretiens avec Picasso au sujet des *Femmes d'Alger*." *Aujourd'hui* 4 (September 1955): 12–13.

———. "Je parle de ce qui est bien." *Cahiers d'Art* 10, no. 7 (1935): 165–68.

———. "La victoire de *Guernica*." *Cahiers d'Art* 12, nos. 1–3 (1937).

———. *Picasso dessins*. Paris: Editions Braun and Cie., 1952.

Erben, Walter. *Picasso und die Schwermut: Versuch einer Deutung*. Heidelberg: Verlag Lambert Schneider, 1947.

Escolano, Victor P., Vicente L. Cenal, Antonio G. Cordón, and Fernando M. Martín. "El Pabellón de la República Española en la Exposición Internacional de París, 1937." In *España. Vanguardia artística y realidad social*, 26–44. Barcelona: Gustavo Gili, 1976.

"Exposition internationale." *L'Illustration* (Paris), no. 4917 (29 May 1937). Special Issue.

Failing, Patricia. "Picasso's 'Cries of Children . . . Cries of Stones.'" *Artnews* (September 1977): 55–58.

Fels, Florent. *Le roman de l'art vivant*. Paris, 1959.

Fermigier, André, ed. *Picasso*. Paris: Librairie Générale Française, 1969.

Fernández Cuenca, Carlos. *Picasso en el cine también*. Madrid: Editorial Nacional, 1971.

Ferrari, Enrique L. "Picasso en Madrid." *Ya* (Madrid), no. 359 (9 March 1936).

Ferrier, Jean-Louis. *De Picasso à Guernica*. Paris: Denoël, 1985.

———. "Lecture d'un tableau: L'exemple de *Guernica*." *Colóquio Artes*, no. 18 (1974): 26–30.

———. *Picasso Guernica*. Paris: Télécip / Denoël-Gonthier, 1977.

Fiero, Gloria K. "Picasso's Minotaur." *Art International* 26, no. 5 (November–December 1983): 20–30.

Frankfurter, Alfred M. "Picasso in Retrospect: 1939–1900: The Comprehensive Exhibition in New York and Chicago." *Artnews* 76, no. 9 (November 1977).

———. "The Triple Celebration of Picasso." *Artnews* (31 October 1936).

Freland, J., Fernand Mourlot, Aldo Crommelynck, and Piero Crommelynck. "Picasso vu par ses compagnons de gravure." *Nouvelles de l'Estampe*, no. 9 (May–June 1973): 3–6.

Freund, Andreas. "136 Picassos Brighten Red Fair." *New York Times* (6 November 1973): 42.

Fry, John Hemming. *Art décadent, sous la règne de la démocratie at du communisme*. Paris: Librairie de l'Alma, 1940.

Furst, Herbert. "Christian Art Now." *Apollo* 28 (December 1938): 277–81.

———. "*Guernica,* Exhibited at the New Burlington Galleries." *Apollo* 28 (November 1938): 266.

———. "Picasso s'en va-t-en guerre." *Apollo* 41 (April 1945): 94–95.

Gallo, Manuel Mujica. *La minitauromaquia de Picasso: O el ocaso de los toros.* Madrid: Prensa Española, 1971.

Gano, D. Agustin. "Los horrores de la guerra de Rubens." *El País* (Madrid) (28 May 1980).

Gasman, Lydia. *Mystery, Magic, and Love in Picasso, 1925–1938: Picasso and the Surrealist Poets.* Ann Arbor, Mich.: UMI, 1981.

Gateau, Jean-Charles. *Eluard, Picasso, et la peinture (1936–1952).* Geneva: Droz, 1953.

Gaya Nuño, Juan Antonio. *Bibliografía critica y antologica de Picasso.* San Juan, Puerto Rico: Ediciones de la Torre, 1966.

———. "El poeta Pablo Picasso." *Indice Literario,* supplement to *El Universal* (Caracas) (16 July 1955).

———. "España, Toreadors, Picasso." *Hora de España* (10 October 1937).

Gedo, Mary Mathews. "Art as Autobiography: Picasso's *Guernica.*" *Art Quarterly* (Spring 1979): 191–210.

———. *Picasso: Art as Autobiography.* Chicago: University of Chicago Press, 1980.

Geiser, Bernhard G. *Picasso, peintre-graveur.* Vol. 1 (nos. 1–257): *Catalogue illustré de l'oeuvre gravé et lithographié, 1899–1931.* Bern: Gutekunst and Klipstein, 1933. Vol. 2 (nos. 258–572): *Catalogue raisonné de l'oeuvre gravé et des monotypes, 1932–1934.* Bern: Kornfeld and Klipstein, 1968. Vol. 3 (nos. 573–730): Brigitte Baer (suite aux catalogues de Bernhard Geiser). *Catalogue raisonné de l'oeuvre gravé et des monotypes, 1935–1945.* Bern: Kornfeld and Klipstein, 1986.

Gelatt, Roland. "Picasso's Legacy: A $250 Million Hoard Comes Out of Hiding." *Saturday Review* (12 November 1977): 8–16.

Giedion-Welcker, Carola. "Picasso: Poet und Revolutionar." *Das Werk* (Wintertur) (April 1945): 113–23.

Gillet, Louis. "Trente ans de peinture au Petit Palais (1895–1925)." *Revue des Deux Mondes* 40 (1 August 1937): 562–70.

Gilot, Françoise, and Carlton Lake. *Life with Picasso.* New York: McGraw-Hill, 1964.

Gioseffi, Decio. "Picasso, *Guernica* e i codici Mozarabici: Part I." *Critica d'Arte* (Florence, 1965) anno 12, n.s. 73: 11–26. Part II: *Critica d'Arte* (1965) anno 12, n.s. 76: 6–24.

Giralt-Miracle, Daniel. "Recording Reality." *Art and Artists* (June 1977): 31–35.

Giraudy, Daniele. *L'oeuvre de Picasso à Antibes: Catalogue raisonné du musée.* Antibes: Musée Picasso / Château Grimaldi, 1981.

Girbal, Jaume Pol. "Curiosa historia del marco del *Guernica* de Picasso." *Destino* (Barcelona), no. 2140 (12–18 October 1978): 21.

Goeppert, Sebastian, and Herma C. Goeppert, "Picassos Minotauromachie." *Picasso in der Stadtgalerie Stuttgart* (1981): 24–35.

Goldwater, Robert J. "Picasso: Forty Years of His Art." *Art in America* (28 January 1940): 43–44.

Gómez de la Serna, Ramón. "Le toréador de la peinture." *Cahiers d'Art*

7, nos. 3–5 (1932): 124–25.

Gonçalves, Rui Mário. "*Guernica* e os mitos." *Colóquio Artes*. Lisbon: Fundación Calouste Gulbenkian (February 1974): 18–25.

Gonzalez, Xavier. "Notes from Picasso's Study." *New Masses* 53 (19 December 1944): 24–26.

Gottlieb, Carla. "The Meaning of Bull and Horse in *Guernica*." *Art Journal* 24, no. 2 (1965): 106–12.

———. "Picasso's *Girl Before a Mirror*." *Journal of Aesthetics and Art Criticism* 24 (Summer 1966): 509–18.

Granell, Eugenio F. *Picasso's Guernica: The End of a Spanish Era*. Ann Arbor, Mich.: University of Michigan Press, 1981.

———. *Social Perspectives of Picasso's "Guernica."* Ann Arbor, Mich.: University Microfilms, 1978.

Greenberg, Clement. *Art and Culture*. Boston: Beacon, 1961.

Greene, Balcombe, Joe Solman, and Clarence Weinstock. "Picasso in Retrospect: Three Critical Estimates." *Art Front* 2, no. 11 (December 1936): 12–15.

Grenier, Jean. "Picasso et le mouvement surréaliste." In *Picasso*, edited by André Fermigier. Paris: Hachette, 1967.

Groth, John. "Picasso at Work, August 1944." *Museum of Modern Art Bulletin* 12, no. 3 (January 1945): 10–11.

Guernica: Picasso und der spanische Bürgerkrieg. Berlin (West): Neue Gesellschaft für Bildende Kunst, 1975; Berlin (West): Elefanten, 1980.

Hart, Jeffrey. "Getting at the *Guernica* Myth: Symposium." *National Review* 25 (31 August 1973): 936–42.

———. "The Great *Guernica* Fraud." *National Review* 25 (5 January 1973): 27–29. Letters of reply: *National Review* 25 (31 August 1973): 936–42. See also the following commentaries: "Picasso and Guernica." *Economist* (London) (5 May 1973); and "Was Picasso Duped?" *Saturday Review / World* (20 November 1973).

———. "Guernica! Guernica! Guernica!" *Die Welt* (9 and 11 January 1973).

Hilton, Timothy. *Picasso*. New York: Praeger; London: Thames and Hudson, 1975.

Hinks, Roger. "Art: *Guernica*." *Spectator* (London) (28 October 1938): 712.

Hohl, Reinhold. "Die Wahrheit über *Guernica*." *Pantheon* 36 (January–March 1978): 41–58.

———. "Ein Weltbild der Grausamkeit: Picassos *Guernica* und Artauds *Théâtre de la cruauté*." *Frankfurter Allgemeine Zeitung*, no. 280 (1 December 1979).

———. "Ich stehe für das Leben ein gegen den Tod: *Guernica* und die Vorprojekte für den spanischen Pavillon von 1937." *Neue Zürcher Zeitung*, no. 247 (24 / 25 October 1981): 65.

Holmes, Richard. "Anthony Blunt, Gentleman Traitor." *Harper's* (April 1980): 102–9.

Horodish, Abraham. *Pablo Picasso als Buchkünstler*. Frankfurt am Main: Gesellschaft der Bibliophilen, 1957. American ed.: *Picasso as a Book Artist*. Cleveland: World, 1962.

Horrigan, J. Brian, "Art and Politics in Thirties America: The American Artists' Congress." Unpublished manuscript. Department of History of Art, University of California, Berkeley.

Imdahl, Max. *Picassos Guernica*. Frankfurt am Main: Insel, 1985.

Jakofsky, Anatole. "Midis avec Picasso." *Arts de France,* no. 6 (1946): 3–12.

Janis, Sidney, and Harriet Janis. "Picasso's *Guernica*—a Film Analysis with Commentary." *Pacific Art Review* 1 (Winter 1941–1942): 14–23.

Janssen, Pierre. "*Guernica,* de stier of het paard." *Museumjournal,* ser. 1, nos. 9–10 (1956): 153–56.

Jardot, Maurice. *Picasso.* Paris: Musée des Arts Décoratifs, 1955.

———. *Picasso Drawings.* New York: Abrams, 1959.

Jordan, John O. "A Sum of Destructions: Violence, Paternity, and Art in Picasso's *Guernica.*" *Studies in Visual Communication* 8, no. 3 (Summer 1982): 2–27.

Jung, Carl Gustav. "Picasso." *Neue Zürcher Zeitung,* no. 153 (13 November 1932). Reprinted in Vol. 15 of *The Collected Works of C. G. Jung.* Princeton: Princeton University Press, 1966.

Junyent, Albert. "Una visita a Picasso, senyor feudal." *Mirador* (Barcelona) 6, no. 288 (9 August 1934): 7.

Kahnweiler, Daniel-Henry. *Confessions esthetiques.* Paris: Gallimard, 1963.

———. "Entretiens avec Picasso." *Quadrum,* no. 2 (November 1956): 73–76.

———. *Les sculptures de Picasso.* Paris: Editions du Chêne, 1948. English ed.: *The Sculpture of Picasso.* London: Rodney Phillips, 1949.

———. *Mes galeries et mes peintres.* Paris: Gallimard, 1961. American ed.: *My Galleries and Painters.* New York: Viking, 1971.

Kaufmann, Ruth. "Picasso's *Crucifixion* of 1930." *Burlington Magazine* 111 (Summer 1969): 553–61.

Keen, Kirsten Hoving. "Picasso's Communist Interlude: The Murals of 'War and Peace.'" *Burlington Magazine* (July 1980): 464–70.

Kemenov, Vladimir. "Aspects of Two Cultures." *VOKS Bulletin* (Moscow), USSR Society for Cultural Relations with Foreign Countries (1947): 20–36. Excerpted in Herschel B. Chipp, ed. *Theories of Modern Art,* 490–96. Berkeley: University of California Press, 1968.

Kibbey, Ray Anne. *Picasso: A Comprehensive Bibliography.* New York: Garland, 1977.

Kieser, Emil. "Picassos Weise von Liebe und Tod." *Pantheon* 39 (October–December 1981): 327–39.

Knott, Robert. "The Myth of the Androgyne." *Artforum* 14 (November 1975): 38–45.

Konig, Gloria M. *Pablo Picasso and the Corrida de Toros.* Master's thesis, University of California, Berkeley, 1962.

Kramer, Hilton. "Political Pieties." *New York Times* (10 January 1971): D21.

Labbé, Edmond. *Exposition internationale des arts et techniques dans la vie moderne, 1937: Rapport général.* 12 vols. Paris: Imprimerie nationale, 1938–1940. For the Spanish pavilion see vol. 9, *Les sections etrangères* (part 1), pp. 169–76.

Lake, Carlton. "Picasso Speaking." *Atlantic* 200, no. 1 (July 1957): 35–41.

Lambert, Jean-Clarence. *Picasso: Dessins de tauromachie, 1917–1960.* Paris: Art et Style, 1960.

Laporte, Geneviève. *Si tard le soir.* Paris: Plon, 1973. American ed.: *Sunshine at Midnight: Memories of Picasso and Cocteau.* New York: Macmillan, 1975.

Larrea, Juan. "Gano el Guernica, 'Contral el ridiculo bestialismo.'" *La Calle* (Madrid) (15–21 September 1981): 36–38.

———. *Guernica: Pablo Picasso.* New York: Curt Valentin, 1947. Spanish rev. ed.: Madrid: *Cuadernos para el dialogo,* 1977.

———. "Tome del *Guernica* y liberación del arte de la pintura." *Cuadernos Americanos* 38 (1948): 235–57.

Leighton, Patricia D. *Picasso: Anarchism and Art, 1897–1914.* Ann Arbor, Mich.: University Microfilms, 1985.

———. "Picasso's Collages and the Threat of War." *Art Bulletin* 67, no. 4 (December 1985): 653–72.

Leiris, Michel. *Haut mal.* Paris: Gallimard, 1943.

———. *Miroir de la tauromachie.* Paris: GLM, 1938.

Leymarie, Jean. *Picasso, métamorphoses et unité.* Geneva: Skira; Paris: Weber, 1971. American ed.: *Picasso: The Artist of the Century.* New York: Viking, 1972.

Lieberman, William S. "Picasso and the Ballet, 1917–1945." *Dance Index* 5 (November–December 1946): 261–308.

Life 65, no. 26 (27 December 1968). Special issue: "Picasso."

Lipton, Eunice. *Picasso Criticism, 1901–1939: The Making of an Artist-Hero.* Ann Arbor, Mich.: University Microfilms, 1975.

Lopez-Rey, José. "La guerre est finie: Picasso and Spain." *Artnews* (November 1982).

———. "Picasso's *Guernica.*" *Critique* 1 (November 1946): 3–8.

Louchheim, Aline B. "Propaganda and Picasso." *New York Times Magazine* (17 May 1953): 14.

McBride, Henry. "Picasso's *Guernica* Here: Sensational Spanish War Picture Shown at the Valentine Galleries." *New York Sun* (6 May 1939): 12.

McCausland, Elizabeth. *Picasso.* New York: ACA Publications, 1944.

McCully, Marilyn, ed. *A Picasso Anthology: Documents, Criticism, Reminiscences.* London: Thames and Hudson, 1981.

Madrid: Ministerio de Cultura. *Estudios Picassiano.* 1981.

Madrid: Ministerio de Cultura. *Picasso y Málaga.* 1981.

Malraux, André. *La tête d'obsidienne.* Paris: Gallimard, 1974.

Markham, James M. "Bulletproofed *Guernica* Goes on Display in Spain." *New York Times* (24 October 1981).

———. "For Spain, *Guernica* Stirs Memory and Awe." *New York Times* (2 November 1981).

———. "*Guernica* Silences, Impresses Spanish Viewers." *International Herald Tribune* (4 or 11 November 1981).

Marrero Suárez, Vicente. *Picasso y el toro.* Madrid, 1955. American ed.: *Picasso and the Bull.* Chicago: Regnery, 1956.

Martín González, Juan José. *Lo hispánico en Pablo Picasso.* Valladolid: Sever-Cuesta, 1958.

Marzorati, Gerald. "*Guernica* Will Hang in the Prado as Picasso Wished." *Artnews* 76 (May 1977): 65–67.

Masheck, Joseph. "*Guernica* as Art History." *Artnews* 66 (December 1967): 32–35, 65–68.

Mayer, Susan. "Greco-Roman Icon and Style in Picasso's Illustrations for Ovid's Metamorphoses." *Art International* 23 (December 1979): 28–35.

Mellow, James R. "Picasso and His Poets." *New York Times* (28 October 1972): 23.

———. "Picasso and the Shy Psychologist." *Lugano Review* 1, nos. 5–6 (Summer 1966): 96–99.

———. "Picasso's Working Autobiography." *Artnews* 85, no. 6 (Summer 1986): 83.

Mellquist, Jerome. "Picasso: Painter of the Year." *Nation* (9 December 1939).

Melville, Robert. *Erotic Art of the West.* New York: Putnam, 1973.

———. "The Evolution of the Double Head in the Art of Picasso." *Horizon* 5–6 (1942): 343–51.

———. "Picasso's Anatomy of Woman." In *The New Apocalypse: An Anthology of Criticism, Poems, and Stories,* 92–100. London: Fortune Press, 1940.

Miller, Lee. "In Paris . . . Picasso Still at Work." *Vogue* 104 (15 October 1944).

Minotaure 1 (25 May 1933): 2–37. Edited by Albert Skira and E. Tériade.

Miravitlles, Jaume. "Revelaciones del arquitecto Bonet: *Guernica* fue un encargo que Picasso cobró." *La Vanguardia* (Barcelona) (20 August 1978).

Monroe, Gerald M. "Art Front." *Journal of the Archives of American Art* 15, no. 1 (1975): 15.

Morse, Albert Reynolds. *Salvadore Dalí, Pablo Picasso—Pablo Picasso, Salvadore Dalí: A Preliminary Study in Their Similarities and Contrasts.* Cleveland: Salvadore Dalí Museum, 1973.

Mujica Gallo, Manuel. *Le minitauromaquia de Picasso.* Madrid: Prensa Española, 1971.

"New York Critics Coldly Revalue the Art of Picasso, Zeus of Paris." *Art Digest* 14, no. 5 (1 December 1939).

Nobile, Philip. "Skirmish over *Guernica:* Politics on Display." *Harper's* (March 1977): 19–20.

Nochlin, Linda. "Picasso's Color: Schemes and Gambits." *Art in America* (December 1980).

La Nouvelle Critique: Revue du Marxisme Militant, no. 130 (November 1961). "Picasso: Numéro special" (Essays by Ilya Ehrenburg, Daniel-Henry Kahnweiler, Ho Chi Minh, Charles Perussaux, and A. Siqueiros).

O'Brien, Patrick. *Pablo Ruiz Picasso: A Biography.* New York: Putnam, 1976.

Olivier, Fernande. *Picasso et ses amis.* Paris: Stock, 1933. American ed.: *Picasso and His Friends.* New York: Appleton-Century-Crofts, 1965.

Omer, Mordechai. "Picasso's Horse: Its Iconography." *Print Collectors' Newsletter* 2 (1971): 73–77.

Oppé, Paul. "Art, Rage, and Reason." *London Mercury* 39 (November 1938): 67–68.

Oppler, Ellen C. *Picasso's Guernica.* New York: Norton, 1988.

Ors y Rovira, Eugenio d'. "Lettre à Pablo Picasso." In *Almanach des Arts,* 179–86. Paris: Librairie Arthème Fayard, 1937.

———. *Pablo Picasso.* Paris: Editions des Chroniques du Jour, 1930. American ed.: *Pablo Picasso.* New York: Weyhe, 1930.

———. *Pablo Picasso en tres revisiones.* Madrid: M. Aguilar, 1946.

Palau i Fabre, Josep. *Doble ensayo sobre Picasso.* Barcelona: Gustavo Gili, 1968.

———. *El Guernica de Picasso.* Barcelona: Editorial Blume, 1979.

———. *Pare Picasso.* Barcelona: Ediciones Polígrafa, 1977.

———. *Picasso en Cataluña.* Barcelona: Ediciones Polígrafa, 1966. American ed.: *Picasso in Catalonia.* New York: Tudor, 1968.

———. *Picasso i els seus amies catalans.* Barcelona: Editorial Aedos, 1971.

———. *Picasso por Picasso.* Barcelona: Editorial Juventud, 1970.

———. "Una obra de guerra, símbolo de paz." In La Cultura, *El País* (11 September 1981), 25.

Parmelin, Hélène. *Picasso: Le peintre et son modèle.* Paris: Editions Cercle d'Art, 1965. American ed.: *Picasso: The Artist and His Model.* New York: Abrams, 1965.

———. *Picasso, secrets d'alcove d'un atelier à Notre Dame de Vie.* Paris: Editions Cercle d'Art, 1966.

———. *Picasso dit.* Paris: Gonthier, 1966. American ed.: *Picasso Says.* South Brunswick, N.J.: Barnes, 1969.

———. *Picasso sur la Place.* Paris: R. Juillard, 1959. American ed.: *Picasso Plain: An Intimate Portrait.* New York: St. Martin's, 1963.

Parrot, Louis. "Picasso at Work." *Masses and Mainstream* 1, no. 1 (March 1948): 6–20.

Parrot, Louis, and Jean Marcenac, *Paul Eluard.* Paris: Seghers, 1969.

Paul, Carolyn. "The Picasso Estate: Untangling the 'Inheritance of the Century.'" *Artnews* (Summer 1978): 80–86.

Payro, Julio E. *Picasso y el ambiente artístico-social contemporáneo.* Buenos Aires: Editorial Nova, 1960.

Penrose, Roland. *Picasso: His Life and Work.* New York: Harper, 1958; rev. ed., 1973.

———. *Portrait of Picasso.* New York: Museum of Modern Art, 1957; 2d ed., rev. and enlarged, 1971.

———. *Scrapbook, 1900–1981.* New York: Rizzoli, 1981.

———. *The Sculpture of Picasso.* New York: Museum of Modern Art, 1967.

Penrose, Roland, and John Golding, eds. *Picasso in Retrospect.* New York: Praeger, 1973. English ed.: *Picasso, 1881–1973.* London: Elek, 1973.

Péret, Benjamin. *De derrière les fagots.* Paris: Editions Surréalistes, 1934. (Illustration by Picasso.)

Perls, Frank. "The Last Time I Saw Pablo." *Artnews* 73 (April 1974): 36–42.

Peterson, Jay. "Picasso as a Spaniard." *New Masses* (21 December 1937): 7.

———. "Picasso's Mural *Guernica:* a Ferocious Indictment of the Fascist Bombers." *New Masses* (16 May 1939).

Picasso, Pablo. *Le désir attrapé par la queue.* Paris: Gallimard, 1945. English ed.: *Desire Caught by the Tail.* Translated by Roland Penrose. London: Calder and Boyars, 1970.

———. *Picasso: Dessins de tauromachie, 1917–1960.* Paris: Art et Style, 1960.

———. *Picasso, 1930–1935.* Christian Zervos, ed. Paris: Cahiers d'Art.

———. *Picasso on Art: A Selection of Views.* Compiled by Dore Ashton. New York: Viking, 1972.

———. "Picasso Speaks: A Statement by the Artist." *The Arts* 3, no. 5 (May 1923): 314–29.

———. *Picasso's Private Drawings: The Artist's Personal Collection of His Finest Drawings, Including 117 Reproductions.* Translated by Matilda Simon. New York: Simon and Schuster, 1969.

———. *Picasso's Vollard Suite*. London: Thames and Hudson, 1956. American ed.: *Picasso for Vollard*. New York: Abrams, 1956.

———. "Pourquoi j'ai adheré au parti communiste." *L'Humanité* 41 (29–30 October 1944): 1–2. (Translated and reprinted in *Art Digest* 19, 1 November 1944: 11, and as "Why I Became a Communist." *New Masses* 53, no. 4 [24 October 1944]: 11).

———. "Six Poems by Pablo Picasso." Translated by George Reavey. *Contemporary Poetry and Prose* 1, nos. 4–5 (August–September 1936): 75–79.

"Picasso." *American Magazine of Art* (March 1939): 179.

"Picasso: *Dream and Falsehood of Franco*." *Art Front*, no. 20 (October 1937): 10.

Picasso: 145 dessins pour la presse et les organisations démocratique. Paris: Edition Société Nouvelle du Journal *L'Humanité*, 1973.

"Picasso and Communist Painting." *Domus* (Milan), no. 208 (April 1946): 38–42.

"Picasso and Spain." *Art Front*, no. 20 (October 1937): 11.

"Picasso and the American Artists' Congress." *Time* (27 December 1937).

"Picasso's *Guernica*." *Studio International* 116 (December 1938): 310–12.

"Picasso's *Guernica* Misses the Masses, but Wins the Art Critics." *Art Digest* 13 (15 May 1939): 11.

Picasso 347. 2 vols. New York: Random House, 1970.

Le Point (Paris) 7, no. 2 (October 1952). Special issue on Picasso.

Portero, José S. *Libros sobre Picasso en el Museo de Málaga: El legado "Jaime Sabartés."* Madrid: Ministerio de Cultura, 1981.

Proweller, William. "Picasso's *Guernica*: A Study in Visual Metaphor." *Art Journal* 30, no. 3 (Spring 1971): 240–48.

Puente, Joaquín de la. "Franco dijo 'sí' al *Guernica* de Picasso." *Blanco y Negro*, 14 February 1976.

———. *Guernica: Historia de un cuadro*. Madrid: Silex, 1983. English trans.: *Guernica: The Making of a Painting*. Madrid: Silex, 1985.

Puig, Arnau. "¿Qué es y qué significa el *Guernica* de Pablo Picasso? ¿Una obra de arte o la representación de la España trascendente?" *Destino* (Barcelona), no. 2107 (23 February–1 March 1978).

Quinn, Edward. *Picasso*. Cologne: Du Mont Buchverlag, 1977.

Quintanilla, Rafael Fernández. *La odisea del "Guernica" de Picasso*. Barcelona: Planeta, 1981.

Raynal, Maurice. *Picasso*. Geneva: Skira, 1953.

Read, Herbert. "Art—Picasso and the Marxists." *London Mercury* 31 (November 1934): 95–96.

———. "Pablo Picasso." In *Philosophy of Modern Art*, 153–63. New York: Horizon, 1953.

———. "Picasso's *Guernica*," In *A Coat of Many Colours*, 317–19. London: Routledge, 1945.

———. "Picasso's *Guernica*." *London Bulletin*, no. 6 (October 1938): 6.

———. "The Triumph of Picasso," In *A Coat of Many Colours*, 273–76. London: Routledge, 1945.

Reff, Theodore. "Love and Death in Picasso's Early Work." *Artforum* 9, no. 9 (May 1973): 64–73.

Richardson, John. "L'amour fou." *New York Review of Books* (19 December 1985).

Ries, Martin. "Picasso and the Myth of the Minotaur." *Art Journal* 32, no. 2 (Winter 1972–1973): 142–45.

Rolland, André. *Picasso et Royan aux Jours de la Guerre de l'Occupation*. Royan: Imprimerie Nouvelle, 1967.

Rosa, Joyce D. "The Beatus Manuscripts: Aesthetic Characteristics of Selected Illuminations from the Thompsonian, Saint-Sever, and Gerona Mss. and Their Influence on Picasso and Léger." Ph.D. dissertation, New York University School of Education, 1975.

Rose, Barbara. "Picasso with Women: Pygmalion to His Galateas." *Vogue* 159 (1 April 1972).

Rosenblum, Robert. *Cubism and Twentieth Century Art*. New York: Abrams, 1961.

———. "Picasso and the Anatomy of Eroticism." In *Woman as Sex Object: Studies in Erotic Art, 1730–1970*, 337–50. New York: Newsweek, 1972.

———. "Picasso as Surrealist." *Artforum* 5, no. 1 (September 1966): 21–25.

———. "The Unity of Picasso." *Partisan Review* 24 (Fall 1957): 592–96.

Rowland, Benjamin, Jr. "*Guernica*." Unpublished notes posted in Fogg Art Museum at time of *Guernica* exhibition, 30 September–20 October 1941.

Roy, Claude. "Picasso: War and Peace." *Graphis* 10 (1954).

Rubin, William. *Dada and Surrealism*. New York: Abrams, 1969.

———. "Picasso's Wishes on *Guernica*." In Letters to the Editor, *Times* (London), *New York Times*, and *International Herald Tribune* (28 November 1975). (Reply to H. B. Chipp's letter of 26 November.)

Rubin, William, Elaine L. Johnson, and Riva Castleman. *Picasso in the Collection of the Museum of Modern Art*. New York: Museum of Modern Art, 1972.

Rubio, Miguel. "Después de 44 años de exilio: el *Guernica* en su casa." *El Socialista* (Madrid), no. 223 (16–22 September 1981): 43–44.

Runnqvist, Jan. *Minotauros; En Studie i förhållandet mellan Ikonografi och Form i Picassos Konst, 1900–1937*. Stockholm: Bonnier, 1959.

Russell, Frank D. *Picasso's Guernica: The Labyrinth of Narrative and Vision*. Montclair, N.J.: Allanheld and Schram, 1980.

Russell, John. "The Prado Readies for *Guernica*." *New York Times* (8 June 1980): D27–28.

Sabartés, Jaime. *A los toros avec Picasso*. Monte Carlo: Sauret, 1961. American ed.: *Picasso: Toreros; with Four Original Lithographs*. New York: Braziller, 1961.

———. "La littérature de Picasso." *Cahiers d'Art* 10, nos. 7–10 (1935): 225–38.

———. *Picasso: An Intimate Portrait*. London: W. H. Allen, 1949. Spanish ed.: *Picasso: Retratos y recuerdos*. Madrid: Aguado, 1953.

———. *Picasso: Documents iconographiques*. Geneva: Pierre Cailler, 1954.

———. *Picasso en su obra*. Madrid: Cruz y Raya, 1935.

Sadoul, Georges. "Une demi-heure dans l'atelier de Picasso." *Regards* (29 July 1927): 8.

Sandberg, W. J. H. B. "Picasso's *Guernica*." *Daedelus* 89, no. 1 (Winter 1960): 245–52.

Sartre, John Paul. *Essays in Aesthetics*. New York: The Philosophical Library, 1963.

Saura, Antonio. *Contre Guernica*. Madrid: Turner, 1982.

Schapiro, Meyer. "Picasso's *Woman with a Fan:* On Transformation and Self-Transformation." In *In Memoriam: Otto J. Brendel,* 249–54. Mainz: Philipp von Zabern, 1976.

Scheidegger, Alfred, ed. *Der Minotauros: Dreissig graphische Blätter.* Frankfurt am Main: Insel, 1963.

Schiff, Gert. *Picasso in Perspective.* New York: Prentice-Hall, 1976.

———. "Picasso's Suite 347; or Painting as an Act of Love." In *Woman as Sex Object: Studies in Erotic Art, 1730–1970,* 238–53. New York: Newsweek, 1972. (Reprinted in *Artnews Annual* 38, 1972.)

Schneider, Daniel E. "The Painting of Pablo Picasso: A Psychoanalytic Study." *College Art Journal* 7, no. 2 (Winter 1947–1948): 81–93.

———. *The Psychoanalyst and the Artist.* New York: Mentor, 1962.

Sebastián López, Santiago. *El Guernica y otros obras de Picasso: Contextos iconográficos.* Murcia: Universidad de Murcia, Departamento Historia del Arte, 1984.

———. "*Guernica* es un symbol." *La Vanguardia* (8 April 1981).

———. "La clave del *Guernica:* Lectura iconográfico-iconológica." *Boletín del Museo e Instituto "Camón Aznar"* (Zaragoza) 5 (1981).

Seckel, Curt G. "Picasso und die Insel des Minotauros." *Das Kunstwerk* 4, no. 5 (1950): 26–29.

———. "Picassos Wege zur Symbolik der *Minotauromachie.*" *Die Kunst und das schöne Heim* 85 (May 1973): 289–96.

Seckler, Jerome. "Picasso Explains." *New Masses* (13 March 1945): 4–7.

Selz, Peter. "The Artist as Social Critic." In *Art in a Turbulent Era,* 191–201. Ann Arbor, Mich.: UMI, 1985.

Seraller, Francisco Calvo. *El Guernica de Picasso.* Madrid: Alianza, 1981.

Serra, Francesc. "Picasso i la revolucio." *Mirador* 8, no. 392 (22 October 1936): 7.

Sicart, José Luis de, and J. Ainaud de Lasarte. *Museo Picasso: Catálogo I.* Barcelona: Ayuntamiento de Barcelona, 1971.

Soby, James Thrall. "In the Shadow of *Guernica.*" *Saturday Review* (13 January 1951).

———. "Life Magazine Stoops to Conquer." *Saturday Review* 30 (6 December 1947): 34ff.

———. "Picasso: A Critical Estimate." *Parnassus* 11 (December 1939): 8–12.

"Spain's Picasso Paints Bombing of Guernica for Paris Exposition." *Life* (26 July 1937): 64.

Spender, Stephen. "*Guernica.*" *New Statesman and Nation* (15 October 1938): 567–68.

Spies, Werner. *Picasso: Das plastische Werk.* Stuttgart: Gerd Hatje, 1971. English ed.: *Picasso Sculpture: With a Complete Catalogue.* London: Thames and Hudson, 1972.

Stein, Gertrude. *The Autobiography of Alice B. Toklas.* New York: Harcourt, Brace, 1933.

———. *Gertrude Stein on Picasso.* New York: Liveright, 1970.

———. *Picasso.* Paris: Floury, 1938. American ed.: *Picasso.* New York: Scribner, 1939.

Steinberg, Leo. *Other Criteria: Confrontations with Twentieth Century Art.* New York: Oxford University Press, 1972.

———. "Picasso: Drawing As If to Possess." *Artforum* 10, no. 2 (October 1971): 44–53.

Steiner, George. "The Cleric of Treason." *New Yorker* (8 December 1980): 158–95.

Stich, Sidra. "Picasso's Art and Politics in 1936." *Arts Magazine* 58 (October 1983): 113–18.

———. "Toward a Modern Mythology: Picasso and Surrealism." Ph.D. dissertation, University of California, Berkeley, 1973.

Sweeney, James Johnson. "Panorama of Picasso." *New Republic* (December 1939): 231–35.

Symposium on *Guernica*. New York: Museum of Modern Art, 25 November 1947 (Unpublished transcript).

Sypher, Wylie. *Rococo to Cubism in Art and Literature*. New York: Vintage, 1960.

Téry, Simone. "Picasso n'est pas officier dans l'armée française." *Les Lettres Françaises* 5ᵉ année, no. 48 (24 March 1945): 6.

Theven, Patrick. "L'heritage Picasso." *L'Express* (Edition Internationale), no. 1344 (11–17 April 1977): 47–52.

Thimme, Jürgen. "Pablo Picassos *Minotauromachie*." *Jahrbuch der Staatlicher Kunstsammlungen in Baden-Württemberg,* vol. 18. Munich and Berlin: Deutscher Künstlerverlag, 1981.

———. "Picasso und die Antike." *Das Altertum* (Berlin) 22, no. 4 (1976): 247–53.

Tillich, Paul. *Theology of Culture*. New York, 1959.

Todd, Ruthven. "Drawings for *Guernica*." *London Bulletin*, nos. 8–9 (January–February 1939): 59.

Torre, Guillaume de la. "Picasso vs Gómez." In *Ramón Gómez de la Serna, obras completas*, 2: 9–29. Barcelona: Editorial AHR, 1956.

Torroella, Santos. "La fabulosa herencia de Picasso." Part I, "La solución final de un pleito familiar." *Destino* (Barcelona), no. 2135 (7–13 September 1978): 36–37.

Tuchman, Phyllis. *Guernica, L'Humanité, and the Spanish Pavilion*. Master's thesis, New York University, 1973. News Micro Microfiche 1039.

———. "Guernica and *Guernica*." *Artforum* (April 1983): 44–51.

Tusell, Javier. "La larga aventura del *Guernica*." *El País*. Series of six articles on the problems associated with Spain's acquisition of *Guernica*: "El final de la transición" (11 September 1981); "Picasso y la república" (18 September 1981); "París, 1937" (18 September 1981); "España pagó el cuadro" (19 September 1981); "Una obra maestra de Picasso" (22 September 1981); "Franco, Picasso y el histórico cuadro" (23 September 1981).

———. "La ultima herencia de Picasso." *ABC* (Madrid) (9 October 1985): 38.

———. "Los documentos del *Guernica*." *Cambio* 16, no. 513 (28 September 1981): 101–3.

Ullman, Ludwig. *Das Bild des Krieges in der Kunst Picassos*. Osnabrück: Universtät Osnabrück, 1983.

Vallentin, Antonina. *Pablo Picasso*. Paris: A. Michel, 1957. American ed.: *Picasso*. Garden City, N.Y.: Doubleday, 1963.

Van de Walle, Odile. "*Guernica:* La guerre est finie." *Le Point* (22 October 1979): 172.

Verdet, André. "Picasso et ses environs." *Les Lettres Nouvelles* (July–August 1955).

Viazzi, Glauco. "Picasso e la pittura comunista di fronte al marxismo." *Domus* (Milan) 208 (April 1946): 38–42.

Vilaro, Ramón. "El *Guernica* de Pablo Picasso llega hoy, por fin, a España." In La Cultura, *El País* (10 September 1981), 25.

XX^e Siècle (1971). "Hommage à Pablo Picasso." Special issue on the occasion of his ninetieth birthday.

Vovard, Paul. "Le martyr de Guernika." *La Jeune République: Cahiers de la Démocracie* (Paris), no. 48 (April 1938).

Wallach, Amei. "*Guernica:* The Bitter Tug-of-War in Spain over Picasso's Greatest Painting." *Newsday Magazine* (4 April 1982).

Wescher, Paul. "Picasso's *Guernica* and the Exchangeability of the Picture Parts." *Art Quarterly* 18, no. 4 (Winter 1955): 341–50.

Wheeler, Monroe. "Meeting Picasso." *University Review: A Journal of the University of Kansas City* 3, no. 3 (Spring 1937): 174–79.

Withers, Josephine. "The Artistic Collaboration of Pablo Picasso and Julio González." *Art Journal* 35, no. 2 (Winter 1975–1976): 107–14.

Zervos, Christian. *L'Art de la Catalogne.* Paris: Cahiers d'Art, 1937.

———. "Conversations avec Picasso." *Cahiers d'Art* 10, nos. 7–10 (1935): 173–78.

———. "Histoire d'un tableau de Picasso." *Cahiers d'Art* 12, nos. 4–5 (1937): 105–11.

———. *Pablo Picasso.* Catalogue raisonné, Vols. 1–33. Paris: Cahiers d'Art, 1932–.

———. *Pablo Picasso.* Paris: Cahiers d'Art, 1951.

III. Catalogues of Exhibitions

1931 *Thirty Years of Pablo Picasso.* London: Alex Reid and Lefevre.

1932 *Exposition Picasso.* Paris: Galerie Georges Petit.

1934 *Pablo Picasso.* Hartford, Conn.: Wadsworth Atheneum.

1936 *Exposition d'oeuvres récentes de Picasso.* Paris: Galerie Paul Rosenberg.

 Fantastic Art, Dada, Surrealism. New York: Museum of Modern Art. Edited by Alfred H. Barr, Jr.

 Picasso. Madrid, Barcelona, and Bilbao: ADLAN (Amigos de las Artes Nuevas).

1937 *L'art catalan du X^e siècle au XV^e siècle.* Paris: Jeu de Paume des Tuileries.

 Artistes français à l'Espagne. Paris: Maison de la Culture and the Union Générale de Travail. Essay by Louis Aragon.

 Catalogue général de l'exposition (World's Fair). Paris. 2 vols.

 Exposition internationale des arts et techniques dans la vie moderne. Paris. Numerous catalogues of varying sizes and in many languages were published under this title.

 La libération dans l'art. Paris: Association de Peinture et Sculpture de la Maison de la Culture.

 Les maîtres de l'art indépendant de 1895 à 1937. Paris: Petit Palais.

 ¡No Pasarán! Spain, 1930–1937. Paris.

 Origines et développements de l'art international indépendant. Paris: Jeu de Paume des Tuileries.

 Société des artistes français. Paris: Palais de l'Air.

1938 Exhibition of Picasso's *Guernica*. London: New Burlington Galleries.

Matisse, Picasso, Braque, Laurens. Oslo, Kunstnernes Hus; Copenhagen, Statens Museum for Kunst; Stockholm, Liljevalchs Konsthall; Göteborg, Konsthallen.

1939 *Picasso in English Collections*. London: London Gallery.

Picasso: Forty Years of His Art. New York: Museum of Modern Art. Edited by Alfred H. Barr, Jr.

Picasso: Guernica. New York: Valentine Gallery.

1955 *Picasso: Peintures, 1900–1955*. Paris: Musée des Arts Décoratifs. Essay by Maurice Jardot.

1956 *Guernica*. Amsterdam, Stedelijk Museum; Brussels, Palais des Beaux Arts; Stockholm, Nationalmuseum. Essay by Daniel-Henry Kahnweiler.

1957 *Picasso: Seventy-fifth Anniversary Exhibition*. New York: Museum of Modern Art. Edited by Alfred H. Barr, Jr.

1960 *Picasso*. London: Arts Council of Great Britain, Tate Gallery. Introduction by Roland Penrose.

1961 *Picasso Graphics from the Mr. and Mrs. Fred Grunwald Collection*. Berkeley: University of California, University Art Gallery. Essay by Herschel B. Chipp.

1962 *Picasso: An American Tribute*. New York: Chanticleer Press, 1962. Edited by John Richardson. Participating galleries: M. Knoedler, Saidenberg, Paul Rosenberg, Duveen Brothers, Perls, Staempfli, Gordier-Wattern, New Gallery, Otto Gerson.

1963 *La tauromaquia: Francisco de Goya, 1815, Pablo Picasso, 1959*. Bern: Galerie Kornfeld und Klipstein.

1966 *Hommage à Pablo Picasso: Peintures*, Grand Palais; *Dessins, sculptures, céramiques*, Petit Palais. Paris: Réunion des Musées Nationaux. Introduction by Jean Leymarie.

Picasso: Sixty Years of Graphic Works. Los Angeles: Los Angeles County Museum of Art. Text by Daniel-Henry Kahnweiler and Bernhard Geiser.

1971 *Picasso et la Suite Vollard / and the Vollard Suite*. Ottawa: National Gallery of Canada. Text by Jean S. Boggs.

1973 *Graphik Bücher und Handzeichnungen von Pablo Picasso*. Bern: Galerie Kornfeld und Klipstein (Georges Bloch Collection).

Une collection Picasso. Oeuvres de 1937 à 1946. Geneva: Galerie Jan Krugier.

1974 *Picasso und die Antike*. Karlsruhe: Badisches Landesmuseum. Text by Jürgen Thimme.

1975 *Guernica: Kunst und Politik am Beispiel Guernica—Picasso und der spanische Bürgerkrieg*. Berlin: Neue Gesellschaft für Bildende Kunst.

1976 *Equipo crónica*. Madrid: Galería Juana Mordo.

1978 *Donation Picasso: La collection personnelle de Picasso*. Paris: Musée du Louvre. Réunion des Musées Nationaux. Text by Hubert Landais and Jean Leymarie.

 Els Quatre Gats: Art in Barcelona around 1900. Princeton: Art Museum, Princeton University. Text by Marilyn McCully.

1979 *Josep Lluis Sert: Architect to the Arts*. Cambridge: Harvard University Carpenter Center for the Visual Arts.

 1937: Exposition internationale des arts et techniques. Paris: Centre Georges Pompidou.

 Picasso: Oeuvres reçues en paiement des droits de succession. Paris: Grand Palais. Réunion des Musées Nationaux. Text by Maurice Aicardi, Dominique Bozo, Michel Leiris, and René Char.

1980 *La guerra civil española*. Madrid: Ministerio de Cultura.

 Pablo Picasso: A Retrospective. New York: Museum of Modern Art. Edited by William Rubin.

 Picasso: From the Musée Picasso, Paris. Minneapolis, Minn.: Walker Art Center. Text by Dominique Bozo, Martin Friedman, Robert Rosenblum, and Roland Penrose.

1981 *Guernica—Legado Picasso*. Madrid: Ministerio de Cultura. Text by J. Miró, J. Renau, J. L. Sert, J. Tusell, and H. B. Chipp.

 Master Drawings by Picasso. Cambridge, Mass.: Fogg Art Museum. Text by Gary Tinterow.

 1881–1981: Picasso i Barcelona. Barcelona: Ajuntament de Barcelona; Ministeri de Cultura, Dirección General de Belles Arts, Arxius i Biblioteques.

 Pablo Picasso: Eine Ausstellung zum hundertsten Geburtstag: Werke aus der Sammlung Marina Picasso. Munich: Haus der Kunst and Prestel-Verlag. Text by Werner Spies.

 Paris-Paris. Paris: Centre Georges Pompidou.

 Picasso: 1881–1973: Exposición antológica. Barcelona: Ayuntamiento de Barcelona. Ministerio de Cultura, Dirección General de Bellas Artes, Archivos y Bibliotecas.

 Picasso: Obra gráfica original, 1904–1971. Vol. 2. Madrid: Ministerio de Cultura. Text by Enrique Azcoaga, Santiago Amon, Catherine Coleman.

 Picasso in der Staatgalerie Stuttgart. Stuttgart: Staatgalerie. Text by Sebastian and Herma C. Goeppert.

 Picasso y los toros. Málaga. Ministerio de Cultura, Dirección General de Bellas Artes, Archivos y Bibliotecas and the Ayuntamiento de Málaga.

 Picasso's Picassos: An Exhibition from the Musée Picasso, Paris. London: Hayward Gallery. Text by Hubert Landais, Dominique Bozo, Timothy Hilton, and Roland Penrose.

1982 *Eluard et ses amis peintres*. Paris: Musée National d'Art Moderne, Centre Georges Pompidou.

 Picasso intime. Hong Kong Museum of Art (Maya Picasso Collection).

1983 *Picasso e il Mediterraneo.* Rome: Accademia di Francia a Roma, Edizioni dell'Elifante. Text by J. Leymarie.

 Picasso the Printmaker: Graphics from the Marina Picasso Collection. Dallas, Tex.: Dallas Museum of Art.

1987 *Cinquantenaire de l'exposition internationale des arts et des techniques dans la vie moderne.* Paris: Institut Français d'Architecture / Paris Musées.

 Pabellón Español: Exposición Internacional de Paris, 1937. Josefina Alix Trueba, curator. Madrid: Ministerio de Cultura.

Page numbers in italics refer to illustrations of works of art. Works of art in main entries are by Picasso except where other attribution is given.

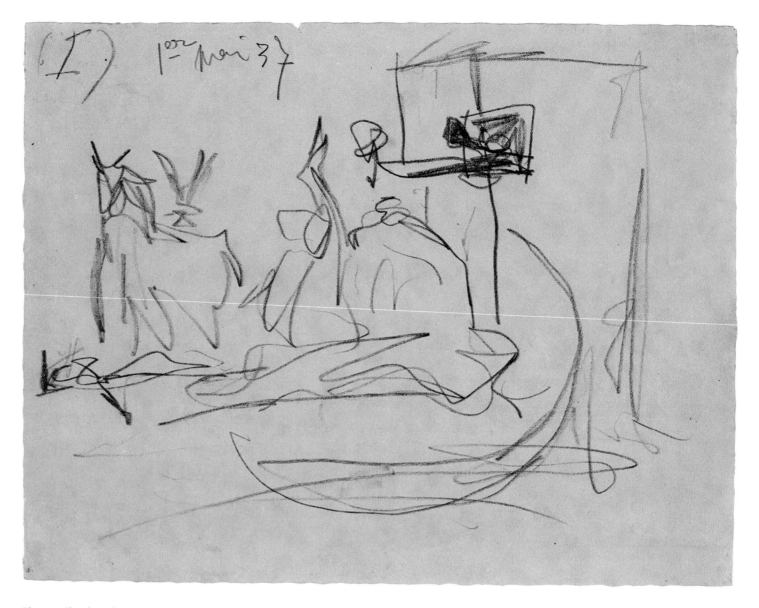

Plate 1 Sketch 1. *Composition Study*, 1 May 1937 (I). Pencil. 8¼″ × 10⅝″ (21 × 27 cm).

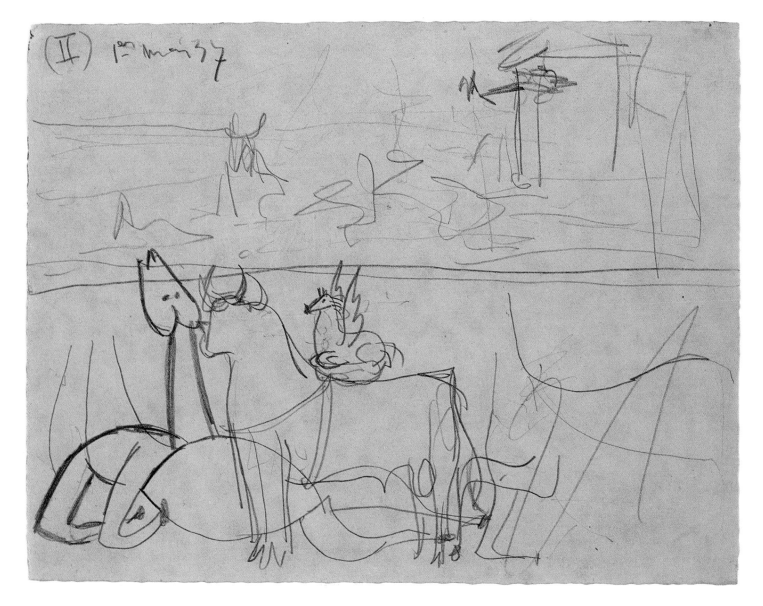

Plate 2 Sketch 2. *Composition Studies*, 1 May 1937 (II). Pencil. 8¼″ × 10⅝″ (21 × 27 cm).

Plate 3 Sketch 3. *Composi-
tion Study*, 1 May 1937 (III).
Pencil. 8¼″ × 10⅝″ (21 ×
27 cm).

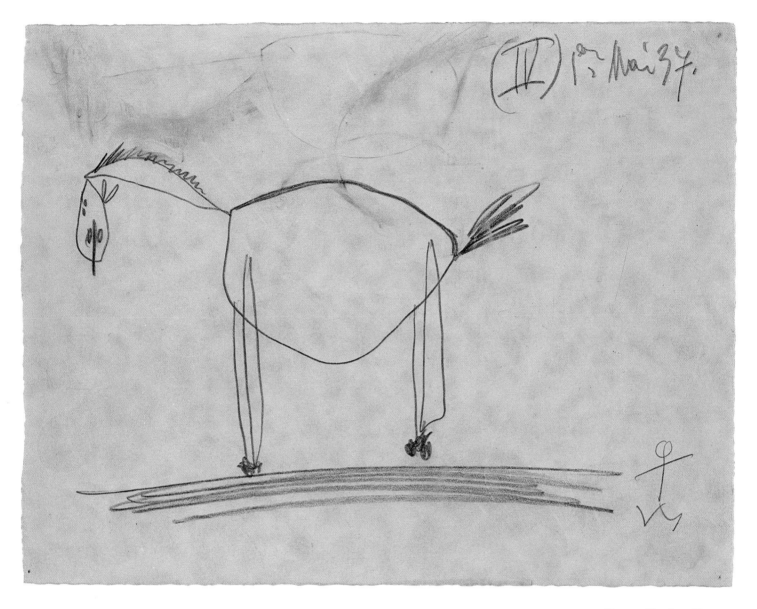

Plate 4 Sketch 4. *Horse*, 1
May 1937 (IV). Pencil. $8\frac{1}{4}''$ ×
$10\frac{1}{2}''$ (21 × 26.9 cm).

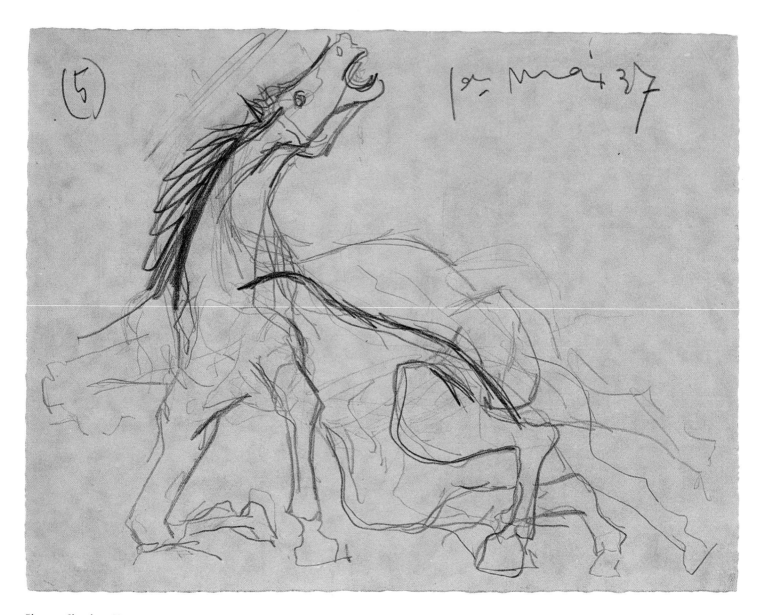

Plate 5 Sketch 5. *Horse, 1*
May 1937 (5). Pencil. 8¼″ ×
10½″ (21 × 26.8 cm).

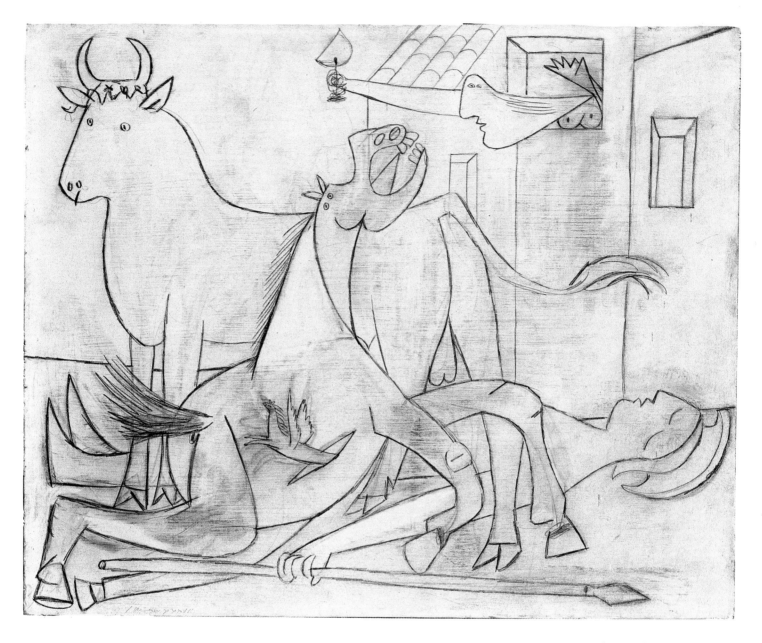

Plate 6 Sketch 6. *Composition Study*, 1 May 1937. Pencil. 21⅛″ × 25½″ (53.7 × 64.8 cm).

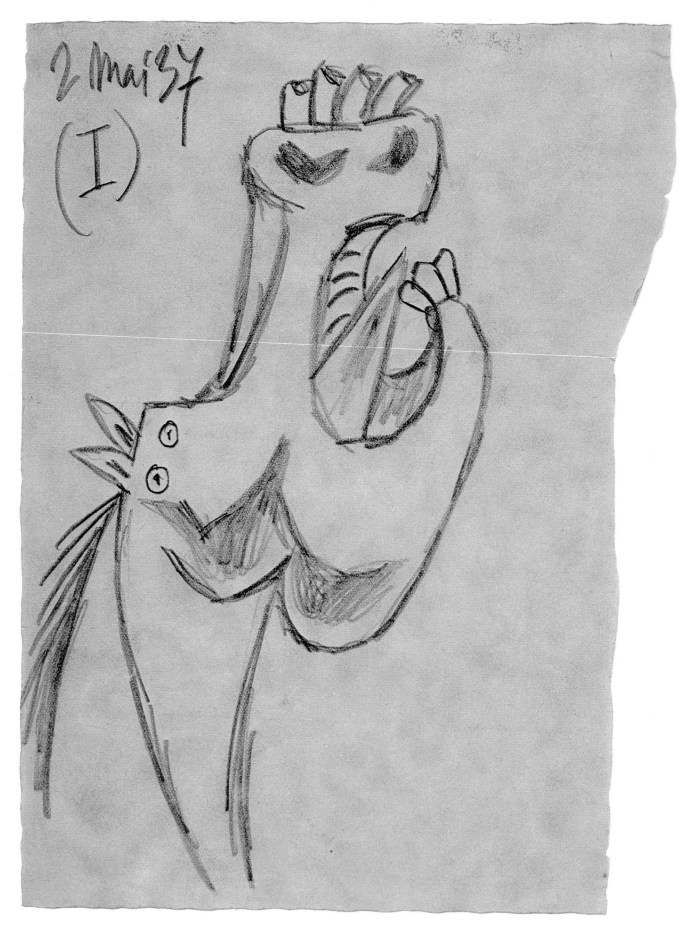

Plate 7 Sketch 7. *Head of Horse*, 2 May 1937 (I). Pencil. 10½″ × 8¼″ (26.7 × 21 cm).

2 Mai 37
(II)

Plate 8 Sketch 8. *Head of Horse*, 2 May 1937 (II). Pencil. 8½″ × 6″ (21.6 × 15.2 cm).

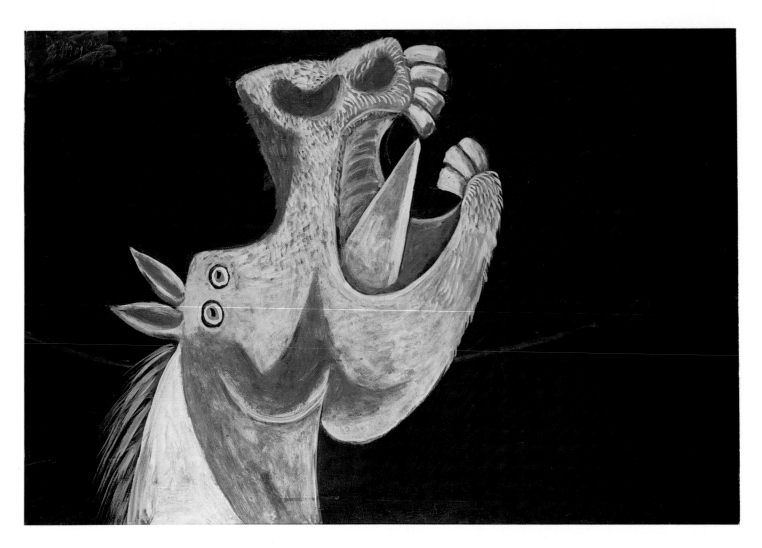

Plate 9 Sketch 9. *Head of Horse*, 2 May 1937. Oil. $25\frac{1}{2}''$ × $36\frac{1}{4}''$ (64.8 × 92.1 cm).

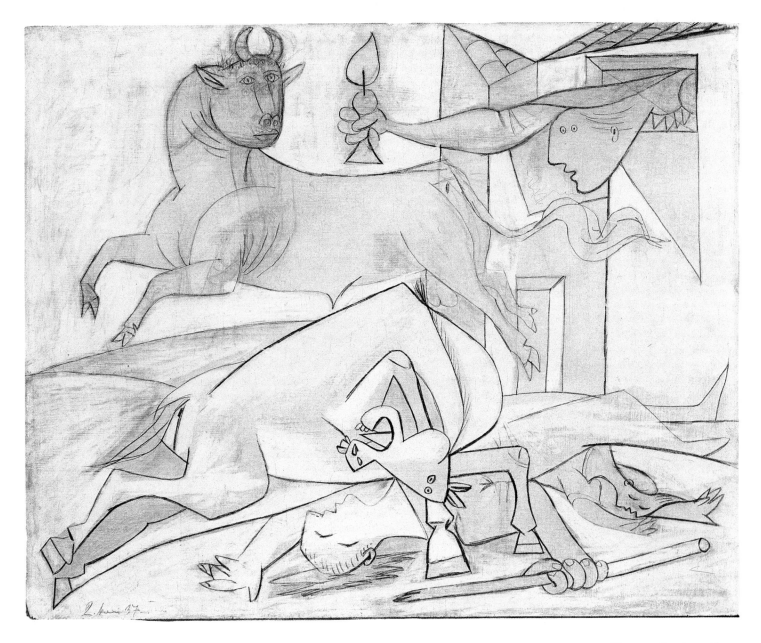

Plate 10 Sketch 10. *Composition Study*, 2 May 1937. Pencil and gouache on gesso on wood. 23⅜″ × 28¾″ (60 × 73 cm).

Plate 11 Sketch 11. *Horse and Bull*, not dated. Pencil on ochre cardboard. $8\frac{7}{8}'' \times 4\frac{3}{4}''$ (22.6 × 12.1 cm).

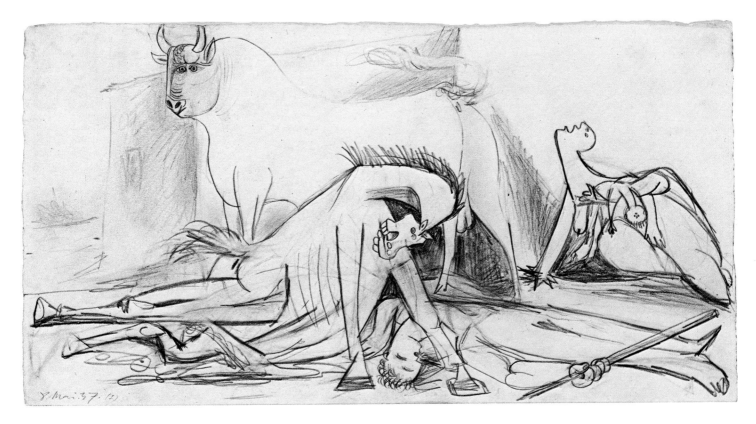

Plate 12 Sketch 12. *Composition Study*, 8 May 1937 (I). Pencil. 9½″ × 17⅞″ (24.1 × 45.4 cm).

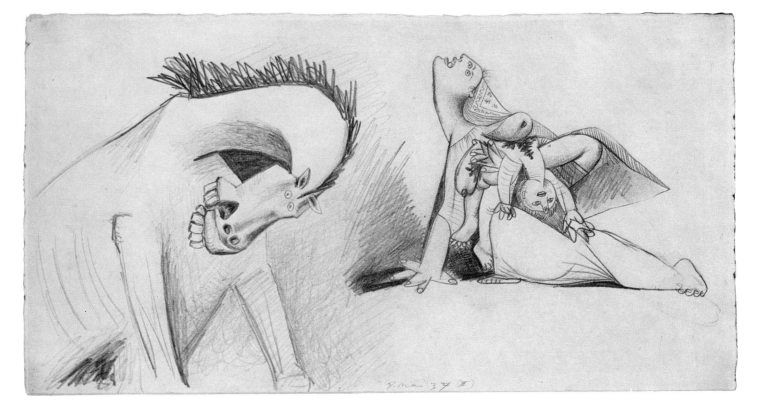

Plate 13 Sketch 13. *Horse and Mother with Dead Child*, 8 May 1937 (II). Pencil. 9½″ × 17⅞″ (24.1 × 45.4 cm).

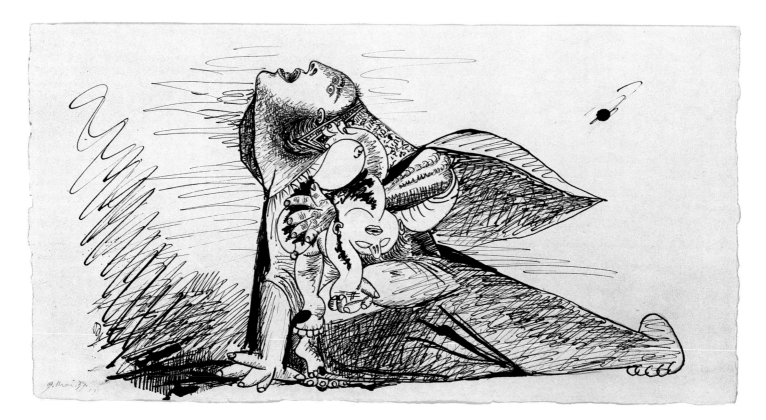

Plate 14 Sketch 14. *Mother
with Dead Child*, 9 May 1937
(I). Ink. 9½″ × 17⅞″ (24.1 ×
45.4 cm).

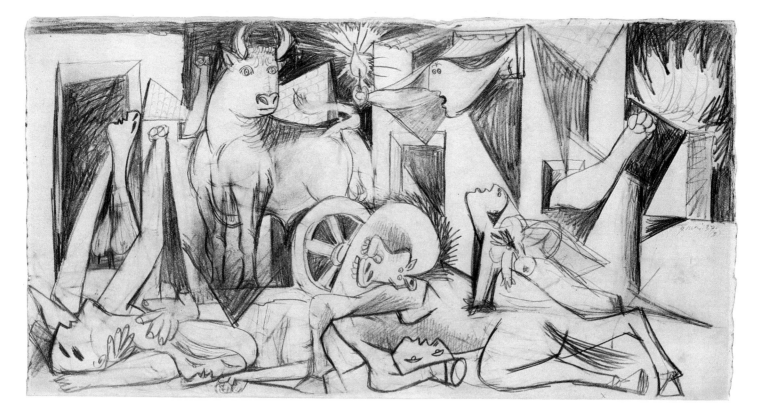

Plate 15 Sketch 15. *Com-
position Study*, 9 May 1937
(II). Pencil. 9½″ × 17⅞″ (24.1 ×
45.4 cm).

Plate 16 Sketch 16. *Mother
with Dead Child on Ladder*, 9
May 1937 (II). Pencil. 17⅞″ ×
9½″ (45.4 × 24.1 cm).

Plate 17 Sketch 17. *Horse*,
10 May 1937 (I). Pencil. 9½″ ×
17⅞″ (24.1 × 45.4 cm).

Plate 18 Sketch 18. *Leg and Heads of Horses*, 10 May 1937 (II). Pencil. $17\frac{7}{8}'' \times 9\frac{1}{2}''$ (45.4 × 24.1 cm).

Plate 19 Sketch 19. *Head of
Man with Bull's Horns*, 10
May 1937 (III). Pencil. $17\frac{7}{8}''\times$
$9\frac{1}{2}''$ (45.4 × 24.1 cm).

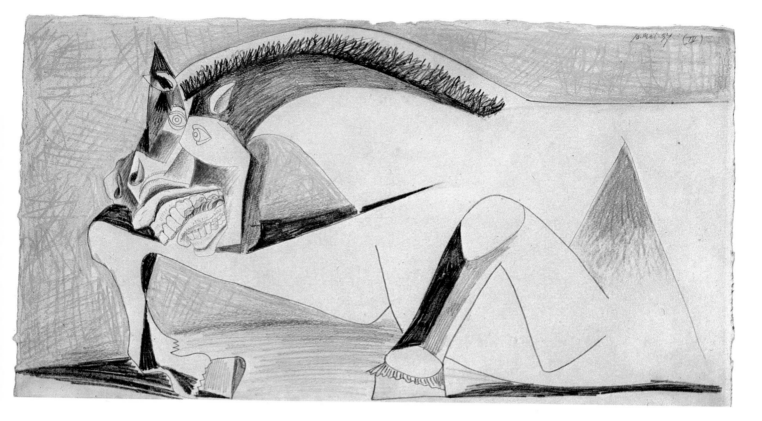

Plate 20 Sketch 20. *Horse,*
10 May 1937 (IV). Pencil and
color crayons. $9\frac{1}{2}'' \times 17\frac{7}{8}''$
(24.1 × 45.4 cm).

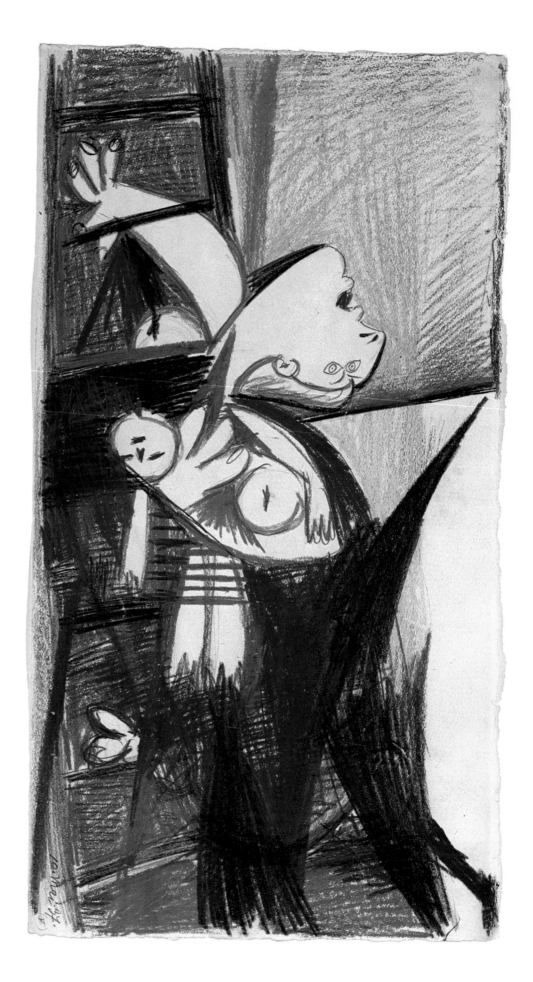

Plate 21 Sketch 21. *Mother with Dead Child on Ladder*, 10 May 1937 (V). Pencil and color crayons. $17\frac{7}{8}'' \times 9\frac{1}{2}''$ (45.4 × 24.1 cm).

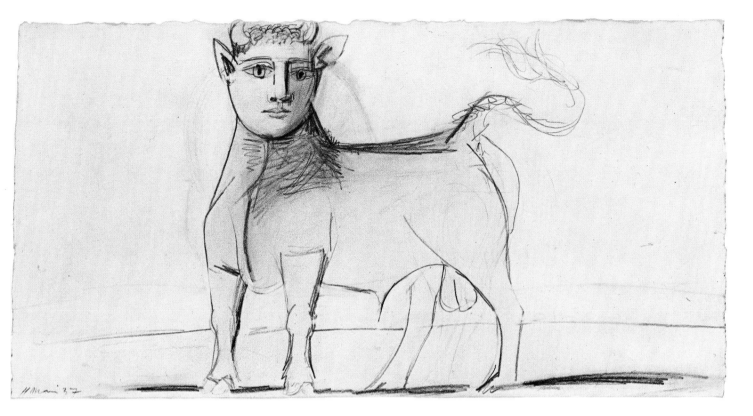

Plate 22 Sketch 22. *Bull with Human Head*, 11 May 1937. Pencil. 9½″ × 17⅞″ (24.1 × 45.4 cm).

Plate 23 Sketch 23. *Head of Woman*, 13 May 1937 (I). Pencil and color crayons. $17\frac{7}{8}''$ × $9\frac{1}{2}''$ (45.4 × 24.1 cm).

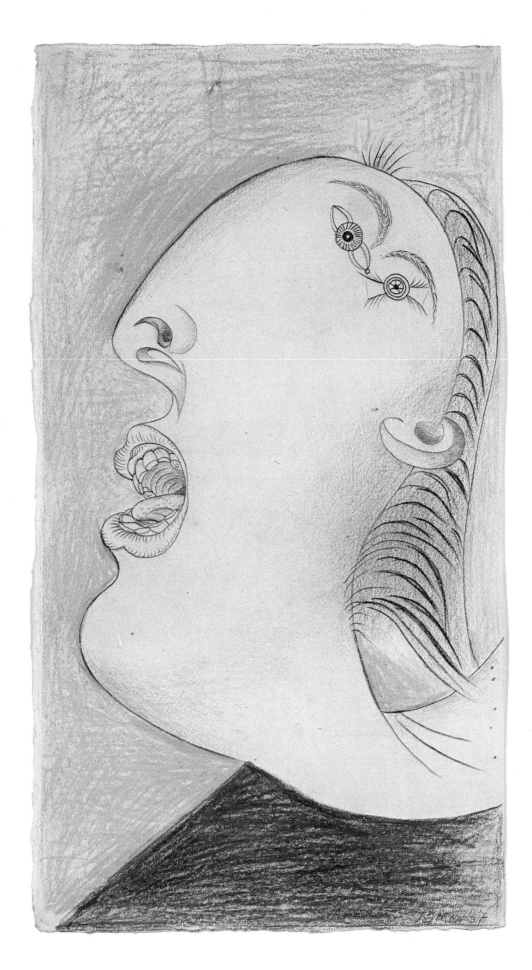

Plate 24 Sketch 24. *Hand of Warrior with Broken Sword*, 13 May 1937 (II). Pencil. $9\frac{1}{2}'' \times 17\frac{7}{8}''$ (24.1 × 45.4 cm).

Plate 25 Sketch 25. *Mother
with Dead Child*, 13 May
1937 (III). Pencil and color
crayons. 9½″ × 17⅞″ (24.1 ×
45.4 cm).

Plate 26 Sketch 26. *Head of Bull-Man*, 20 May 1937. Pencil and gouache. $9\frac{1}{4}'' \times 11\frac{1}{2}''$ (23.5 × 29.2 cm).

Plate 27 Sketch 27. *Head of Bull-Man with Studies of Eyes*, 20 May 1937. Pencil and gouache. 9¼″ × 11½″ (23.5 × 29.2 cm).

Plate 28 Sketch 28. *Head of Horse*, 20 May 1937. Pencil and gouache. 11½″ × 9¼″ (29.2 × 23.5 cm).

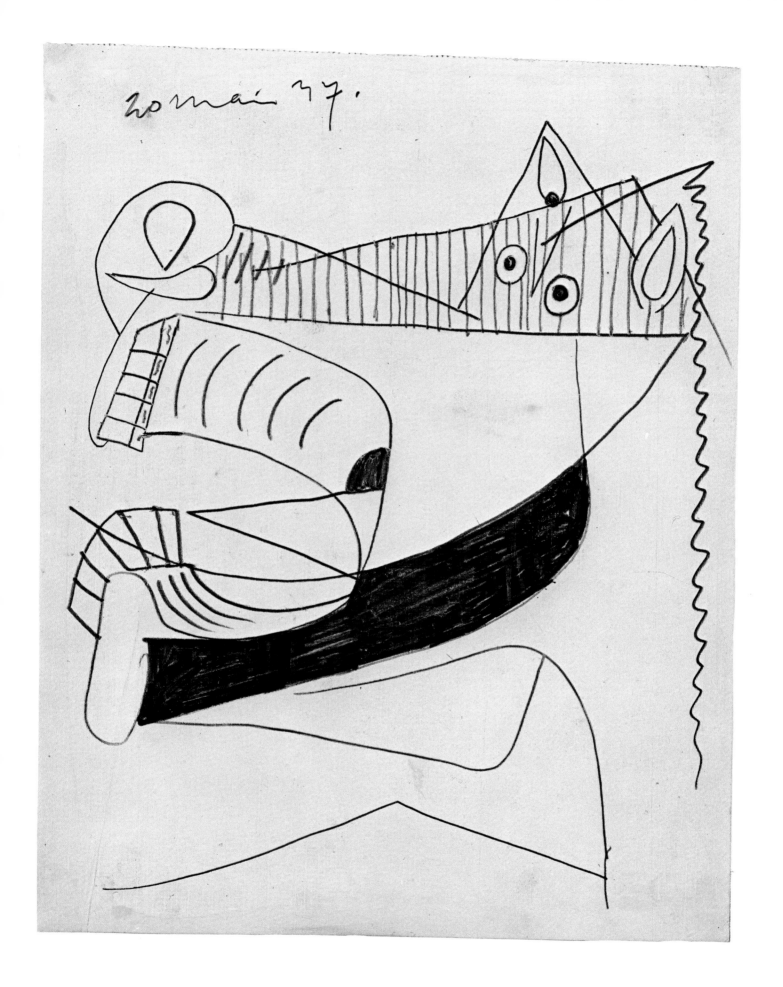

20 mai 37.

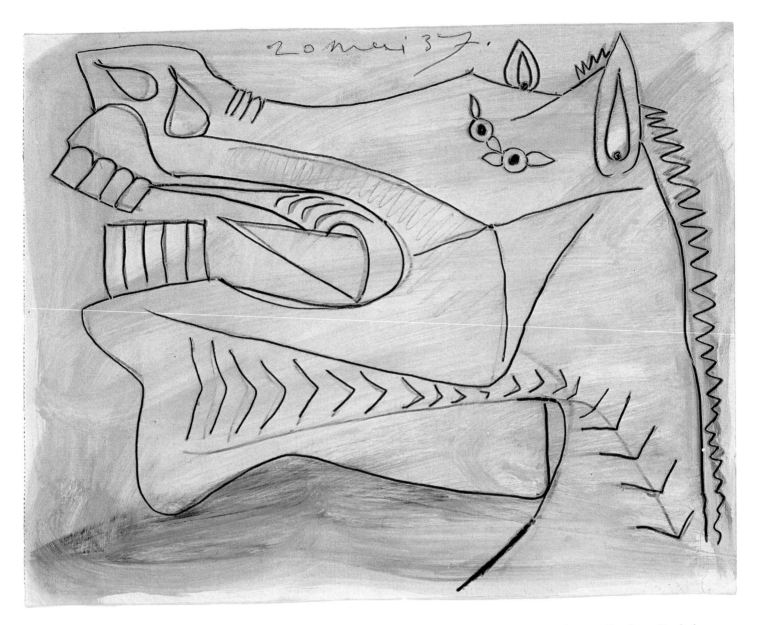

Plate 29 Sketch 29. *Head of Horse*, 20 May 1937. Pencil and gouache. 9¼″ × 11½″ (23.5 × 29.2 cm).

Plate 30 Sketch 30. *Head of Woman*, 20 May 1937. Pencil and gouache. 11½″ × 9¼″ (29.2 × 23.5 cm).

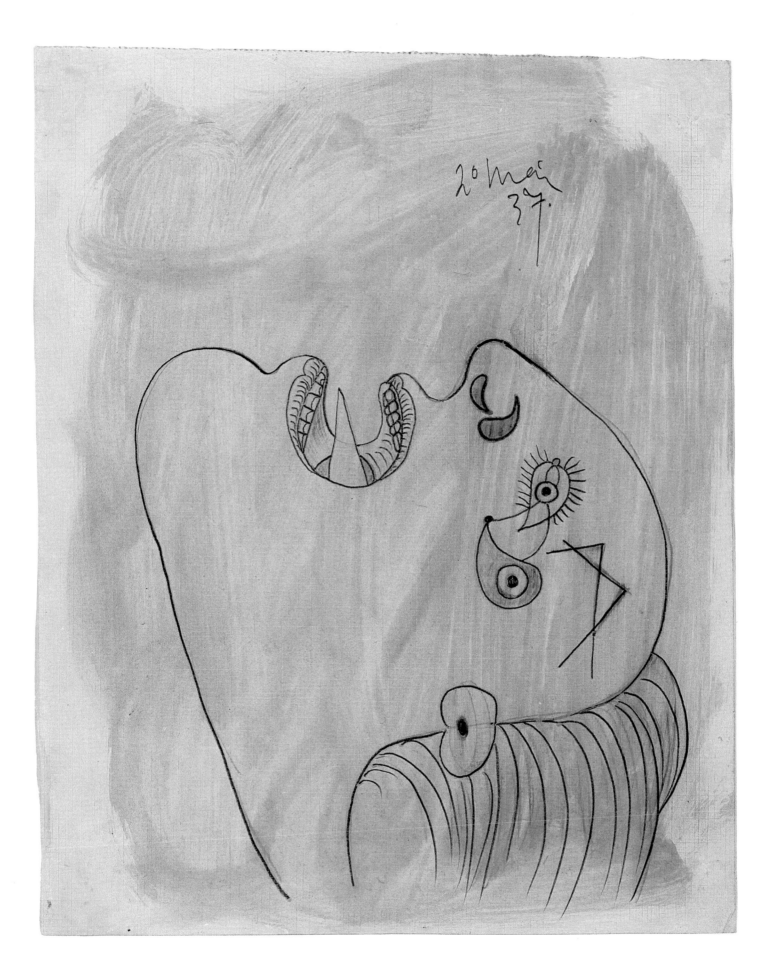

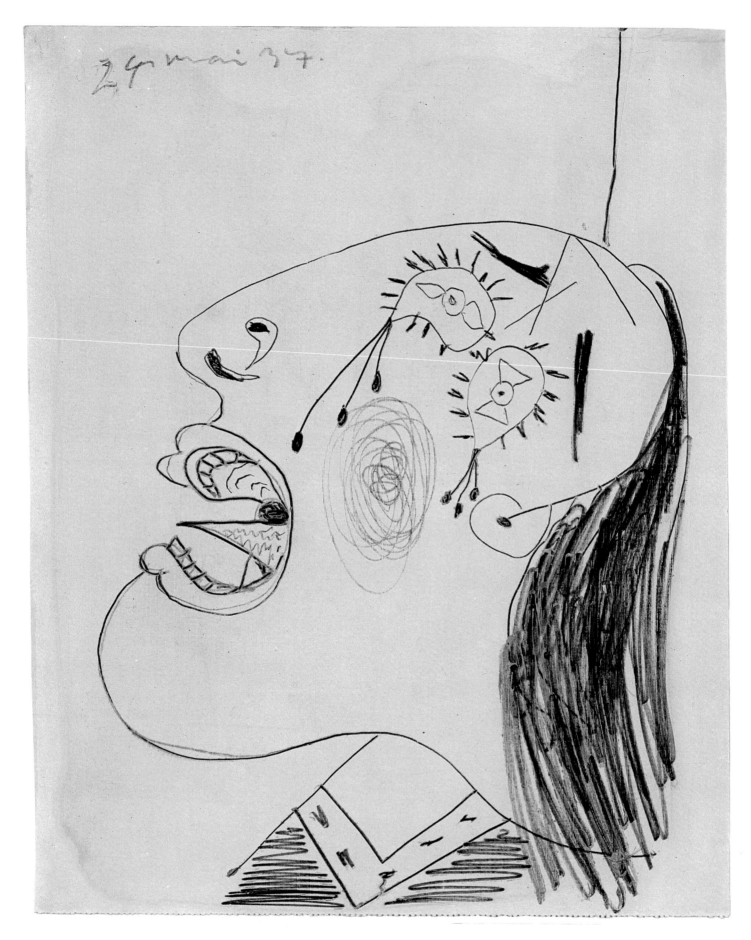

24 mai 37.

Plate 31 Sketch 31. *Head of
Weeping Woman*, 24 May
1937. Pencil and gouache.
11½″ × 9¼″ (29.2 × 23.5 cm).

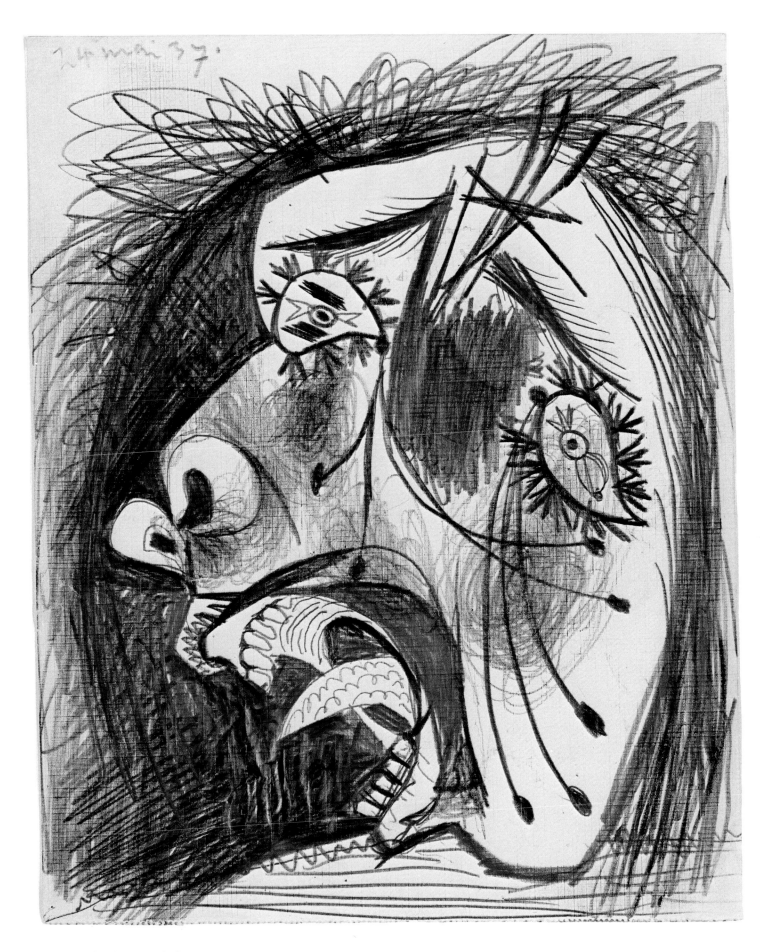

Plate 32 Sketch 32. *Head of
Weeping Woman*, 24 May
1937. Pencil and gouache. 11½″
× 9¼″ (29.2 × 23.5 cm).

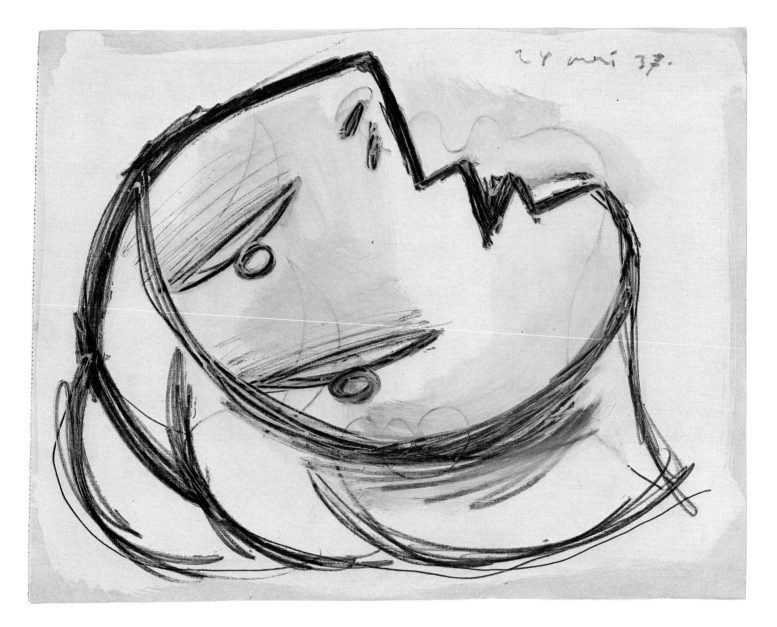

Plate 33 Sketch 33. *Head of*
Fallen Figure (woman?), 24
May 1937. Pencil and gouache.
9¼″ × 11½″ (23.5 × 29.2 cm).

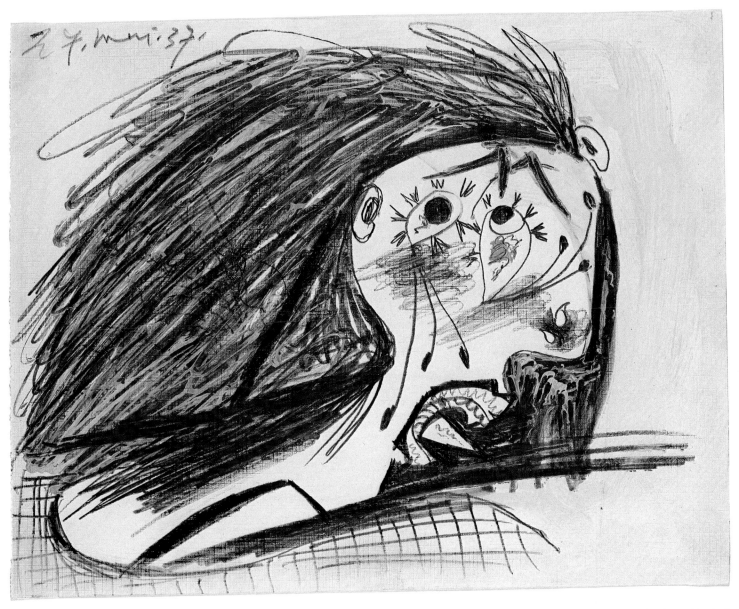

Plate 34 Sketch 34. *Head of Weeping Woman*, 27 May 1937. Pencil and gouache. $9\frac{1}{4}''$ × $11\frac{1}{2}''$ (23.5 × 29.2 cm).

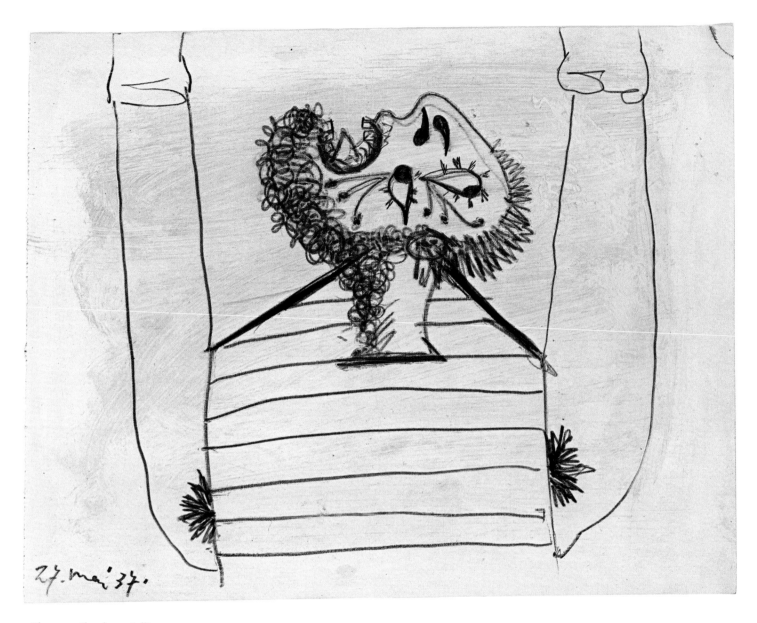

Plate 35 Sketch 35. *Falling Man*, 27 May 1937. Pencil and gouache. 9¼″ × 11½″ (23.5 × 29.2 cm).

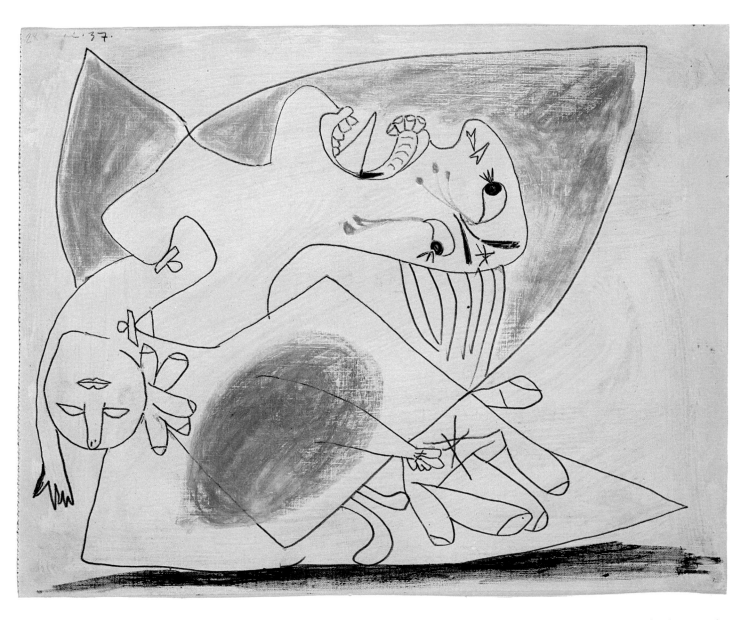

Plate 36 Sketch 36. *Mother with Dead Child*, 28 May 1937. Pencil, color crayons, and gouache. $9\frac{1}{4}'' \times 11\frac{1}{2}''$ (23.5 × 29.2 cm).

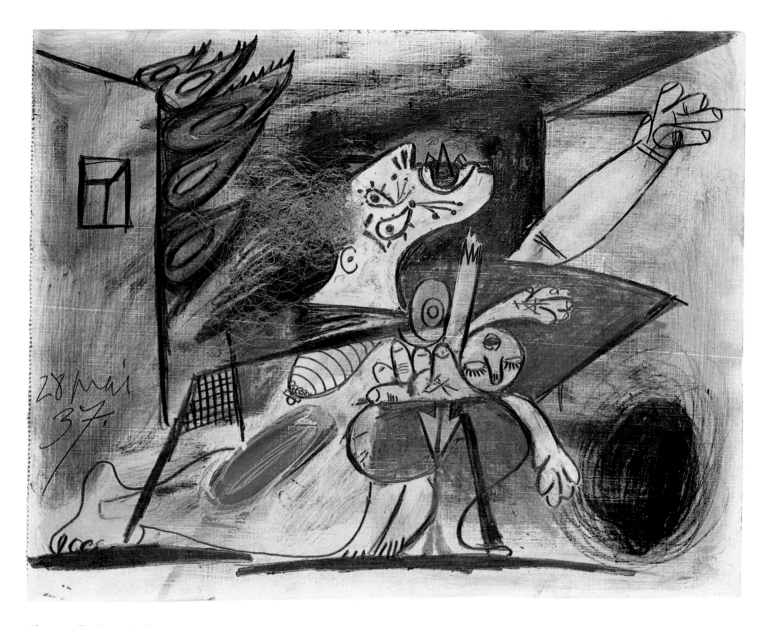

Plate 37 Sketch 37. *Mother
with Dead Child,* 28 May
1937. Pencil, color crayons,
gouache, and hair. 9¼″ × 11½″
(23.5 × 29.2 cm).

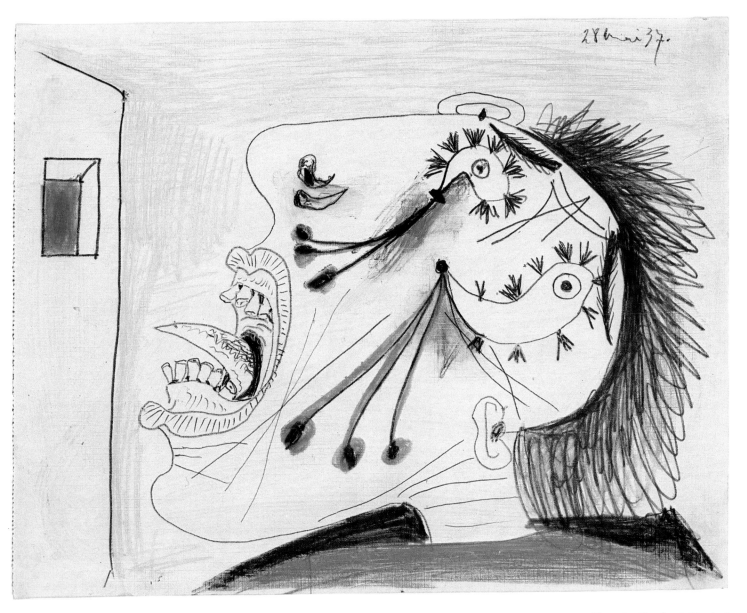

28 mai 37.

Plate 38 Sketch 38. *Head of Weeping Woman*, 28 May 1937. Pencil, color crayons, and gouache. 9¼″ × 11½″ (23.5 × 29.2 cm).

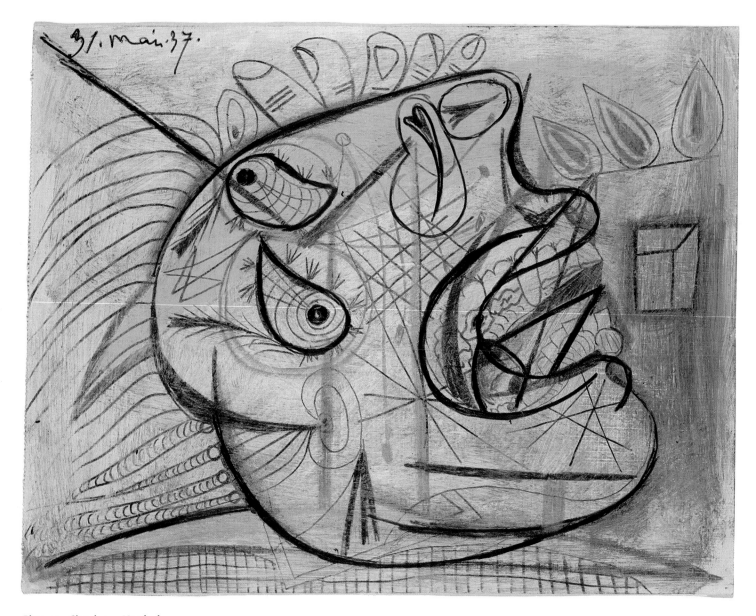

Plate 39 Sketch 39. *Head of
Weeping Woman*, 31 May
1937. Pencil, color crayons,
and gouache. $9\frac{1}{4}'' \times 11\frac{1}{2}''$
(23.5 × 29.2 cm).

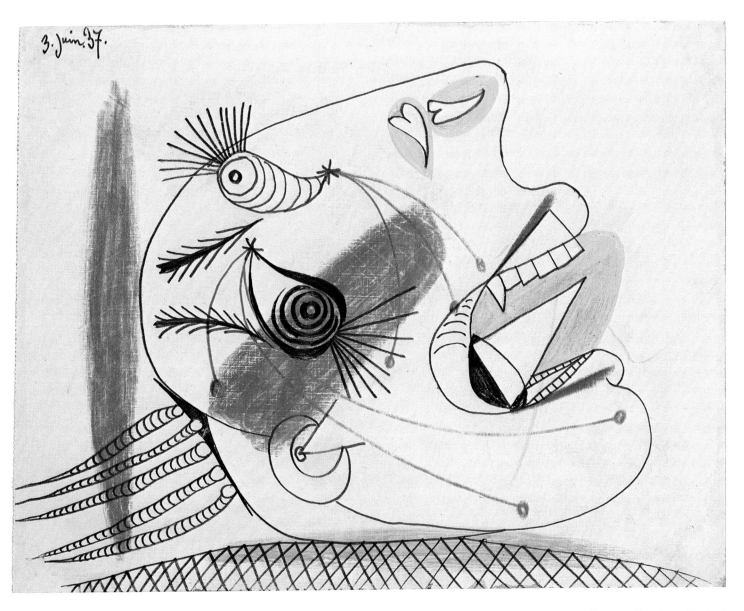

3. juin. 37.

Plate 40 Sketch 40. *Head of
Weeping Woman,* 3 June 1937.
Pencil, color crayons, and
gouache. $9\frac{1}{4}'' \times 11\frac{1}{2}''$ (23.5 ×
29.2 cm).

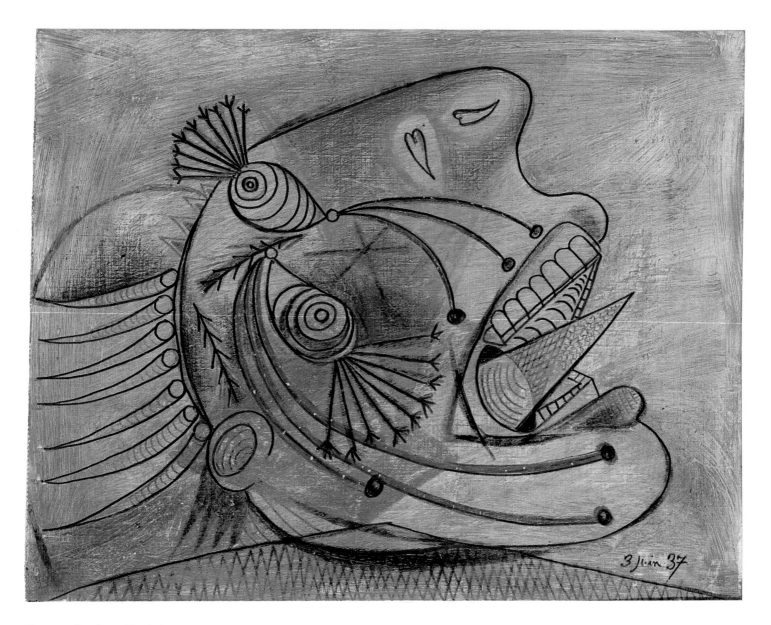

Plate 41 Sketch 41. *Head of Weeping Woman*, 3 June 1937. Pencil, color crayons, and gouache. $9\frac{1}{4}'' \times 11\frac{1}{2}''$ (23.5 × 29.2 cm).

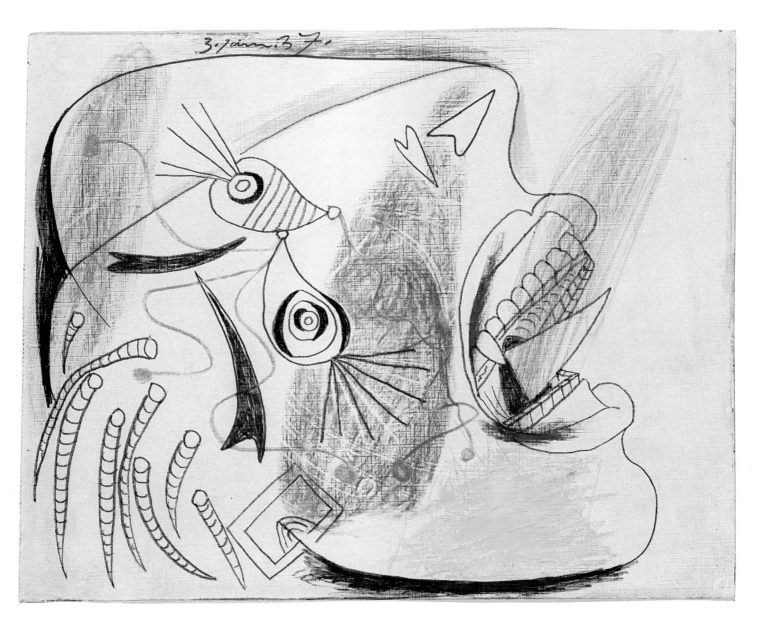

Plate 42 Sketch 42. *Head of Weeping Woman*, 3 June 1937. Pencil, color crayons, and gouache. $9\frac{1}{4}'' \times 11\frac{1}{2}''$ (23.5 × 29.2 cm).

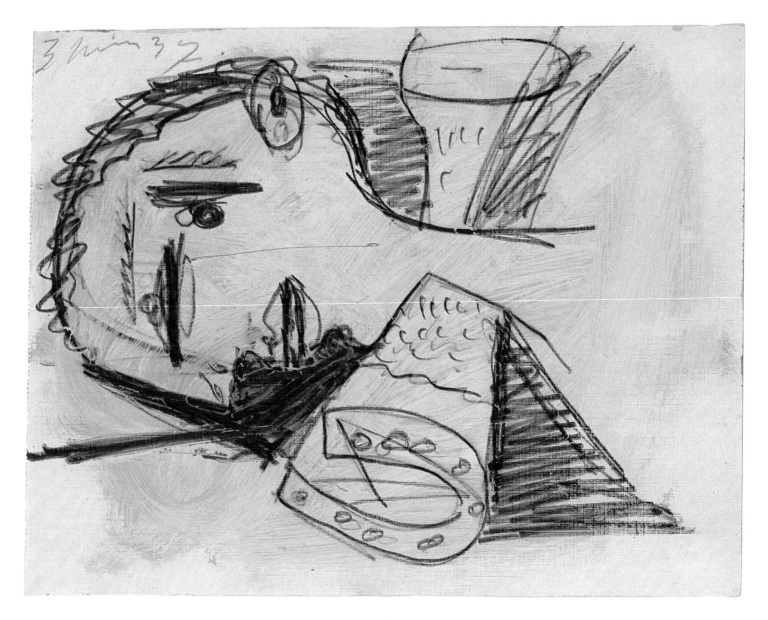

Plate 43 Sketch 43. *Head of Warrior and Horse's Hoof*, 3 June 1937. Pencil and gouache. $9\frac{1}{4}'' \times 11\frac{1}{2}''$ (23.5 × 29.2 cm).

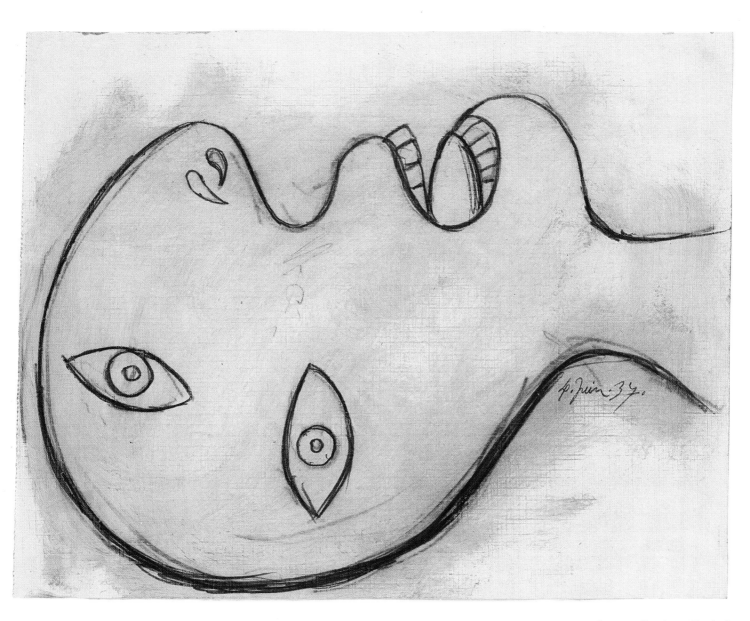

Plate 44 Sketch 44. *Head of
Warrior*, 4 June 1937. Pencil
and gouache. $9\frac{1}{4}'' \times 11\frac{1}{2}''$
(23.5 × 29.2 cm).

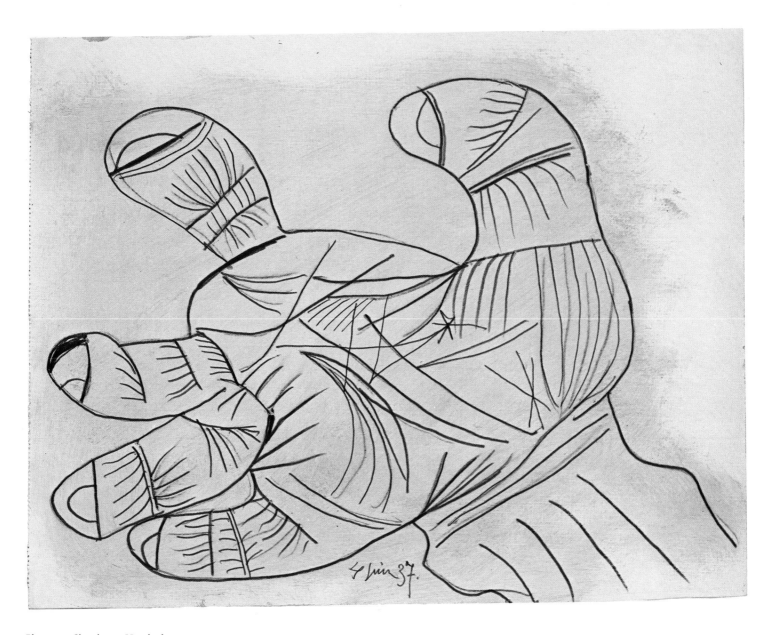

Plate 45 Sketch 45. *Hand of
Warrior*, 4 June 1937. Pencil
and gouache. $9\frac{1}{4}'' \times 11\frac{1}{2}''$
(23.5 × 29.2 cm).

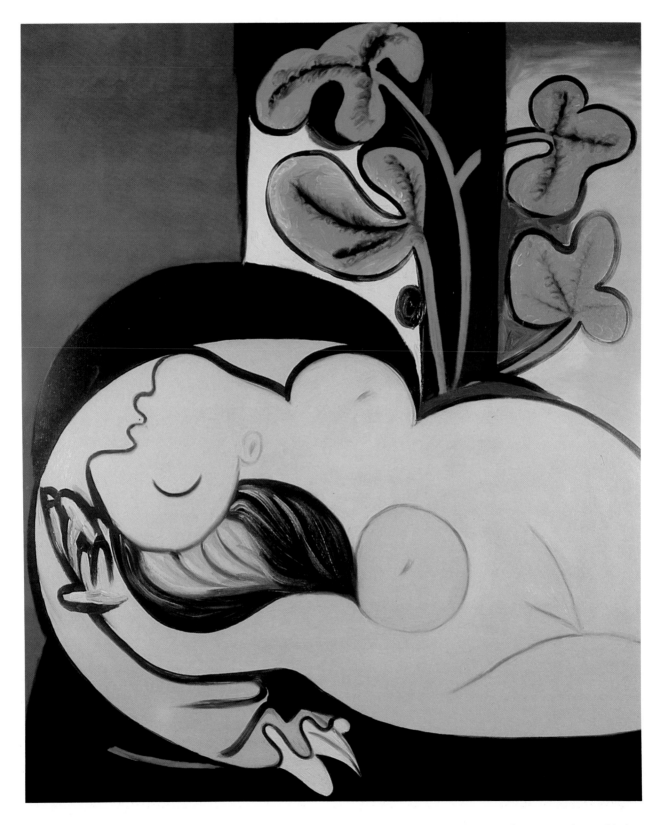

Plate 46 *Nude on a Black Couch*, 9 March 1932. Oil. 63¾″ × 51¼″ (162 × 130 cm). Z VII, 377. Private collection, San Francisco.

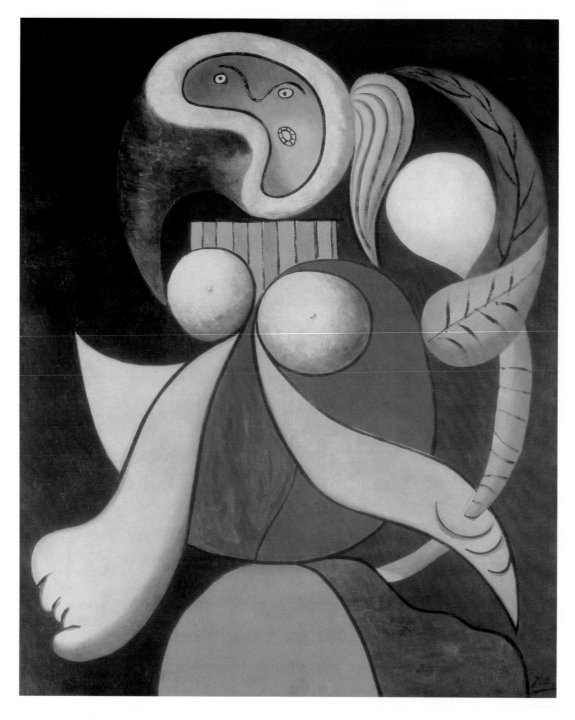

Plate 47 *Woman with a Flower*, 10 April 1932. Oil. 63¾″ × 51¼″ (162 × 130 cm). Z VII, 381. Collection Galerie Beyeler, Basel.

Plate 48 Sketch 48. *Head of Weeping Woman*, 13 June 1937. Pencil, color crayons, and gouache. 11½″ × 9¼″ (29.2 × 23.5 cm).

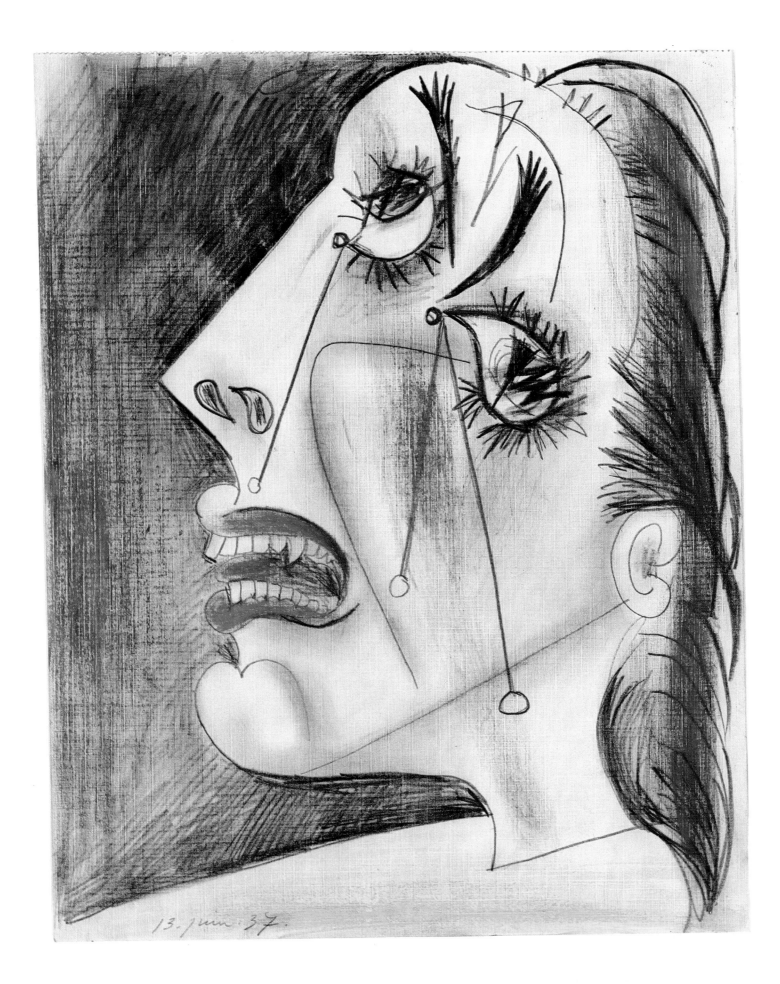

13. juin 37.

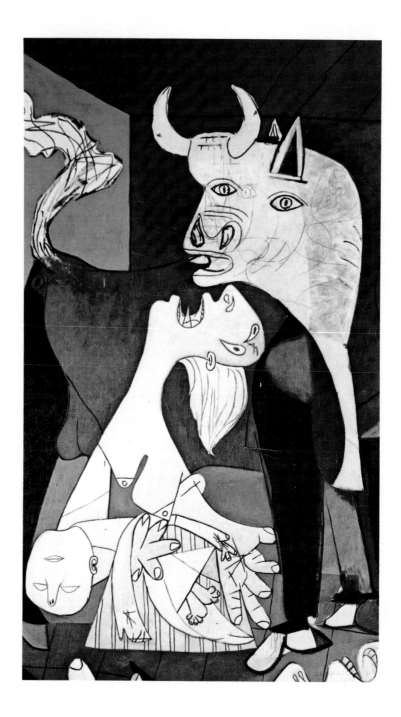

Plate 49 *Guernica* (det.).
Bull, woman, and child.

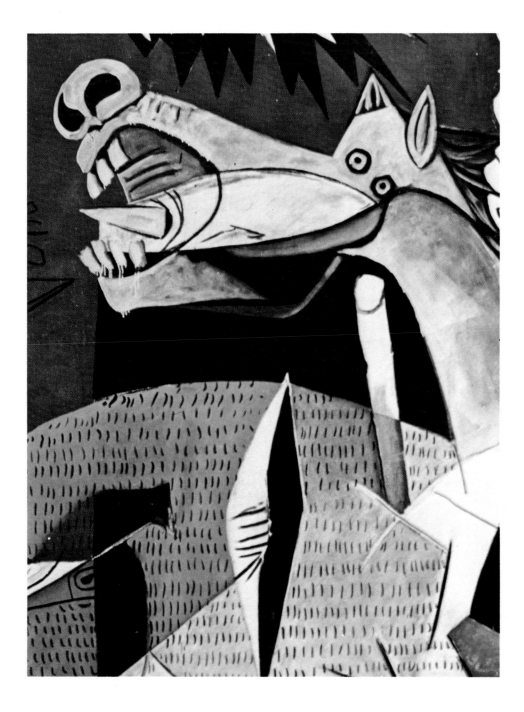

Plate 50 *Guernica* (det.).
Horse's head.

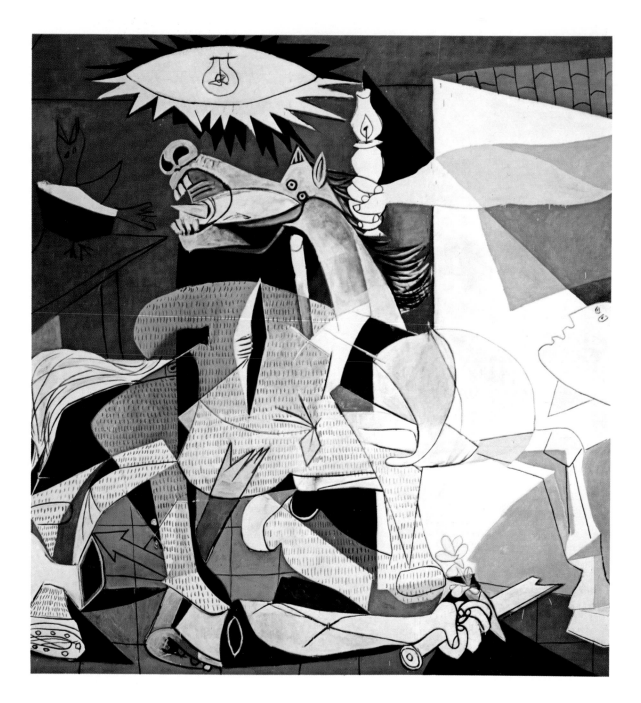

Plate 51 *Guernica* (det.).
Central pyramid.

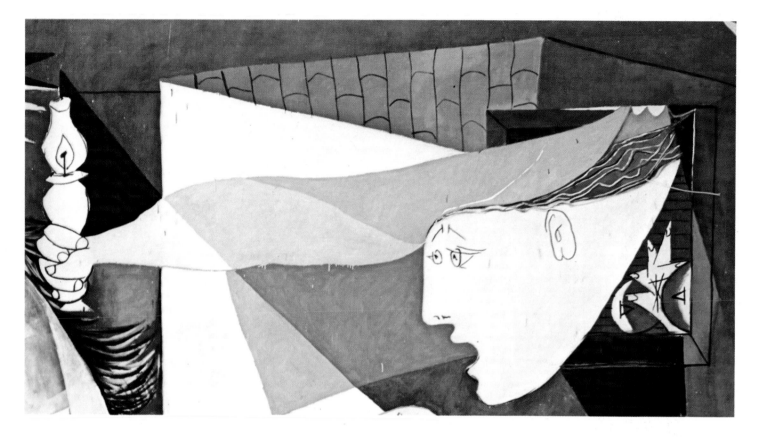

Plate 52 *Guernica* (det.).
Woman with lamp.

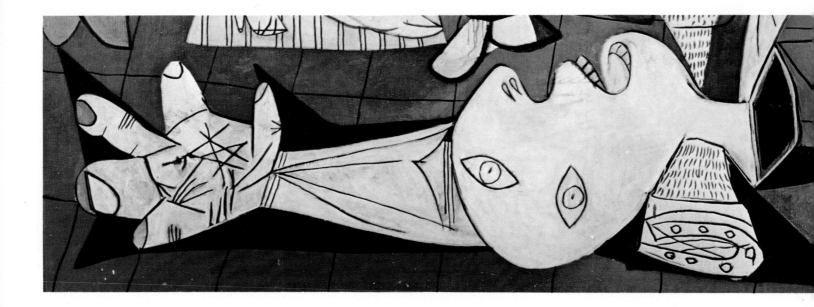

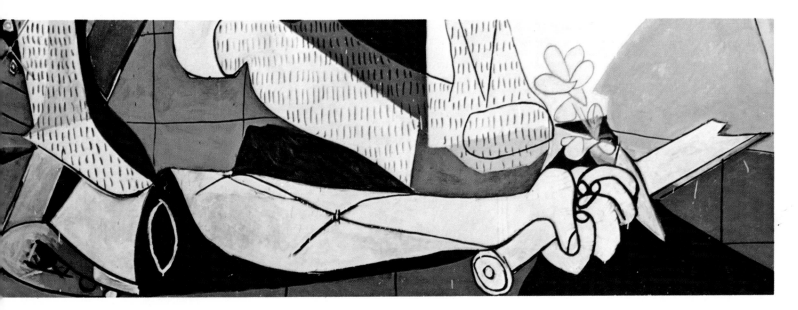

Plate 53 *Guernica* (det.).
Fallen warrior.

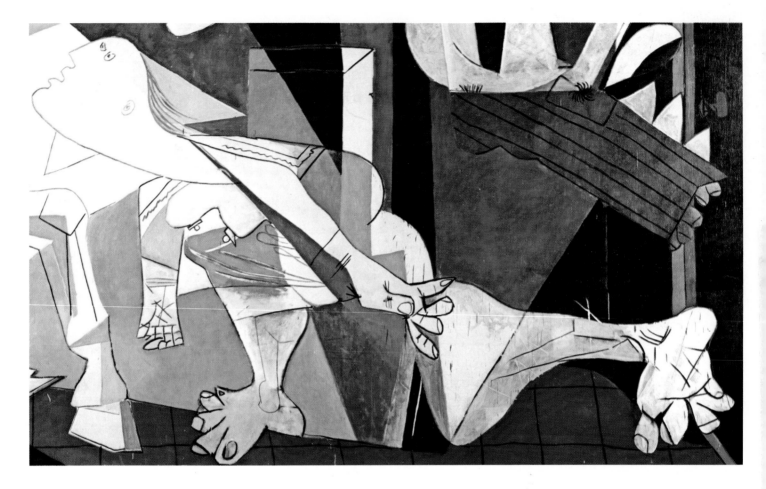

Plate 54 *Guernica* (det.).
Fleeing woman.

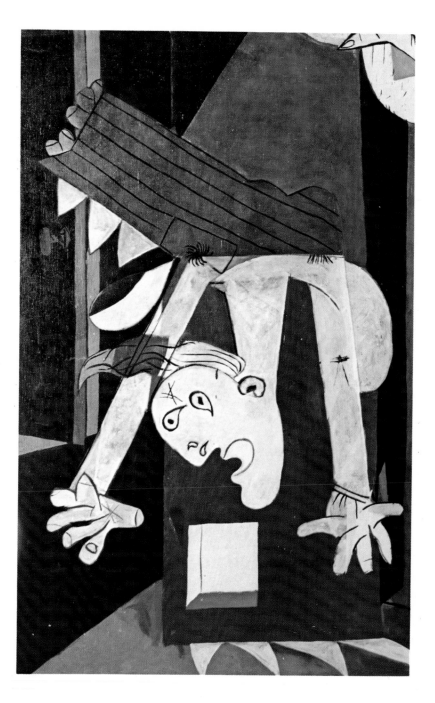

Plate 55 *Guernica* (det.).
Falling woman.

Designer: Steve Renick
Mechanicals: Campaigne & Somit
Compositor: G&S Typesetters, Inc.
Text: Linotron 202 Sabon
Display: Futura Book
Printer: Southeastern Printing Co., Inc.
Binder: H & H Bookbinding Co., Inc.
Editorial Coordinator: Stephanie Fay
Production Coordinator: Ellen M. Herman